CAPTURED

LESSONS *from* BEHIND *the* LENS *of a* LEGENDARY WILDLIFE PHOTOGRAPHER

MOOSE PETERSON

ACCLAIMED WILDLIFE PHOTOGRAPHER

CAPTURED

Lessons from Behind the Lens of a Legendary Wildlife Photographer

Captured
Book Team

CREATIVE DIRECTOR
Felix Nelson

ART DIRECTOR/DESIGNER
Jessica Maldonado

TRAFFIC DIRECTOR
Kim Gabriel

PRODUCTION MANAGER
Dave Damstra

EDITOR
Cindy Snyder

COPY EDITOR
Kim Doty

PHOTOGRAPHY BY
Moose Peterson

PRODUCTION SHOTS BY
WRP Staff

**GRAPHIC ELEMENTS
COURTESY OF:**
iStockphoto.com

**BACKGROUND TEXTURE
ON PAGES COURTESY OF:**
**László/Bleeding-Dragon
at DeviantArt**

Published by
New Riders
New Riders is an imprint of Peachpit, a division of Pearson Education

Copyright ©2011 by Kelby Corporate Management, Inc.

FIRST EDITION: October 2010

Composed in Frutiger, Hypatia Sans, and Zemke Hand by Kelby Media Group.

Trademarks

Warning and Disclaimer

ISBN 13: 978-0-321-72059-7
ISBN 10: 0-321-72059-8

9 8 7 6 5 4 3 2 1

www.peachpit.com
www.kelbytraining.com

PRODUCED BY

Kelbymedia
GROUP INC.

To my family—
Sharon, Brent & Jake—
who have stuck by me
and supported me as
I've chased the windmills.

About the Author

Moose's true passion is wildlife photography. He considers himself incredibly fortunate to be able to be amongst North America's critters and to bring back their story with his camera. Along the way, in Moose's 30-year career, he has been recognized for his assion by being named a Nikon Legend Behind the Lens and a Lexar Elite Photographer, receiving the John Muir Conservation Award, and being named a Research Associate with the Endangered Species Recovery Program, just to name a few.

Moose shares his knowledge through his writing—he's been published in more than 131 magazines worldwide, and is author of 24 books—and lectures across the country to thousands upon thousands of photographers. One of the original Nikon shooters to receive the D1 in 1999, Moose embraced this new technology, becoming the only wildlife photographer in the world to shoot strictly digital in the early years.

While acting as a beta tester for all the major hardware and software manufacturers, Moose continues his main goal of photographing the life history of North America's endangered wildlife and wild places. Being a creative innovator of new techniques, both behind the camera and the computer, is the driving force behind his photography and his goals.

Moose Peterson

Acknowledgments & Introduction

The nip in the air that signals fall slips into the open window of the truck. The notebook is open and the click of its keys can't be heard over the sound of the bugling elk. I've been incredibly fortunate and blessed in my photography career. This is a perfect example: I'm on a meadow in Yellowstone, writing, starting this book where it all started for me—in the great outdoors.

Being personally involved, I have a unique vantage point and can look inside to understand something about myself that you should understand in order to make the most of what follows— I am a living oxymoron. I'm at the cutting edge of digital photography, yet my photography is governed by some of the oldest traditions I learned at the beginning of my career. I love my 600mm VR lens with the 1.4x teleconverter attached, yet I'm not an eyeball photographer. I'm an incredible romantic always looking on the bright side of life, working mainly with subjects that end up going extinct—the cruelest reality of life next to the loss of a loved one. I'm fiercely loyal to my dear, dear friends, but breaking down my walls to get to that point scares most away. My priorities are real simple: Sharon, Brent, and Jake come first, photography comes second, and at the very end of the list is money. It's always been that way.

When Scott asked me to write for Guest Blog Wednesday on his blog, it came right at a point where a whole lot had just clicked in my head about life and photography. Sharon, Jake, and I had just returned from an incredibly amazing shoot in Alaska, photographing grizzly bears in three amazingly different locales (which you'll read about shortly). I saw in Jake's photography elements of my influence. More importantly, I saw his own vision emerging, bursting through, taking his wildlife photography on a path that will most definitely surpass mine. And that's how it should be. What I wrote for Scott's blog is what being involved in this glorious profession for 30 years brings to light: great photography is a lifetime in the making!

My good fortune started at birth—literally! I was two weeks old when I first visited the Sierras and where we now call home, Mammoth Lakes. I remember it like it was yesterday—not. But I can't help but think that original introduction to the pines and granite somehow started all of this wandering I still do through the wildernesses of North America. My mom and dad loved the outdoors, and being the last of four kids, many of the adventures were saved for me. We spent many a summer at the cabin on Lake Mamie, with my father and I donning our backpacks and taking off into the backcountry for days. That's where I saw my first mountain lion, alongside the John Muir Trail at Deer Creek. We had just passed a large boulder and made a turn when, behind us, we heard that call of the wild that sends shivers down your spine. We turned to see, just five feet above us, a magnificent cat staring down at us. I said something stupid like, "Think it likes trail biscuits?" My dad gave me that all-too-familiar "Don't be stupid" look, and we continued down the trail enriched by the experience.

My dad opened the doors to experiences that, early on, would truly shape who I have become. Devotion to family, my work ethic, and enjoying the simple things in life are just some of the lessons I learned from him in the short time we had together before his passing. Knowing how to use an axe properly was very important to him. Being able to strike a match and light it, and making the perfect kindling to create the perfect fire to bake pancakes might not seem like real important life lessons to some, but try it! (Funny, I passed those on to my boys, too.) He never gave me the answer to my questions; I had to think. He would help me find the answer, but it was in the finding that I learned. The whole time, it was to the simple mantra: Keep It Simple Stupid.

There are so many to thank who have pushed me up the trail. An old and dear friend Dave Dick, the editor who published my first article after telling me the writing sucked. He's the one who gave me this love affair I have with writing. At the start of this journey

was my good friend, Victor Borod at Nikon, who gave me that original encouragement and support (and loan of his camera) to take my dream and push it to a reality. My first photographic "boss," Peter Kolina at *Popular Photography*, who gave me the greatest words of advice I have ever received, and which I still work by to this day: "Write from your files." The crazy New Yorker, Peter Gould, whose faith that I knew everything Nikon way back when, but who wanted Sharon to write the book, because I "couldn't write." With that, he published my first book, *Nikon System Handbook*, which was the vehicle in which I made it onto the world stage (yes, I wrote it).

Dr. Dan Williams, one of the world's most amazing biologists, who took me under his arm and helped me understand, in a scientifically passionate manner, the natural world I'd been exploring with a camera. Dr. Patrick Kelly, who, despite his tireless working to save California's wild heritage, manages to keep me in mind and in the thick of things, keeping a focus on the little things in life. In fact, the roll call of biologists who have so impacted my life and photography requires a database to keep track of. My deepest thanks to George Sheppard, Dr. Ted Murphy, and Dr. Brian Cypher, who started, and have worked tirelessly to quench, my thirst for one of my favorite subjects (you're gonna have to read the rest of the book to find out who that is). I thank each and every one of you from the bottom of my heart!

There are so many in the photographic industry who have influenced my photography—I need more paper! Vincent Versace, who, early one morning showed me his vision of where digital was going (this was before the world had heard the word digital) at a PMA show. He later introduced me to Photoshop and folks who have become not just dear friends, but family: Scott Kelby, Dave Moser, Kathy Siler, RC, Margie, and all the rest at Kelby Media Group.

My dear friend Roger, who since high school has helped me into and out of trouble more times than any book could contain. There's my dear friend Laurie Excell, who has been along for the ride for a long time now. There's Kevin Dobler, who has gone on more crazy adventures with me, many that fill this book, taking wildlife photography to locales where it hadn't been taken before. I feel immensely fortunate to call Joe McNally my brother in crime and inspiration. Photography is a collection of more than shutter speeds and apertures—it's a collection of life experiences. Experiences shared with others who influence the way you see and, more importantly, feel about the world as you explore it. I can't say it enough, and the mere words "Thank you" don't quite cover it. I'm incredibly fortunate!

Most of all, I wouldn't be who I am, nor where I am at, without the unconditional support and love of my family, Sharon, Brent, and Jake! They know how I feel about them and you'll know by the time you've turned the last page.

Okay, no more mush. Down to business!

Author Note: My dad was a huge influence on my life, probably no more so than giving me the name Moose. Yeah, it's on my driver's license and passport. It's what I've been called by everyone, except my mom, from the very start. How did that come to be? Why Moose? (Better than Sue. Besides, that's my sister's name!) I wish I had a straight answer for the question, but my dad passed away before I could get one. Funny how life unfolds, though. It's hard to forget him or the lessons he instilled in me, since I'm reminded of them every time someone says my name.

Table of Contents

CHAPTER 1
You Gotta Start Somewhere

Sharon & I on southern sea otter watch on the San Simeon coast; BK (before kids).

On a ridge in the Yukon: -10° and Dall sheep all around.

Sharon & I at our home in the Sierra on my 50th birthday.

I used to determine a trip's success by the number of rolls shot. Now I know that was the wrong measuring tool.

My good ol' faithful '71 Camaro.

❝Will you go out with me?❞ That question launched the two great love affairs of my life. In my dad's new Dodge Dart Swinger (what a name for a car), I picked up my date. In the trunk was my new Minolta SRT202 (that I worked all summer to buy), with a 50mm f/1.4 lens, a 105mm f/3.5 lens, a 24mm lens borrowed from a friend, and my brother's tripod and cable release. With that, we made the drive down to Huntington Beach, and picked up gourmet sandwiches to eat on the beach (all this big spender could afford).

We parked, grabbed dinner and the camera gear, and walked down to the surf. The blanket was spread with care on the sand. A young boy's twitter filled the air as we laid out dinner (I'd been in love since the first time I saw my date months before), and the camera gear was carefully placed on the blanket. We sat down, unwrapped the sandwiches, and looked out over the ocean. What a beautiful sunset. Sunset?! "Excuse me," I said, dropped my dinner, grabbed my camera, and ran off down the beach, leaving my date (on our first date) sitting alone on the blanket.

I returned 20 minutes later, quite satisfied with the couple rolls of color negatives I'd exposed. My date was still sitting where I had so rudely left her. She hadn't touched another bite of dinner, and had carefully wrapped mine up. She greeted me with the smile and twinkle in her eyes that caught my heart the first time we met. One of the photos from that night won an award at the Los Angeles County Fair later that year. And the date? She's been my friend, partner, and companion on this photography quest that has filled our lives ever since. That's how the two great love affairs of my life began.

I'm telling you this because you need to understand something right from the start: I've been fortunate ever since that day (and before, as well, but that's a story for another time). You can't plan this stuff—I couldn't even dream it. Finding, at age 16 (Sharon was 15), a path in life and someone to share it with is, well, something you'd see in a sappy Disney movie. Yet, it's our life and plays a huge part in my photography.

You're Only as Good as Your Last Shot

Like many nerds in those days, I was in the high school photography class and club. A year after those sunset photos, I was working with what, back then, was pretty cool special effects stuff—grayscale lithography silhouettes. (I had a marvelous high school photography teacher. So many of the lessons he taught I not only use today, but teach to others.) I had a simple gull-in-flight shot that we took to litho and printed in various shades of gray and different sizes on a single sheet. It turned out pretty cool and, while I can still picture it in my mind, the actual print is long gone.

My photography teacher, Mr. Traub, took that print and, unbeknownst to me, submitted it for the big year-end Southern California high school photography competition. It was pretty high-tech back then and, while I made the original capture, the concept and technique for the final print was all Mr. Traub's. I just had to listen and execute. Well, that print cleaned up, taking all the top trophies and medals. I'll never forget the day Mr. Traub told my classmate Ricky and I that we had cleaned up the awards for a competition we had no clue we'd entered. It made one heck of an impression.

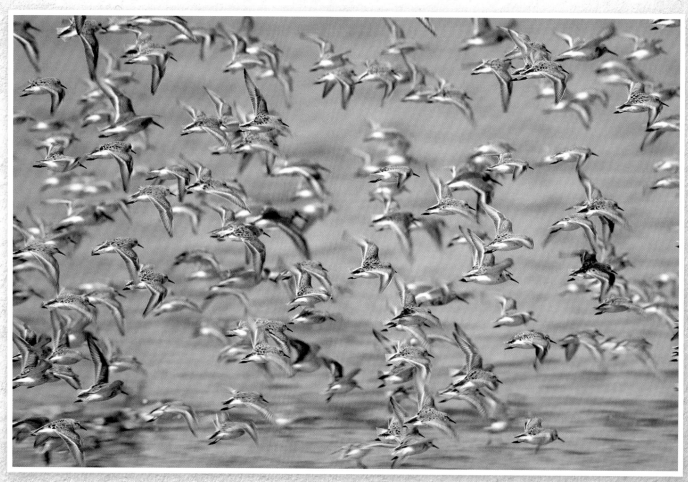

Sanderlings in flight. Photo captured by Nikon F3/T & Nikkor 400mm f/5.6 lens with TC-14 at f/8 on Kodachrome 64.

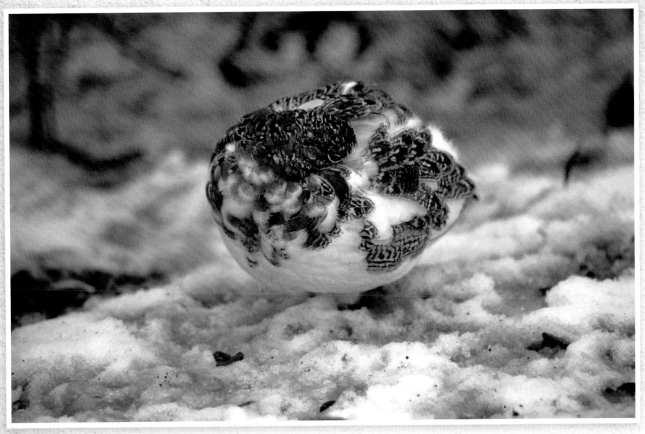

Willow ptarmigan. Photo captured by Nikon F5 & AF-S Nikkor 300mm f/4 lens on Agfa RSX 100.

That semester, though, Mr. Traub gave me a C. I was furious! Straight As, except that one C, and in a class in which I had won all those awards. That was a lesson I didn't understand or appreciate for a while, but it was real simple: "What have you done lately?" Or, "Don't let it go to your head; it's just one photograph." Or, more to the point these days, "You're only as good as the last photo you've taken." I still have that report card.

Because of my success in high school, I was recruited by Brooks Institute, a photography school. If I had to sum up what I took away from Brooks (I didn't graduate from there), it would be what it is to be a "professional" photographer: do your homework for every shoot, think through what you're trying to say with your camera, and have the tools to accomplish it when the camera goes click. It has served me well.

Experience Is the Best Teacher

I left Brooks when I decided I wasn't learning what I wanted to (and I was broke—it was darn expensive). What did an aspiring young photographer do in the 1980s to pursue photography? Go work for a camera store. Being different, I didn't apply at a big, conventional

Did you know you can save money by buying used gear? I buy a lot of gear that is called "Class B" or "refurbished." This is gear Nikon has loaned to folks like me for two weeks to review and then send back. It can't be sold as new after that, but it's like new, so it's a great savings.

Working a tree swallow nest at Mono County Park with my original TTL flash rig. I miss that hat!

store. Nope, I went to a store that was in an office smaller than a hotel room, where the camera gear—all Nikon—was laid out on a single coffee table. For the next few years, that's where I put in all my working hours. It's where I learned the Nikon system inside and out, as we built a larger and larger store with more and more Nikon gear, especially exotic and long glass. I became manager and had access to all of it, so when it came time to go shooting, if I didn't own it, I could borrow it.

One thing you should understand about me: I love camera gear. The smell of new gear coming out of its box, the feel of gear never before used, makes it hard for me not to buy something new all the time. I have a camera with a 600mm VR lens on a Gitzo tripod sitting by my desk, not only because I photograph the birds outside my office window, but because I simply like looking at it. I admit it's a sickness that, thankfully, there is no cure for and that my family puts up with.

I left Brooks knowing I wanted to be a landscape/nature/wildlife photographer. In the beginning, my mind was on landscape photography. That is, until that day "she" came through the door of the store. It was love at first sight! She might have been used when I bought her, but that Nikkor 400mm f/5.6 IF-ED lens was all shiny and new to me. I could be a wildlife photographer now—all it takes is a long lens, right?

Oh man, was my handholding technique for the birds back then. Getting a sharp image handheld, manually focusing for the first time, was a challenge to master and an important lesson from that lens. She was a faithful companion, and always in my lap with a Nikon F3 body attached as I cruised down the road shooting. Back then, my "shooting" vehicle was unique to say the very least. The rumble of the headers in my '71 Camaro was anything but silent, but that's what I had.

Right after buying the 400mm IF-ED lens, Sharon and I prowled the Santa Ynez valley (in the Camaro) for anything wild. Like any dutiful wildlife photographer, I was up before sunup, doing the sunrise shoot thing. How we ever saw anything with the rumble of the Camaro audible 100 miles off still puzzles me, yet we did (that damn car made the glass display windows on State Street vibrate when we passed).

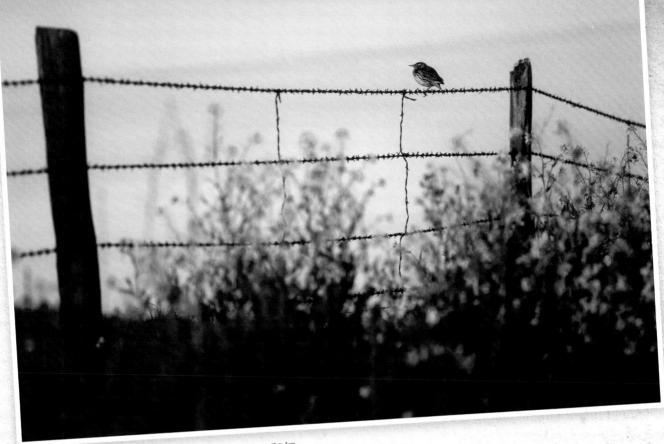

Western meadowlark. Photo captured by Nikon F3/T & Nikkor 400mm f/5.6 lens with TC-14 on Kodachrome 64.

Because of its noise, I learned one of the first lessons about using a vehicle for a blind: kill the engine and coast up beside the subject to get the shot. After a couple of failed attempts, we finally managed to roll up to one of the many western meadowlark males we saw that morning, perched on a barbed wire fence and singing. This time, the engine was off (the only way in that bad boy I was going to get a sharp image), and I'd learned to slowly ease the 400mm out the open window as we coasted up.

We were on a slight hill, so I took my foot off the brake, and we slowly, ever so slowly, rolled up on the singing male until the Camaro would roll no more. I slowly put the F3 with the 400mm lens up to my eye, then focused (this was before auto-focus was a tool). The male tilted his head back, and just as he started to sing, I hit the

If there is one lens I would recommend all wildlife photographers start with, it's a prime 400mm, and not a fast one. Canon shooters have it made with the EF 400mm f/5.6L—a schweet lens. Nikon shooters, our option is the very sweet 300mm f/4 AF (darn sharp lens) with a TC-14E II—a great combo, but a prime 400mm is best.

Sharpness in question? Shoot a burst because, more often than not, the middle frames in the burst will be the sharpest.

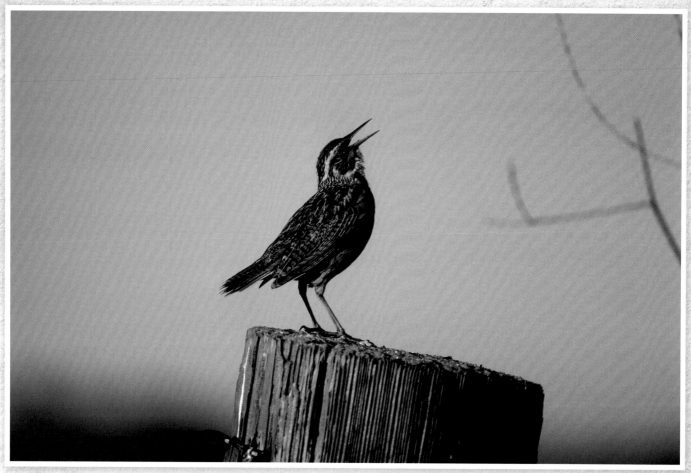

Western meadowlark. Photo captured by Nikon F3/T
& Nikkor 400mm f/5.6 lens with TC-14 on Kodachrome 64.

shutter release. I captured a couple of frames before he decided the competition with the shutter noise was too much and flew down to the ground. We continued to drive around looking for targets of opportunity, and once it was time for lunch, we headed back to Santa Barbara and the lab. By the time we finished lunch, the film was ready.

Nothing has changed, I'm still always very anxious to see my images. We raced back home with those white boxes. I went through them with reckless abandon in search of the western meadowlark sequence.

When I came upon it, the excitement was almost overwhelming. The subject was sharp, the exposure was correct, and I liked the images. They were perfect—perfect enough to encourage me to move forward, perfect enough that in later years they would be published many times (I didn't know that would happen back then). It was a start, with some lessons learned, that led to small successes.

Sharon and I were married now, just barely. She interrupted her college studies when we got married, so I could finish my time at

Inyo California towhee. Photo captured by Nikon F4e
& Nikkor 800mm f/5.6 lens with TC-14 on Fuji 100.

Brooks. When I hung it up at Brooks, we moved to Los Osos, near San Luis Obispo, so Sharon could finish her business degree. I managed to get a job as an assistant for a natural history photographer who lived in the area.

During my time at Brooks, I had gone to Los Angeles and "volunteered" to be an assistant for a couple of days just to learn what it was like to be an advertising photographer. (At that point, that's what I thought I wanted to be when I grew up.) By the time I got to

Los Osos, I had seen and worked in some of the biggest and best advertising studios (in those days), so I had one thing in my mind about what an assistant did. That idea was totally different, I would learn, than when I went to work as an assistant for a natural history photographer.

The first thing I learned at my new job about the wildlife photography business (and I wasn't even in the business yet) is that folks are not knocking down your door to buy your images. So, what do you

do to pay the bills? Just about everything you can think of! I spent the first few weeks at my new job out in the garage being a photographic supplies shipping clerk (and not a very good one at that) and product assembly guy. While it was a paycheck, it wasn't what I thought a photo assistant should do, and definitely wasn't taking me in the direction I wanted to go. I wasn't very happy. These were lean times, when the credit card was used way too much to buy film and pay for processing handled by the local Rexall drugstore. But we were newlyweds, living on the beautiful California Central Coast, so both love affairs flourished.

My First Nesting Bird

Living on the Central Coast affords a heck of a lot of photographic opportunities to the aggressive wildlife photographer. Our move to Los Osos coincided with the hummingbirds' nesting period (on the Pacific Coast, most hummingbirds start nesting in December). The Central Coast has a whole bunch of hummingbirds—they seemed to be literally everywhere, including in our own front yard, where I had a fuchsia garden growing. I'll never forget climbing on the roof of our duplex to photo-

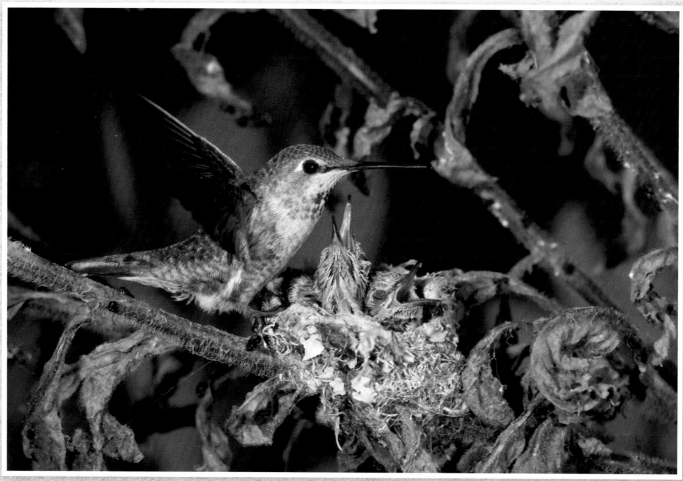

Anna's hummingbird with young. Photo captured by Nikon F3P & Nikkor 200mm f/4 IF micro lens, using two SB-12 flash units, on Kodachrome 64.

graph a nest using the boss's Norman 200B flash pack. Oh, did I get stares!

One day, a local naturalist/photographer dropped by my boss's home office. He'd found a cool nest and wanted to share it. This would be one of the first "shoots" I would go on as his assistant. The next morning found us walking through this gorgeous grove of dwarf oaks in a state reserve. After a short while, we came upon a very large clearing of poison oak. We stopped on the edge and looked where the naturalist was pointing. The nest was in the middle of the poison oak! We're talking about the stuff that, when it rubs your skin, can cause a nasty rash and horrible itching.

From the safety of the edge, we peered in with bins (binoculars). We spent some time there and determined that the female was sitting on eggs. The boss decided it wasn't a nest he wanted to photograph, so I asked if I could. When he said yes, life narrowed down my path a little more.

This nesting hummingbird, the very first nesting bird I ever photographed, set the stage for what has become my M.O. throughout my career, but I had two major issues/concerns/problems to deal with before I ever set up a tripod: I didn't know a thing about my subject, and I hadn't a clue how I was going to tackle the photographic aspects of what I had in my mind. The solution: homework and testing (what I do to this very day for every new project).

I had to hit the library to learn about the nesting biology of the Allen's hummingbird (this was before the days of the Internet). Luckily

Waiting for the plane to pick us up on Icy Reef in the Arctic National Wildlife Refuge. I still love having books to reference!

for me, Sharon had a part-time job at the Cal Poly (California Polytechnic State University) library, so I had access to its extensive biology section. The problem was that the library was a 40-minute drive from the house, so every time a new question came to mind, I had to write it down and wait until I went to the library or the library came home to me. Being impatient, this situation didn't work for me. Thus began my own personal biological library, which today is pretty darn extensive (even with the Internet, I still love having books to reference). There were two books I championed right off the bat, *A Guide to the Nests, Eggs, and Nestlings of North American Birds* by Paul Baicich and Colin Harrison (the most recent edition is 2005) and Arthur Bent's *Life Histories of North American Cuckoos, Goatsuckers, Hummingbirds and Their Allies* (long out of print, but a series of books to own).

Your first English teacher probably said to you what mine said to me, "To write about a subject, you have to know it." This applies 100% to photographing wildlife, and is something that occurred to me right from the start. Reading about who tends the nest and when, how long the eggs are incubated, how long there are hatchlings/nestlings, and when they fledge is all essential.

> If you have to narrow down the #1 reason why wildlife photographers don't capture "the" image, it most often is simply not seeing it coming. Biological knowledge makes all the difference. Yeah, we all get lucky at times, but time in and time out, success comes from knowing your subject!

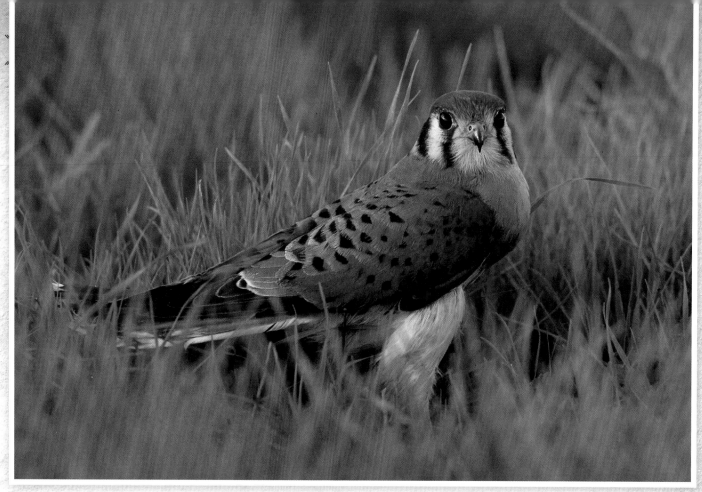

American kestrel. Photo captured by Nikon F3P
& Nikkor 400mm f/5.6 lens with TC-14 on Kodachrome 64.

During my research, a story had come to my ears about another photographer who was fairly well known back then (he's now long gone from the scene). He decided getting the photograph was worth any price—be it the expense of the gear, the allotment of time to capture the image, or the life of the subject. The photographs I saw were pretty cool, especially by the day's standards (which are much higher now), but then came the story of the price that was paid to get the photographs and how, because of the photographer's actions, the subjects died. I was totally appalled!

Thinking about it now gets my blood pressure going. The fact that this photographer is now history is neither here nor there, but the photographs themselves—the only record of that subject—are history, as well. They had such little worth, they didn't survive the test of time, and the subject—a gorgeous bird—gave its life for what? A moment of glory for the photographer, perhaps. That's why I said out loud to this photographer (who didn't seem to like me much afterward) what is on my website to this day: "No photograph is worth sacrificing the welfare of a subject!" I wasn't going to make that mistake, ever! From this very valuable lesson came my drive to always test before push comes to shove and the subject is in my viewfinder.

As I read more and more about the nesting biology of the Allen's hummingbird, I realized the clock was ticking. I only had a few days before the eggs would hatch and the show would begin. So with

the biology read, analyzed, and thought through, the technology had to be ironed out.

Controlling the Flash

Working in a dark forest with a subject whose wing beat tops out at 200 beats per minute, who can fly backwards, and who can hover while feeding its young, I realized a shutter speed of 1/30 of a second wasn't going to stop 'em for a moment! My only answer to this #1 technical problem of no light and stopping the action was flash.

This hummingbird nest was in a forest that didn't see much sunlight—what little it did see came early in the morning as the sun peeked in from the east under the canopy of dwarf oaks. It was obvious there would never be any ambient light to shoot with, the nest would have to be all lit with flash. In 1982, the options for portable flash were slim, and all required using guide numbers (aperture times flash-to-subject distance) to determine the flash exposure. This completely leaves out control over depth of field (DOF). I had the venerable Vivitar 283 flash in my bag, had access to the Norman 200B (a big, portable, and very powerful flash—the first burst would have reduced my subject to a single, crisp feather), and this new thing called the Speedlight SB-12, Nikon's first TTL (through-the-lens) flash.

TTL flash was brand spanking new. Olympus brought it out a couple of years prior to its introduction in Nikon's SB-12. The principle is pretty darn simple, really: The light from

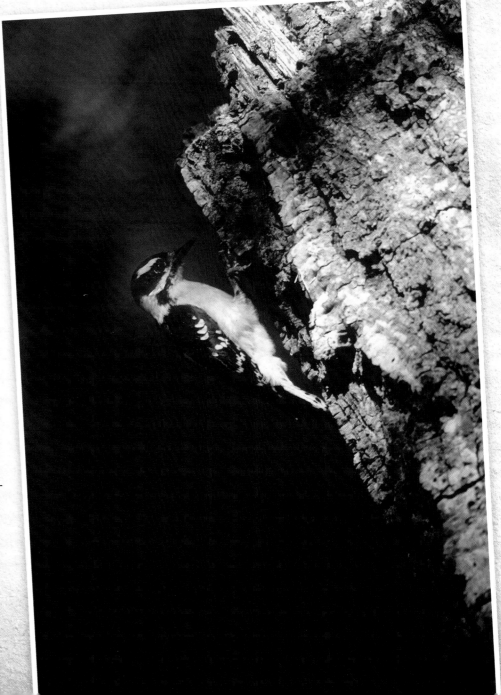

Downy woodpecker. Photo captured by Nikon F4e & Nikkor 75–300mm f/4.5 lens, using a Speedlight SB-16 flash unit, on Fuji 100.

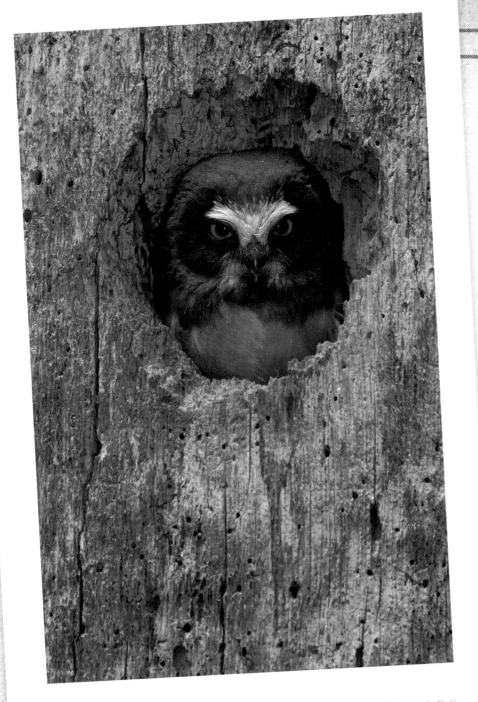

MOOSE PETERSON GALLERY SERIES

Northern saw-whet owl. Photo captured by Nikon F4e & AF Nikkor 600mm f/4 lens with TC-14, using an SB-16B flash unit, on Fuji 100.

the flash bursts out, that beam of light hits the subject, it reflects back, and travels through the lens barrel. At this point, it strikes the film, literally, and bounces down to a sensor that reads the light. This is when the computer works its magic. Based on what you, the photographer, desire, the camera gives you the right exposure for the flash. It's as simple as the light switch on your wall—you flip it up to turn the light on, and flip it down to turn it off. That's what the camera's computer does for you: turns the flash on and off to give you the right exposure.

What's amazing to me still (the technology has changed so little in 20 years) is this all happens at the speed of light. The main component of flash's exposure gets upstaged by TTL. TTL permits us to select the aperture *we* want for the DOF. TTL gives us control of the DOF, one of the most essential tools in our photographic arsenal. Now, guide number and flash-to-subject distance still play a role in our flash photography because physics is still physics. And flash power at the point of the subject is still governed by the inverse square law, but you don't have to think about those things at all anymore like I did when I first tested flash for the hummingbird nest. All you need now is to watch the red light on the back of the flash.

The hummingbird nest location dictated that the flash would be the key light and any ambient light that might squeak in would be the fill. When the nest and bird are both round, a single light source won't work. Two flashes are required. At the time, though, there was only one off-camera TTL cord: the SC-12. If you slave a flash, you lose TTL, which I needed to control the DOF. Again, two flashes were required, and only one cord was available. I had a soldering gun, so to me the answer was obvious: splice two SC-12s together. One night, that's what I went and did.

Splicing the SC-12s wasn't easy for many reasons: There were no schematics to follow, and no one to ask how it should go. Figuring out which LEDs carried information, which were power, and which were ground was exciting to say the least. If I blew up a flash, or camera, or both, not only could I not afford to replace anything, I could get injured. Those capacitors are not to be screwed with, and the one zap I received in the process garnered my respect for them.

After a night of work, I had a spliced SC-12 cord that fired off two SB-12 flash units. The ready light in the viewfinder worked—it would blink or go on/off indicating everything was working—so it was time to put it to the test. With the batteries recharged and loaded, I took the rig outside to do a real world test on a red-bulb

Being innovative in wildlife photography is important. I'm not talking about just owning the latest gear, but using your knowledge to make simple DIY accessories that make life easier, like I did in this case. Another example: Use a Velcro tie on your tripod head to attach the battery pack for your flash—a simple, clean, and effective innovation that makes you more efficient in the field.

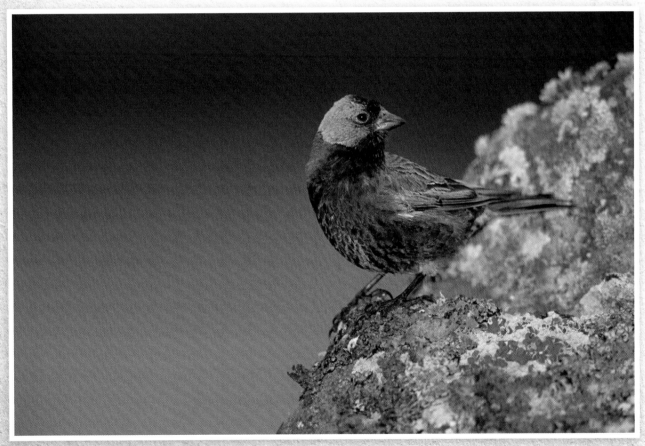

Gray-crowned rosy-finch. Photo captured by Nikon F5 & AF-S Nikkor 600mm f/4 lens with TC-14, using a Speedlight SB-80 flash unit, on Agfa RSX 100.

Christmas ornament. Why a red ornament? The gorget (throat patch) of a hummingbird requires a wraparound light in order for it all to glow. I needed something that color, shape, and size to test with. In a dark corner of my fuchsia garden, I shot my test roll and rushed it to the drug store for processing. It was just days before the eggs would hatch, and I was feeling the pressure.

The film came back overexposed! I was totally stumped. I rechecked everything a couple of times. I tried testing the light output using a flash meter, but that was useless. I shot a test partially using the flash meter anyway. Flash compensation in those early days was dialed in by a ring on the flash connector on the end of the SC-12 cord. Setting it to 0 worked perfectly fine when a single flash was attached to a single cord. Looking at the exposure of the original test, it appeared the flash was overexposed by a stop. The last half of the second test roll, I tried every combination I could think of, dialing in compensation on the body, then the SC-12 cord, then both of them.

The next day, which I had calculated was the day before the eggs should hatch, the film came back. I spread it across the light table, and there before me was one test image with the dead-on right exposure. I dug out my notes and frantically located the magic combo for that

On the Arctic plain in the Arctic National Wildlife Refuge, waiting for caribou to come through the pass. Waiting can be the hardest thing at times—on patience and the back!

one image. As it turned out, just setting one of the controls on the end of the SC-12 to –1 gave me the perfect exposure. I grabbed my gear and a couple rolls of film, and headed to the forest.

My camera setup was pretty simple, and remained the same during the whole nesting project. I had the new Nikon 200mm f/4 macro IF lens (which focused to one-half of life size) mounted to a Nikon F3. Using a macro bracket, the two SB-12s were attached to the SC-12 cord, attached to the bracket. That basically held the flashes 45 degrees away from the lens barrel and slightly above it. This was mounted, via the lens collar on the 200mm macro lens, to a Gitzo tripod (I've used Gitzos since day one). The last tool I had was a hat blind. I really hate blinds— I did then and still do—but this particular female hummer wasn't going to come into the nest without it, so that was that.

That first time we visited the nest, I wasn't able to actually look up close at it, so I didn't personally see the eggs. I didn't want to create a bigger or deeper path to the nest that a predator could follow, so I just hung back. Because of this, though, I didn't know the color of the eggs. Why is that important? Eggs that have been laid in the last few hours have a really cool reddish glow about them. This glow tells you that the eggs are new and helps you determine when they should hatch.

This thought went through my mind as I started into the forest. I parked and selected a different route than the first time, so as not to attract attention to myself or the nest. It meant a longer walk, but it protected the site. Coming in from the backside, it took me a couple of minutes to find the nest—everything was backwards. I stopped about 40–60 yards away and looked into it with bins before going right to it to set up. With hummers, only the female incubates the egg—the male is off making more babies. So if there is a hummer on the nest, it is the female. Once I finally zeroed in on the nest, I could see the female sitting on it. I put down my gear and waited. After a time, she left (probably to feed). That's the cue to get in and set up.

I quickly, but carefully, walked toward the nest, stepping where I wouldn't break branches or crush plants, so no visible trail was created. The rig was already mounted to the tripod, so I just set it down, put

My favorite tripod is the giant and pricey Gitzo 5560S GT. Do you need this same tripod? Nope. You have to determine what tripod works best for you. Head to Chapter 4 for more on this.

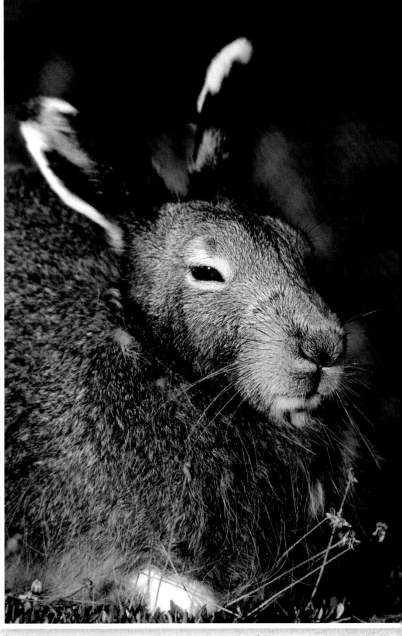

Arctic hare falling asleep. Photo captured by Nikon F4e & Nikkor 800mm lens on Fuji 100.

the hat blind on, and got into place. Not a moment too soon, because I heard the female come back (can't miss the buzz of those wings). While I could hear her, I couldn't see her (I hate blinds, because they make you blind). Then I heard nothing. She'd perched somewhere, most likely watching me. I froze in position after I checked the time. I knew I could only keep her off the nest for a maximum of 20 minutes—after that time, the eggs could be at risk.

After 10 minutes, my back started to bark at me, but I still didn't know where the female was. I wiggled ever so slightly, and instantly heard the buzz of her wings. Damn, she was watching me and I startled her. The buzzing stopped almost right away. After a few minutes, I heard her wings again, and then, out of the corner of my eye, I could see her off behind the nest. She hovered back there for a minute or two (my back said it was longer than that), then slowly moved toward the nest, keeping it between us. In a heartbeat, she was on the nest. Phew!

> ❝Always let the subject get comfortable before taking a photo.❞

The one thing you don't want to do in these instances is to just start blasting away. Always let the subject get comfortable before taking a photo. Here, I wanted the female to start warming the eggs again before I did anything, so five minutes went by. My back said it was time to go home. Eggs, yeah, but no hatchlings yet! I was off on the lay day, so I had the wrong hatch day. I took the obligatory "sitting on a nest" shot, which, after you have a couple, doesn't really change, so that's all you take.

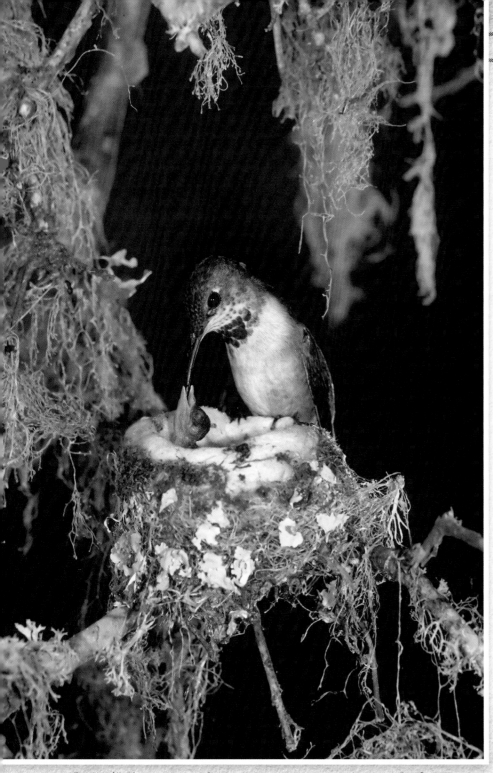

Female Allen's hummingbird feeding young. Photo captured by Nikon F3P & Nikkor 200mm f/4 IF micro lens, using two SB-12 flash units, on Kodachrome 64.

The next morning, I went through the same drill all over again. This time, though, when I peered at the nest through the bins, the female had a new energy. She would take to the wing and lift ever so slightly above the nest, settling back down after a few moments in a slightly new position. When she left, I walked in, and when I peered into the nest, there were two, spanking new, ugly-as-sin, miniature, cockroach-looking, black and shriveled baby hummingbirds. The eggs are not much bigger than a pea, and the hatchlings aren't any bigger when they come out. It wasn't an "Ah, how cute" moment, but rather an "Ooooh, oooh" moment as the hatchlings are rather ugly. After looking for a couple of moments, it was into the hat blind— just in time as the female came buzzing back in.

Birds can easily abandon a nest when there are just eggs. Laying new eggs when a nest with eggs is lost is not uncommon, but once the eggs hatch, the chance of a second clutch is quite slim, so there's another whole level of care once life appears. That's when I saw the most amazing sight: the hummer took that long bill of hers and shoved it into the mouth of the chick, all the freakin' way down to the other end—I swear! I figured the next thing I'd see was a harpooned chick on the end of the mother's bill, but the bill went in and then up and down, up and down, up and down—like a sewing machine needle—as she fed the chick. I didn't take a single photo! I was in such shock at the sight, I totally forgot to push the button. Luckily she fed the young again later, so I could get the shot.

Twelve days later, the young fledged, left the nest, and went out on their own. I visited the nest every other day to photographically record their

You're probably wondering how, after nearly 30 years, I remember so many details. Partly, that's just what my mind latches onto and retains. But, I also keep a journal for all my wildlife shooting adventures.

growth and watch the sword-swallowing act. It was an amazing show, watching the two chicks grow. I've never seen such growth in such a short period of time. I used the same gear the entire time, and it worked perfectly. The two SB-12s on the spliced SC-12 cord nailed the exposure and froze the subject, just as in the tests.

By this point, my light table had evolved from a small 8x10" portable to an actual table—a ping-pong table, that is. On trips to my parents' home, I often worked in the woodshop, building furniture that we needed for our duplex. (Ever tried to shove a table through the window of a Camaro?) The light table was one of those projects. When I asked my dad what scrap wood he had around that would work for it, he said the old ping-pong table would work nicely (still have that table 25 years later). My precious hummingbird photos came to life by the glow of those fluorescent tubes. I was only 22, but I already had some incredibly unique images in my files. While it's just a nesting story, the experience seared a mark in my consciousness and quickly narrowed down life a little bit more.

It was about this time when the boss decided he wanted to tap into some of my other talents. He had a pretty nice light table/sorting table in his corner office. His wet darkroom was almost finished, so he had me build a six-foot-tall drying cabinet for his film. Then, he took me into his "office" with the light table/sorting table, where there were piles and piles of yellow boxes held up by piles of slides. He opened the drawers in the filing cabinet, where there were more yellow boxes (for you young kids out there, that's what slides came in from the lab back in the old days), and said something like, "I want you to sort and file all of this."

He had looked at my images just once prior to this (about a month before) and had given me his prediction for my career as a natural history photographer: "You'll never make it as a photographer. Stick to carpentry; you're much better at that." With that still ringing in my ears, I said I wasn't going to sort and file his images. They were his images, and in my opinion, they were his to deal with and decide what got tossed or not. But it was another important lesson learned very early on, which really has served me well with digital: edit your images instantly and get them filed!

Allen's hummingbird chicks. Photo captured by Nikon F3P & Nikkor 200mm f/4 IF lens, using two SB-12 flash units, on Kodachrome 64.

> When is the best time of the year to photograph birds so they look their best? In the spring, just prior to nesting—they have their best feathers in their best condition for mating. This is when you want to photograph them, if at all possible.

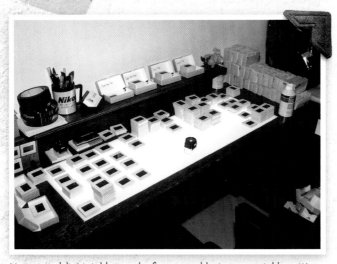

My original light table, made from an old ping-pong table, with slides spread out for editing. I miss the romance, not the work, of the light table.

Ever since that day, I have been persistent in that pursuit, and it's why I think my photography still improves to this day: because I look at what I shot that day, seeing what worked and what didn't, and learn from that. The one thing that improved my photography the most is digital. That's because I can review all my day's images *that night*. No lens, no technique, and no location did more to move my photography along than seeing every night what I shot that day. The #1 mistake all wildlife photographers make is that they don't go back and look at their images to figure out their failures and successes—what worked and what didn't, and what part of the story still needs to be covered.

Learning to Walk

As winter melted away into spring, the many shorebird species that come to Morro Bay showed up in their spring finest. We'd visited Morro Bay for a long time, but this was the first spring I looked at it as a photographic opportunity. The wetland and mud flats around the bay are just that: flat, but rich with life. You can see anyone out on them, even if they are in a canoe in one of the tidal creeks. You can seemingly see for miles with no obstructions. So, when you're 6'2" and walking around with what appears to be an Uzi, you really stand out. I know.

Wearing knee-high boots, I traveled the tidal creeks to access parts of the marsh that were otherwise only accessible by canoe. I worked the shorebirds by slowly walking the tidal paths with my 400mm f/5.6 lens and TC-14 teleconverter on my F3, all attached to a gunstock. The gunstock was a metal-and-plastic black unit, pretty slick and lightweight. This I held the same way a hunter carries a shotgun, ready to nail a pheasant coming off the ground. Since there was a duck hunting season on the bay, many assumed as they saw me walk around that I was a hunter (that is, during the hunting season. When it was not hunting season, I was a poacher—a really stupid one since I walked out in plain sight and hunted ducks with an Uzi). Parts of Morro Bay marsh are part of Morro Bay State Park, and the park rangers had jurisdiction over the marsh I shot in a lot. I got to know them really well! They soon knew that when a call came in about a 6'2" poacher carrying an Uzi on the marsh, Moose was out shooting—a camera.

By this point, I had acquired the TC-14, a 1.4x teleconverter (which in itself taught me a lesson or two). This gave my bird photography a big boost, and not just because I had a 560mm f/8 lens. After my hummingbird experience, I had no desire to work the shorebirds from a blind as I had been advised. (I have to admit, I wasn't really good at accepting photography advice way back when—I was pretty darn stubborn. I've never worn camo, either, and often make fun of those who do. On one project, the biologist told me I could wear a clown outfit, as long as I was

in the right place at the right time. Knowing basic biology trumps camo any day!)

With only a 560mm, the only way I was going to get the image size I required was to get physically close to the subject. In the beginning, there was failure after failure, disappointment after disappointment. I wasn't even getting close enough to fire off a frame. That helped with my budget, but not my goals. Then that all changed.

One morning, a red fox went zipping out across the marsh. I noticed, while it loped along, how it scared up the birds in its path. Then, when it thought it might have found prey, it drastically slowed up, got really low to the ground, and its legs went into cartoon slow motion. Each and every one of its steps was a rhythmical up and down, their placement on the ground methodical and exact. That crafty fox soon had its snack, and I had another lesson. When coming up to a bird, I started to walk much, much slower and my feet barely

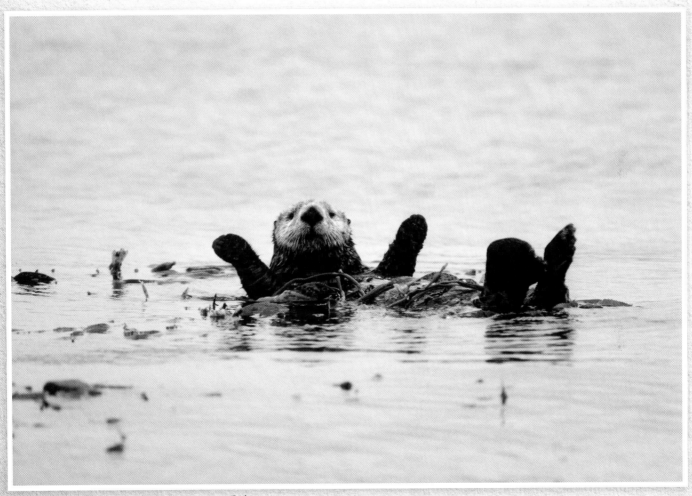

Southern sea otter. Photo captured by Nikon F3/T & Nikkor 400mm f/5.6 lens with TC-14 on Kodachrome 64.

came off the ground, moving rhythmically, with each step methodically placed. Forward motion was slow, but you know what? I started firing the camera, and the next day I had images on the light table to look at. Be smart as a fox—don't be in a rush to get nothing!

That first hummingbird nest was by no means the only photographic nest opportunity available to me that spring. There were other hummingbird nests I had an opportunity to photograph, but none from day one to day 12, like that first one. Hummingbirds weren't the only nesting birds around, either. While walking the marsh, I came across many killdeer nests. A very common shorebird, it's best known for doing the "broken wing" routine to lead a predator away from its

Be smart as a fox—don't be in a rush to get nothing.

nest (most shorebirds do this). You can use this biology to follow an adult back to its nest. Most of the nests I found on the marsh weren't photographable—they were either out where anyone could find them, so my sitting there with my Uzi would attract too much attention, or the nest was in a really ugly spot, like the gravel path to the golf course. One day, though, I found a nest a ways out in the marsh that could be safely photographed, so into research mode I went.

When I spotted this killdeer nest, I noticed that the eggs had the red glow. That was great news because it gave me the date they were laid. The red fox was about, though, and I didn't want to go

Lesser Yellowlegs. Photo captured by Nikon F4e & Nikkor 800mm f/5.6 lens on Fuji 100.

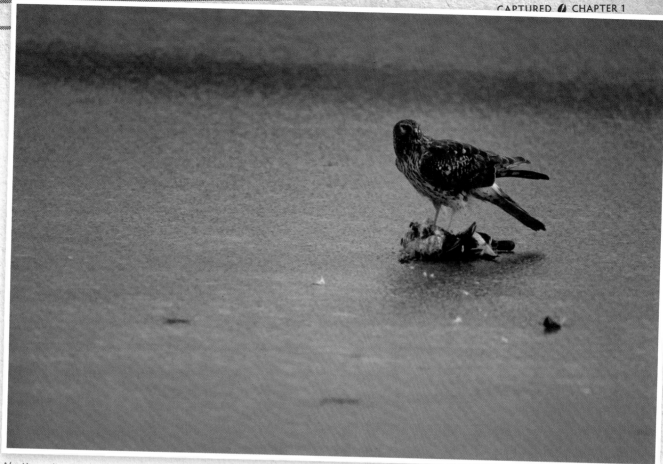

Northern harrier with prey. Photo captured by Nikon F3P & Nikkor 800mm f/5.6 lens with TC-14 on Fuji 100.

How do I find so many nests? I've been asked this many times, and it's one question I don't have an answer for. Is it a sixth sense I've been blessed with? Am I able to take in enough clues that nature provides and put them together in a way that leads me to the nest? I don't honestly know. I do go looking for them—it is a conscious effort, since I am so intrigued by the process of new life.

to the nest until the eggs hatched, so I backed out and left the nest alone. I faithfully told my boss what I saw on my scouting trips and what I photographed, but nothing caught his attention. (I will always remember that April, when I shot—on my transparently thin budget—21 rolls of film and he shot two. I never understood how a photographer could hone his craft, improve his visual communication skills, and call himself a photographer by only making 72 clicks in one month.) For some reason, though, when I told him about the killdeer nest, he wanted to photograph it. That was a good thing, because I needed to use his Norman 200B.

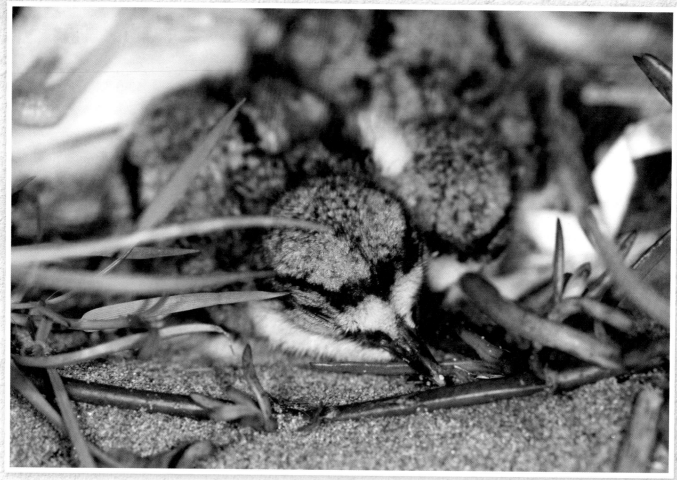

Killdeer chicks. Photo captured by Nikon F3P & Nikkor 400mm f/5.6 lens with TC-14, using a Norman 200B & two SB-12 flash units, on Kodachrome 64.

Once again, I plotted the hatching date. Unlike the hummingbirds, there was only one chance with this nest, because shorebird chicks are precocial, which means that as soon as they hatch and are dry, they leave the nest, not to return. They hang with mom and dad and go about the marsh, but the chicks feed themselves. On hatch day, we were out on the marsh not long after sunrise, glassing the nest to see what was up. It was way too cold to be getting the killdeer off the nest if my calculations were off. So there we were, standing, watching the nest, the boss watching his watch, as well as the nest. Had I, the young, overenthusiastic assistant who already had little credibility, gotten him out for nothing?

I swear, the boss started to wiggle like he was heading out and his mouth had just cracked like he was going to say he was out of there when the killdeer got up excitedly from the nest. We stared and stared in an attempt to confirm something. The clock seemed to stop. Then, after a few minutes, we saw a small head appear through

the grasses. That was the signal the hatching had begun. The parents didn't leave the nest and we weren't going to scare them off just for the photo. But to get the shot, we needed to get in and set up. By the time we could get to the nest safely and set up, all the eggs but one had hatched.

We had no ambient light to shoot the nest with (it was becoming a pattern), so we used three flashes to light the nest scrap (killdeer gather a couple of twigs and a rock or two into a circle and call it a day): the Norman 200B was at the camera and was the main light, while two small pocket flashes were slaved stage right and left, working as fill. It was quick and simple, and with a quick check with a flash meter, we were in business. Sitting on the ground, wrapped up in the hat blind, the boss shot first. It might have been my find, my research, and my calculations, but he was the boss and the owner of the 200B. I watched in the background (we were 10–12 feet away). Time was slipping by and I knew at some point the parents would fly off a short distance, do whatever they do to tell the chicks it was time to go, and they'd be off in the marsh—gone.

The boss shot his two rolls and was done. I got my turn in the hat blind and lucked out—the chick in the one egg that had not hatched was just emerging. I had a little time before it was dry and they might all leave. I shot and shot, two rolls were gone in nothing flat. That's when the fun really began. The one parent would

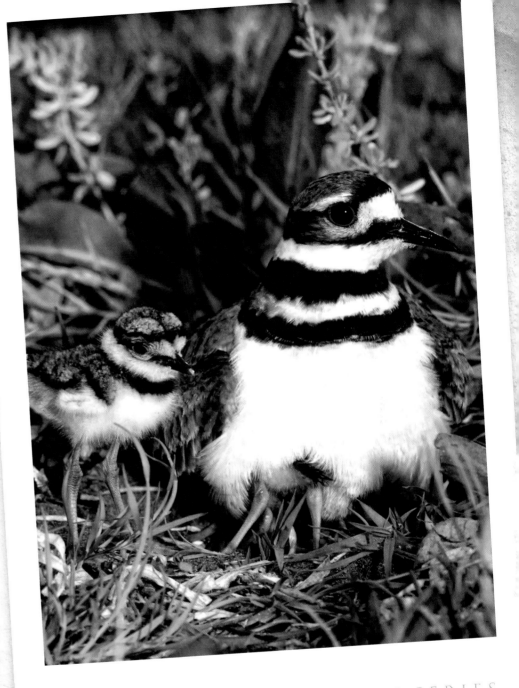

Killdeer parent & chick. Photo captured by Nikon F3P & Nikkor 400mm f/5.6 lens with TC-14, using a Norman 200B & two SB-12 flash units, on Kodachrome 64.

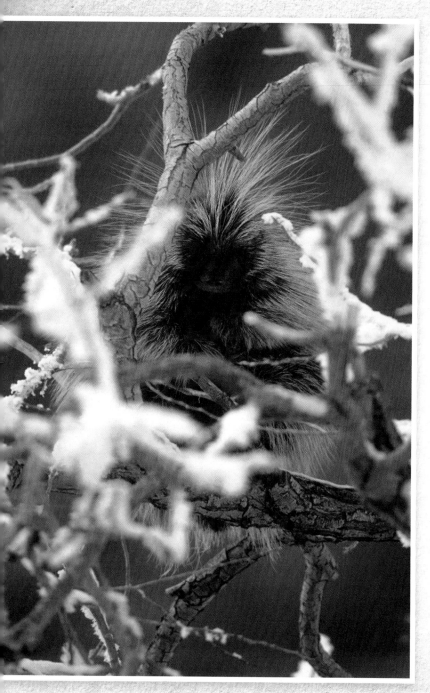

come and go from the nest cup, just barely moving out of lens shot, and then back to hover over the nest. When this happened, the chicks froze in whatever position they were in the instant the parent left. Standing, sitting, one leg up in the air, it didn't matter. This is a natural predator avoidance tactic that, along with the parent's broken wing routine, would keep the predator from spotting the chicks in the nest. Well, when the parent would come back to the nest (no way of telling the sexes apart visually), the chicks would spring back to life, and in a mad frantic dash, dive to get under the parent all at once.

The chicks would push with all their might to get under the parent. At times they would push so hard another chick would squirt out, and as fast as its legs would carry it (they looked like cotton balls on Q-tips), it would run to the front of the parent and start pushing to get right back in. Then, they would pop out through the wing, and go up over the parent's back. It was a minute of mayhem until, finally, all were safe and sound out of harm's way, tucked under the parent. I was about out of my five rolls of film (all I could afford to shoot that day) when the boss said it was time to go back to work. I didn't want to go, both because I wanted to shoot more (funny, I thought that was the job) and because it wasn't time for them to leave the nest yet. No matter, time to go! I eased up from the ground, and the parent walked off a short distance and instantly started to fake the broken wing. Click, click, click. Then I looked at the nest and saw the chicks there frozen—click, click, click. Time is everything in wildlife photography, and this was a prime example of an opportunity lost because of a lack of time.

Porcupine in tree.
Photo captured by Nikon F3P
& Nikkor 800mm f/5.6 lens
with TC-14 on Fuji 100.

Panning in Yosemite

By the end of June, I was out of work. I had been let go. Fired. Now what? A wannabe wildlife photographer already on a shoe-string budget with perhaps 200 images to his name ain't gonna get too far. How do you pay the bills? I spent a little over a year at non-photography jobs—Mervyn's department store and a shoe store. Sharon kept me well stocked with books from Cal Poly, all biological- or California history–oriented, so it was a great time of learning. The downside was that I wasn't shooting much (or at all). That was gnawing away at me (still does when I don't shoot for a day or two).

Then life once again stepped in and took over. One day, the boss at the old camera store called and asked if I would come back to work and expand the store. Sharon wasn't finished with school—she still had a semester left. There were no leftover funds at the end of the month to pay for photography and the shoe store was closing. Taking the job would mean my living part of the time in Santa Barbara and commuting, at the very least, on the weekends back to Los Osos and Sharon. I took the job and went back to the camera store.

What's the first thing you do when you get a new job? Hell, you go on vacation. At least that's what we did. Our longtime good friend (and best man at our wedding) Roger drove up to Los Osos and piled his camping gear with ours into the Camaro, and off we went to Yosemite. It was my first trip to Yosemite by car. I had hiked into the

> Where is my favorite place to shoot? This is a very common question and the honest answer is: home. I am very fortunate to live in the mountains surrounded by pine trees and wildlife, which is why I have a camera with a 600mm lens on it next to my desk. It is my favorite place to shoot!

> Being a beginner has a HUGE advantage that most beginners don't realize: Everything is new— every bird, mammal, body, and lens. Nothing is old. Nothing has been done before. It's all fresh, a challenge, and energizes your shooting by simply walking out the door. That's a HUGE advantage!

valley three times previously and was then driven out by car, but to actually drive into Yosemite to camp and explore the valley floor? These were firsts!

We drove up the east side of the Central Valley, up into the Sierra foothills, through the oaks and pines. We came out of the forest to a cliff edge, peering down to see the Merced River far below. The sign read "Turn On Headlights" as we entered a tunnel with a microscopic dot of light at the far end. That very first time we came through the tunnel and saw Tunnel View will forever be etched on the thin emulsion of my mind!

Before us, the entire Yosemite Valley was wrapped in a fog, just like an Ansel Adams photograph. Off in the east, in the distance, was Half Dome peeking through the clouds, and Clouds Rest totally invisible. After taking it all in, we descended into the valley and set up camp at Upper Pines (our favorite campground). It was fall and we hit the spectacular color perfectly: the oaks were ablaze with oranges and reds, which against the granite gray is just stunning.

We spent the first day as we still do to this day: walking and hiking the many trails in the valley. We had traveled down to the deli— a few miles from the campground—and were out on the meadow when the clouds started to come in. The light grew dark and moody, and with that, the camera was out. I was knocking around with a Nikon F3 and 35–200mm lens (a longtime favorite of mine). A Sierra storm was blowing in, something I did know quite a bit about. We started back toward camp.

On the way, we passed one of the many coyotes that call Yosemite home. I should say it passed us, since we were just standing there watching as it casually loped by us. Without thinking about it, I put the camera to my eye and shot. It was all over in a heartbeat, and ours were beating pretty darn fast—that was just darn cool! I then looked at my camera and noticed I was shooting at f/16 with Koda-chrome 64 slide film rated at ASA 80. My shutter speed was in the basement—1/30 of a second. "Oh well, those photos aren't going to turn out," I thought to myself. But they did come out and have long been favorites. That's how the technique of panning while shooting at a slow shutter speed was added to my photographic arsenal.

We woke the next morning to a fresh blanket of snow, and instantly took care of camp stuff so we could head out. The battery in the Camaro had gone dead in the cold, so on the bus we went. We headed down to the same meadow where we saw the coyote

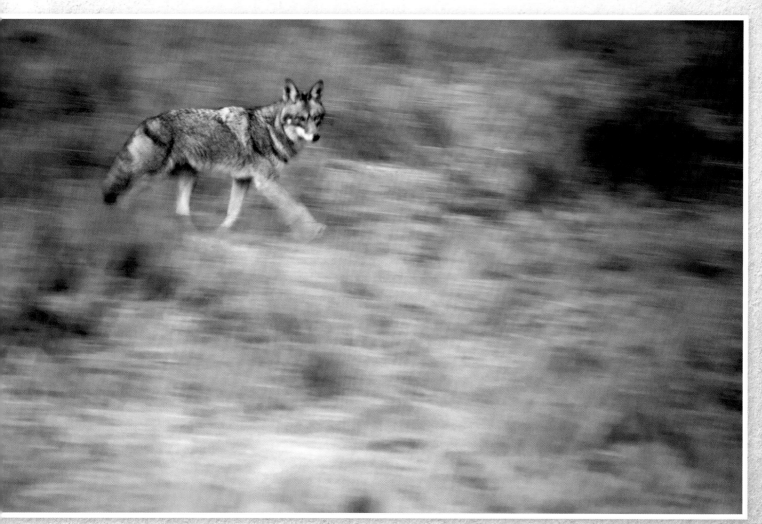

Coyote in Yosemite. Photo captured by Nikon F3/T & Nikkor 35–200mm f/3.5–5.6 lens on Kodachrome 64.

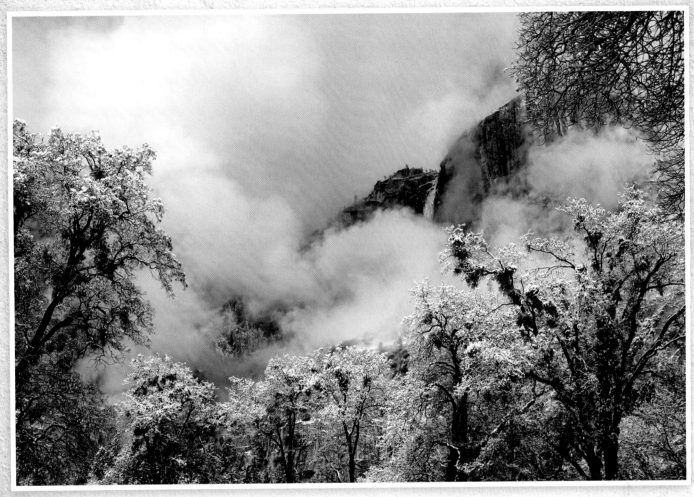

*Upper Yosemite Falls. Photo captured by Nikon F2AS
& Nikkor 35mm f/2 lens on Kodachrome 64.*

the day before. He was gone, but oh my, the valley all dressed in white was quite a sight! We walked down along the meadow and looked up just as the storm clouds started to part around Upper Yosemite Falls. It was magnificent! I dashed across the street, managing not to slip on the ice or get hit by a delivery truck. My faithful 35mm f/2 lens was on the camera. Click…click…click…click. It's still one of our favorite images, a simple time when everything was new.

Redefining Greenhorn

I was right back in photography (well, at the back door knocking, at least), and back amongst camera gear. Now that I was "flush" again, it was time to get out shooting. There lay the challenge: I exchanged having time and no money, for having money and no time—the next important lesson. I was working 60-hour weeks, which helped rebuild the bank account, but did nothing for my shooting time.

Add to that the four-hour commute back and forth a couple times a week to get home to Sharon, and shooting time was pretty nonexistent. At least I could afford film, even if I couldn't expose any. Multitasking entered my life.

I don't remember what started it, but something entered my mind around this time and we started to look for peregrine falcons. In 1983, they were on the edge of extinction, with only a handful in California. We had seen one along the coast and I got it in my

On the edge of St. Paul Island's cliffs on a rare sunny day. What you don't see is the Coolpix 900 in my pocket that contains the first digital photo I would take and sell.

mind that I wanted to photograph them. I had none of the tools that I do now for finding the bird (or biologists), so the desire was there but going nowhere. My limited knowledge and search abilities left me frustrated, especially since the peregrine was kind of a local star in Morro Bay, with nests on top of Morro Rock. Then I heard through the local birding network that a student at Cal Poly worked for The Peregrine Fund, which helped restore the peregrines in California. Finding one student in the whole student body was like trying to find a needle in a haystack. I tried the best I could, but still struck out.

One day, Sharon was working at the library and, during a break, told the other kids there the story of my wanting to photograph the peregrine falcon and about this guy who worked for The Peregrine Fund. When she finished, one of the guys in the group said, "That's me!" That's right, the guy I was looking for who worked as a nest watcher for The Peregrine Fund worked with Sharon at the library the whole time. I told you my search abilities weren't too good back then.

It was my first project, and I was so woefully unprepared for what was required to make the most of the opportunity. I added a whole new meaning to the term "greenhorn." I did my research: I knew how endangered the peregrine was from DDT (a synthetic pesticide); I knew about the three subspecies, and understood the one I'd be working on migrates at times only inland and other times to South America; and I knew that, at the time, there were less than a dozen mated pairs in California and that The Peregrine Fund worked tirelessly to save eggs, hatch them, and then return the two-week-old chicks to the parents to maximize the survival rate.

The aerie, or nest site, I'd be at was on an oceanside cliff near Pismo Beach, California. It was on Union Oil property, so a hold harmless agreement had to be signed in order for me to venture onto their property. I was a nobody back then, so approval also had to be obtained from The Peregrine Fund to be with their program and spend time with one of their nest watchers, and I had to agree not to divulge the location of any of the aeries I visited. By the time

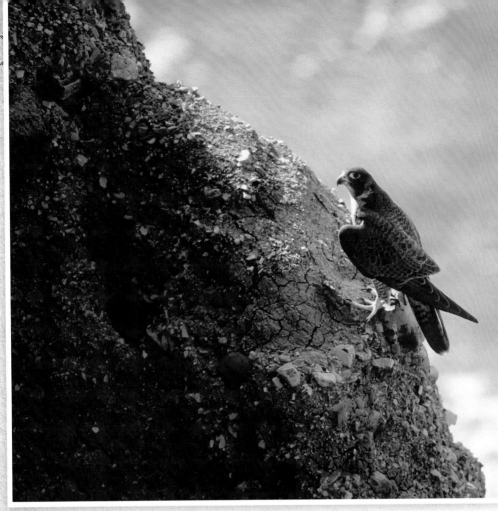

Peregrine falcon. Photo captured by Nikon F3P & Nikkor 400mm f/5.6 lens with TC-14 on Kodachrome 64.

I actually saw the first aerie, I thought I'd purchased a home with all the paperwork involved. Why was I doing this? I mean, I wasn't getting paid; it was all out of pocket (which barely had any lint, let alone any cash). If we'd known this would be a repeated pattern in our lives, I wonder if we (it was most definitely a Moose and Sharon venture) would've started down this path? Yeah, we would have!

Gary (the nest watcher for The Peregrine Fund who worked with Sharon) and I met at the local mini-mart, and with camera gear, lunch, and a folding chair in the trunk, I followed him down the road, through the locked gate, through the oil storage field, and out the dirt road that took us to the OP (biological speak for observation point). I had a whole day at the site. We parked, I grabbed my camera gear and chair, and followed Gary. The sun was just hitting the cliff tops, and the cool snap of the damp Pacific air smacked us in the face as the breeze from the ocean came up to greet us. With a giant, white oil storage tank behind us, we plunked down our chairs. Gary instantly glassed the cliff—no birds.

That's when the waiting game began. What was the goal of this whole project, both for myself and The Peregrine Fund? My goal, I thought at the time, was to photograph a peregrine falcon up close, to just see its face and have it tack sharp—that wildlife portrait trap so many wildlife photographers fall into. That goal would grow

considerably and quickly. The Peregrine Fund had a team of nest watchers watching every known aerie, so they knew when the eggs were laid.

In the '80s, because of DDT (which is still in the system to this day, coming up from South America in small passerines), the peregrine egg often came out as a slimy sack, not the hard eggshell you find in your store-bought egg. The fragility of the eggs often caused them to be crushed by the parent when it tried to incubate them, so they were lost. The Peregrine Fund would rescue the eggs almost as soon as they were laid, take them to their facility, and incubate and raise the young until they were about two weeks old, then the chicks would be returned to their nest to be raised by their parents. This process of exchanging the eggs was called "the manipulation." While this process sounds extreme, keep in mind that, today, the peregrine falcon thrives and is no longer a listed endangered species—one of our few success stories.

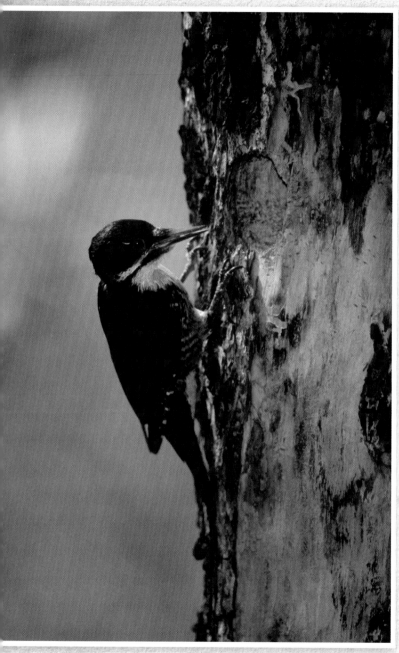

Black-backed woodpecker. Photo captured by Nikon F4e & Nikkor 800mm f/5.6 lens with TC-14 on Fuji 100.

Sunblock is a really good thing to use, but it can cause an oil slick on your gear. Be sure to give your gear a good cleaning that night if you've used sunblock while shooting that day.

Is a spotting scope a necessary tool for the wildlife photographer? I do use one on rare occasions, but not enough to say it's an important tool. You've probably heard of digiscoping (taking digital photos through a spotting scope) and wondered if it works. Oh yeah, it sure does, but the problem is that you have no control of DOF—that's a real liability!

So, there we sat: a stinking oil storage field behind us, and the spectacular Pacific Ocean and California coastline in front of us. At this point, we didn't know if the peregrines we were here to watch had laid eggs yet (they mate for life and these two had a reputation for being great parents). More than likely, not. Gary, a biology student at Cal Poly, was incredibly well qualified to watch the behavior of peregrines, and he knew from watching where they were in the nesting cycle. So, there we sat, looking out, waiting, talking. Time ticked by, the sun came up, sunblock went on, and no peregrines were seen.

Northern Pygmy Owl. Photo captured by Nikon F3/T & Nikkor 400mm f/2.8 lens on Kodachrome 64.

Telling a Story

Gary knew this pair of peregrines really well. When the male, called a tercel (the female is called a falcon), finally came screaming into the small notch in the cliff and sat on a particular rock perch, Gary instantly knew what was about to unfold. He had told me where the aerie was on the cliff. We couldn't actually see into it, but could see the edge of it. Gary had me watch it, because a few moments after the tercel's landing, the falcon came to the edge of the aerie and took to the air. From my reading, I thought I knew what would transpire next, but I was not prepared for what I saw.

Once the falcon took to the air, the tercel followed. Tercel is French for one-third, and the male is called that because he's about one-third the size of the female. The female can take much bigger prey than the tercel, but the tercel, because of its size, is a superior flier. The tercel soon caught up with the falcon as she winged up over the ocean. When he did, he flipped over on his back and, in midair,

handed her the prey he'd caught. Once she had the prey in hand (talon), the falcon turned around and headed back to the cliff, where she landed and ate it. It was simply amazing, and I never even raised my camera! Even if I had, nothing would have appeared on film, since it was too far for my 560mm focal length lens. But I was in such awe, the thought of taking a photograph never entered my mind.

Witnessing that event totally changed me, and I knew with all my soul why this project was important to me and why I had to succeed photographically. The head shot—the portrait—wouldn't tell the peregrine story. They were meant to be in the sky, on the wing, exploring the air and slicing it with their agility. The story was the peregrine in its world, and its world was the air.

Poor Gary. At this point, the questions started to stream out. The accounts I had read didn't describe the aerial exchange with any justice. They were dry, factual accounts—very biological—with

Peregrine falcon defending her nest during the manipulation. Photo captured by Nikon F3P & 25–50mm f/4 lens on Kodachrome 64.

no wow, romance, or excitement. How could I do that with my camera? How could my images bring that home in just *one* click? I required more knowledge, more thinking, more camera gear, and more importantly, techniques.

"Look, there," Gary pointed. That shook me back to the task at hand: watching for the production of eggs. The behavior of the falcon told Gary that an egg would be laid that day, and it was. Over the next couple of days, a couple more were laid, which gave The Fund a date for the manipulation. I had already learned a lot about peregrines in this short amount of time—a lot more than all my reading. For example, you read about what good eyesight and flight abilities the peregrine has, but until you watch a tercel take off from its cliff perch, fly like an F-117 straight out over the ocean to where you can barely pick him up as he goes into a stoop (aerial dive), and then wing back with a western sandpiper (a bird smaller than a tennis ball) in his talon, you can't truly appreciate their natural power.

The day of the manipulation came. Late in the afternoon, the team from The Peregrine Fund got in place above the aerie on the cliff. As soon as the tercel saw them, he was out of there! This was not the first, nor would it be the last, time this pair would go through this process. To put human traits to the pair's reaction (which you're not supposed to do), the male wanted nothing to do with the stress, so he chose to deal with it by splitting.

The falcon took the total opposite tack. The moment the climber took to the rope, the falcon was in his face. She called out so the whole world could hear her displeasure with the invader while she flew in circles in front of the aerie. The climber went down the face of the cliff, into the nest, placed the two eggs in the special, portable, heated box on his back, and replaced them with warmed porcelain eggs. Up he scrambled—passing the very pissed off falcon—to the top, where the team grabbed the box on his back, the ropes, and within 10 minutes of their arrival on the cliff top, were gone, mission accomplished.

Back in those days, the F3 was my main body. It was my workhorse, so it was mounted to the 400mm f/5.6 lens with the TC-14. This whole rig was attached to the gunstock, which had a strap, so it hung from

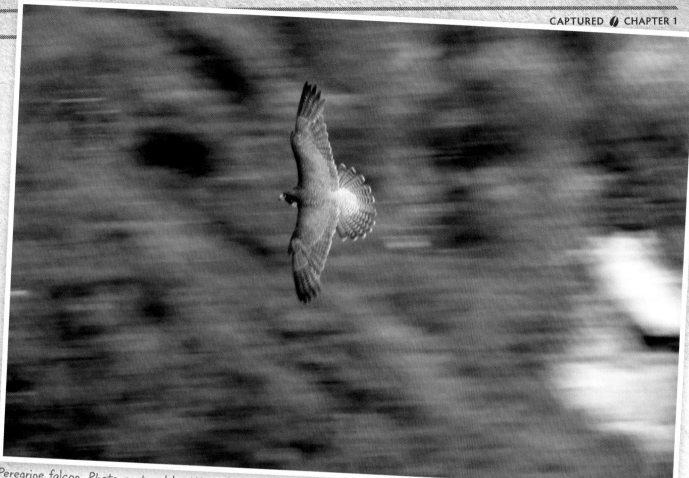

Peregrine falcon. Photo captured by Nikon F3P & Nikkor 400mm f/5.6 lens on Kodachrome 64.

my right shoulder. My second body was a borrowed FE2 from work. On it was the 35–70mm f/2.8, a beautiful lens. I had been shooting with the FE2 during the majority of the manipulation, putting on it at times a borrowed 80–200mm f/4.5 lens. Lucky for me, Gary was a veteran of this pair's reaction to the manipulation. He gave me a heads up that the falcon would dive right into the nest to check her precious eggs the second the climber was gone from the cliff face.

Sure enough, within a heartbeat of the climber leaving the cliff, the falcon spun in midair and dove for the aerie. I had barely gotten my eye up to the viewfinder of the F3 when it seemed she was about to disappear into the cliff. I didn't even have time to check the settings (and I was too inexperienced then to have preset any), so I just

focused and shot. I got three frames. Just like the coyote in Yosemite, I looked at the camera settings after the fact.

I was shooting in aperture priority mode. With the low sun and overcast haze, and being at an effective f-stop of f/11 at ASA 80, my shutter speed was 1/60 of a second. What was I thinking? Panning and manually focusing weren't enough of a challenge for my technique, so I had to lower the shutter speed to throw in an extra challenge? Thankfully I hadn't thought it through, because my inexperience probably would have made the wrong choice. As it turned out, the slower shutter speed helped make the non-native, ugly ice plant in the background disappear into a green blur. Another lesson to get tucked away in my photography subconscious.

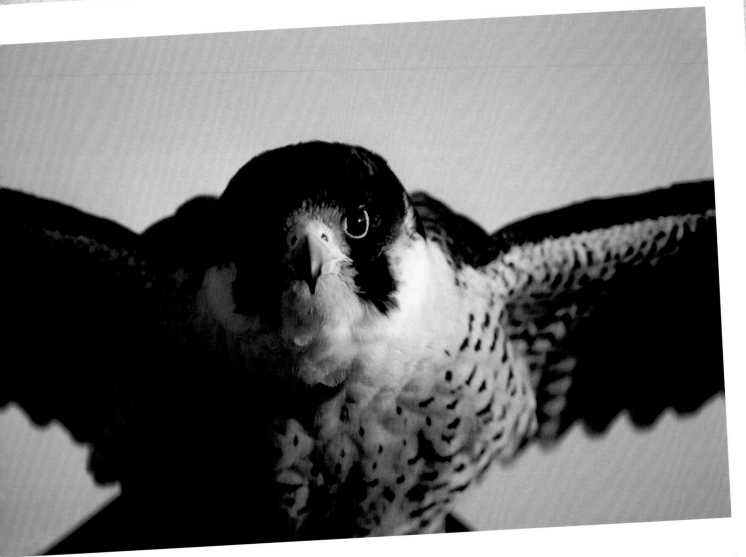

MOOSE PETERSON GALLERY SERIES

Mike, a pure anatum peregrine falcon. Photo captured by Nikon F3P
& Nikkor 200mm f/4 IF micro lens on Kodachrome 64.

I learned a whole lot on this project, and had important concepts set in concrete. The main one: you've got to watch and think about backgrounds. If the background had been more in focus, that darting falcon would have blended right in, and I would have had no photograph. Her slightly out-of-focus nature would have meant the photograph was trash. By blurring the background, though, I not only managed (by sheer luck) to make it disappear, but to reinforce the fact that the falcon was ripping through the air, allowing the viewer to accept her not being tack sharp (yes, I would have preferred a tack sharp falcon).

My head was still spinning the next day. I plotted how to take days off, what aspect of the peregrine to tackle next, and when they might replace the porcelain eggs with chicks. I had to find a solution to my lens issue. I knew 560mm would not be enough lens for the biology coming up, so I borrowed the 800mm f/8 for the next trip, and when that wasn't enough, I borrowed the 1000mm f/11 mirror lens.

With the 200mm macro attached to the F3, I put the camera to my eye and looked into Mike's eye. Staring back at me was the determination of a critter to succeed in the pending hunt, and get his reward at its successful end.

When the film came back, there were good images, and great images missed—a hit-and-miss success, with the hits coming (in my mind) by luck only. I sucked! An amazing opportunity, and out of all the rolls of film I shot, I only had a couple that told the story of what I witnessed. Where to go next with the idea of a photography career?

Connecting with the Subject

For the next few weeks, I didn't visit the aerie—nothing much was happening. Gary sensed that I was disappointed in my efforts and felt I needed a boost. He told me to give him a call the next time I was driving back home. He didn't say why, just to plan on being in the town of Guadalupe around 4:00 p.m., and to be sure to have my camera (it never left my side, even when I sat in my office at the camera store).

I headed home a few days later, so I met up with Gary in Guadalupe at a building that, back then, was called The Muse (a falconer's term for a house for their birds, but I didn't know that then). As he led me up the back stairs, he didn't say anything. We walked into the second story and were greeted by this big guy with an even bigger smile. Don shook my hand and introduced me to Mike, the reason Gary had brought me here.

Don was a special volunteer for The Peregrine Fund, doing special projects critical to its success, like building their incubating facility. He was also a falconer and Mike was his pure anatum peregrine falcon (a subspecies nobody had back then). Gary had arranged for me to go out on a hunt with Don and Mike. Up to this point, the peregrine falcon was something I had watched either through bins or my long lens; I had not made a personal connection. Yeah, I was in awe of the bird and my heart went out for its plight, but I hadn't let the bird into my heart. Mike changed all of that for the peregrine, and for every other species to come into my life. He grabbed my heartstrings and made it clear to me that I had to do the same with my images.

That evening, on the edge of an agricultural pond whose surface contained cinnamon teal ducks, Don put Mike up on his glove in the last rays of the day's light. With the 200mm macro attached to the F3, I put the camera up to my eye and looked into Mike's eye. Staring back at me was the determination of a critter to succeed in the pending hunt, and get his reward at its successful end. In that one click I made then, I realized that while photographs to come might suck every now and then, my photography didn't, and it now had a mission. Very few folks have the opportunity I'd already had in my very short career to witness the majesty of our wild heritage. I just had to succeed with my camera! (The print from that hunt to this day hangs on my office wall, Mike on top of the teal he caught.)

Gary took me under his wing, so to speak. I needed more knowledge about my subject and, at the time, the only thing I thought about was birds. While at the OP or on other field trips, Gary taught me how to determine a bird species, not by looking at them through bins and seeing this color or that marking, but rather by learning the habitats species used, how they used them, and their calls. The bins only came up to confirm an ID or when we wanted to enjoy a personal look. These were such important lessons, and ones I depend on to this day. I was blessed with great eyesight and, coupled with the biological

What are the top five mistakes
AMATEUR wildlife photographers make?

1. Thinking, "I've got the shot" and giving up on a subject too quickly.
2. Not going out with their longest lens.
3. Not knowing their subject.
4. Not paying attention to the background. Background is everything!
5. Not giving themselves time to improve.

What are the top five mistakes
PRO wildlife photographers make?

1. Not tapping into their passion for wildlife or incorporating it into their photography.
2. Not pushing themselves every time they go shooting.
3. Blowing off the common species.
4. Not going out shooting every waking moment.
5. Not sharing what they've learned with others.

knowledge, I can figure out who is who in a forest faster than almost everyone else—a big photographic and business edge.

Back at our nest site, the second manipulation happened: the porcelain eggs were replaced by two live chicks. I arrived just after it was all done, only to barely see the falcon dive back into the nest. I have always wondered what she thought—she left the nest one moment with two eggs, and returned the next moment to find two, two-week-old chicks. The tercel instantly went into action, catching starlings right in front of our eyes and either providing them to the falcon in spectacular midair exchanges or caching them in the cliff for her to retrieve when needed. The tercel is the main provider, and once the chicks appeared in the nest, watching the two parents in flight (peregrines catch their prey on the wing) was like nothing I had experienced in my life—it was nothing short of jaw dropping. Soon the chicks were fledging, receiving flight lessons from the master (the tercel), and then leaving the nest.

The project and the peregrine had one more lesson to teach me. I decided, like all stupid beginning photographers, to write an article, with my images, on the peregrine falcon. Oh man, do I remember struggling with that text, its content, and the painful process of typing it on a typewriter. (Whenever I say that word, my boys point to the antique typewriter I have in our office that belonged to my grandfather and ask, "You wrote using that?") My first rejection letter (and not my last) came from none other than National Geographic. I'm pretty proud of that now, but I wasn't then. Especially 18 months later, when I saw an almost identical piece to the one I submitted appear in the magazine. Another life lesson learned.

A few weeks later, Sharon graduated from college, and we packed up the duplex to move back to Santa Barbara. Our two years in Los Osos was a hell of a learning process—some coming easily and some painfully hard. But, looking back, it all was a great time, when it was good being young and mistakes were easily recovered from. Heading back to Santa Barbara started a new chapter in our lives: the start of a business and a family. The two great love affairs in my life were firmly in place! So remember, you gotta start somewhere.

Here's proof that when I pull out the cameras, the family hides. I'm shooting in one of my favorite places in Alaska, the Tony Knowles Coastal Trail, with one of my favorite subjects.

CHAPTER 2
No Illusions, I'm Not in Control

Just a couple of Moose in the woods.

A favorite place to watch the light—Minaret Vista. It's home to the alpine chipmunk, which I've still not got glass on, despite a lot of effort.

Helping get a mule deer out of a capture net as part of a mountain lion project I participated in for many years.

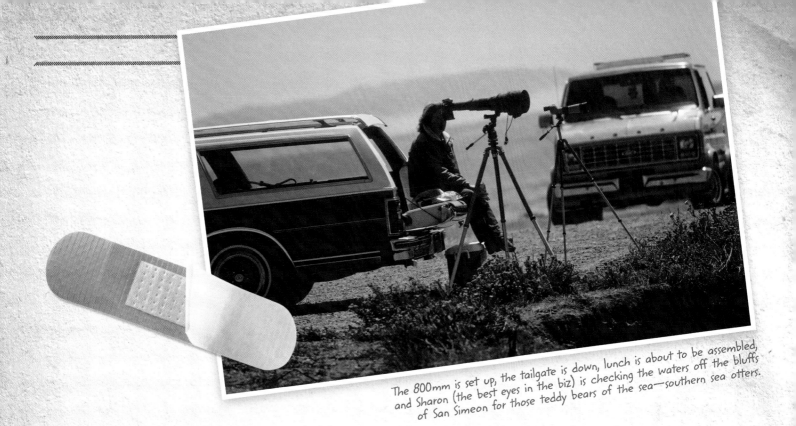

The 800mm is set up, the tailgate is down, lunch is about to be assembled, and Sharon (the best eyes in the biz) is checking the waters off the bluffs of San Simeon for those teddy bears of the sea—southern sea otters.

"There are forces in life that, without our knowledge, change our direction. Then there are our moms, who just can't help but be our moms."

We went down to visit our folks a lot when we lived in Santa Barbara—it was just a two-hour shot and the food was great. I'd often go down to work in my dad's woodshop on projects for our place. On one visit, my mom said I should come with her the next day to school. She ran a Christian preschool, and that day was "What Your Father Does" day (it actually had a fancier title than that).

One of the fathers coming in was a biologist for the U.S. Forest Service. Mom thought that since I had an interest in birds, I might like to hear his talk on them (geared for preschoolers—my level of education at the time). I didn't know it then, but Mom had already told the father I would be there and that I was a wildlife photographer and really into birds. That was a title I hadn't assigned myself yet, and now, with Mom getting involved, well, let's just say I was nervous.

At the school, I joined the three-year-olds for the presentation (I blended right in; they never knew I was there). The biologist saw me, and when I stood up to introduce myself, we both realized we'd been set up by my well-meaning mom. We've all been there more than once, that awkward moment when you realize that Mom has done it to you again—put you in a place where you'd rather not be, but you've got to go through with it. After introductions, he went back to the kids and the drawers of study skins from the museum he'd brought with him.

Mom was all atwitter, putting the two of us together (I just kept telling myself she meant well). Afterwards, the kids went back to their classroom, mom went back to work, and the biologist, Tom, and I had a moment to talk. He was the first biologist I had come in contact with who was paid to do one thing: study critters. Without my knowing it, with no game plan or list on a piece of paper, I started to ask a whole hell of a lot of questions. I didn't realize it until much later in life, but I have an incredibly inquisitive mind when it comes to

Black turnstone. Photo captured by Nikon F4e & Nikkor 800mm f/5.6 lens on Kodachrome 64.

critters. I'm the perpetual three-year-old, always asking, "Why? Why? Why?" when I'm with biologists. Bless them, they have always made time to answer my constant flow of questions.

At the time, Tom was compiling a huge set of data (to be placed on maps) about the locations of bird populations in Southern California. It was a massive project when such things were done mostly manually (no computers). He was an avid birder and very knowledgeable about the Southern California coastal plain. He was very much involved with T&E species (threatened and endangered), and was a master bander (someone who has a permit from the U.S. Fish & Wildlife Service to trap birds, place a band on their leg to mark a population for study, and then release them). A master bander is permitted to teach others the science of banding and help them become master banders themselves.

Loggerhead shrike. Photo captured by Nikon F3/T & Nikkor 800mm f/5.6 lens on Fuji 100.

A Bird in the Hand

Hate to admit it (I'll never live it down), but Mom did good this time. Tom and I struck up a friendship and started a number of adventures together (sadly, only completing one). He introduced me to the Salton Sea, a massive inland sea in the California desert with a unique ecosystem, and to a place called Bolsa Chica, a very special area on the Southern California coast. (Later on, we became directly involved with its preservation.) We did a massive trip to southeast Arizona to see its amazing birds, with Tom introducing us to and teaching us about the ecology of each locale. We also spent a lot of time at the nets, banding birds for a project he was working on at the time. The large nets used to catch the birds are amazingly transparent— a very fine weave—and getting a bird untangled takes a unique skill set to be able to handle them without harming them, all the while working a wiggling puzzle.

Coming up to a net after 30 minutes to see what you've caught is an excitement hard to find elsewhere in this profession. It's like a flying Easter egg hunt. One has a whole new appreciation for birds when they are in the hand. You learn specifically what makes each one unique (besides the different colored feathers), and then after all that science, you just open your hand and they fly off. It's not until you've had a loggerhead shrike in your hand, after carefully untangling it while trying to impress your teacher, and had it look you right in the eye in total amazement, then with its raptor-like bill, suddenly grab the cuticle of your thumb, rip it back nearly one-half inch, and gush blood all over you and itself, that you know the joys of bird banding! (I did get my master banding permit—still have it today, and it's the only permit I've ever received.)

Cactus wren. Photo captured by Nikon F4e & Nikkor 800mm f/5.6 lens on Kodachrome 64.

> *A landscape photographer photographs the land;
> a nature photographer photographs everything
> between the land and the sky; a wildlife
> photographer only photographs wildlife.
> I am a wildlife photographer.*

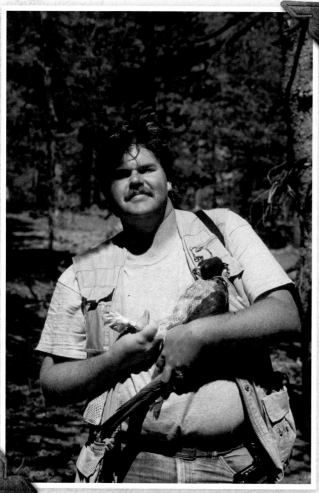

*I got driven into the dirt (I was the bait) by
this northern goshawk we captured for banding.*

All of this was pretty much right on the heels of my first season with the peregrines, when I'd been thinking of making a real go of being a wildlife photographer. Having a bird in the hand and effectively removing it from its environment struck me. The portrait of Mike, the peregrine, was a cool shot, but it didn't tell his story. Even though I still love it, these "in the face" views of critters changed my photography. My single clicks of the camera had to be more than a portrait. All that time spent with birds in the hand convinced me that I needed to back up from my subjects and incorporate their whole world in the photo to tell their stories visually.

I started out with the brief illusion that I wanted to be a landscape photographer, but it only required a couple of heartbeats to see I wasn't going to make a living doing that. There's so much more financial security being a wildlife photographer—*not*! While I wasn't going to be an eyeball photographer (a photographer who gets so close to a critter and uses so much lens, that the only thing you see in the photo is the critter's eyeball), my images had to be more than just pretty pictures. Something had planted a seed in my mind—one that would take a long time to bear fruit—that science had to be a part of my photography.

I've never had a single class in biology, natural history, or environmental studies. I've learned all I know by working in the field with biologists and critters—the hands-on approach, literally! None of this had gelled in my head yet, but it was in the back of my mind, lingering, pushing me quietly down a path I honestly had no knowledge of. My photographs had to do more than just entertain. But, what?

Research, Research, Research

It was about this time I was volunteered for a project—my first. Keep in mind, I was just a greenhorn photographer battling my way through the myths of photography like all photographers do in the beginning, with no formal biological training, just one of thousands. I was about as ill prepared as one can be for such a duty, but Tom thought enough of my skills, so in the hat my name went. I was about to learn just how

small the biological community is and the power a single photograph can have on life.

There was a Forest Service project over the hill from where we lived in Santa Barbara. Tom, being in the Forest Service, heard about the project and knew the biologist in charge. Without asking me, he talked with Maeton (the lead biologist in the Los Padres National Forest, and soon to become a lifelong mentor) and volunteered me to do the project. Not be a part of it, but to do it! A greenhorn working a 60-hour week (at the camera store)? And on the weekends, I'd run a biological survey for the Forest Service? I might be a quick study and have a knack for this biology stuff, but this was serious.

Nonetheless, I met with Maeton and had the job. What did it pay? Nothing! I was a volunteer, which to this day is how we've worked on every project (I wouldn't change a thing). That's right, I work for free on all my projects. For this job, I had a Forest Service four-wheeler and gas to use, but was paid nothing for my time. With the truck key, office key and combinations for the various gates in the forest, topographical map, and job description, I started the project in April 1985.

Santa Barbara has a killer Museum of Natural History with a great research library (not a lending library). It was into this room, with history oozing from the walls, and that smell that you'd only recognize in a great hall of science, that I ventured my first time to do research on what I had been volunteered to survey. Terry, the librarian, became a really great friend and an invaluable resource. Sheepishly, I asked her,

> To this day, I've never been paid for a single wildlife project I've worked on. I've been a volunteer, donating my time and talents, working for free. We fund working on a project ourselves, from my earnings as a photographer. And at the end of the day, I give selected images from each project to the project biologist to use in his or her own educational programs. It's all part of the process that pays dividends much bigger than can be measured monetarily.

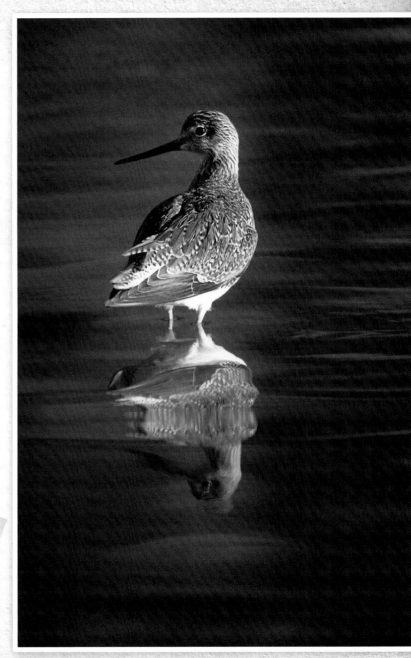

Greater yellowlegs. Photo captured by Nikon F3P & Nikkor 800mm f/5.6 lens on Fuji 100.

Mono Basin. Photo captured by Nikon N2020 & Nikkor 25–50mm f/4 lens on Kodachrome 64.

The first thing I learned about the bird I was volunteered to survey was that it's described as a "drab, gray, little bird." That was a rather deflating thought: I was "hired" to look for one of the most boring looking birds in North America! Nonetheless, I had said I would do it, so I gathered all the info I needed. My job description was pretty straightforward: I was to head into an area called Mono Basin and survey for singing males, territories, and nests, then count eggs and fledgling success. When my job was done each day, the time left over was mine for photography. Sounded simple enough and photography was involved. I was good to go.

"Where do I find information on the least Bell's vireo?" (The quickest way these days to find scientific papers on wildlife and the biologists working on them is to do a Web search. But don't use Google, instead use Google Scholar [http://scholar.google.com] as your search engine.)

I've been spreading the answer she gave me all over the land ever since because, before too long, *The Auk, The Condor, The Wilson Report*, Bent's *Life Histories* series, and more were before me—the greatest resources for any wildlife photographer. I had no bloody clue at the time what she'd placed before me, and didn't know how to extract the info I needed, but I had Terry, and shortly, I was researching along with the best of them. (I think David Sibley's *The Sibley Guide to Birds* is currently the best book for wildlife photographers, and I prefer the complete guide to the regional versions. Birds tend not to respect our boundaries—they have wings, you know—so the complete edition covers all bases.)

That first Saturday, the drive was a little over an hour. I was in a little Ford Ranger Forest Service truck painted that sage green color and with the door emblem. When I saw people in other vehicles with that "Oh no, I've been caught!" look, it gave me a slight feeling of power—there was an importance to my task. I was alone and I had no guide, no one showing me the way, no in-field training. I had topo maps and the truck—that was it. Just as the sun was breaking over the mountains, I parked the truck, donned the daypack (which had everything from tape recorders to maps, my camera, first aid kit, and lunch), and off I went down the trail.

I parked in a campground that was only really used on holiday weekends. It was deserted that morning, so all I heard were the birds singing. Mono Basin had more than 60 species of nesting birds, so it was very loud in the beginning of spring. It was a good thing Gary made me learn bird songs; I recognized many that I was hearing. The one I needed to hear, though—that of the LBV—wasn't coming

Wanna have a better idea of the size of birds? Head to a natural history museum. Understanding a bird's physical size (which is hard to picture by only knowing its length measurement) really helps in knowing just how physically close you need to get. You're going to be going out with your longest lens, preferably 600mm, so the main variable in image subject size is how close you get to the subject.

One of the most often forgotten and most essential things in a photographer's pack is water. It can do everything from save your life to get a dry rock wet for that killer landscape photograph. Water—don't leave home without it! Insect repellent is also a must in some locales. But be forewarned that the active ingredient DEET eats through plastic and can clean the paint right off your bodies and lenses.

through the chorus. (These days, the easiest way to learn bird calls is to buy a bird song CD, rip it in iTunes, and put it on your iPod. This takes up almost no hard drive space [compared to the iPhone apps], it's easy to access and learn, and it costs almost nothing.)

The Basin isn't a giant place, about 1.5 miles long and a few hundred yards wide, but it's a rich and thick riparian forest (next to a stream or lake, and often a floodplain). Within no time, it was hot and muggy with flying, biting bugs becoming annoying. That first day was a hell of a challenge. I had to find my way around the basin in a way that didn't damage the habitat, yet afforded portals to survey it all. I had to find ways to get through the creek that bisected the forest and was the lifeblood of the forest, yet not become soaked. And, I had to find the least Bell's vireo.

I had with me the 400mm f/5.6 ED-IF lens on a gunstock, and on it a new camera body, the N2020. Managing a camera store had many perks. Having the latest and greatest equipment was

most definitely one of them. What made the N2000 so cool was that it had a built-in motor drive. I had just pulled it out and photographed a black-headed grosbeak when I heard my first LBV. As I listened, I heard it coming closer and closer to my location.

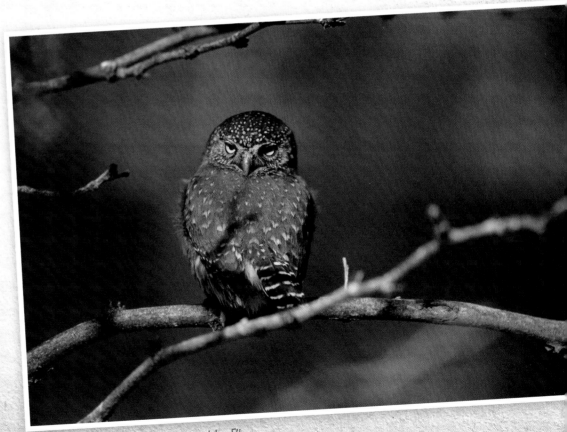

Northern pygmy owl. Photo captured by F4e & Nikkor 800mm f/5.6 lens on Fuji 100.

It appeared at the top of a willow, swaying on the limb as it sang. I had the camera out so I made a couple of snaps. Then it disappeared back into the forest. This bird—no more than four inches long—instantly, and for some unknown reason, grabbed my heartstrings. I was hooked. The camera went back into the daypack and off I went looking for more. By the end of that first day, I found eight males. Hadn't seen any females, and no nests, but I found eight males. The species was being surveyed because there weren't many around. Mapping their location on the topos was meaningless (the scale didn't work for precise mapping of this small locale), the shoes I wore didn't work for the terrain I had to negotiate, and I had more "stuff" in my daypack than I needed. I had some work to do that night to be prepared for the next day.

The sun rose the next day to find me walking down the trail, heading for what I had determined was the closest male's territory to where I parked the truck. I wanted to see how the LBV greeted the day. (There are some very interesting studies on bird songs and what time of day they start and stop singing. Unfortunately, they weren't available back then.) The LBV isn't an early riser, I discovered, so finding them when it was still cool and the light great for photography wasn't going to happen. But I did find the eight males again on the territories I'd discovered the day before. I spent the day walking the entire basin, discovering more paths, ways to access all of it, and finding good sites that could become territories. I wouldn't be back for five days, so I was trying to take it all in as best I could.

That workweek seemed like it would never end. I had the couple rolls of film I shot the weekend before processed, and was kinda happy with my results. Finally, Friday night came. I picked up the FS truck so I could depart early the next morning. Sharon was off on Saturday, so she was venturing to the Basin with me. We arrived early, parked, got our gear out, and headed down the trail. We hadn't gotten too far when we heard the song of an LBV come through the forest where there wasn't one the prior week. In fact, there were a heck of a lot more birds singing. There was more of everything: more green leaves making it harder to see into the forest, more spider webs to walk through, more heat, and more biting insects. What a difference five days makes in the life of the riparian forest in spring.

I pulled out the topo map enlargements I had made, noted the new male, spent a little time determining its territory (they have posts they sing from that make up their territory), and kept walking down the trail. We came to our first creek crossing, and it was obvious that the water level had gone down since the prior weekend—amazing to see such a drop so quickly. We crossed the creek into the territory of the

Riparian forest in Mono Basin. Photo captured by Nikon N2020 & Nikkor 25–50mm f/4 lens on Kodachrome 64.

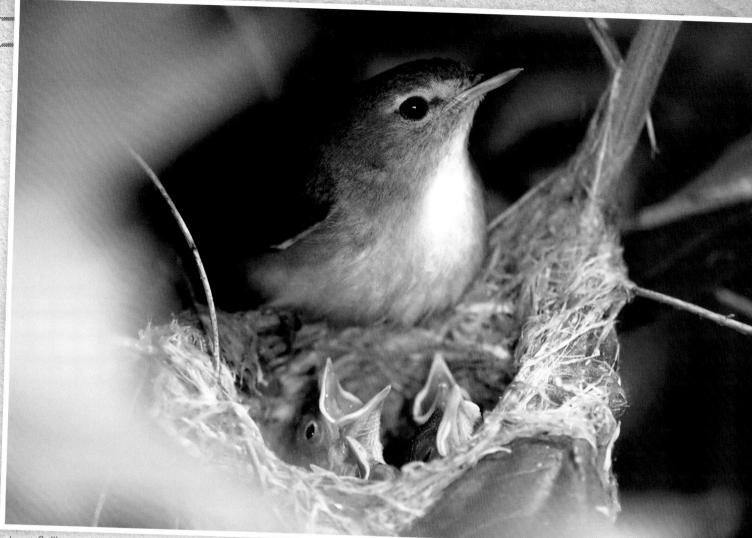

Least Bell's vireo with young. Photo captured by Nikon N2020 & Micro-Nikkor 200mm f/4 lens, using an SB-16 flash unit, on Kodachrome 64.

Topo maps are so yesterday, but there are times when knowing where you are can be really important. I prefer the Garmin Orgeon 550t, which has all the modern tools of GPS, along with a topo map display. This is in addition to the Nikon GP-1 GPS unit that is attached to my camera body.

first LBV I had ever seen (or photographed). It was quiet. When doing transects (a scientific method of surveying an area in a repeatable pattern), you learn to stop in one place and not start counting wildlife until 10 minutes have gone by. If critters are "residents" of that area, they will become accustomed to your presence and go about their activities. Ten, and then 15 minutes went by and no singing. We continued on.

You Can't Control Everything

By lunch, we'd finished the circuit, picking up a couple new males and mapping slightly changed territories, and found a couple of new bird species that had just arrived and that I hadn't seen the previous week. We started back toward the truck. If we made a beeline and didn't stop, we'd reach it in about an hour. We walked for a while, checking out every faint call to see if it was an LBV we'd missed earlier.

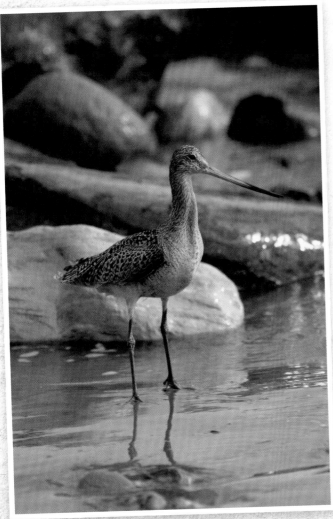

Marbled godwit. Photo captured by Nikon F3P & Nikkor 400mm f/5.6 lens with TC-14 on Kodachrome 64.

We didn't discover anything new and didn't see any sign of females, which was disappointing. We were just coming up on the territory that had a male the previous week, but hadn't that morning, when I spotted a dash of gray go past us. I stopped and watched. I kept moving a little, trying to get a better vantage point, straining with the binoculars to determine what had sped past us. Finally, I got a clean look: it was an LBV. No, it was *two*! Was that why he was quiet in the morning—he'd already mated with a female?

The next morning, I took the direct route down to that territory, which is where I spent the majority of the day. I've been blessed with many gifts, although some make no sense and don't really serve any amazing purpose, and as I mentioned earlier, one of them is that I can find bird nests. Don't know why, but finding nests is really easy for me. Such was the case that morning. I instantly found the nest these two LBVs were constructing.

While that's exciting, it doesn't always mean they will nest in that exact nest cup. LBVs have a unique habit of building a nest, taking it apart, and moving it (sometimes a couple of times) before they actually occupy the nest and lay eggs. So with bins only, I watched them from a distance going back and forth with nesting material, busily building. I made the rest of my rounds that day, found two more females in territories, but no other active nest building going on.

The next Saturday couldn't come fast enough. I hadn't taken much other than habitat shots the previous week, so I didn't have anything to feed my desire to flip to the next page of the story. (One of the mistakes I made starting out was not taking enough of those basic "I was here" photos. You know, a picture of you by the truck, walking the trail, eating lunch, etc.—those photos that fill in so many blanks in the story years later.)

So, first light that Saturday found me at the territory, looking for that nest. They had moved it, and it seemed that they'd left the territory, but I finally found them on the very western edge of it, which also put them nearly on the edge of the riparian forest and surrounding chaparral. After watching for a while to be certain what I saw, I went on with the rest of my rounds. Sunday confirmed everything I'd

Finding nests is an art requiring the combination of biological knowledge and jigsaw puzzle skills. In winter, you can look at trees when they've dropped their leaves to see where nests were built the previous spring. But if you want to find active nests in spring, a great place to start looking is in *A Guide to the Nests, Eggs, and Nestlings of North American Birds*. This book will tell you everything from size, shape, and nest placement to the number of eggs, nestling period, and fledging for all the bird species in North America (there is also a European and North African edition) and is a must for every wildlife photographer.

Up on Minaret Vista chasing the alpine chipmunk.

discovered on Saturday. I didn't do much shooting again, and I had to wait another five days to be back to this place that had really taken a seat in my soul.

I was at work on Wednesday when the private line rang. I answered it and Sharon said in a frantic voice that I needed to call Maeton, the biologist. My report wasn't due for a couple of days, I had called in and made my voice updates, and returned the truck full of gas (that was a freakin' biggie!), so I couldn't figure out why there would be any excitement. I called Maeton, who asked if I was available right then to head over to Mono Basin. A controlled burn got out of control and burned down into the Basin and the riparian forest. He needed to know the damage to the least Bell's vireo population. There were less than 120 pairs in the world then—65% living in Mono Basin—and there was no room for any loss. So, off I raced to the station to meet him and head over the hill.

When we rounded the first corner, I saw the smoke and the burnt forest and my heart sank. Wow, to say the burn got out of control was an understatement. We continued on, parked in my usual spot, and ventured off into the forest. The look on the firefighters' faces said it all: "The boss is here. We screwed up big time. Uh-oh!"

The small animal trail I usually followed into the forest was now replaced by a control break—a dirt path the width of a Caterpillar bulldozer. It had been cut through the western edge of the Basin to stop the fire, and had done some damage. I pointed out to Maeton territories that were now just ashes or a dirt pad. We kept heading down the new road. I had to really look for permanent landmarks to figure out where things used to be.

Mono Basin after the controlled burn. Photo captured by Nikon N2020 & Nikkor 25–50mm f/4 lens on Kodachrome 64.

While traveling down a dirt road with your camera gear in the vehicle, dust can still get into the vehicle and onto your gear. I work on a lot of dirt roads and, with digital (and electronics) especially, dust can be a drag. When I know I'm going to be traveling on a dirt road, I wrap the camera bag in a towel. The dust, which tends to come in when you open the door, floats onto the towel. I stop and then wait a moment before opening the door, waiting for the dust to settle, then lift up the towel to access the camera gear. When I come back from shooting, I shake the towel out before putting the camera gear away. It's a little thing, but does help keep gear clean and functioning in nasty environments.

It was about then it dawned on me that we were coming up on the one territory that was occupied by the two LBVs making the nest. We rounded the bend in the creek to see the Cat had gone through their territory, as well. The dense forest I had to strain to see through to find the vireos was now completely open, with hardly a tree present. It was an incredibly depressing afternoon— we heard no LBVs singing, not one. In fact, no birds were singing and at least six territories were flattened.

This was an awful lesson to learn: the fragility of our planet, and the ease with which an entire natural community could in one morning disappear without a trace. It left a big impression on me. I arrived home smelling like I'd been rolling around in a campfire (a smell that's hard to get out of your nostrils), pants all black, covered in ash, and with smudges of black on my face. Sharon could tell from my expression it wasn't good news. While fire is a natural cycle and chaparral is made to burn, this was the wrong time of year for a controlled burn, and a horrible price to pay for human error.

Life Goes On

Saturday morning found me back in the forest. The area was closed to the public because there was still some fire being actively fought. My truck got me right in, though it was strongly suggested I not be there. (I've never been really good with authority figures.) I had to see what was left and I knew an early morning survey was the only way to accomplish that. I no sooner got out of the truck, than I was greeted by the song of a blue grosbeak. Slowly, as the sun rose, the forest

chorus began to rise and so did my spirits. I kept walking, and soon the song of first one LBV greeted me, then another. Things were all mixed up. The fire pushed a number of males out of their territories on the west and to the east, so it was like someone had rewound the clock to a month earlier when competition over a territory was fierce. It was good to see. It meant a lot of work, but it meant life was going on. A great lesson!

I walked the new "road" through the forest, since it made my travel a whole lot easier. I got down to the territory where the two LBVs had been so busy the weekend before lickity split. At first, the sight of the burnt trees, the smell of the ashed chaparral, and the dirt road going through it made tears well up. And then came that silly song of the male from right in front of me. It was as if he was saying, "Did you miss me? I'm still here!"

He had no bands on his legs, so there was no way of knowing if it was *the* one, but I wanted it to be. He saw me, sang some more, darted back into the slight cover, and after a few moments, emerged again in front of me. This time there were two and one had nesting material. The one with nesting material dove down into a small bush right in front of me, just a couple of feet off the road. I put the bins to my eyes, and what did I see but a nest! The LBV is described in scientific literature as a tenacious little bird. Damn if that wasn't so!

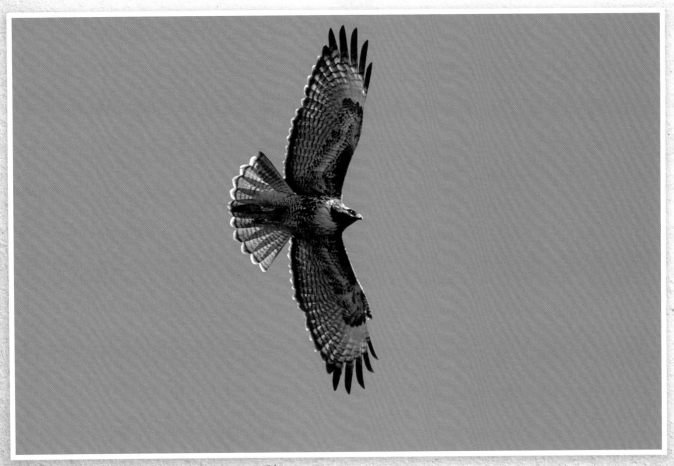

Red-tailed hawk in flight. Photo captured by Nikon F3/T & Nikkor 400mm f/5.6 lens on Kodachrome 64.

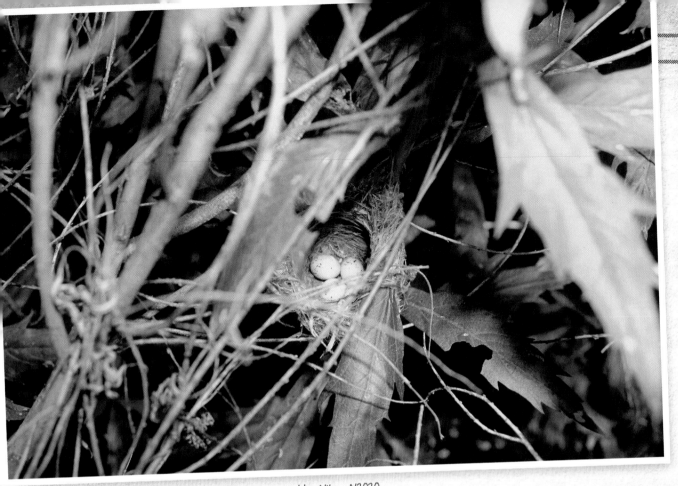

Least Bell's vireo nest with eggs. Photo captured by Nikon N2020 & Micro-Nikkor 200mm f/4 lens, using an SB-16 flash unit, on Kodachrome 64.

That weekend, I counted a couple more individuals, finding more females with males, and more nests being built. Later, I would discover that the fire pushed some LBVs completely out of the Basin to another drainage, where they started another little colony of LBVs. In the meantime, the pair I was rooting for were there, and going on as if seeing their home burnt down was an everyday occurrence.

The next weekend, I arrived with some slightly different gear. If my calculations were correct, there should've been some eggs in the nest, so I brought an original Lepp macro bracket (much better than the current one) and two Nikon SB-16B TTL flashes. I made my rounds slowly, planning to end up at my favorite territory at the end of the circuit. There was a lot of nesting going on now, so many nests had to be found and the stage of nesting determined before I could move on.

Finally, late in the afternoon, I arrived at the territory of my friends. (You're not supposed get emotionally attached, you're supposed to keep everything in scientific perspective. I didn't know that then; I was a silly, dumb volunteer.) I approached slowly, because the nest was so close to the road that there was no cover and I didn't want to flush them off it. I was looking around with the bins at the very top of the tree for the male, since the nest was at its base, and froze at what I saw. There in the top of the tree was a Cooper's hawk nest. The Coop's main prey is small birds. This nest was literally only 20 feet away from the LBV nest site. It would seem that these little guys just couldn't catch a break.

I slowly walked up to the LBV nest, looking as hard as I could with the bins to see into the nest cup. About 10 feet out, I could finally see in, and staring back at me from the nest was one of the LBVs. It was on eggs! I sat down and watched and waited. I needed to know where they were in the cycle. Finally, the adult left and I could go look in. Great skill and care has to be observed when checking a nest, so a trail to the nest isn't created through the vegetation, and a scent trail isn't left for predators. Having a dirt road carved by a Cat made this real easy. I peered in to see three rosy eggs. It doesn't get any easier—they were newly laid.

Get Creative

When the time came for hatching (as I'd calculated it), I took the day off from work, got the FS truck, and headed over to the Basin. It was all for naught; they hadn't hatched. I was there at first light the following Saturday, and there they were: four little nestlings. Least Bell's vireo nests are low to the ground, usually no more than three feet up in the fork of a shrub. The ground cover of a riparian forest is never very robust, and can easily be blown away by a wind or flood. In this case, the nest was in textbook stuff: mugwort. This plant, if you stare at it crossed-eyed, will fall over, so walking into the nest site had to be done with incredible care. Thankfully, I only had to worry about a couple of feet, because the Cat road was right there.

Binoculars can be a critical tool at times, but I don't always carry them with me. Certain projects require them, and some don't. I normally have Sharon with me and she always has her bins, which is a good thing since she's my second set of eyes. We prefer the Nikon Premier SE 10x42 (Sharon) and 12x50 (Moose). They are light, bright, and powerful, which is really important when you're scanning. When using them, try to first scan with your eyes to find the subject, and then when something is in question, bring the bins up to your eyes without taking your sight from the questionable subject. This makes it easier to pick up the subject in the bins and later with a camera lens.

Glassing a nest. Binoculars are an important tool for a wildlife photographer.

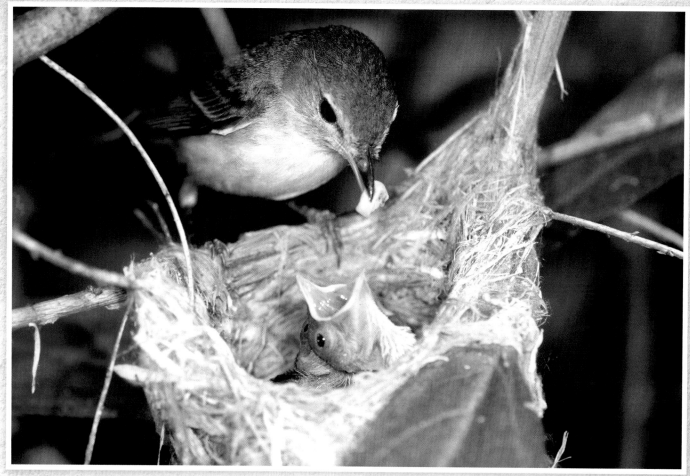

Least Bell's vireo feeding young. Photo captured by Nikon N2020
& Micro-Nikkor 200mm f/4 lens, using two SB-16 flash units, on Kodachrome 64.

Because they nest so low to the ground, LBVs don't fly right to the nest. They often land many feet away, and "hop" to it using various branches. They "mouse" their way through an imaginary tunnel. If you look really hard, you can see the tunnel they use through the foliage to come and go from their nest. That Coop's nest was still active overhead and, to this day, I wonder if it knew the LBV nest was down below.

Photographing a nest so low to the ground in dense foliage is a challenge. Getting a clear shot with the lens and flashes takes great care. You can't cut branches out of the way; you have to hold them back gently. I made tiebacks using two small binder clips and nylon cord, so I could bundle branches carefully and pull them out of the way. This way I could shoot, and they could easily fall right back into place when I removed the ties.

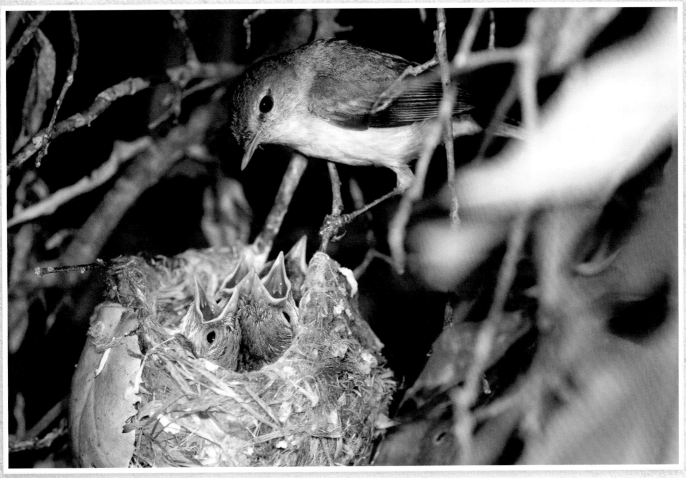

Least Bell's vireo and nestlings. Photo captured by Nikon N2020 & Micro-Nikkor 200mm f/4 lens, using two SB-16 flash units, on Kodachrome 64.

If you're wondering how I came up with this solution, I honestly don't know. These things just spring into my mind—a solution to a problem. My dad always said he was a "mec-a-nec" (mechanic with a twist) and was darn good at making things from nothing. Perhaps some of him rubbed off on me. I dunno. It's just what I've always done and I rather enjoy the challenge. Mixing biology with technology—even if it's just binder clips for ties—just makes my mind spin.

A simple, but important, accessory to keep in your photopack: Velcro straps. You can use them for everything from tying back a branch when photographing a nest, to cleaning up your flash cables, to holding a gobo (which controls the shape of the light) on your flash.

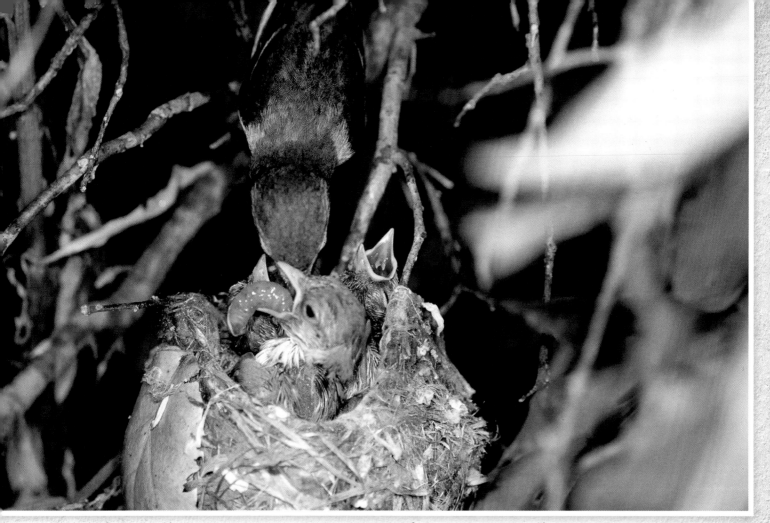

Least Bell's vireo feeding young. Photo captured by Nikon N2020 & Micro-Nikkor 200mm f/4 lens, using two SB-16 flash units, on Kodachrome 64.

Is there a best lens for photographing a nest? If I can get physically close to the nest safely, I prefer the Nikkor 70–200mm f/2.8 VR II with the TC-14E II teleconverter, and if I can't get close physically, I prefer the Nikkor 200–400mm f/4 VR. If it's a larger bird like an owl or raptor, then I prefer the Nikkor 600mm f/4. Angle of view is everything in visually removing the busyness of a nest site, which is why these scenarios call for these lens selections.

I was shooting with a Nikkor 200mm f/4 macro lens (the original, not the AF model) on the N2020 with two SB-16Bs connected hard-wire to the camera for TTL flash. I had a little Gitzo tripod that the lens attached to, the Lepp bracket, with the flashes attached to the base of the N2020 (what I use to this day isn't a whole lot different for nest photography).

So how much do you know about flash? I ask, because this is when expertise with portable light really comes into play. I'll be going into it in greater depth later, but for right now, just remember that flash exposure is in part determined by the flash-to-subject distance. If you

have a leaf that is halfway between the flash and the nest, and you're lighting the nest, that leaf will have twice the exposure. In this scenario, shooting the nest through all the mugwort, this problem was literally smack dab in my face. At the same time, a strategically placed leaf can hide a lot of the natural distracting branches and limbs (I needed the biological photos as much as artsy ones).

I photographed this nest just a couple of times. One of the lessons I learned on this project was the need for time. Life being life, with the needs of the overall project, I simply couldn't plant myself at this one nest for the 12 days there were nestlings and photograph just them. Besides, that wasn't safe for the LBVs—I wasn't going to risk their creation of the next generation for a photo. It's just a photo. I've always hated that aspect of this job—there never seems to be enough time.

I finished up that season of work, counted all that there was to count, finished all the paperwork, handed in my final report, and turned in the keys to the truck. Looking back at that report now, it's rather embarrassing, but at the time, it was the best I could do. The important thing was I successfully not only monitored the population and found a new population, but had photographed parents at various nests coming back with insects. I wasn't a scientist or biologist, and hardly could be called a researcher. I sure wasn't, nor am I, an entomologist. I did, though, watch with my own eyes the LBVs leave the riparian forest and go into the chaparral to forage for insects that they brought back to feed their young.

This was not known by science at the time, so just my saying it wasn't going to make it so. I had proof, though. I had photos that clearly showed the bugs that an entomologist could identify. While the data was anecdotal, it was photographically documented that the bugs were those from the chaparral, not the riparian forest. This, along with my dedication to the project, must have impressed Maeton.

Not long after the LBV project wrapped up, I received a call from Maeton wondering if I would like to be part of a tule elk release. It wasn't all that exciting, watching some horse trailer doors open,

When it comes to holding flashes for photographing a nest, you need a tool that is light, takes little space, and won't disturb the habitat. You might try a Magic Arm from Bogen-Manfrotto, a flash bracket from either Wimberley or Really Right Stuff, or something DIY. There is no one perfect answer, because each and every nesting situation requires a unique setup, so if you get hooked on nest photography (which is easy to do), be prepared to own a closet of flash brackets.

tule elk bolt out and, five minutes later, just dust lingering in the air. But this proved I wanted to get involved in other projects, and they didn't have to be glamorous, high-profile ones. Biologists have been burned by many wannabe wildlife photographers, a barrier I've had to knock down with my own actions. But taking on this elk release led to a bigger project—a sheep capture.

Get the Biologists on Your Side

Maeton worked in the Los Padres National Forest, and was part of the sheep working group. They were going to capture Nelson's (desert) bighorn sheep in the San Gabriel mountains and translocate them to the Los Padres NF to reintroduce them to an area where they had been extirpated. It was a big project. The manpower was massive: helicopters, explosives, hay, nets, everything but the kitchen sink. And there I was, this kid (and I was a kid) with one little survey project under my belt taking on this huge project. I had two things going for me: The first and main one was Maeton. He had a reputation for being damn good at what he did, and when he said I was okay, that carried a lot of weight. The other was the camera. All involved had seen the LBV images. There is no better fan base than biologists.

Biologists have been burned by many wannabe wildlife photographers, a barrier I've had to knock down with my own actions.

The guy in charge of the capture was this really tall, and at times very scary, guy Vern. He was one heck of a biologist whose passion was sheep. He was the one who made things happen. This project was a couple-week affair. We had to travel down to the capture site a month prior to the actual capture to set up the net. We're talking 40-some-odd volunteers making their way up into the mountains from all around California. And this wasn't any old butterfly net, this was

How many flash cards should you take in the field with you? I personally don't think you can ever have enough. Being an old fart, I still think in rolls of film—36 exposures equals one roll, so I want a minimum of 40 rolls, or 1440 captures. Now, depending on your camera and file settings, one 16-GB card may serve you all day. Me, I travel into the field with 10 Compact Flash cards: both bodies are loaded with two cards each, and I have six spares in a card wallet. My cards of choice? Lexar 16-GB and 32-GB UDMA cards.

a heavy woven net, 40x40 yards, held up by five poles and connected to ropes that had explosive charges in them that, when they received the signal, blew and dropped the net. It was right out of *Mutual of Omaha's Wild Kingdom*!

The capture site was in the base of a canyon wash. All of the gear had to be airlifted in and carried up the wash to the site. The net area had to be flattened and groomed, so when the net came down on the sheep, there were no objects under them that would harm them as they went down. All that rock had to be cleared by hand (I think I wore out a pair of gloves that weekend). Generators were flown in, so big drills could be used to create the anchors for the poles and ropes in the giant boulders. The hay that would be spread out below the net for the sheep to come eat had to be hauled up the wash and stacked (them things are heavy!). All of this was accomplished in one day.

For the next month, a volunteer, Bill, was at the bottom of that canyon feeding the sheep under the drop net. His job was to get them accustomed to being under the net at a particular time each day. Since sheep really aren't that scared of people, it wasn't as difficult as you might think. As long as they have an escape route, they usually just go about their business. I spent the month photographing birds I found around town on the weekends.

I thought about the capture at times, and planned as best I could, but this whole thing was new to me. I had a new Nikon F3HP Titanium (F3/T) body that would go with me. I had the new 35–200mm lens, the 20mm f/2.8 lens, and, of course, my best friend, the 400mm f/5.6 IF-ED lens, so lenses were pretty simple. How many rolls of film to take, though? That was a really hard one, especially since I had a finite film budget. Unfortunately, it's not in my journal—I still wonder how much I took.

Heading down a California canyon to release the bighorn sheep we'd settled into a pen the night before.

Nelson's bighorn sheep. Photo captured by Nikon F3P & Nikkor 400mm f/5.6 lens with TC-14 on Kodachrome 64.

Before I knew it, I was in camp; it was dark when I arrived, but horse trailers, wooden crates, trailers, tents, and campfires made finding the spot easy and quite inviting. The next morning, we'd be flown into the canyon and, if everything went perfectly, tomorrow night we'd be driving sheep to their new home. Being an "outsider"—not part of this close-knit group of professionals and volunteers giving so much of their time, money, and hearts for the sheep—was a challenge, but not as much as you might think.

I approached this as a project to document, a thought that wore mighty thin as we busted our butts to get everything set up. Putting down the camera and pitching in was common. A thought had been simmering for the past month, and that night around the campfire my definition of a "project" solidified: the story I was about to

Working on a project with biologists, you'll need a way to carry your gear that permits quick access and is really compact. That's required to move through habitat really quickly and stealthily. The latest sling bags, like Mountain Smith's, which hold no more than a lens or two and a flash, are great solutions. They permit quick access to gear, take no extra space if working out of a truck or helicopter, and provide just enough protection from small bumps that can occur working on projects.

Supplies & people were ferried to the capture site by helicopter. Photo captured by Nikon F3/T & Nikkor 35–200mm f/3.5 lens on Kodachrome 64.

Shooting gloves—is there a magical pair everyone should own? I have a heck of a time with shooting gloves. After I've tried on every glove at every store in search of the perfect pair, I just might find one. For nearly a decade I loved cross-country ski gloves, but they've gone to bulky styling. In the last year, I've fallen in love with the new series for mountain bikers, which have a wind blocker material on the back of the hand. I recommend that once you find a pair you love, you buy a number of them so when one pair wears out, you have a backup without having to go through the pain of finding a new glove.

witness and attempt to record was more than an event, it was an action to make a difference in the world. That probably sounds like a gray area, and even then, when it started to seep into my photographic thought process, it was, but now reflecting back on that evening, the seed was firmly rooted.

The camp was abuzz as the predawn light illuminated the overcast skies (perfect for sheep capturing) the following morning. The sheep captured in the canyon below would be checked out, and airlifted up to the camp, where the final medical checkout would be performed and they'd be loaded into the trailers. When the pilots said we could go (we had two helicopters working that day), the canyon team, which I had earned the privilege to be a part of, was flown into the canyon. Once in the canyon, we split into two groups. The main group was out of sight of the net, but where they could instantly boulder hop up the canyon to it. I was permitted to be at the forward OP, where only five folks would be stationed, including Vern, who would blow the ropes to drop the net.

That's when the waiting began. Folks watch me sit for hours and ultimately say something like, "You're an awfully patient person." I'm not, but I can sit for hours watching wildlife go about their life, waiting for the moment to happen. Some call that patience. I just call it being in love with the world unfolding in front of me. After all, the *most* important ingredient in a successful photograph is passion.

Biologists are great conversationalists, with very little prodding— just the right question and these living encyclopedias come to life

with firsthand stories that make time go faster. That's what we did for a couple of hours, until it was time for Bill to call the sheep down. That's right, Bill called them down on cue!

He walked out under the net at the prescribed time and threw out hay, then took a lid from one of the 55-gallon drums and pounded it against the massive boulder. The ringing resonated throughout the canyon. At the same time, he yelled out what he said was Spanish for "Here sheep, here sheep," but I think it was something else. He kept this up for five minutes or so until we saw the first ewes come *running* down the canyon to the net. They couldn't wait to get to that hay. The goal of the capture was a particular mix of ewes, lambs, and rams (a mix determined to be what was required to establish a new herd). So we continued to wait for the right mix to form under the net.

About thirty minutes into this, we were told to hush. A big ram came down the slope right behind the OP. We didn't want to startle him, because that could panic the herd under the net. He came on down a little ways and, suddenly, he was right in front of us (I got permission to raise the camera to get a couple of snaps—three to be exact—before I was told to stop). Then, two smaller rams started down the same path. Rams being rams, the two younger ones came running down with that, "I'm bad, come mate with me" attitude and took it right to the net. At that, the entire herd burst from under the net and ran up the slope right behind it. Oh, the horror that came across Vern's face. It wasn't anything we'd done, it was just life. I loved it, though—it created a great photo, but that's not why we were there. After a few moments, the alpha ewe kicked one of the young rams and led them all back down under the net. Phew!

Nelson's bighorn sheep. Photo captured by Nikon F3/T & Nikkor 20mm f/2.8 lens on Kodachrome 64.

Waiting for the right mix of sheep. Photo captured by Nikon F3/T & Nikkor 35–200mm f/3.5 lens on Kodachrome 64.

Jumping in the Mix

With the sheep under the net, we had a whole new problem: there were more sheep than personnel to deal with them once the net was dropped. You can only wait so long before the sheep eat their fill of hay and move on. So, the word was sent down the line, the net was going to be blown. By the way, my cameras are always set to CH (Continuous High), whether I'm shooting a rock or a critter. You want to always be ready to capture action, even if there is no action immediately seen. If you have to take time to change a camera setting once the action starts to unfold, it will be over by the time the setting is made. Be prepared for shooting action from the get-go and your odds of capturing it go way up!

Vern counted out loud and when he hit the number 1, I hit the shutter release button. By the time he hit zero, folks were bursting out from their hiding places to reach the net and calm the sheep. I had on my photo vest, which I used in the days of film, had the F3/T with the 35–200mm on it, and the 20mm in a pocket as I found myself dashing across the wash to jump into the mix.

My thought was to photograph the action, which I started to do. (Looking at the files now, I have 21 images of folks securing sheep.) It was then I noticed that there were three ewes in the net with no one holding them down. Their natural reaction, as you can imagine, is to escape. We were out of bodies, so I decided to jump in, not as a photographer, but as a volunteer. You've seen me in photos here by now. I'm not a small guy, and back then, being an avid volleyball player, I had more bulk where it matters, so I jumped onto one of the three ewes. I had one leg on one ewe, another leg on another ewe, and my left arm holding down the third. I had switched to the 20mm lens just prior to this, so I raised the camera and

Dropping the net, photo captured by Nikon F3/T & Nikkor 35-200mm f/3.5 lens on Kodachrome 64.

took three snaps when one of the ewes kicked the camera out of my hand. I decided that was a hint to put it down and just hold on for a while.

After that, everything went pretty much like clockwork, just as planned. No sheep were hurt, the transporting and translocation went off without a hitch, and the next evening, the sheep were in their new home. It's an interesting side note that these sheep literally fell off the planet for about a decade. They weren't seen again after their release, until one day a hiker reported seeing sheep about 30 miles from the release site. The translocation was successful, the sheep did repopulate the area, but on their own terms.

You might be wondering, other than a good story, putting new images in the files, and teaching new lessons about working with biologists and projects, how did all of this advance my photography? The lead biologist, Vern, just happened to be watching me during the chaos when we all reached the net (for my own safety, probably). When he saw me put down my camera and jump in, because the critters were more important than the photograph, well, that left one hell of an impression on him. He'd never seen a photographer do that. He told me as much later that day. Not only did I make an important and influential friend, but something very important clicked in my own head, something that to this day many wildlife photographers ignore, but which has been my mantra: *No photograph is worth sacrificing the welfare of the subject.*

It took only a couple of heartbeats in time for word to travel the biological circuit, "Moose Peterson can be trusted with your projects—he's not a bad photographer, and he's an even better partner in our work to preserve our wild heritage." Maeton's faith in me, and what he had seen of my work with the LBVs, took me to this next project where, as fate would have it, I managed to take another step forward.

Chasing a Vanishing Species

Around this time, we joined the local Audubon club for two reasons: the presentations by researchers and biologists provided contacts and project ideas, and the birding trips. I reasoned that if they went places to look at birds and found them, then I could learn these locales for the purposes of photography. We made many new friends, and learned about places to haunt after work and on the weekends where I could shoot. Time went quickly. I kept in touch with Gary and Don, and traveled north occasionally to visit Mike and peregrine nests on the Central Coast. In mid-summer, Gary asked if I wanted to see a California condor. He was part of that program, too, so it was easy to get involved and only took a moment to say yes.

Sharon and I would leave early in the morning, and drive two hours over to "The Sign" where we'd spend the day looking for California condors. The Sign was just that, a National Forest sign in a large turn-out where we could park and look to the east, watching for them.

Holding the sheep down. Photo captured by Nikon F3/T & Nikkor 35–200mm f/3.5 lens on Kodachrome 64.

Rough-legged hawk. Photo captured by Nikon F4e & Nikkor 300mm f/2 lens on Fuji 100.

At that time, there were around 20 California condors flying free in the world! One, Topa Topa, was a male living at the Los Angeles Zoo. The others were wild birds still doing their condor thing. Only a couple had wing tags, including AC-2 (AC = adult condor), the Santa Barbara male. All the rest of the population had no markings on them.

To understand a species, biologists often need to mark them. With a bird that can lift off from its nest in the sequoias, fly south to Fort Tejon, then turn north and be in Monterey by lunch (you'll need a map to figure out how far that is), keeping track of individuals is a challenge. That's where photography came into play. A couple of biologists figured out that, every other year, an individual condor molts its primary feathers in the same pattern. If you photograph those primaries open during flight, you can determine who is who and understand who is mated with who and where they are heading to nest. This is a very direct purpose for photography in wildlife work, and has a direct correlation to its use for biological data collection.

At first, I didn't fit in, probably because I was too gung-ho to get the shot. (Me? Too eager or determined? Hard to imagine.) There were three requirements to get the photos for this project: First, was spotting the condor as it flew through the range we were scanning, a big area on the side of a mountain overlooking the entire lower portion of the San Joaquin Valley. (Tourists would drive by and, because of the congregation of folks in the middle of nowhere, would stop and ask what we were doing. We often answered, "Waiting for the space shuttle to land," or "Watching for the San Andreas fault to move," or "Ronald Regan is coming by.") Condors use more calories to perch than fly. They would rip past us without a single flap, riding the air currents. Often they would come from behind us, what were called sneak attacks. So, the first thing was to find them in flight.

The second thing was to get to the condors as they flew over the road, so the primaries could be seen. This required a car that could negotiate the windy mountain road—often with a driver not concerned about staying in his own lane—fast. That isn't what most college students who did the field research possessed back in the '80s.

California condors in flight. Photo captured by Nikon F3P & Nikkor 400mm f/5.6 lens with TC-14 on Kodachrome 64.

A hard skill to master is getting a bird in flight in the viewfinder. Tracking the entire sky with a 1-degree angle of view while looking for a moving black dot is a challenge. Heck, just finding a bald eagle perched on a branch with a 600mm lens can be a challenge in the beginning. Tricks? Shooting with both eyes open is one—I shoot with my left eye and have the right eye open to track the subject. You can use the knob on your lens barrel or shade like a gun sight. But the one sure way to master this very important aspect of wildlife photography is lots of practice!

I had one, though. My Camaro was made for just such a role, and it took to the job with great glee.

The third and last thing: a camera was required in that car that found the condors flying over the road. The 400mm f/5.6 on the gunstock fit that requirement to a T! So, as best I could, I chased the condors, and photographed them with the primaries open. When photographing birds in flight, keep this little mantra in the back of your mind for the greatest success: For birds in flight, have the sun and wind on your back. The combination of sun and wind on your back means the bird flying at you will be going slow (wind) and will have front light (sun). One of the ways to almost *never* be successful photographing birds in flight is to have a gray sky background. That's a no-win exposure scenario.

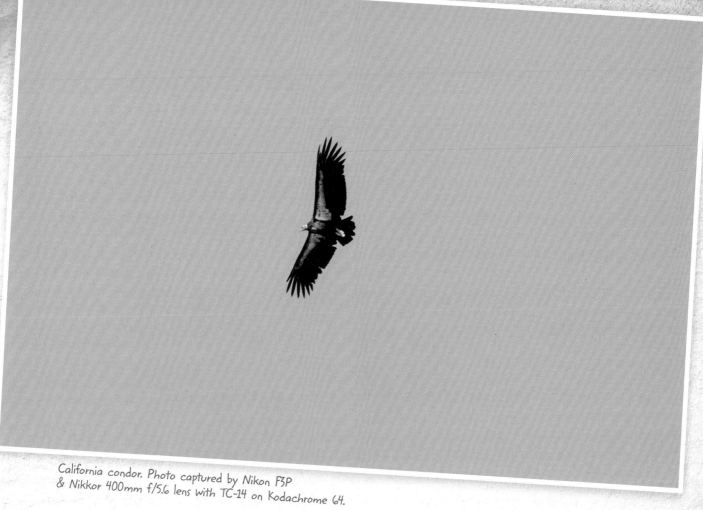

California condor. Photo captured by Nikon F3P & Nikkor 400mm f/5.6 lens with TC-14 on Kodachrome 64.

I gave dupes of my condor images to the researchers for their work. We did this for a number of seasons, until the population crashed and the decision was made to capture all the condors and bring them into captivity for their own safety. We were there the day the last condor was captured by our good friend, Dave. That was a very hard day for us. It does our hearts good to spring forward to today, when we have 140+ condors out there flying wild, and to know that in a very small, minute way, we contributed to that success with a fast car and lens!

The condor project is when reality set in. The reality that I loved what I was doing behind the lens and what I was doing with my photography. I seemingly was making a difference. The reality that I had been a volunteer for all of these projects, and the reality that I wasn't going to be paid to be out behind the lens had come over me. I could get paid by what I created with the lens in outside venues, but that would take some time—quite some time.

My favorite f-stops? F/8 for birds, and f/4 for big game. My favorite shutter speed? From 1 second to 1/8000 of a second, because I shoot in aperture priority mode and the shutter speed is determined by the light falling on the subject.

Making a Difference

I was starting to become a walking encyclopedia on California's T&E species—particularly those that were in the greatest peril of blinking out (going extinct). Frustration was welling up in me. How was I going to make a difference and make a living? It's a frustration that's still with me to this day. Sitting in the back of one of those Audubon presentations, the light came on—not the room light, but the light in my head. I could make presentations. I could get the story out verbally and photographically.

Life took control again. By this time, I had written a piece on the least Bell's vireo and sent it to a magazine (*Birder's World*) that hadn't published its first issue yet, but was looking for articles. The article came back as fast as it went out, which was a crushing blow. We needed the income as much as validation that, photographically, we were on the right path. That's when we learned of a magazine published by the California Department of Fish and Game, *Outdoor California*. It was a color publication, but paid nothing for materials it used. The story of the very endangered least Bell's vireo was greater than our need for income, so I sent the piece to them.

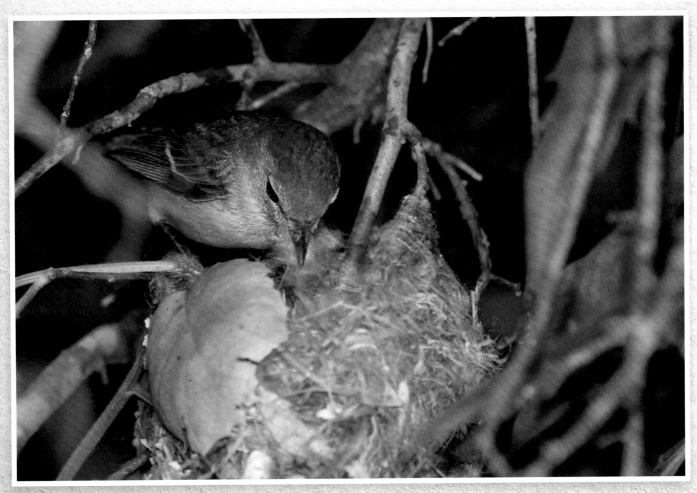

Least Bell's vireo building nest. Photo captured by Nikon N2020 & Micro-Nikkor 200mm f/4 lens, using two SB-16 flash units, on Kodachrome 64.

A couple of weeks later, Sharon made a follow-up call. The voice on the other end of the phone sounded like a knock-off of Peter Falk's *Columbo*. The cigarette smoke leaked through the phone receiver, and the popping of sunflower seeds echoed in our office. "Oh yeah, I remember the article. Got it right here. The photographs are marvelous, but the writing leaves a lot to be desired. If I could help you rewrite it, make every word count for 10, then we might have something we can publish." Publish? Did he say publish? Fixing the writing is all it would take? Sign me up!

In April 1986, our very first article was published. I had one photo published prior to this, an old boss' portrait, which didn't count in my mind. This was the first for everything! It was a simple four-page spread telling the basic story of the LBV biology and my experiences with them. That very same month, the least Bell's vireo was listed federally as an endangered species. This meant that all my previous work at Mono Basin was even more important, especially the photos of

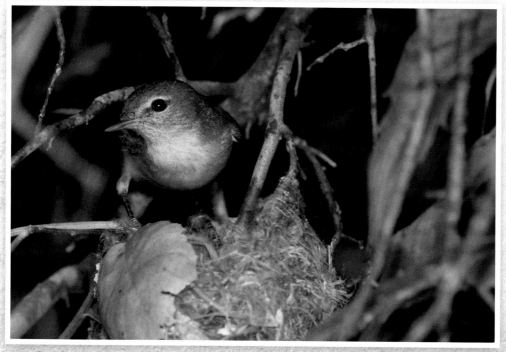

Least Bell's vireo with nest. Photo captured by Nikon N2020 & Micro-Nikkor 200mm f/4 lens, using two SB-16 flash units, on Kodachrome 64.

the LBV with the insects from the chaparral. This aided in getting more critical habitat designated. Politically, it was not a popular listing. The housing boom was just gearing up in Southern California and the listing meant some plans had to be modified—not stopped, modified. There's a big difference.

We didn't know it then, but that first publication would change our lives. A few months after the article ran, I received a call from a biologist with the USFWS in Southern California. Karla told me a story she thought I'd appreciate. Outside of Oceanside, there were two elderly gentlemen who took daily walks together. One day, the one gentleman knocked on his friend's door to pick him up for their walk. When the door opened, the friend was all excited. "You know that funny little gray bird we see down in that strip of forest by the road? I know what it is!" He grabbed his copy of *Outdoor California* and showed his friend our article about the least Bell's vireo. "Sure enough, that's it all right." The gentleman went on to say, "I just passed that spot and there are bulldozers down at that forest, and I think they mean to flatten it." The contractor wanted to take advantage of a loophole in the Endangered Species Act. He didn't know about these two gentlemen, who called the USFWS to report him, and before he could blade the forest, he was stopped.

"Want proof your photographs can make a difference?" Sharon asked. She'd always encouraged me in her own way that what we thought was our mission, was really our mission. It didn't take being smacked in the head by a two-by-four to realize that we were on the right track. Later, a muckity-muck at USFWS told me he thought our article saved the

Moose...on the road.

least Bell's vireo from extinction. I've never been convinced of that, but I know we made a big impact on its survival. The reality is that it was the photographs and the story behind them getting in the hands of the public that made the difference.

For the next six months or so, we hit the road making presentations throughout California on the LBV, condor, and sheep projects. Being paid basically just gas money, we took the stories to whoever would listen. We went to a lot of Audubon meetings. I didn't talk about f-stops or shutter speeds; I talked about habitats, nestlings, helicopter flights, and biologists.

Who knew that Mom's being a mom would lead to this? Who knew the path we started down would so interweave and propel us further down the road? I sit here writing this with eyes partially teared up, shaking my head in disbelief, seeing where life has taken us. It was obvious at this point in our career—ours, because Sharon was very much a part of it—that we had no illusions, and we weren't in control.

Want to make a difference for our wildlife heritage? Get your images out to the public. The easiest way to do that is to set up a blog with a gallery. Head to KelbyTraining.com and watch my good friend RC Concepcion's classes on WordPress. You, too, could save a wild place or critter with your images!

CHAPTER 3
Hold onto Your Pants!

Sharon entertaining Brent, who loved to play with the camera, while I got to know Keebler.

The original BRD CHSR at Tule Lake in −20° as I worked with bald eagles.

Working with my favorite subject, the San Joaquin kit fox, as it's processed and set loose with a new telemetry collar. Photo by Josh Bradley.

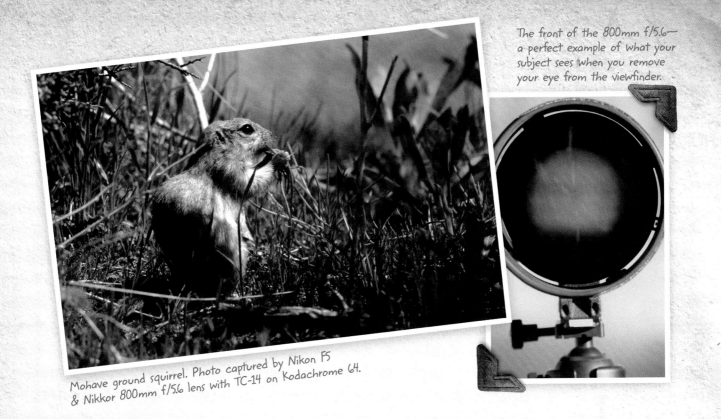

The front of the 800mm f/5.6— a perfect example of what your subject sees when you remove your eye from the viewfinder.

Mohave ground squirrel. Photo captured by Nikon F5 & Nikkor 800mm f/5.6 lens with TC-14 on Kodachrome 64.

It was a Thursday, late afternoon, and I remember it like it was yesterday. I was setting up my projectors and sound system (in those days, I did a two-projector slide presentation using a tape sync system), because I had somehow gotten myself invited to be a guest presenter at the big annual ornithological meeting that was to be held that year at the Santa Barbara Museum of Natural History. I was presenting on a topic I had presented numerous times to many an Audubon audience: the least Bell's vireo.

By the time I was to present, I had changed my shirt I don't know how many times. To say I was nervous is an understatement. Maeton was in the audience. We had gone to his home quite a few months before and I had done the presentation for him to make sure all my ducks, so to speak, were in a row. Here I was, a greenhorn photographer, a nobody, an imitation biologist, getting up in front of a group of professionals, biologists, researchers, and academia and giving a biological talk. What the hell had I gotten myself into, and why? This was the first time my "science" was going to be presented live to those in the know. Sometimes I question just how wise I really am.

I started off with my usual: a slide show put to music. The music was Elton John's "Funeral for a Friend" turned up real loud. All the images in the opening slide show were from Yosemite, and not to toot my own horn, but there weren't too shabby for a greenhorn. The audience wasn't prepared for that—they were looking for a couple of purty pictures and lots of graphs. I didn't have one graph in my presentation. I had bird photos and a laser pointer.

After the music quieted, the audience kinda stared at me, wondering what the hell was coming next. Any thought of a normal biological presentation had left the room. I started off with my best "biological" image of the least Bell's vireo, making a statement normally not made at such a meeting. In a nutshell, I said something like, "This is about the bird that captured my heartstrings." Holy crap! Talking emotions at a scientific meeting? Maeton was probably in the back of the room saying, "This is not the presentation he showed me!"

In the darkened room, I could see the shock and pleasure on their faces. Yet, no one dared to move or say a word because they feared what would come next. For the next 30 minutes, I took the entire room on a visual—what we now call virtual—tour of Mono Basin and the life of the least Bell's vireo. I kept saying important words, like anecdotal, transect, nestlings, and information collected, avoiding saying data. I finished with a secret weapon I learned on my limited Audubon circuit: my strongest photo, the heartstring puller of the LBV at the nest with the perfectly exposed leaf on the left. I let the photographs basically do all the storytelling.

Greater sandhill cranes at Soda Lake. Photo captured by Nikon F3P & Nikkor 400mm f/5.6 lens on Kodachrome 64.

The lights came up in the room—not by someone hitting the switch, but from the roar of the applause! Oh man, there is no audience like one full of biologists. They know better than anyone else all that goes into making a wildlife photo. I took questions, which weren't really the questions you'd expect at such a meeting. They were more like congratulatory comments. Afterwards, I went in for the kill.

I've always tried to send the audience home with a song in their heart and I wasn't going to stop now. I had images of greater sandhill cranes, taken at a special place called Soda Lake in California's Carrizo Plain National Monument, set to an inspirational instrumental piece. The closing shot is of a flock of sandhills flying past the moon. This audience was set to leave—they'd never had a presentation like this—

I'm a huge advocate of photographers sharing their images, and one great way is through a slide show. Unlike when I started out—with slide trays and pushing buttons on a wired remote—today we have digital. I prefer ProShow Producer from Photodex, and with it, it's really easy to create the show and export it as either Web content or a DVD for playing on a television. Whatever method you select, share your images and change the world!

so waiting for a closing piece was, well, unheard of. Many started to get up as I rushed to the back of the room to change carousels. I ignored them. I was set in a second and, with Sharon at the lights, the room went dark again.

At that, they stopped where they were, sat back down, and stared at the screen. They were probably set for rock-and-roll music again. I know they weren't ready for some romantic piece. I counted on that! The music played, the slides rolled on, the mouths started to drop. I saw one lady's hand head up toward her cheek. Score! The lights came up and, with that, I was now part of the clan. I was all right.

I felt really good about my presentation. Maeton came up and said I had done well. I was taking questions about photography, congratulatory statements, basically being the belle of the ball. I was on cloud nine until Charlie (a biologist) walked up to me and introduced himself. I'd heard about him. A photographer working at one of his recent projects had been a total jerk, and Charlie did what he should have done (as it was told to me): he literally threw the guy off his project site. I never asked Charlie if it was true, and I sure wasn't going to ask him then as he shook my hand and said he really liked my presentation. It was going through my mind, though, as he asked me if I was interested in photographing the island scrub-jay of Santa Cruz Island, the California least tern, elegant tern, black

skimmer, and black swift. The fear that went through my mind was instantly replaced by panic as I heard myself saying, "I'd love to work with you on those projects."

Charlie isn't just a biologist—hardly. Charlie is a world-renowned ornithologist who has literally written the book for, not just a species, but a whole family of birds. He is a great guy and turned into one of our best friends and biggest supporters, and another one of my mentors. Charlie would be heading out to Santa Cruz Island within the month and had room for one more, which he filled with me.

Working Without a Net

Charlie was the portal to a whole new level of projects—all with endangered or rare California species, and all long term. This was serious shit I was committing to. I questioned my photographic skills, I worried about our budget (budget? Ha! I checked all the couch cushions), and I stressed over taking time off. Now it was time to juggle family (Sharon was pregnant with our first son), work, and a "blossoming" career along with the huge desire to not be confined within four walls, but out with a camera. There had to be a reason for it all falling into place as it did. So, with the inexperience of youth, Sharon and I threw caution to the wind and went for it all!

This would be the first project I would work without the safety net of the car. These days, after all the travel I've done, it's like falling out of bed, but this was the first time where I would have to be able to take care of myself and my photography without having the kitchen sink packed in the trunk. It was a hell of a learning experience. I thought through all I would need to support me and the camera, got it all packed for transport, got it in the Camaro, and headed to the docks in Ventura.

We literally got a lift to the island from the U.S. Navy, on a PT boat, just like you'd see (back then, at least) on *McHale's Navy.* I carried my little bit of gear and personal items, including food, to the dock, all in one trip. I got down there to see piles and piles and piles of stuff. Where I brought dehydrated food to save space and for ease of prep,

One of the "oldies" on the island, this Santa Cruz Island scrub-jay shows off its well-worn bands (and smarts, since it's not going back in the trap). Photo captured by Nikon F3 & Nikkor 400mm f/5.6 lens on Kodachrome 64.

Charlie and the crew called out this and that species name, but I didn't recognize a single one (know them all now). The camera never came out. I just sat there listening and ingested all I could.

We reached the island, transferred our gear to trucks, and drove to the research center. As soon as we pulled up to the center, we were greeted by a Santa Cruz Island fox. The keeper of the research center had done his Ph.D. on the fox, so there was no lack of information on this very charismatic creature. It was hard to stay focused on what I had come to do: document the research on the island scrub-jay. The island scrub-jay looks like the western scrub-jay, but is a unique species living on the island of Santa Cruz.

Charlie and his crew brought ice chests of fresh food to cook. They assured me they brought plenty of food for me, too. I told them I was saving space for all the film I had brought. They bought that line, and thought I was wise to make that sacrifice. One of my challenges, though, was not only getting my gear over to the island safely, but then being able to work out of whatever "bag" I used. This was before the days of the photopack, so I converted a daypack I used into my first photopack. It was the last thing to come aboard, and was with me all the time.

Man, was that flight across the channel ever cool! The captain had us up to full speed just one foot past the outer harbor marker, and didn't slow down until we reached the island. We flew over the waves, turning only to miss obstacles like whales. We all sat on the bow, hanging on for dear life, and we saw blue whales, gray whales, pilot whales, and pelagic birds—a totally new bird family to me.

The gear I took with me was pretty simple: two F3s (a P and a T), a 20mm f/2.8 lens, a 35–70mm f/2.8 lens, a 35–200mm f/3.5 lens, and a 400mm f/5.6 lens. I had flashes, a bracket, film, a tripod, and a shooting vest. All of this was in an expensive daypack, each item in its own Domke wrap for protection. I worked on the island with the gear mostly in the vest pockets and the 400mm f/5.6 lens on the F3P always

Whenever I travel to a shooting location by either plane or car (driving for hours and hours), I find that no matter how clean my sensor might have been before the trip, the vibration has put goobers on my CCD. So I always clean my sensor after traveling and before I shoot.

hanging from my shoulder. I look at this list today and have to giggle to myself. In many ways, those days were so simple compared to today. The tonnage that's required today to do the same task is amazing to me. What I took got the job done, and I still have the images.

Getting Information for Peanuts

This was a basic science project outing to mark a given population with USFWS bands and color bands, so scientists could watch the marked jays to learn about territory selection, use, and defense by pairs. All this required capturing the jays to attach the bands. Since they have such large ranges and constantly fly throughout them, the normal means of capture (a mist net) couldn't be deployed. Rather, a special trap was required—a large, open-wire affair.

Jays—every single species—have a thing for peanuts. Doesn't matter if they've never seen one before in their life—throw a peanut toward a jay, and they gotta check it out. Once they check it out, they gotta bury it. It's just what they do. I learned that on this trip and it's something I use to this day with the jays in my yard when it comes time to get them down to my perches. More about that later.

Elegant terns. Photo captured by Nikon F3/T
& Nikkor 800mm f/5.6 lens with TC-14 on Kodachrome 64.

California least tern. Photo captured by Nikon F3/T & Nikkor 800mm f/5.6 lens with TC-14 on Kodachrome 64.

Black skimmer. Photo captured by Nikon F3/T & Nikkor 800mm f/5.6 lens on Kodachrome 64.

So, peanuts were used to get the jays into the traps. The door on the traps was right out of the cartoons: propped open with a stick, with a string tied to the stick that, when pulled, closed the trap. Peanuts would be thrown inside the trap and the jays, because they are jays, had to go in and get them. Just to sweeten the deal, some peanuts were thrown on the ground outside the trap (we had hundreds of pounds of peanuts at the research station to keep us supplied).

Pairs that had never been caught before blindly went into the trap after a peanut. The door closed behind them and they would soon be in hand and be processed. While jays mate for life, loss of a mate is not uncommon, so the mate with no band would need to be caught. This is when the fun would begin (the ladies reading the book will like this part).

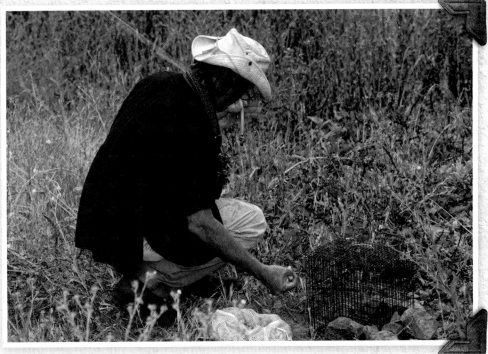

Santa Cruz Island scrub-jay project. Photo captured by Nikon F3P & Nikkor 35–200mm f/3.5 lens on Kodachrome 64.

When it comes to doing the "dirty" work, like getting a peanut out of a trap, if the pair is trapwise, the female sends the male in to get the peanut. Even though they know it's a trap, the drive for the peanut is so strong, they gotta get it. Well, if the female needs the band, you've gotta catch the male first. These are smart birds who can problem solve. The first thing the trapwise male does is gathers all the peanuts from around the outside of the trap, leaving just those inside the trap. Next, he'll go around the outside of the trap and reach in through the holes in the wire cage to get all the peanuts he can without going into the trap. It comes down to the one last peanut that he can't reach, and that is wired to the bottom of the cage. With the female perched nearby, calling her demands, the male finally goes into the trap. Voilà!

Experimenting with Flash

I was there as both a student and photographer. Other than the sheep capture, working directly with biologists was a new thing. Actually photographing the biologist working, where the subject was the work being performed, was totally new to me. I knew shooting would often be in shade, since it was hot and captured birds need to be kept cool. Folks, working in the shade means bright background, dark subject. Only one solution: flash fill. I was shooting with an F3P body and SB-16a flash, and while it had TTL (which was a huge improvement), it was nothing like the digital age where you can check lighting on an LCD. In fact, every time you wanted to change a roll of film, you had to remove the flash from the camera to access the rewind knob.

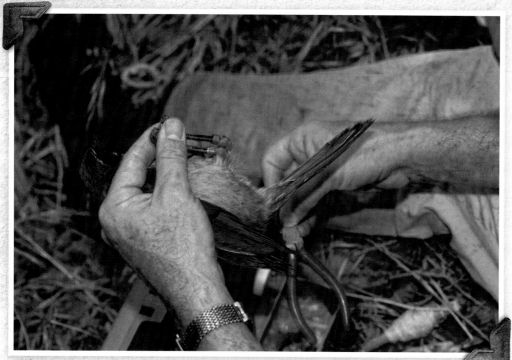

Banding a Santa Cruz Island scrub-jay. Photo captured by Nikon F3P & Nikkor 35–200mm f/3.5 lens on Kodachrome 64.

hands in the shade of a tree, just hadn't entered my thought process. I was basically "experimenting" on Charlie's time to get the shot.

The SB-16a was a big, bulky flash with no bells or whistles, but about the same power as we're used to working with today. Off-camera cords were available (I'd spliced them for the hummingbird), but it didn't occur to me to use one, so for all the photos, the flash was on-camera. Not good. Looking back, what did I do right with flash? The SB-16a, while it worked TTL, had no way to dial in any compensation—it just sent its light out the same each and every burst. Using the basics of flash-to-subject distance, and bouncing off a card, a means of limiting the flash's output was a must.

Working with flash wasn't foreign to me, and neither was this camera/flash system. But putting it all together when photographing biologists working, that was totally new (and, of course, I had to get my hands involved with the work, as well. I wasn't just a photographer). I had done some testing before heading over to the island, but testing on a person in close quarters, working on something with their

All of this adjusting without an LCD to see if my ideas were working was a challenge. Thank goodness they worked, because the images turned out. I got the photographs Charlie needed for the project, and didn't make a fool of myself. In fact, I was pretty darn good for a greenhorn. I had made a new friend and shored up my reputation a little more—all good things in this business.

> As I've mentioned before, there was—and still is—no pay involved in these projects. I volunteer. In fact, you could say I pay to be out there, because I give the biologists dupes of my images. These days, that's a mere copy of the digital file, but back then, it meant actually making a duplicate slide.

People Do

I watch a lot of TV (I should qualify that—I *listen* to a lot of TV). Current events and trends affect what I do, and I learned early on that it helps me, subconsciously at least, zero in on species I want to work with. I also read everything I can get my hands on. I used our growing list of contacts at Fish & Game and Fish & Wildlife to

get species reports. I read all of these as they came in (remember, there was no Google, so I had to do research the old fashioned way).

About this time, Chevron ran a print and television ad campaign called simply "People Do," highlighting a number of endangered species that they were "protecting." (History shows it was a good ad campaign and that's all.) One of the featured species was the San Joaquin kit fox. I saw the ad, and it struck a chord with me.

After my brief experience with the island fox, and from my built-in barometer, I knew the kit fox would be the species I wanted to work with next. This would be the first species that I selected. Fate didn't pick it. Or did it?

At this same time, WRP (Wildlife Research Photography) became an entity, and its first employee was Sharon, who was (and always has been) my ace in the hole (she still worked a part-time job at night).

Santa Cruz Island scrub-jay. Photo captured by Nikon F3P & Nikkor 400mm f/5.6 lens with TC-14 on Kodachrome 64.

Morro Bay kangaroo rat. Photo captured by Nikon F4e & Nikkor 35—70mm f/2.8 lens with 6T close-up lens on Fuji 100.

It was good timing, because while I worked at the camera store, Sharon worked the phone at the office (the spare bedroom in the condo) to get a contact name for a biologist who worked with the kit fox over in Bakersfield, and a date for me to go out with the biologist. I packed everything in the back of the Camaro, including my new baby—the newly acquired Nikkor 800mm f/5.6 IF-ED (a great lens!).

> *Why do I shoot Nikon gear? Flash! Flash is an incredibly important tool for the wildlife photographer and Nikon makes it real simple to use. I need simple, following the K.I.S.S. (Keep It Simple Stupid) theorem all the time.*

George worked for the U.S. Bureau of Land Management (BLM). His work with the San Joaquin kit fox wasn't your typical hands-on study. Rather, he watched out for and protected the species/population as a whole in their southern valley home—what's called a regulatory job. That day, I was a sponge, because George was one knowledgeable and tuned-in biologist. He laid out before me the basic biological and political history of the Central Valley. We never saw a fox that day, but I saw how the southern end of the Central Valley had been exploited, carved up, saved, destroyed, manipulated, and treasured, and why the kit fox only had 10% of its historic range left in which to survive.

We were on U.S. Department of Defense (DOD) and Department of Energy (DOE) land, as well as Chevron, Santa Fe Petroleum, Exxon, and Arco property most of the time, and a little public land, weaving in and out of oil derricks, storage tanks, and pipelines. This also included

what was then the National Strategic Petroleum Reserve in Elk Hills. George showed me kit fox den sites, prey, kills, and even a kit fox road kill (which I should have photographed, but didn't). George wrote up infractions like oil spills on endangered plants and fox dens most of the day. It was one of those gray, damp, cold winter days in the valley, and what I saw didn't make it any brighter or warmer.

We finished off the day in Lost Hills. We pulled up to two office/work trailers out in the middle of nowhere off Hwy 33, got out of the vehicle, and walked over to two mounds about 20 feet apart. I must have looked at them quizzically because George said, "These are it." "These are what?" I asked. They were the supposed safe dens Chevron made that were featured in the "People Do" ads. What I was looking at was nothing like what I saw in the ad. Then he told me the story behind it all.

The guys working the oil field saw the kit foxes all the time and had come to like them. The foxes would use the empty space under their trailers as a shelter and the guys would feed them, so they basically became pets. One old codger decided he wanted to do more and so, with the help of a biologist, made these two "unofficial" artificial dens. It was made clear at the time of construction that the dens in no way were any type of mitigation for any wrongdoing.

The company then was bought by Chevron and some bright ad guy heard the story and the commercial was born. The fact that the dens, at the time of my visit, had only been used by a couple of jackrabbits didn't matter. A fox never even looked at them as far as anyone knew. For the TV ad, Chevron got a trainer to teach a captive kit fox to run a path like it was being chased by a coyote and then look scared while in a pipe, only to be saved by this artificial den—an artificial den that, in reality, had never seen a kit fox.

Least bittern. Photo captured by Nikon F3/T & Nikkor 400mm f/5.6 lens on Kodachrome 64.

Is zoo photography real wildlife photography? Photographing captives is for some the only wildlife photography they can do. I personally have no problem with it, though it's not my thing. But it can be a great place to learn. And if you're about to photograph, say, grizzly bears for the first time, heading to the zoo to photograph them and try out exposure, lens, and exposure composition is really smart. You don't want to figure it all out with the real deal. Make your mistakes before that opportunity knocks.

Biologists processing a San Joaquin kit fox in one of Bakersfield's sumps. Photo captured by Canon EOS-1D Mark II N & Canon EF 17—40mm f/4L USM lens on Lexar digital film.

It was a long ride home. I never saw George again, and I think I only spoke to him one more time, but he'd really opened my eyes. The idyllic world of Santa Cruz Island was quite different from the real world of California's wild heritage in man's backyard.

How screwed up a society we are kept smacking me in the face. We've screwed up the environment and we know it, but we're so screwed up we have to create false ads to cover it up. That act, demonstrating that we know we're screwed up—that we've screwed up and only money matters—just sat wrong with me. Chevron later got in trouble for the ads and, in one of those backroom deals, made amends by shelling out a bunch of money for some "good guy" projects.

Captivated by Keebler

Then and there, I knew I couldn't let this stand. But what could a 28-year-old, broke photographer and expectant father do? (That question still drives me every day, because nothing has changed, except the kids are now in college.) We're talking giant corporations, government, and the most imposing, a public who at the very least is indifferent to the whole thing. What the hell could I do? The first thing was I had to see a San Joaquin kit fox, in person, and if at all possible, get some glass on it.

Sharon lit up the phones, but as you might expect, finding a wild kit fox you can just drive up to and photograph ain't going to happen with a phone call. Sharon did locate two kit foxes in captivity at a place called CALM (the California Living Museum—we later had an exhibit and book signings there). They take in injured native wildlife, and release them after rehab if they can or keep them on exhibit if they can't. Sharon arranged for us to go into the facility before the public to see, and possibly photograph, their two foxes.

It was a long drive over to CALM, which is east of Bakersfield, especially for Sharon, who was five months pregnant. We went with the arrangement that I could go in the enclosure with the foxes to shoot. Photographing a captive wasn't great, nor is it the way I like to shoot. This was the first, and last, time I would photograph

Keebler, a San Joaquin kit fox. Photo captured by Nikon F3P & Nikkor 300mm f/2.8 lens on Kodachrome 64.

a captive, so I wasn't really sure what lay ahead of us. I grabbed a 300mm f/2.8 lens from work, so I could blow away any sign of the enclosure with f/2.8 if need be. We arrived at the facility, were greeted by the very nice folks there, and were led back to the kit fox enclosure. It was, again, one of those depressing gray Central Valley winter days, which (for what I had to see and photograph) seemed very apropos.

We walked up to the enclosure and the first kit fox we saw was a sad case. As it turned out, it would pass on in the next couple of weeks. Its big black eyes looked up at us, and it could barely give us the kit fox growl of disapproval before putting its head back down to ignore us. It was then that Keebler emerged— a stunning male in full winter coat. He stood and looked at us, and it was an instant love affair. These animals, which are smaller than a house cat, have the most expressive eyes that seem to look right into your soul. He was a magnificent animal and there was no way I wasn't going to photograph him.

These animals, which are smaller than a house cat, have the most expressive eyes that seem to look right into your soul. He was a magnificent animal and there was no way I wasn't going to photograph him.

He looked perfect, not "damaged" like the other fox, so I asked why he hadn't been released. "Chevron made this commercial where they needed a kit fox to run this path and look scared. They brought in an animal trainer from Hollywood, who within a week of working with Keebler had him running the path and looking scared on cue," the CALM staffer answered. "How'd he do it?" I asked. "Keebler loves Keebler cookies, so that was the treat he got when he performed, and how he got his name." Life came full circle, and if there was any doubt, that moment sealed it. This was what I was meant to do with my life and my photography.

Folks ask how I got started in wildlife photography, and I say, "It just happened. It's the way life unfolded. It wasn't anything I planned." I often get a disbelieving look. There is no way in 20 words or less I can tell this story. There is no way I could have planned on being moved by a commercial, or finding a biologist who both stirred something inside me and showed me the dark side of that commercial,

or finding the kit fox trained for that commercial and falling for the species. We were not only not that good at that kind of thing back then, but we also didn't have those kind of contacts or the money to do it. Life is what life brings.

As for Keebler, what became of him? Well, we photographed him all right. Working in the enclosure made for horrible backgrounds, so I stood outside, against the fencing, shooting through one of its holes as Keebler lay in front of me. He was perhaps five to six feet away when he first lay down. He looked at me, and I was able to make three clicks as he slowly fell asleep. One pose that came from it is in about every slide show I do— he is never far from my thoughts. He has been on environmental posters and campaigns, congressional reports and reviews, the cover of numerous magazines, and in about every article ever written about kit foxes. Long after his passing, Keebler is still the spokesman for his species and its plight. He is the reason that, to this day, I'm still out with the kit fox every year, and that it's our longest running photographic project. That's one hell of an impact for one small critter to make in his short life.

I had been a Nikon geek since 1980, and while I still love the smell of a new piece of gear, after Keebler, the lens or body took on a whole new role. Gear has to not only take the picture, but solve the problems of working with endangered critters and biologists with *no* impact on either. I went to the camera store a little happier with this new direction. I say a little, because I was still going to a camera store to earn my keep and not out the door to the wilderness.

What's the mammal I like photographing the most? The San Juan kit fox, with moose being a close second.

The kit fox and its story was/is at the forefront of my thoughts. As a kid, my family would load up the station wagon on Sundays and hit the road. Traveling and exploring new California landscapes was something I was born and raised to do. Sharon was brought up not too differently, so it's something we've always enjoyed doing together. Keebler changed our vision a little, though. Landscapes were replaced with habitats, and looking for interesting man stuff went to looking for no-man stuff.

One Species Leads to Another

Kit fox habitat, what was left of it, was what we wanted to explore and know better. In researching the kit fox, I had come across a fact that just blew me away: their prey was another endangered species, the giant kangaroo rat. The GKR is a keystone species—the endangered San Joaquin antelope squirrel, blunt-nosed leopard lizard, and some endangered plants depend on its activities. This was something we had to explore.

Blunt-nosed leopard lizard. Photo captured by Nikon D2H & AF-S II Nikkor 600mm f/4 lens with TC-14E II on Lexar digital film.

Is there perfect footwear for the wildlife photographer? I really, really, really wish there was one pair, model, or style that worked for everything. I feel like a clotheshorse at times with light walking shoes, light hiking shoes, hiking boots, LaCrosse Ice King snow boots (go to −40°), knee-high rubber boots, hip boots, and even waders in my closet. You're on your feet all the time as a wildlife photographer, so finding the right footwear—preferably waterproof—is really important. It's definitely one of the hidden costs of photography.

Sharon made some calls and reached the lead biologists for the California Department of Fish and Game's (DFG's) endangered species department. Ron at DFG, gave her the name of a professor who knew the GKR, was the one responsible for getting it listed as endangered, who created the entire list of endangered mammals in California (a Herculean task), and so much more. Even better, he had just started a project that spring on the GKR in an area we knew pretty well off the Carrizo Plain. With that contact info, Sharon was back on the phone. Oh yeah, and kit foxes live there, too!

At this same time, there were some innovations on the camera front. Nikon introduced the N8008, a body with a built-in motor drive

Mohave ground squirrel. Photo captured by Nikon F5 & Nikkor 800mm f/5.6 lens with TC-14 on Kodachrome 64.

and TTL flash. With it came the SB-24 flash, an early predecessor of the current SB-900 that had flash compensation (hurray!). This was a huge advancement for my work. About this same time, the formula for our long-trusted Kodachrome changed, so I switched to Fuji. This gave me a bump in ASA from 80 to 125 and, when it comes to flash, that's a help. Why was this all good timing? The giant kangaroo rat is a nocturnal subject, and flash was required. New testing had to be done, and finding a stand-in for the GKR was a challenge. I ended up using an old wool sock stuffed with paper, but it worked.

Sharon called the contact, Dan, then called me at the store. Dan was more than happy for us to come out, gave us directions, and told us when they would be on the plain working. The date was about 10 days before Sharon's due date! Her doctor wasn't particularly thrilled with the idea, but Sharon was up for it. (She's always hated pit toilets since that trip—go figure.) So when the day came, we packed up and headed out. Dan and Sue (his wife and assistant) were staying on the plain for a few days, camping, and offered to

let us join them. With Sharon's due date so close and sleeping on the ground while pregnant not really doable, we just went for the day.

The location of the camp is someplace where most would not even stop: A barren looking slope rising up to a ridge line that is the San Andreas fault—it's brown and barren dirt for 320 days out of the year. It's so cold in the winter, it has killed, and so hot in the summer, it has killed. And yet, to us, it's gorgeous. You just can't judge a book by its cover or landscape from a car window.

Do you need to know Latin? It's a common question, especially on the business side. I know only one name in Latin: Ratus ratus. What's that? A Norwegian rat—the sewer rat you see in horror movies (I've never photographed one). That's how important knowing Latin is when working with biologists.

Riparian woodrat. Photo captured by Nikon F5 & Micro-Nikkor 60mm f/2.8 lens on Agfa 100.

Dr. Dan Williams working with the giant kangaroo rat. Photo captured by Nikon N8008 & Zoom-Nikkor 35–70mm f/2.8 lens on Kodachrome 64.

A skill most wildlife photographers don't work on polishing is people pictures, or portraiture. This is important in the storytelling. Whether you're photographing a birder, teacher, or biologist, that simple human interest, when added to a story, can make a world of difference in reaching your audience.

Photographing Popcorn

We made introductions and, before you knew it, we were on the study plots (a number of lines of traps placed in a precise grid in order to live-trap the giant kangaroo rats). I don't remember exactly why Dan was running the traps early in the morning, but it was the only time we worked by the warmth of the sunlight. I had the F3P over my shoulder with the 35–70mm f/2.8 lens attached as we started to walk the grid.

This was all new to me, every single aspect, from the locale to the science, so I was nothing but questions. And Dan was great answering every question, providing me with more info, more science, and more passion than I could imagine, let alone soak in. Sue made sure Sharon was okay, while making sure Dan remembered to do everything he needed to do when he processed a GKR as he talked to me—a huge distraction!

A number of GKR were caught and processed that morning. They are nothing like the horror movie rats people conjure up in their mind when you say rat. Their tail is unique and an important part of how they get about. They hop like a kangaroo, which is where their name comes from. While in midair, they can swing their tail and change direction by 90 degrees in mid-hop. Their pelt is very soft, and their touch is incredibly soft. At night, you can lie on the ground, fill your hand with seed, and they will hop up in your hand and clean it all up, every grain. Other than their hind feet resting in your palm, you can't feel a thing. And, of course, there are those big eyes!

That evening, we stayed until dark to see the rats emerge from their burrows and go about life. This was a colony of about 260 individuals spread out over a few acres. There are always a couple "camp rats" who, since they are in camp and not on the research plots, get spoiled with basically all the seed they can carry away. This is when the new technology came in handy.

Up until this time, biologists tried to photograph the nocturnal activity of the GKR with a flashlight between their knees, attempting to keep the beam on the moving GKR while they focused the camera.

Giant kangaroo rat. Photo captured by Nikon N8008 & Micro-Nikkor 200mm f/4 lens on Kodachrome 64.

They would then have to work out their guide number, dial in their aperture, and, one click at a time, try to make the shot. When I brought out the N8008 with the SB-24, I got Dan's attention. Using the AF illuminator and the TTL of the SB-24, and with the built-in motor drive, I picked off image after image. I burned through the film. Personally, I hadn't ever had so much fun—it was like trying to photograph popcorn as it was popping, with the GKRs bouncing in and out for the seed that had been put out. It was a great day!

The photos turned out nicely. I had dupes made and sent them off to Dan. He was quite pleased. He said we'd be welcome back anytime and he'd keep us in the loop about their plans. In fact, we spent the next 20 years together in the field, and Dan became one of my greatest mentors, teaching me more than I can ever thank him for. Our son Brent, who was born not too long after this visit, celebrated countless birthdays on the plains, working with GKR.

A Life Both Rewarding and Frustrating

It's hard to understand the science side of this if you've never experienced it. It's lonely work most of the time—long, hard hours in conditions that scare off the sane. The reward is gaining of knowledge that, in this case, can save a species or an entire ecosystem from extinction. When you have PBS come out and film what turns out to be their number-two-rated show of you and your family working on the plains with this biologist, that's fun (happened our fourth year out). When the project becomes so important that you have the head of the BLM, Secretary of the Interior, and state governor come out to see it, you know you're making a difference (I've lost count of how many times it happened). And, I'm there just as a silly photographer, recording it all and going along for the ride.

> *Then, one day…it occurs to you that perhaps your photographs and actions really do make a difference.*

Then, one day, you see your name on the first multi-species federal recovery plan as a contributor, and it occurs to you that perhaps your photographs and actions really do make a difference. It seemed only right that our first photo to appear in *National Geographic* was of a giant kangaroo rat (Dan said later that one photo made more impact for the rat than anything he'd seen up to that point in time). And then you get a piece of paper in a ceremony on the plains that says you're now a research associate for the Endangered Species Recovery Program. Well, it's just darn hard not to burst out with tears of gratitude!

We headed out to the plains to see the GKR because of its role in the life of the San Joaquin kit fox, and while we saw all the rest of the pieces, we didn't see the SJKF on that trip. Dan filled in a ton of holes, though, so it was time to move on with working with the fox.

The last piece of my life goal finally fell into place. I returned from that first trip with the GKR totally unsatisfied. Why? I had new technology and I applied it safely with the biology, and came back with images. But, I realized I had come back with snippets of the visual story—the GKR is so much more than a portrait sitting outside its burrow. Portraits just don't cut it. They are needed for the editorial market, and are important if you want covers, but that's not where it's at for me. Photographing the life history of a critter was the only way to fill my goal. This realization was depressing. Who was going to pay me to spend my life photographing critters that, for the most part, society doesn't care about? The answer was obvious: no one. We realized we'd have to pay ourselves to do this thing.

It was then I started to become very frustrated. At the camera store, a client walked in with a $25,000 grant to record flute music to the hum of the African savannah. He needed to buy camera gear to photograph it all. He'd never picked up a camera before and walked out that day with a $23,000 rig. I had other clients, going on a hunt in Africa, who wanted a kid they met at church to photograph it all. He walked out with an $18,000 rig. Sucking in this frustration was a good lesson, as no one was giving us money to photograph endangered species.

Discovering Our Own Backyard

One day, Sharon called the camera shop and said Charlie had called and wanted to know if I would be interested in a tern project. His primary work was with the California least tern, and to a lesser extent, the elegant tern, and their northern migration to nest in Southern California. Beach work was in our budget: it was a couple-hour drive and we could stay with family. While we lived on the coast, we weren't knowledgeable about the coastal ecosystem, so this was a great opportunity to expand our ability to do more in our own "backyard."

Charlie met us right at the site in Huntington Beach, in a parking lot off the Pacific Coast Highway. When Sharon told me where, I was a bit puzzled, because it was a place I used to surf as a kid. It was

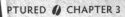

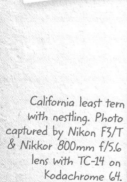

Black skimmer.
Photo captured
by Nikon F3/T
& Nikkor 800mm
f/5.6 lens on
Kodachrome 64.

California least tern
with nestling. Photo
captured by Nikon F3/T
& Nikkor 800mm f/5.6
lens with TC-14 on
Kodachrome 64.

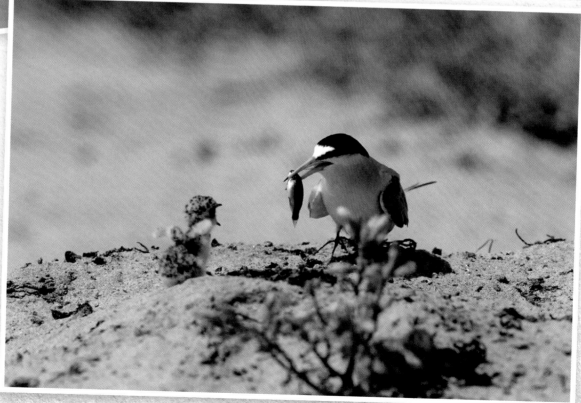

a newly formed sanctuary, a mitigation site for habitat destroyed in Los Angeles Harbor, called Bolsa Chica. We walked across the bridge, went through the locked fence, got in the back of a pickup, and headed down to North Island. It's pretty surreal, because there are oil derricks pumping away to the east, the ocean to the west, and in the middle, a couple-acre man-made pond (with tidal flow) and two man-made islands. When we first made the turn and headed down to the islands, they appeared as if covered with moving snow. The congregation of life was staggering, and I was blown away by the site one moment and in a panic the next. How to communicate this with a still camera in one click? With that thought came the elation of the challenge. Let me at 'em!

I met the biologist from Fish and Game, met Charlie's assistant, and after making a hat check, we were rowed across the water. When we stepped out of the boat and onto shore, all hell broke loose. There are five tern species and black skimmers nesting on the island. They are all colonial nesters for defense: when a predator appears, they take to the air and dive bomb the predator. They also like to crap on them and, since they just eat fish, that's pretty dang nasty.

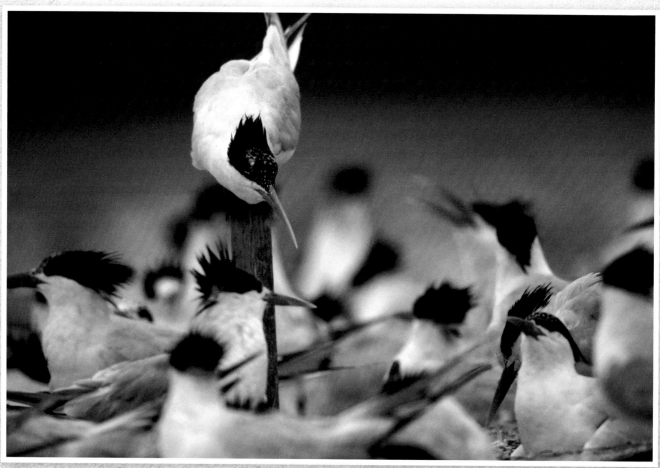

Elegant tern. Photo captured by Nikon F3/T & Nikkor 800mm f/5.6 lens with TC-14 on Kodachrome 64.

When we stepped on the island, we became the predator and felt the full brunt of the colony's defense. The Caspian terns are the big guns. One came down and made contact with a biologist's head and drew blood. They mean business. Thankfully, after a short time, they seemed to get used to us and, for the most part, settled down, permitting us to go about our work.

I made a number of trips to the colony that spring. Besides photographing the biologists' work, I was permitted to set up my Lee Rue blind for one hour. It was great to photograph all the hubbub of the island. The blind was really more for bird crap protection than anything else. By the end of the season, it was pretty disgusting and we couldn't get the fish smell out of it. But it afforded me the ability to be right amongst the life and photograph it. The biggest session was 83 rolls of film in an hour—a lot of film for me to shoot back then, and a big bill. Both left a lasting impression on me.

Bolsa Chica is home to a couple of endangered species: the Belding's savannah sparrow and light-footed clapper rail, along with the California least tern. After coming ashore from the first trip, I asked more and more questions about Bolsa Chica, its critters, and access to it all for my camera. Sharon and I got hooked on the place and, since it was only a two-hour drive from home, we frequented it, building a pretty decent image library and knowledge base. We also got to know the folks involved in fighting for its continued preservation and against a movement to make it a condo/harbor complex. Bolsa was the first place we got environmentally involved, using our images to make a difference. One of our great egret images taken at Bolsa became a poster for the preservation fight. I also created the first in a long line of slide programs on conservation that we presented for the next 10 years.

Charlie also worked another unique reserve just down the road: Upper Newport Bay's Back Bay. It has a number of islands that support small colonies of terns and skimmers, but Charlie

Light-footed clapper rail. Photo captured by Nikon F3/T & Nikkor 800mm f/5.6 lens on Kodachrome 64.

Light-footed clapper rail. Photo captured by Nikon F3/T & Nikkor 800mm f/5.6 lens on Kodachrome 64.

California clapper rail. Photo captured by Nikon F3/T & Nikkor 800mm f/5.6 lens on Kodachrome 64.

California clapper rail. Photo captured by Nikon F3/T & Nikkor 800mm f/5.6 lens on Kodachrome 64.

was there to look at white-throated swifts. The Back Bay is also home to the light-footed clapper rail, and Charlie put me in touch with the lead biologist for the clapper rail, a former student of his, Dick.

Dick is darn good at what he does, and isn't a guy to mince words—he's pretty straightforward and blunt. We met before first light and he told me about the plight of the light-footed clapper rail, a species nearly wiped off the planet, with only a couple of strongholds left. With this cheery start, I slung the 800mm over my shoulder and we started to walk. At first we were surrounded by coastal sage scrub. We came around the corner and upon the first stretches of marsh. Off in the distance, a foreign sound resonated, like someone clapping their hands. No sooner did it stop, than it began again, but from a different corner of the marsh. Dick looked at me and said, "Those are the clappers."

Soon, we were at a bend in the road where the marsh kisses the edge. I looked out, trying to find the chicken-sized bird in what would be my first sighting of the species, until Dick finally said, "The problem with birders: they never look right down under their feet." I thought it was funny until I looked down and, literally, right below our feet was a clapper rail! It was tucked in this little undercut in the bank, peering out and paying us no mind. It was way too close for me to focus the lens, but it snapped my mind into sharp focus.

It was a morning of learning important lessons. Any confidence that I was learning this biology thing, so I could combine it with technology to make the image, was dented, but in the long run improved. Dick and I worked together more with the clappers, and I came to understand its biology pretty dang well. It wasn't all hard work—Dick put me in a canoe on a naval weapons center to have

access no other photographers would ever have to work with clappers. Sharon and I later spent days in the sun at what we called Turnout #2 at Back Bay, waiting for clappers to appear and be photographed (the rest of time, we worked on our tans).

An Expensive Lesson Learned the Hard Way

We headed back to Bolsa Chica one morning to work with the Belding's savannah sparrow. I was able to get a really clean shot of one, so I was quite happy, but the shooting died off really fast, so we packed up and headed to Upper Newport, since there was still good light. We spent most of the rest of the morning shooting there. With the afternoon light, we went back to Bolsa. We got there with only one thing in mind: get over the bridge and down the path for some afternoon shooting along the inflow channel.

When you set up an 800mm lens on a tripod in a public parking lot—one used by beachgoers—you tend to draw attention to yourself. I was always careful about that back then. With Brent on Sharon's back in his backpack, the 800mm over my shoulder, and another body and lens hanging from my shoulder, off we went down the trail. We came back an hour later to find our vehicle had been broken into and the majority of my camera gear stolen.

I have a rule that once I leave a locale for the day, I don't return, because the big lens just draws too much attention. I broke the rule that day and paid the price. After that, I also started to not only look around incredibly closely prior to setting up gear to see if I'm being watched (we were robbed by a team— one guy on the bluff watching cars with a scope, and the other doing the actual robbery), but also to set up my gear

Belding's savannah sparrow. Photo captured by F3/T & Nikkor 800mm f/5.6 lens on Kodachrome 64.

Belding's savannah sparrow. Photo captured by Nikon F3/T & Nikkor 800mm f/5.6 lens on Kodachrome 64.

Santa Cruz Island scrub-jay. Photo captured by Nikon F3P & Nikkor 400mm f/5.6 lens with TC-14 on Kodachrome 64.

by another car. It sounds bad, but what can I say? I set up my gear so it appears to come from a vehicle other than mine. We had no business insurance at the time, and nothing was ever recovered. It was one of those very hard life lessons that one learns and moves on from.

While the wind was let out of our sails by this turn of events, we still had the 800mm, so I could keep working on a limited basis. With money now horribly tight, driving even a couple of hours for a project was out of the question. I started to look in our own backyard for subjects, especially right out the office window. We had scrub-jays in our yard, so I made friends with them by offering them peanuts. Before too long, I could photograph them pretty easily. The one problem was that every perch they landed on, no matter the time of day, was in shade. While I liked the lighting, I didn't like the color. The color was way off. The magnificent iridescence was missing. It took me a while to come up with a solution, but when it hit me, it was bloody obvious: flash.

This would be an expensive lesson to learn—every combo of camera exposure compensation/flash exposure compensation cost $10 (the price of a roll of film and processing). I took tons of notes to correlate the roll/slide number with the lighting combo. Once the film was back, info was put on the slide mount and the slides lined up on the light table to see the actual results. That's what you did then, there was no real other solution other than a Polaroid, and they were expensive! I finally got the exposure compensation dialed in. I wanted to clean up the colors, so I spent much of my time working with this while rebuilding the camera bag.

Come the next spring, we were up and going again. We were expecting our second son, but that didn't slow anything down. Sharon kept on going along on the projects with Brent. Charlie was busy in the field and included us in his tern work, while

Will water ruin your camera? If you drop your camera into a lake or ocean, yeah, you now own a paperweight. But rain won't hurt your camera. My own rule is if I can stand the rain, my gear can. I don't use covers—no plastic bags—I just make sure to blot my gear dry, not wipe it dry. Blotting assures you don't wipe water into joints where it shouldn't go. Keep in mind one of my mantras: the worst weather can produce the best images.

adding a new twist to the routine: swifts—black swifts to be exact—which some say are the fastest flying birds in the world. They are amazing, and I spent the next couple of summers working in a magical place with them.

Ever Tried to Photograph in a Cave?

In the mountains of Southern California, the black swifts return each spring to raise the next generation. The location of all the nest sites is still not really well known, and those that are known are kept under wraps. Charlie took us to his main location, high in the mountains, at about 8,000 feet in elevation. We parked at a turnout in the road, walked back down the road a ways, and then hopped over the guardrail. We walked down the side of a steep hill to a big creek (by SoCal standards), and scrambled up the middle of it (we were prepared, so we were wearing the right shoes)

until we came face to face with a waterfall. No shit, we walked right up and not only kissed the waterfall, but had to walk through it to get to the other side!

It was a darn good thing we were doing this in daylight—it would be way too dangerous any other time, as I found out later. All of us, with all our gear, made our way through the waterfall. On the other side, it was a different world: dark, damp, and very loud. The flashlights and headlamps came on. Charlie shined his light way up on the roof of this "cave" and there was a black swift nest. These little birds are such powerful fliers, they fly through the waterfall to get to their nests. Wow!

Now the work began. It was a darn good thing I spent most of the winter working on my flash skills—I needed them on this project. Charlie's assistant, Kevin (now the refuge manager for a National Wildlife Refuge complex), had brought with him an 8-foot ladder. He put it up, and Charlie shinnied up the rock to

A rare photo—Moose playing model for a Joe McNally flash lesson at falls in the Sierra mountains in California.

start collecting data (Charlie literally wrote the book on the swifts of the world). It was hard to communicate with the roar of the water crashing on the rocks, but the experience was like none before or since. In a short period of time, the data was collected, gear packed back up, and out we went the same way we came in.

At the time, very little was known about black swift nesting biology. They nest at 8,000 feet and then fly out and up another 5,000 feet to forage on high-flying insects, only to come crashing back down to earth like a speeding bullet to hit the waterfall and jet through to the rock face on the other side to visit their nest. This was the first project to totally suck me in and put my camera technology to the test. For the rest of the summer, while they nested, I drove down from Santa Barbara to the mountains outside of Idlewild by myself on the weekends. Just after dawn, I'd enter the cave, and before dark, I would get out of the canyon and back to the safety of the Camaro. In between, I would sit behind the falls on the narrow rock ledge right outside one of the swift's nests.

The black swift takes off from its nest predawn and doesn't usually return until dark. The single egg they lay sits in a moss cup nest—moss they scrape from the roof of the cave—and as the moss degrades, it gives off heat, keeping the egg warm. This is important, since there's no parent incubating it. The nest I was photographing was nestled into a rock crevice and, luckily, I could sit next to it on that narrow ledge. Why wait there all day? So I'd be in place when the parent came back late in the afternoon. If I waited outside the waterfall and came in once the parent came back, I couldn't get to the nest for fear of scaring off the adult. The swift didn't care if I was there in place, but cared if I wasn't and walked in (true for most wildlife).

The days were long, with no one to talk to and the roar of the water a constant. I could look out of the falls at the edges and see into the forest. I saw a California spotted owl come into the canyon once and watched other birds flit in and out of it. The photography end of it was pretty easy. Shooting with the F3P, I had two flashes working TTL on a bracket attached to the 200mm micro lens. The granite walls were natural reflectors, so all I had to really worry about was not overexposing the walls closest to the flashes, which I dealt with by scrimming the light with gaffer's tape.

My mind would wander to the task of understanding the nesting biology better. The adults came into the nest at night and (it was believed) fed their young then. With the danger to humans being in the cave at night (it was wet, steep, and not made for humans), how could we get the answers to the nesting biology question? Once the egg hatched at the nest I was photographing (there were eight nests in the cave

Charlie collecting data on the black swifts. Photo captured by Nikon F3/T & Nikkor 35–70mm f/2.8 lens on Fuji 100.

California spotted owl. Photo captured by Nikon F4e & Nikkor 800mm f/5.6 lens with TC-14 on Kodachrome 64.

that year), the possibility of seeing the adult and photographing it on the nest grew. That thought was the only thing that made the hard, cold rock any softer to sit on as the day wore on.

The cave faced west, so as the sun began dropping, the canyon took on a whole new life, which fascinated me since I love watching light. I was staring out late one afternoon—the skies were clear blue and the water level in the falls had lessened, so I could see up. I don't know why I looked up at the right moment, but I did and saw little black specks in the sky. At first I thought it was a group of gnats coming out, but as I strained to make visual sense of them, the specks got

bigger and bigger. Then it was obvious they were headed my way. In less time than it took to read this, a black speck was at the bottom of the canyon and screaming—just hauling ass—right at my head!

Before I could analyze what I was seeing, there was a slight disturbance at the waterfall, and then sitting right next to me was a black swift. It perched on the near-vertical rock face next to me, its uniquely adapted feet holding on as if Velcroed there. It just sat for a moment and looked at me. My face (if it could be read by a bird) must've said something like, "How in the shit did you just do that?" It looked back at me as if to say, "What the shit are you doing here, and I do it all the time!"

I had borrowed a Noct-Nikkor 58mm f/1.2, an amazing lens, from the shop. Since I was working "in the dark" most of the time, I figured the extra speed might come in handy. With this magnificent creature literally inches from me, I slowly eased my hand down into my pack to grab the lens, then slowly took the F3P off the 200mm micro and attached it to the 58mm. I eased the rig up to my eye. With the 58mm set to f/1.2—wide open—my eye came up to the viewfinder. The lens was at its minimum focusing distance, but I was physically too close, so I couldn't get a sharp image. I started to lean back, knowing I really couldn't go too far without falling into the water. Finally, the bird's giant black eye came into focus and I hit the shutter release. The slow sound of the motordrive told me my shutter speed was in the basement (I've always shot in aperture priority mode). After six frames, the swift left its rock perch and flew up to its nest.

> Don't think for a moment that wildlife photography isn't an emotional pursuit for me. Wrapped up in all that gear and technology is the desire to reach out to a world that doesn't function as ours, and make a connection deeper than burning some pixels with a click.

You can't help but be moved by such a personal experience—I was. This totally wild creature that seems to fly faster than anything else on the planet, just happened to stop by for a moment to be polite (since I took time to visit) and say hi. Don't think for a moment that wildlife photography isn't an emotional pursuit for me.

> Do you wear glasses? If you do, you know what a pain it can be. There is no great solution for pushing your eye up to the viewfinder and seeing everything. If you're shooting with a camera with a square exit hole, you might try a body with a round exit hole, which often is a "high-eyepoint" model. You also might try shooting without glasses, using either a diopter you can buy from the camera manufacturer or one made specifically for you by your doc. I wish I had the answer for you, but to date, I've never found one.

Wrapped up in all that gear and technology is the desire to reach out to a world that doesn't function as ours, and make a connection deeper than burning some pixels with a click.

Solving a Problem

As with so many things in my career, it struck me while driving back home after this encounter how I could find some answers to the nesting question. A remote camera! The answer today is pretty obvious, but back then remote cameras were the stuff of organizations with giant budgets, really brainy folks, and lots of time. I had none of that. But I had an imagination, so I put that to work. The main problems to solve were: enough film to take pictures all night, light, power for all that, and a means of firing the shutter remotely after a set duration of time.

The film problem was solved by using an MF-4 250-exposure film back. The light would be the two flashes. The power was a question of testing to see how many batteries were required. The timer, however, would be a challenge. Our budget was expanded with a credit card, so we ordered the MF-4, special cassettes for it, and a bulk film loader. The flashes were already in hand, but I had to find an answer to the batteries. That required determining how long the flashes would be on and, during that time, how many times they would flash (at what f-stop and what distance).

I had to find a timer, better known as an intervalometer. Nikon had one, but it was physically big and required 120v. I needed something battery operated. Canon had a little thing called the TM-1 that was a simple battery-operated timer. Being Canon, it didn't plug into a Nikon. By the time I got the F3P and TM-1 to talk to each other, I had gone through three TM-1s, but in the end, they worked together (I have a little electrical engineering skill).

You gotta understand, I was in heaven this whole time. Acquiring camera gear to solve a biological problem, taking it apart, customizing it to solve the problem, testing it, and succeeding is as good as it %$&@*! gets. With the MF-4 in hand, a dummy roll of black-and-white film loaded, and the timer connected and tested, I tested the flashes and batteries. Since the rig would be working remotely using TTL, I had to create a "cave" to test in. Using blankets and gaffer's tape, I transformed the office. I knew which nest I would be photographing—there was only one option where I could set up the tripod and leave it all night secured. It wasn't the nest I had been photographing, but was another nest that would be about 10 feet from the camera. That meant the flashes would be putting out some juice to make the exposure.

I'd figured out the very last minute in the day I could be in the cave and get out before dark safely, as well as the very first minute I could enter the cave in the morning to retrieve the rig. By dividing that time by 250 exposures, I knew the rig could take a picture every two minutes and have enough film for the entire night. I set up the rig in the test cave, set the TM-1 to two minutes, and let it rip. I closed the office door, so we wouldn't have to see the flash every two minutes. (But the neighbors had to. Ha!)

Later that night, before going to bed, I checked on the progress—no flashes! The batteries had died. It took another week and more money before I had the right batteries—the new Quantum big boys—and the rig could make it through the night with power left over. Everything was tested over and over again to make sure the first success could be repeated. Time kept moving on, so it was now the next summer. It was time to see if the swifts returned and where they were in their nesting cycle.

Black swift. Photo captured by Nikon F3T & Noct-Nikkor 58mm f/1.2 lens on Kodachrome 64.

What is today's equivalent of an MF-4 250-exposure back? Any Nikon body with a 16-GB memory card and with an MC-36 multi-function remote cord attached. Could you use the intervalometer now in many camera bodies? You bet, but test first for battery consumption.

A biologist on the black swift project. Photo captured by Nikon F3/T & 35–70mm f/2.8 lens on Fuji 100.

Putting My Skills to the Test

I went out to buy the bulk color film for the project. No problem, it was delivered the next day. I checked into how much it was going to cost to get it processed (I still had a limited budget). Have you ever tried to get a 250-exposure roll of film processed? These days, I think I know the answer, but even back then (it does seem like a lifetime ago, even though it was only 20 years), there weren't many labs set up to process a 33-foot-long piece of film. I found one, finally, but ouch, the price and turnaround time kinda sat me down, but this was one problem I found I had a solution for. Darn if money was going to get in the way. With everything ready, off I went to the cave and the swifts.

I was excited to see which birds were back, wondering if the nest I planned to photograph was active and if the rig would produce results. The water level was considerably lower than the previous year, so walking in was no problem, and the waterfall was smaller, so getting in the cave didn't require getting wet. Once behind it, I could see changes made by the big waters of winter roaring through. I looked up on the wall to the nest I wanted to photograph, but it wasn't there. My heart sank. I started to look around and, at first, didn't see any nests in the places they were before. It's not like there were a ton of options for nest sites. I got out my flashlight and finally found a couple nests. The one I planned to use had moved a little to the right and appeared to be active. It was one foot farther away than the nest I made all my tests on in my artificial cave.

I spent the day in the cave. As dusk began to settle in, the rig was set. I made a couple of test clicks to make sure the TTL was happy, and all systems were go. At the last moment, I turned on the system, turned on the timer, waited two minutes for the first exposure, and as the flashes went off and MF-4 whirled, I headed down the creek. Every so often, I could see down to the cave, and I would wait to see the flashes light up the darkness, then off I scurried up the hill.

If you're wondering about flashes going off every two minutes in a cave at night and its effect on the swifts, flash doesn't bother critters. Some biologists wonder if they can even see the burst of light. It's

no more than lightning, at the very most, to them. Now, if a critter were flashed in the eye and, at the same time, was beaten by the flash so a negative reaction was generated, then you might have a concern. I don't think that happens.

I spent the night in the Camaro not too far from the trailhead. I was going to make sure someone didn't accidentally head down that trail and wonder what the light show was all about. You could only see the cave from the creek or a couple spots on the trail, but I wasn't going to take any chances with my investment. I slept some, but I was much too anxious to see if all the testing worked. At the first hint of light, off I flew. I got down to the cave and saw the swifts had already left for the day. I also saw the ready lights on the flashes were not glowing, and the battery indicators on the Quantums were glowing red. The batteries were dead! When did they die? How many frames were exposed? Was any behavior captured on film? I also wondered where my testing had failed. Two days later, when I got the film back, I had my answer: the flashes only worked for four hours.

Back in my test cave, I loaded the dummy roll of film, hit the timer and let 'er rip. The next morning, the lights on the flashes and battery packs were still on. Just for fun, I set the timer to continue to run and got another 90 minutes. What happened that night in the cave? I charged everything up and ran the test two more times with the same result. Did waiting 10 hours to hit the start button (drive and setup time) make a difference? I charged everything up, let it sit 10 hours and ran the test again—same result. It was really getting on my nerves. It's not like there was a black swift/MF-4/flash tech line in India I could call for help.

The Cutting Edge

The next day in the shower (where I seem to get so many ideas), it hit me. The nest was *one* foot further away. That meant the flashes had to put out more light. Was that enough to make such a big difference? I charged everything up, waited 10 hours and hit the

Tucked onto a ledge in the cave, I'm right in front of the crevice with the nesting black swift.

The one thing I never leave without? A pad of paper and a pen, but not just any paper or pen. I use Rite in the Rain products. They make waterproof paper that safeguards anything you write down and all-weather pens. Taking notes is very important—notes on everything from biology to technical information to business ideas.

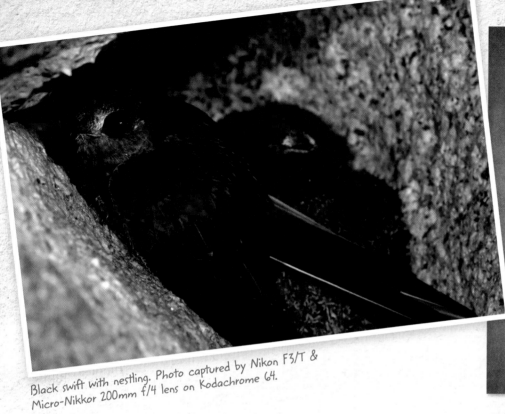

Black swift with nestling. Photo captured by Nikon F3/T & Micro-Nikkor 200mm f/4 lens on Kodachrome 64.

Five mistakes wildlife photographers make when starting out:

1. They doubt they can do it, and give up way too soon. It takes years to see consistent success.

2. They think they don't have a long enough lens. Biological knowledge is worth 200mm of lens!

3. They don't put in enough time behind the camera. Shoot, shoot, shoot your way to being better.

4. They delete way too many images. You can only learn from your mistakes if you have them to look at.

5. They don't embrace flash from the get-go. That light source is SO important!

start button. Seven hours later, the red lights came on. I got four hours in the cave, now up to seven in my test cave. What's sucking up the other three hours? I was tempted to stand in the shower until the answer came to me, but it wouldn't have helped. Then I thought: What about the cold, damp environment of the cave? I charged everything up, waited 10 hours, packed ice packs around the batteries, and hit the button. Four hours later, red lights!

All right, I had answers and solutions: I went to the sporting goods store, bought a bunch of hand warmers and large wool socks to hold them in place around the flashes and Quantums. A week had gone by and the rig was in place, doing its work, while I sat in the car.

Again, no results! This time, something had hit the camera, so I had a full night of images of a piece of granite. I was running out of time—the swifts would soon be fledging their young—and the

money, well it was already gone. The good news is I had a full night of rock pictures, so the bugs had been worked out. The next weekend was my last opportunity for that season.

The third time is the charm, I kept telling myself. Two days after my third try, I unrolled the film (it came back uncut) on the light table. The first and last frame had the same good flash exposure, so the rig had done its job. What about the swifts? As I slowly unrolled the film, I saw the same nest with the nestling moving its head slightly between frames. I came up to the 01:00 mark (30 frames = 1 hour) and the nestling was moving quite a bit. Then there was a frame with an adult in it. In the next frame, the adult was still there but the nestling had moved, and for the next 10 frames, you could see feeding going on. Two more feedings were recorded before sunup. The first hint of nesting biology had

been uncovered! I was so excited, I instantly called Charlie. All the film from that night ended up going to him. He wrote a scientific paper and got it published on our success.

The satisfaction of the entire process and the end result kept a smile on my face for some time to come. Combining biology and technology to find an answer, and to use photography to make a difference, is the most rewarding thrill I know. Did it change the world? Nah. Now it's pretty much old hat, but back then, it was cutting edge and I was pioneering it. The challenge then—a huge challenge—was, how do you match or top that?!

Looking for a New Job

At this point in my career, I was project hungry. I was also going crazy working in the camera store. Although I really didn't have the business to support the action, I left my job at the camera store (a huge security blanket) and went full-time with photography. Most definitely not the smartest move I've made in my life. What money the business made paid the bills, but didn't leave much to work on projects. As my good friend Wayne Lynch would say, "Wildlife photographers look for a new job every day."

We had become tied in with many biologists at the California Department of Fish and Game, and one of them told us about grants made available each year from the environmental license plate fee. We were encouraged to apply. Getting paid to shoot was a really exciting prospect, so we did. Our project, wrapped in a neat bow, was to photograph a select group of endangered species to create an additional education program to complement one we'd finished the previous year.

Doing the paperwork was pretty easy—the proposal goals, execution, and completion simple to write. Since the grant was awarded by a senate committee, we were advised that

Yuma clapper rail chick. Photos captured by Nikon F4e & Nikkor 35–70mm f/2.8 lens on Fuji 100.

> Wildlife photographers need to be fairly good at predicting and reading weather. These days, you have lots of help in this department. There are a number of iPhone apps, from The Weather Channel to Weather Radar, that work great. You can also learn weather signs, like knowing a lenticular cloud pattern means winds are coming, and combine it with biology, because big game often have their asses pointed toward a coming storm. And, if all of a sudden the hair on your head stands up, kiss the dirt! Lightning is about to strike way too close to you!

to get to the top of the pile, we should get letters of recommendation. We got a number of them from biologists, state and federal senators, and educators. We sent it in and it was a hit. It passed the committee, was approved, and was in the basket for the governor to sign. With that news, we arranged all the dates with the biologists and made commitments for the next year. To say we were excited is an understatement—it was a photographer's dream come true.

The budget for the proposal covered only the cost of being in the field. We were advised not to include the acquisition of any gear in the proposal, because that was frowned on. But new technology had come along—the F4s had just been announced. Did I need it? Sorta, kinda. Did I really want it? Heck yeah! I took a long shot. I had met and become business friends with the western regional sales manager for Nikon. I made an appointment, drove down to Torrance, and presented to him in person the same proposal waiting for the governor's signature.

He looked it over, told me about the hundreds of requests for free gear that came to him, said this was the first "real" proposal he'd seen, and he'd get back to me. All Nikon, all business. A month later, at the F4s release party in Los Angeles, Victor came over and told me Nikon would be able to provide the F4s for our project. This is one of the

only two pieces of gear Nikon ever gave me. Many wonder why I've always been with Nikon. Now you know—they supported me and my project from the very start. I don't forget those things!

Then the phone rang. The governor had signed the budget and our project wasn't in it. As it turned out, someone in the office saw our project proposal, thought it was very interesting, and removed it to read it. They returned it back to the basket after all the others had been taken to the governor to sign. It was too late; it was a done deal and there was no way to undo what had been done. That was life. The real problem was we had made commitments to do the project, and I'd given my word I would be there to do the work. Nikon had delivered the F4s. So we started an amazing year with the financial backing of MasterCard. Hold onto your pants!

My go-to system for a project in 2010:

- Nikon D3x & D3s (always two bodies)
- AF-S VR Zoom-Nikkor 200–400mm f/4G IF-ED
- AF-S Nikkor 70–200mm f/2.8G ED VR II
- AF-S Nikkor 24–70mm f/2.8G ED
- AF-S Nikkor 14–24mm f/2.8G ED
- AF-S VR Micro-Nikkor 105mm f/2.8G IF-ED
- SB-900 AF Speedlight flash unit

MOOSE PETERSON GALLERY SERIES

Salt marsh harvest mouse. Photo captured by Nikon F4e
& Nikkor 300mm f/4 AF lens with PK-11A extension tube on Fuji 100.

CHAPTER 4
In All Honesty, This Is Really Just a Starting Point

Brent imitating Dad with his camera squirt gun at a black-chinned hummingbird nest.

Jake & gear @ McNeil River, Alaska

Brent in Dad's arm as they head out in the Santa Barbara foothills, looking for birds.

The Arctic plain is a vast place where life finds amazing ways to hold on. I'm down on all fours photographing one of its many miniature flowers, called belly rubbers. Photo by Kevin Dobler.

Ah...no finer place to greet the day than at 10,000 feet in the Sierra. It also happened to be my 50th birthday—a special treat!

"What the hey? What's with the Moose history lesson?"

Well, looking at other photography books, and looking at my own from the past, they all have the same basic thread to them: f-stop, shutter speed, Nikon or Canon, this lens or that, blah, blah, blah. There is so much more to photography, and that's what I want to bring to you. As Sally Field said, "People are meant to grow old, and with that age comes wisdom meant to be passed along."

There is a history that comes into play with every click, no matter whether you've never made a click before or you've been doing it for decades. If you don't understand where I've come from, you surely won't get where I'm at, nor where I'm going. You especially won't understand where I want to take you.

It's the logic behind my thought process that I need you to understand (that's a scary prospect!). To do so, you've gotta know the facts on which I base that logic, hence the history lesson. I only have so much space here to share my experiences—ones on which my logic is based. Hopefully I've chosen correctly, so they illustrate my points.

Remember, you've gotta be true to your own images. The last thing I want to create is a bunch of Moose clones (God forbid). It's very important that you read what I have to offer, take what works for you, and apply it to your photography. Everything else? Throw it away, fast! I'm not an expert, don't pretend or want to be, and I certainly do not have all the answers. I do have answers, though, that work for me, and that I've learned up to this point. That's what I'm sharing here with you (it means

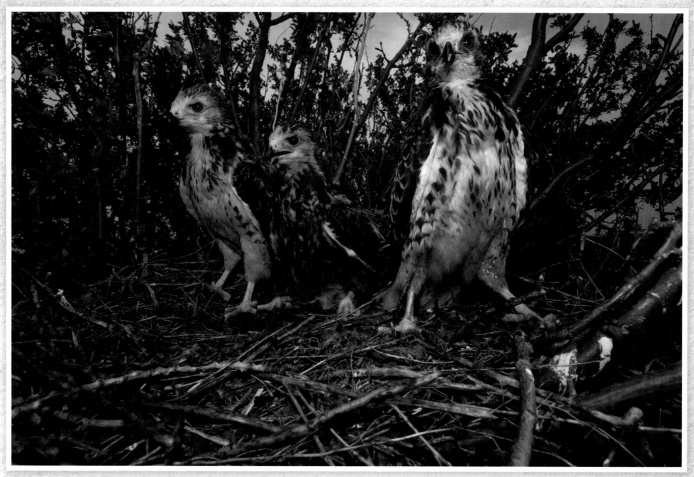

*Swainson's hawk fledglings. Photo captured by Nikon D1H
& AF-S Zoom-Nikkor 12–24mm f/4 lens on Lexar UDMA.*

I'm constantly learning, which is cool). You shouldn't have to reinvent the wheel in this day and age.

I bring this up because I'm about to delve into camera gear—photographers' favorite conversational topic. I've actually been talking about it from the beginning, but not in specific terms, and certainly no recipes. You have to understand that, from where I sit, I feel the best, most important pieces of equipment lie between your ears and in your chest. The first few chapters were all about

your mind and heart, and making them the best they can be, setting the groundwork for the years to come. Someday, we'll insert a little card behind our ear, pull on our ear, and we'll be able to record what we're seeing and feeling. But for right now, we have to depend on camera gear, so that's where the story heads next.

The lessons I learned from my early years (and learn to this day) prepared me, so when I go out to photograph birds, mammals, landscapes, people, fashion, products, planes—you name it—I do

a good-to-great job. Each and every time I pick up the camera and venture out with it, I have (and still do) learned something new. I don't have all the answers, but without this foundation, I have no way of improving—I have no comparison to see if I improved, how I improved, and what needs improving. And without this foundation, there is no way you'll understand what I'm talking about from here on in. It's one of the most important lessons the biologists taught me, and it's simply called baseline data.

The Bag of Confidence

I coined this phrase back in '94, when I was the nature columnist for *Popular Photography*. The camera gear you take with you on your adventures, that you labor so hard to buy, is the vehicle for capturing what you see and feel, so you can share your visual journey with the rest of us. This is not to be taken lightly—this is a big responsibility not to be left to some review on the Web (or video on some guy's blog). This is a very personal thing that your photography demands you think through, so you are true to your own visual belief.

> If a piece of gear isn't producing, just like an employee, it has to be reviewed and the decision made to keep it or let it go.

"Yeah, yeah," you say. "You've got all that gear, so it's easy for you to say." The reality is that I don't have all that much gear quantity-wise. But, what I do have is the top of the line, so it cost me dearly. When it comes to the number of lenses and bodies I have in my camera bag, I don't have much. That combo of being costly and not having much means that each piece of gear that I do own has to pull its weight and then some. What do I mean by that?

When folks look at my blog, or *BT Journal*, or even this book, it's easy for them to lose sight of the fact that I am a businessman, and that my images provide the income to keep a household running. Like any business, expenses and investments must be scrutinized so the business keeps moving forward. The capital investment in equipment gets the most scrutiny, because of both its expense and its role in producing the images required to keep the business going. If a piece of gear isn't producing, just like an employee, it has to be reviewed and the decision made to keep it or let it go. This is one of many reasons I envy the "weekend warrior" at times, because he can buy what he wants and have no financial stake if the lens or body isn't pulling its weight.

When I leave the office to shoot, be it around the corner or across the country, I have to have the gear I need to make the images happen. This is obvious. What is not obvious is just what that combo of gear might be. What's also not obvious is that the answer to this question comes over time.

"Whoa," you're saying. "Time? I never saw any camera manufacturer selling that" (I wish someone did). Time, which really means: the compacting of all the experiences you've learned from and can repeat again and again successfully. The size and content of my camera bag has the normal ebbs and flows, like that of any photographer, starting with just one lens, then getting overinflated with way too much, to the size it is now, which is just the right amount (see Appendix 1). Getting a bag of confidence to that size requires that hidden ingredient of success: time.

So when I leave on an adventure or project, I have with me the gear I require for the task at hand (I do have those senior moments when I forget something. But I do have it to forget). That's the place I want to help you get to. Time, and money for that matter, is too precious to be wasted with the silly games of "this piece of gear or that brand" is better than the other. When you move beyond those games and read every review on a piece of gear is when you'll know you are at a good place in your photography and you have in your camera bag what you need. You need to know that what's in your camera bag is *the* gear for *you* and your photography. It's gotta be your bag of confidence.

> "Will your equipment list change after the book is published?" I'm sure it will, if for no other reason than I'm always taking on new projects and the problem solving process often requires new tools.

That's So Easy for You to Say

I started with the incredible opportunity to literally try every single piece of Nikon gear made. I not only could hold it in my hands and look through the lens or click the buttons on the body, but more importantly, I could take it out and shoot with it for an extended period—one of the good things about working at a camera store. It's in shooting with a piece of gear that you see if it fits you and your photography—not looking at specs, not looking around through it in a camera store or on a convention floor, but out making images is where you find that perfect fit.

I am still incredibly fortunate that I can shoot with a piece of gear before I buy it. I'm a Nikon boy, and I have been since the day I began making money from my images. Besides always having the best flash technology, they stood by me and my goals when no one else did, so I am loyal to them. A benefit of being one of their Legends Behind the Lens and a Nikon Professional Services (NPS) member is the ability to try camera gear prior to purchasing it. I never buy anything blindly— I always shoot with it before I buy. You need to do the same thing!

So you're not a Legend Behind the Lens yet, or a member of NPS or Canon Professional Services (CPS). It doesn't mean you can't try before you buy. Renting gear is one of the greatest resources untapped by photographers coming up the ladder. Renting permits you

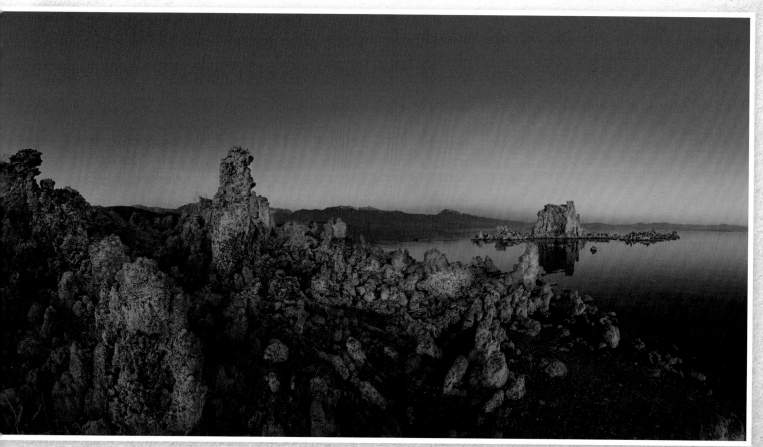

Mono Lake, California. Photo captured by Nikon D3 & PC-E Nikkor 24mm f/3.5 lens on Lexar UDMA.

to have the piece of gear in your hands long enough for the "gear worship" to wane enough to see it for what it's really worth to your photography. There are tricks, though, to making rentals work.

The key is in the timing (there's that time thing again). You want to rent that particular piece of gear for at least five days, if not longer. Why? First, to get over the "Oh, I have the $%^& in my hands—it's beautiful" phase. Next, so you have a minimum of two shooting days with it—not shooting your big toe as you sit in your favorite chair, but actually going out and spending serious time shooting with it. Personally, I'll go out with just that piece of gear and nothing else, forcing my mind to think about how it works in my photography. The goal here is spending quality time with what might be your next big purchase.

There are great options for renting gear, no matter where you are on the planet. I highly recommend LensProToGo.com or the folks at Adorama. They have a great locker of gear, and prices that make it advantageous for you to use renting as a vehicle for finding your next piece of gear and buying the right piece the first time.

Another option many don't think about is workshops. There are a number of workshops sponsored by Nikon (and Canon) where they put loaner gear in the hands of the workshop participants for use during the workshop. This is a great opportunity for you to try something new, with the help of an instructor if need be. If you're the gregarious type, you might also make friends at the workshop. Your new friend might just have that piece of gear you want to try out. Finding out that piece of gear you were thinking about buying isn't right for you after all can pay for the price of the workshop.

I'm repeating myself but it's so true, photography is a problem solving process. Identify your problem and find the solution, and you will be successful. New gear acquisition is a problem we all face and this is the solution I have turned to over and over again. It has put the best gear in my hands for my photography at the least expense. It will do the same for you.

Santa Cruz kangaroo rat. Photo captured by Nikon D1H & Micro-Nikkor 60mm f/2.8 lens, using a Speedlight SB-800 flash, on Lexar UDMA.

Experience is the best teacher, but how do you get more experience? By shooting more and more and more. There is no replacing being out in the field and behind the camera when it comes to improving your photography!

San Joaquin kit fox project. Photo captured by Nikon D3 & AF-S Nikkor 14–24mm f/2.8 lens, using a Speedlight SB-800 flash, on Lexar UDMA.

Speed Kills

I have a quick note, or rant, if you can spare a second. There is nothin'—nothin'—sexier in the lens world than the 300mm f/2.8 lens. That beautiful 122mm front element reflecting back your giant smile as you stare at it is a heart stopper. The honking front element instantly tapers back into a sleek barrel that just screams expensive. When I started out, it was the lens that made other photographers look at you and say to themselves, "There's a successful photographer" just because you owned it. It was *the* lens for wildlife photographers for such a long time.

Then there is the lonely 300mm f/4 lens, with its 77mm front element that can barely reflect back its lens cap. It's small, has a not particularly sexy profile, and hardly anybody knows it exists, let alone owns one. But compare the 300mm f/2.8 image next to the 300mm f/4, and

you'll see no difference—both are wicked sharp. Compare the lens envy in the eye of a photographer looking at the 300mm f/2.8 or 300mm f/4, and you'd think the 300mm f/4 carried some social disease. Then look at the price of $5,000 compared to $900, and all of a sudden that expression changes to one of mass confusion.

What you're paying for is literally the technology to deliver that one extra stop of light to the film plane. That's right, $4,000 for one stop of light! The classic example I like to use is shooting football. To make the linebacker pop visually from the background (a stadium of fans), f/2.8 is a must, because at f/4 you start to see enough detail that the fans aren't a seamless background, but have shape and form (a great photographer will move past that obstacle). That extra stop is not for shooting in the pitch dark in a barn, but for depth-of-field control. It's for controlling the elements that are and are not in focus around your subject. Go back and look at the photograph of Keebler in Chapter 3, and look at how his nose is out of focus. It's just three inches away from his eyes, the focus point. That's a narrow band of focus at f/2.8.

There are times when you'll have the option to buy a fast lens or not-so-fast lens. My advice, especially when you're starting out, is to spend money on time behind the lens, not the lens itself. You'll learn more and create better images the more you're behind the lens, not by paying for that extra stop of light. End of rant (at least this one).

What's in a Lens?

I count my blessings every day, no more so than when I think about my first exposure to photography in a competitive atmosphere. There probably was no more competitive place than the high school photo darkroom (sadly, a thing of the past). I will never forget a photo our teacher showed us of an old fisherman type in his slicker, taken with a Nikkor 55mm f/3.5 macro (a legendary Nikkor lens). You could count every single dirty whisker on that face! Our teacher held it up and said something like, "This is the very definition of sharp!" Counting hairs, it was a reference, and an image that has always stuck in my mind as the definition not only of sharp, but the very craft of making an image. It was a high benchmark Mr. Traub set for us—what defined sharp and quality—and I'm glad he did.

The final quality of your image, no matter if it's going to the Web or to a billboard, can be made or broken by the lens the image is captured with (although, many times, post production kills lens quality). Is this to say that the lens is everything? Nothing in photography is that absolute, but personally, I think it's real close to that line.

The problem we all face is that we really don't know what the final destination for an image will be. Sure, when we make the click we have a destination in mind. But we don't know when and where someone will see a photo and say, "I really like that photo. I want to wrap buses with it." (Yeah, that has happened to us.) If you shoot thinking your image will never go beyond a blog posting, never requiring better quality than what the Web requires, you could be in a world of hurt if someone comes a knockin', wanting your marvelous image for something much grander (and I hope someone does).

"I always see you with a GPS unit attached to your camera. Is that a requirement?" Not at all. I have it there for two reasons: to provide information to biologists and so I know where I was in case I need to return. But it is not a requirement for anything or anyone.

Moose. Photo captured by Nikon D3 & Zoom-Nikkor 200–400mm f/4 VR lens on Lexar UDMA.

One of the hardest concepts to learn and teach is sharpness. In the digital age, the sharpness of an image is judged on a computer monitor. Because of that, I always buy ones that have at least 1900-by-1200 resolution. Even with this, it still takes experience to determine the degree of sharpness that is your minimum.

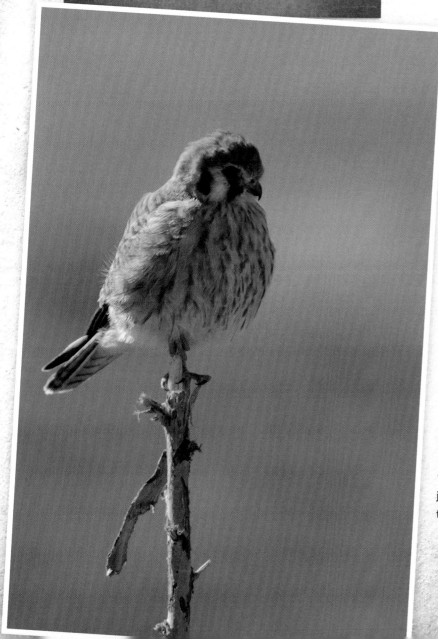

American kestrel. Photo captured by Nikon D3S & AF-S VR Nikkor 600mm f/4 lens with TC-17E II on Lexar UDMA.

On the flip side, setting up a resolution chart, making sure it's parallel with the film plane, and shooting a whole series of test images to see if a lens is sharp and where its sweet spot falls is really silly, as well (most post-processing slop ruins more resolution than a bad lens to start with). Think it through logically for just one moment: How often do you photograph something that is (1) perfectly flat and (2) where you have the film back perfectly parallel with that flat subject? If your answer is anything like mine—nearly never—then logically, wouldn't the depth of field affect the image in such a way that the test results won't be relevant in the practicalities of day-to-day shooting? (I'm tempted to go into a rant about light and contrast here, but I'm holding back, for now.)

So, what should you look for in your next lens? One consideration has to be price. I'll pass along a piece of advice my brother gave me long ago in these regards: "Buy the best you can afford at the time." It has served me well—thanks bro! Next would be functionality. How practical is it in your system? Nikon produces lenses that are DX and FX. Do you mix and match or stick with the core format? If you want a 500mm lens, you ain't got no choice. If you're going wide angle, you have lots of options, but getting the most from your format size requires a lens made for that format. These are the obvious things photographers rightly think about when making a lens purchase. Let's take it a step further and look at something not so obvious.

Minimum Focusing Distance (MFD) is an incredibly important aspect of a lens that most photographers have never heard of, let alone taken into consideration. I'm going to use my favorite example: the 600mm lens. The AF-S II Nikkor 600mm f/4 focuses down to 18 feet, the 600mm f/4G ED VR focuses down to 16 feet. You're probably saying, "Two feet? Are we talking just two feet?" The image size difference between those two feet when you're that close to a small subject (I tend not to use

a 600mm with a bear) is a radical difference! In the old days, we'd carry an 11mm extension tube in our pockets to deal with this problem. Both Nikon and Canon have made big strides in reducing their MFD in their big lenses. The AF-S II got handed down instantly when the 600mm VR came out, for this one very important reason. To me, those two feet (and not the VR) were worth the $10,000 investment—it paid for itself within the first month.

Does MFD apply to other lenses? You bet it does, but sometimes you don't have much of an option. For example, the 200–400mm f/4 VR is the only such animal, so it is what it is. You could compare it to the 200mm f/2 VR and the 400mm f/2.8 VR for discussion's sake. The 200–400mm f/4 VR MFD at 200mm or 400mm (or any focal length in between) is 6.6 feet, where the 400mm f/2.8 VR is 11 feet. How about vs. the 200mm f/2 VR? Again, the 200–400mm f/4 VR MFD is at 6.6 feet, while the 200mm f/2 VR is at 6.2 feet. Wow, now we've got something to really chew over.

The 200–400mm f/4 VR seems to be a killer option when it comes to MFD, price, and size. And you have 200–400mm of focal length to work with. The other option you have is to carry two heavy lenses, and the price…ouch! But (you knew that was coming), the other two lenses, the 200mm f/2 VR and 400mm f/2.8 VR both have speed going for them. You cannot replace the 200mm f/2 VR depth of field with the 200mm end of the 200–400mm f/4 VR, because you're shooting at f/4. There simply is no comparison between them in those regards.

Violet-green swallow taken at 18 feet. Photo captured by Nikon D3X & Nikkor AF-S VR 600mm f/4 lens on Lexar UDMA.

Violet-green swallow taken at 16 feet. Photo captured by Nikon D3X & Nikkor AF-S VR 600mm f/4 lens on Lexar UDMA.

Mule deer. Photo captured by Nikon D3
& AF-S VR Nikkor 200mm f/2 lens on Lexar UDMA.

You should be asking yourself what the hey I'm talking about. I seem to be going in circles. That can be the case when you're talking lenses and looking at the attributes that work best for your photography. The 200mm f/2 VR is a wicked-sharp lens with the depth of field of a hair. The incredibly shallow DOF really isolates a subject, and it's so sharp you can count hairs like no other lens on the planet. Whether that's your style of photography is another topic, but that's what you need to think through when you're considering purchasing a lens (great reason for renting first).

On the other end, there is the 400mm of the 200–400mm f/4 VR and the 400mm f/2.8 VR. Here, the MFD of the two lenses is quite different, while the maximum aperture isn't. The image size with a 400mm at 6.6 feet compared to one at 11 feet, you can quickly see, would be double. By simply being able to get closer and focus closer, you double the image size without using a teleconverter or any other tool. But the 400mm f/2.8 VR has that f/2.8 thing going for it. Both are gorgeous lenses, and you can't go wrong optically with either. But what problems in your photography are you trying to solve, getting close to the minimum DOF?

Are you trying to find one lens that can "do it all," so you can shoot and still have money for coffee afterwards? Are you heading to the bush to photograph big game and need to make that distracting world disappear and be out of focus? Is your shooting environment really dark and you need a fast lens, so the AF system works at its fastest? Or, maybe you need that extra stop of shutter

speed and, like me, don't raise your ISO to get it. Do you need a lens you can handhold or pack easily? Are you traveling to Africa, with its travel restrictions, and are size and weight a real concern? The list of photographic problems that pop into your mind should be like these when looking at your next lens purchase. There's a lot more that goes into a lens than just a brand name!

What *Is* the Best Lens?

This is the #1 question I get asked by email, and has been since email hit the masses. Along the same lines is the question, "Which is the best lens for me: this one or that one?" My problem with this question (which is a very valid one) is I can't answer it for the majority of the folks who ask it. I have a Quicktext set up with a pat response to this question that's real simple and sincere: "Since I don't know you, your style of photography, or abilities, I don't have an answer for you." This is as honest an answer as I can make, and by breaking its three components down, perhaps you'll find answers for yourself in it.

You—I think that's the *most* important part of this equation. Women often say that they are too "fragile" to carry a 600mm lens in the wilderness. Yet, I know two "little ladies" who keep up with me, and we're all carrying 600mm lenses (their short legs are the only thing slowing them down). I know a lot of older shooters— in their mid- to late 80s—who still get the big glass around just fine, which gives me encouragement for that day for me. So don't let weight scare you off.

There is always the price barrier, for sure. Wildlife photography is not a poor man's sport. The price to play is high, and there's really no way around that, especially when outfitting the camera bag. While I typically have less gear by quantity than folks I go shooting with, the price tag of mine, when all added up, is more. I lay down the pennies for the good stuff. This rambling still brings us back to: What *is* the best lens?

As far as I am concerned, it's the one that permits *you* to bring back what you see with your mind and heart, and communicate that wonder to others. We're going to get into the lenses I use soon enough, but I want to make sure that you don't just copy down my list, go buy them, and think you're golden, that there isn't a photo you can't capture now that you have your own Moose's camera bag.

Rocky Mountain bighorn sheep. Photo captured by Nikon D3s & Zoom-Nikkor 200–400mm f/4 VR lens at 400mm (handheld) on Lexar UDMA.

I posted a bunch of aviation photos on my blog. They were from the air races in Reno, Nevada. We're talking planes-traveling-in-excess-of-500-mph-just-100-feet-over-your-head kind of photo ops. The majority of the time, we shot 1/250 of a second or less, so the prop blurred and wasn't frozen, to give the illusion of speed and movement. I received a number of emails asking what lens I was using, because the images were so sharp. I answered that it wasn't the lens capturing the sharp images, it was the panning technique. Most didn't understand that answer. To be successful in this game *you* must understand that.

Stopping the motion of the plane (or a bird in flight) is not an action of the lens, nor of shutter speed. Only when you stop the movement of the plane traveling 500 mph can you get a sharp image. That stopping comes from keeping the film plane perfectly in sync with the travel path of the plane. When you keep the film plane perfectly in sync with the moving subject, whether you're shooting at 1 second or 1/1500 of a second, the subject will be tack sharp no matter the lens. (Of course, keeping the film plane in perfect sync at 1 second just isn't physically possible. I struggled at 1/60 of a second.)

Mono Lake, California. Photo captured by Nikon D3X & AF-S Nikkor 14–24mm f/2.8 lens on Lexar UDMA.

Bald eagles in flight. Photo captured by Nikon D2Xs & Zoom-Nikkor 200—400mm f/4 VR lens on Lexar UDMA.

A photographic style is not something that comes instantly, nor is it something you should panic about not having. Like everything in photography, all good things come with time. Give yourself time behind the camera, and your style will follow.

The method we use to keep the film plane in sync with the subject is panning. It's not some special lens, but plain old technique.

There are specialty lenses—like micros or perspective correction—that have a specific purpose in photography. But even those can be used for general photography, as you'll see. In that search for the holy grail of lenses then, there is no one answer and perhaps not even multiple answers to the question. This is something camera manufactures know, which is why they keep coming out with new flavors of the month. So, take a deep breath, realize that the "best" of anything in photography comes from within and is not something you can buy, and you will improve your photography!

Down to Brass Tacks: The Long of It

What the hell is in my camera bag? This is no secret—it's on our website and is one of the heaviest pounded pages there. I'd really like to not focus on which lenses I have, but why I have a particular lens, for all the reasons I just talked about and much more. I remember all too well a reviewer of my first book on wildlife photography frying me big time because most of the images in the book were taken with an 800mm f/5.6. He stated that the info was useless, since no one else owned, or could afford, an 800mm (he's no longer a name in photography—wonder why?). The point of, and bottom line for, this whole book is that if you enjoy the images here, which is not the same as thinking they are the best in the world (and I've not shot my best work yet), then there has to be something in the gear I use day in and day out to produce these images. The proof is in the pudding (or pixels, whichever you prefer).

> How often do I "chimp" when shooting wildlife? Almost never—the exception is when I'm wondering if I have a blown-out highlight in the background that is distracting. Anytime you take your mind's eye away from the subject, you are going to miss "the" photograph.

I'm constantly asked (as if the answer means diddly squat), "If you could only have one lens, which one would it be?" There is no such magical lens for being a successful wildlife photographer. But, if I had to pick one lens I truly love shooting with all the time (and one that I actually do shoot with a heck of a lot of the time), it would be the AF-S VR 600mm f/4 (it is my baby). It is the only lens parked next to my desk so I can constantly shoot even when, well, when I'm writing this book, for example. When it comes to wildlife photography, there really isn't anything—anything—it can't do by itself or with the addition of a simple accessory or two. To be honest with ya, I don't know how you can get real serious about wildlife photography and get real serious images without this big gun.

I mentioned how, in a previous book, all the images were taken with an 800mm f/5.6 lens. That is truly the focal length I love the most, because of its very narrow angle of view of only 3 degrees. The 600mm has an angle of view of 4 degrees (numbers rounded off). That 1-degree difference in the angle of view is very important to my style of photography. As I've

Black-tailed prairie dog. Photo captured by Nikon D3X & AF-S VR Nikkor 600mm f/4 lens with TC-17E II on Lexar UDMA.

mentioned, and as you can see in the photo-graphs, I'm not an eyeball photographer. I am, though, a background control freak! These two things are why I rarely shoot with the straight 600mm lens. The majority of the time, the TC-17E II or TC-14E II is attached. These provide a focal length of 1020mm or 840mm, respectively. More importantly, they bring back the angle of view I so want, down to a little more than 2 degrees.

You probably thought I was going to say the 600mm f/4 VR is wicked sharp, and that's why it's my go-to lens for wildlife photography. I thought that was obvious, so I didn't mention it, but as you can see, there's more to it than just that. Focal length is often equated with image size—the bigger the lens, the bigger the image size—and while that is true, real practitioners of the art of wildlife photography take the big lens way beyond this starting point.

Black-bellied plover. Photo captured by Nikon D3X & AF-S VR Nikkor 600mm f/4 lens with TC-17E II on Lexar UDMA.

The 600mm sings for me when photographing birds. The reasons are many, as you'll read throughout the book, but the main one is its ability to isolate the subject optically as I get close physically. What does that mean? Birds live in a very busy world of branches, twigs, seashells, and grasses, and all too often to make the photograph, we have to eliminate many of the unwanted items, while including those elements important to the photograph. Have someone put a tennis ball out in an uncut lawn, making believe it's a bird you're stalk-ing, and try to make a great photo of it. You'll soon find that getting a clear shot of the eye(s), while telling the story, is pretty dang tough without that 600mm lens. (If you don't own a 600mm, don't feel dis-couraged, as there are some options, renting being the very least.)

As I said before, the physical size of the 600mm scares a lot of folks—it's heavy, no doubt. That comes from that very important f/4 maximum aperture. Letting all that light in for AF operation and DOF control exacts a price in weight. I know a lot of folks who you wouldn't think could get around with it on their shoulder, but you'd be surprised what you can do when taught the most effective way. Getting it in and out of a plane's overhead compartment is a totally different matter!

Before moving on, we need to talk about the teleconverter and the big lens. The TC-14E II and TC-17E II are *always* with me (I go with the TC-17E II most of the time). There is both a plus and a minus to using them that you need to consider. The plus that everyone knows about is the "magnification" they bring to the image. There is no doubt this is a real big plus when you want to get close physically, but can't, so glass is your only option. Another plus has to do with a double whammy when it comes to isolating the subject. The magnification, yeah you get that one. The narrowing the angle of view, you have a hint of that potential now. But what about DOF?

The teleconverter works by magnifying the image and, in the process, that extra glass doing the magnifying is sucking up one or more stops of light (1.4x = 1 stop of light; 1.7x = 1.5 stops of light). When you attach, for example, the TC-17E II to the 600mm f/4 (my favorite combo, since the 2.01 D3 firmware update, which provided hugely better low-light AF operation), the f/4 in the viewfinder goes to f/6.7 (f/6.7 is the effective f-stop). This is because of the loss of light caused by the glass magnifying the image. Most people assume that this increased f-stop results in an increase in DOF when the viewfinder displays f/6.7. Actually, you have less DOF than f/6.7!

Yeah, here's where we have to get technical for a moment, pull out the ol' calculator, only to forget the info as it really is trivial. Depth of field is a formula, taking into account the size of the aperture, the focal length of the lens, the distance of the subject, and the circle of confusion (probably lost you already in the confusion—it gives me a headache). The bottom line is that the teleconverter doesn't change any part of this formula, other than to alter the focal length. The hole at the back of the lens is the same diameter with or without the teleconverter attached.

When you attach the TC-14E, adding 1.4x to any f/4 lens, the effective f-stop becomes f/5.6, but renders a DOF of f/4.9. When you attach the TC-17E II, adding 1.7x, the effective f-stop of f/6.7 renders a DOF of f/5.7. It's called an effective f-stop because of the light loss of the extra glass, effective for the calculation of exposure only. It's actually in the fine print in the little folded instruction manual sheet that comes with the teleconverter, but if you're like me, you don't read them. All you really need to know is that the DOF you're getting is less than the f-stop you're using.

My bird lens? The Nikkor AF-S 600mm f/4 VR.
My big game lens? The Nikkor AF-S 200–400mm f/4 VR.

"Where's the 2x teleconverter in your camera bag?" While I have the TC-20E III, I rarely use it. Why? I prefer to get close physically and can rarely sacrifice the two stops of light. Why do I have it? There are times when I just can't get close physically, like when there are alligators in the water.

This brings us back to the plus and minus of using a teleconverter. The plus, as I see it, is the narrowing of the angle of view, and the slightly narrower band of DOF. This permits you to isolate the subject in the frame, and while it might not fill the frame, the eye can't help but go to it because of the plane of focus. The negative, as I see it, is the narrow band of DOF when you really want or need that extra DOF in limited light situations. Ah, one of the many "compromises" photography is so well known for—the yin and yang of the teleconverter. Personally, the pluses outweigh the minus, but each photographer must make that decision for themselves.

Since a prototype was put in my hands at a Photoshop World precon, I have been a huge fan of the AF-S 200–400mm f/4 VR lens. These days, I see this great lens in the hands of most wildlife photographers and for very good reasons, some of which I've already mentioned. Its small size and price make it easy for many to deal with, both in the field and in the wallet. But here's where I probably diverge from most shooters using it: I use it basically just for big game.

The most common combo in which the 200–400mm VR is used is on a DX body, so the effective focal length is 300–600mm. This is a real sweet focal length range for bird photography. And with the MFD of only 6'6", that produces a much bigger image size than the 600mm lens on an FX body. I would like to encourage you, though, to not be focused on image size, but rather the relationship between the subject and its world contained within your viewfinder.

The 200–400mm on the DX body might give you an effective focal length of 300–600mm, but its perspective—angle of view—

is still that of the 200–400mm. Man, we are really splitting hairs here when we talk about this stuff, but I think this ever-so-slight difference is enough that I own both the 600mm and 200–400mm. I'm putting my money where my mouth is. In the balancing act of the subject and the world around it, splitting hairs is often the difference between good and great images. And to be honest with you, when starting out, you can own the 200–400mm VR and DX body for less than the 600mm lens, so it makes good sense to start there. Just don't stop there!

The question that is probably floating around in your mind is: Why the 600mm for birds and the 200–400mm VR for mammals? That's a darn good question and, really, the answer lies in the mind of a fanatic. Photography, as I see it, is a constant wrangling of subtleties into the viewfinder that, when all added up, produce big-time drama. Little nuances that, when seen and included, set the stage for everything else.

The angle of view, the perspective, of the 400mm compared to 600mm is different enough it can make a subtle difference in how a subject is perceived in a photograph. Never forget that we are working more with perceptions than reality in photography, especially wildlife photography. The Rocky Mountain elk is a very majestic critter. When you say the word "elk" to someone, they think wilderness, wild and wooly, with snow blowing and wolves howling. Deliver less than that in your photograph and you run the risk of not getting that "wow" you might be after. For me, I might not be tugging at those heartstrings. In this case, shooting the elk with the 600mm, you "compact" it, more so the physically closer you are to it. What's this "compacting" I'm talking about?

It is best described using a reference we're all familiar with: the Hollywood car chase scene. Those scenes, when not done in a computer, are filmed using a specially rigged telephoto lens: 600–1200mm. The cars in the final cut appear to be stacked on top of each other, driving so close the audience wonders how they survived the making of the film, let alone the movie.

Rocky Mountain elk. Photo captured by Nikon D2H & Nikkor AF-S II 600mm f/4 lens at 600mm on Lexar UDMA.

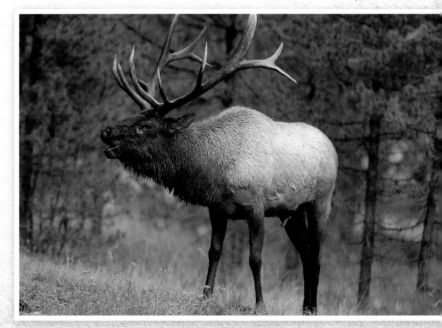

Rocky Mountain elk. Photo captured by Nikon D1H & Zoom-Nikkor 200–400mm f/4 VR lens at 400mm on Lexar UDMA.

In reality, the cars are not nearly as close as they appear—the distance between them is visually compacted by shooting with long glass. This same thing can happen to big game, making them look less wildernessie (I know that's not a word, but it works).

With this all said and done, does it mean I never use a 600mm to photograph big game or the 200–400mm to photograph birds? Hell no, I use the tool required and at hand to make the image. I don't like photographing big game with the 600mm, but I have, and the results have been published. I have photographed birds with the 200–400mm with the same results. But these images don't make it as my own personal all-time favorites (I actually went and checked because I was curious). What it does mean, though, is that I own both lenses, and when I go out to shoot birds or big game, I take either the 600mm or 200–400mm, depending on what I foresee as being the best tool for that particular shooting scenario.

This is where the AF-S 200mm f/2 VR comes into the war chest. It's not your normal wildlife photographer's lens by any stretch of the imagination. I do not recommend it to you as a wildlife photographer (but do as a photographer), and in the interest of complete disclosure, I feel I need to talk about this lens because I freakin' love it!. It's an

essential lens in my arsenal for basically one reason: f/2. Besides being wickedly sharp, its very narrow DOF at f/2 when shooting at 200mm (or with the TC-14E II, at f/2.8) makes any subject its trained on leap out from its surroundings. It's a lens I've had from the beginning—since 1988—from manual focus to the current VR version.

One large advantage of this lens is the f/2, not just for DOF, but for working in minimal light or dark forests. I'm not a "crank up the ISO" kinda shooter. I leave the ISO in the basement. But that's not what I'm referring to when I talk about using f/2 in minimal light. Our AF cameras need light, contrast, and vertical or diagonal lines to operate, to focus. When you start getting in marginal light, you start to have focusing issues shooting with a lens whose maximum aperture is f/4. Working at f/2, you have AF operation, where you otherwise might not. I don't wear glasses, but I do depend on the AF to make the initial focus and, because of that, I have the tools to make it work.

As I mentioned, when I started out, the 300mm f/2.8 was considered the lens for wildlife photographers. I had one for a year back when the first AF-S model came out. Looking back on it, I have no clue why I had that lens. Looking at my files, there are only one or two images taken with that lens that have any meaning to me now. When I look at my files and look at the lenses that have taken the majority of the wildlife images that make me smile, they were taken with the three lenses we've talked about. I mention this because you need to do the same thing. There is so much "This is the lens!" stuff out there, it's hard to find your way sometimes. Heck, I just said I don't see you making it without a 600mm, then I told you a way you could. No sooner is that said, than someone will come down the road with killer images captured with a 500mm VR and teleconverter.

You should have a better idea now about my answer to the question, "What's the best lens?" It really does all depend on you, your style, and your abilities. You might never enter a dark forest to photograph a moose, so why shoot with a 200mm f/2? You might live on the coast and never see a big mammal (whales don't count here), so a 200–400mm VR isn't a smart buy. You could live in the north, where big game rule the land, so a 600mm VR just doesn't make sense. You will need to think through your photography and your

> A great example of little nuances is the very serious video promo we did at Kelby Training for my Yellowstone DVD. The first time through, most don't notice the detail that was put into the promo, and that's how it should be. The trash barrel with the large snow shovel leaning against it (any idea how hard it is to find a snow shovel in Tampa, Florida?) and the large glob of hair on the stylist's brush when she backs away from doing makeup are just some of the subtleties incorporated into the shoot. Yet, those little details, while they blend in, take the viewer down the road, believing what they are seeing is real and not a spoof. Subtle details—you can take that tip to the bank!

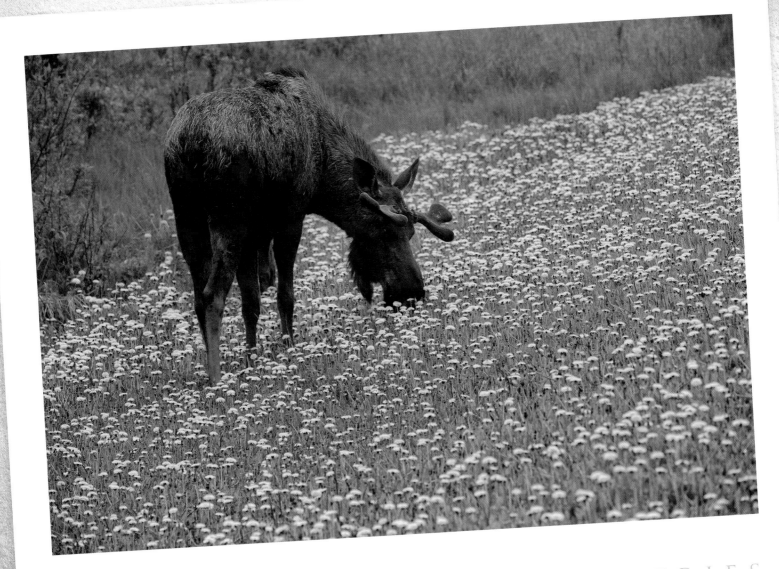

M O O S E P E T E R S O N G A L L E R Y S E R I E S

Moose grazing. Photo captured by Nikon D3
& Nikkor 200mm f/2 lens on Lexar UDMA.

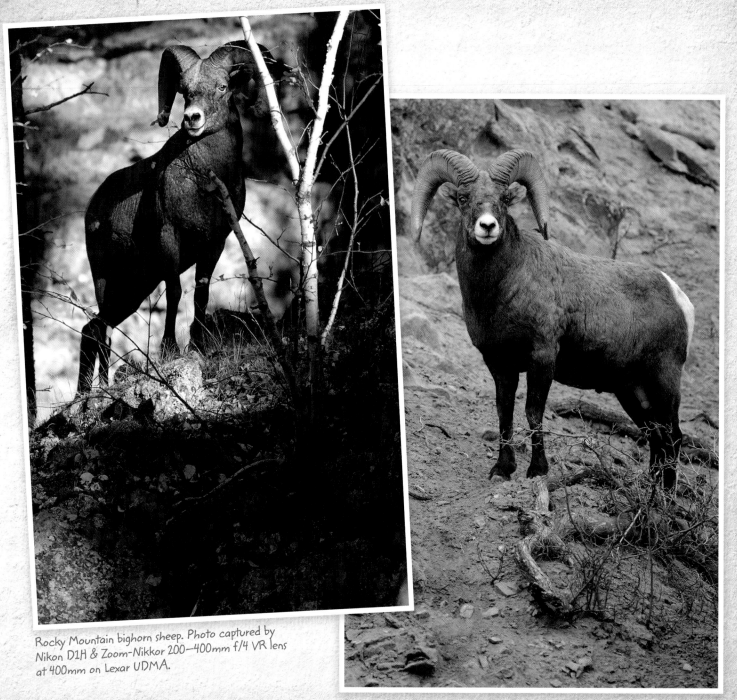

Rocky Mountain bighorn sheep. Photo captured by
Nikon D1H & Zoom-Nikkor 200–400mm f/4 VR lens
at 400mm on Lexar UDMA.

Rocky Mountain bighorn sheep. Photo captured by Nikon D3
& AF-S VR Nikkor 600mm f/4 lens at 600mm on Lexar UDMA.

passions, and use that as a guide in finding the right lens for you and your photography!

The Short of It

One of the greatest things about wildlife photography is you're outside! When you look at what was on this continent when Europeans first landed on its shores and compare it with what we have today, it can be a little depressing for sure. When you look, though, at all the treasures we still have today to point our lenses at, it's still pretty darn amazing. As my good friend (who lived in Yosemite) used to challenge his audiences at the closing of his shows: "If John Muir didn't have the foresight to fight for the preservation of Yosemite, we wouldn't we have it today to enjoy. The question is: Do we have the foresight to preserve what we have today for future generations?"

We are incredibly fortunate to be able to venture into the wilds with our cameras in pursuit of our passion: wildlife photography. Wildlife has to have a home to live in. Without it, they perish, and with them, our ability to photograph them. If for no other reason than this, we must take with us the lens(es) that permits us to capture not only the critters our hearts pursue, but also their homes—what most simply call landscapes.

Yeah, personally, my style of wildlife photography is to include their world in the photograph with them. I often take that a step further and turn the long lens on the landscape itself, removing the critter and just photographing the home. These can be incredibly dramatic and powerful images when all the elements come together in the narrow perspective of the telephoto. But when it comes to the photographs of the grand sweeping vistas that grab heartstrings and play that romantic ballad, short lenses are the main instruments creating that harmony.

When we venture into the realm of short lenses (less than 200mm), making such distinctions like the 600mm is for birds and 400mm for mammals just doesn't happen. We can talk classes, like short telephotos, wide-angles, and ultra-wides or fisheyes, but the bottom

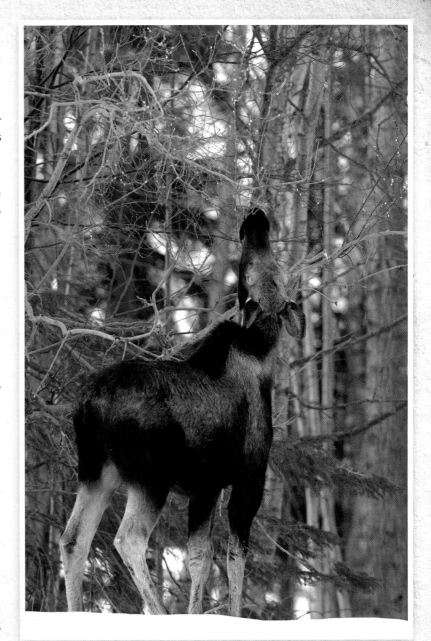

Moose foraging in woods. Photo captured by Nikon D2Hs & Nikkor 200mm f/2 lens on Lexar UDMA.

Ever wonder why there is such a huge assortment of lenses at the lower end of the scale and there are only a few in the upper end? It comes down to a statement a shooter once made of my photography: "I can see images in your images, you always shoot everything so wide!" It's a big, grand world and I love squeezing every pixel I can into a landscape photo. This is why I have the short lenses I do.

line doesn't change from any other focal length when it comes to *your* photography. You've gotta find the tool (lens) that brings your passion from your vision to your camera, and then to the viewer of your image.

As you've probably noticed, I have a combination of prime lenses and zooms in my bag. The reasoning for that has been spelled out. That same logic and reasoning carries through in my short lenses, as well. I will more than likely head out with just one of the lenses we'll talk about in this section when I think I'll be shooting with the long glass more than shooting landscapes. So, before I go into these lenses, here's a little bit about what's going on in my head:

Mono Lake, California. Photo captured by Nikon D3X & AF-S Nikkor 14–24mm f/2.8 lens on Lexar UDMA.

In the very beginning, I wanted to be a landscape photographer and make my living traveling and shooting the land I was so blessed to be shown by my parents. Those long weekend drives, along with all the John Ford movies I inhaled as a kid, I have no doubt affected how I look at the land. Living in a cabin in the Sierra—"The Range of Light," as John Muir so correctly named it—as a kid influenced me, as well. But it was real obvious when I started that there was no way I was going to make it as a landscape photographer, no way to support a family or business. Not that I was settling on wildlife photography instead (or that it is any more secure), it was just that I could focus one way or the other, so I went with wildlife.

The love of landscape photography didn't go away, it just tends to play third or fourth fiddle (photographically, that is). It really wasn't until the early 2000s that I became comfortable with how I tell the visual story of the landscape that I am so fortunate to venture through. And it's only of late that I like my landscape photographs. It was when I started to get comfortable with my landscape work that I reinvested in the really good short lenses and added more lenses to the short end, where I had been eliminating them prior to that time. I still ponder the cause and effect of this on my photography, and I'm just throwing it out there to give you some thought about your own pursuits.

The short lenses in my bag must serve many masters. They are not there just for landscape photography. If I had to say what their main purpose is, it would be photographing people (biologists mostly) as they go about what it is they do. Then they serve as landscape lenses, and lastly micro lenses. The reasons for this are pretty simple: money, weight, and space—all the same reasons really as with the long glass (there are two lenses that don't fit this mold, though, as you'll see). All of this is just to say that I don't see how you can go wrong with basically any lens you love, as long as it brings to life what you feel. Please don't carry on with the myth that a 14mm at f/22 is the perfect landscape setup, though. Photographers spread and carry on with the horrible habit of pigeonholing lenses and focal lengths. That's a guaranteed recipe for killing the growth of your photography. Push past the myths, and your photography will be successful!

Walter (I found him in a Montana diner). Photo captured by Nikon D3X & AF-S Micro-Nikkor 60mm f/2.8 lens on Lexar UDMA.

"If you had your choice between the AF-S VR Zoom-Nikkor 70–300mm f/4.5–5.6G IF-ED or the AF-S Nikkor 300mm f/4D IF-ED, which would you use?" Hands down, the AF-S 300mm f/4.

Santa Cruz kangaroo rat project. Photo captured by Nikon D1H & Zoom-Nikkor 17–55mm f/2.8 lens, using a Speedlight SB-80DX flash, on Lexar UDMA.

One of the challenges I think we face as photographers is taking a very three-dimensional world and smashing it down flat onto our film plane and then onto a print, wall, page, attempting to bring it back to life in three-dimensional glory. Bringing visual depth to your images is what you worry about after you're comfortable with the basics, and is one of those big steps in the evolution of your photography. One of the easiest ways to bring visual depth to a photograph is shooting over it. You take the camera and tilt it down so it's about at a 45-degree angle to the earth, then move in physically over the subject with the camera. This is shooting over a subject.

When you do this—tilt the camera and get physically closer—you visually extend the horizon line at the top of the frame, while including more of the foreground. The relationship between the two is exaggerated and, by doing so, we are truly manipulating the image and the viewer into feeling like they are "falling" into the photograph. This brings visual depth and life to our otherwise paper-flat image. The ultra-wide lens, which is basically any lens between 14mm and 20mm, lends itself naturally to this technique, which is why I, most times, first think of grabbing the 14–24mm.

Shooting the FX format (keeping in mind it's the format in which I was trained) gives me the luxury to use lenses on the wide end to their fullest. I just love wide, really wide, ultra-wide, ultra-pano-wide images, so quite often that's where my vision heads.

That's why, when I head out, I always think of the AF-S 14–24mm first for my second lens. That 14mm end of the lens, the sweetest Nikon has produced, takes in a whole lot of the world with a single click. More than with most lenses, the dance between including and excluding elements is done the most at this focal length. One of the most "unwanted" elements that this lens often includes is bright sky—sky so bright it's a blinkie (that discussion is coming soon). With this being the case, it leads us to how I like to use this lens the most, shooting over the top of a subject. What the heck does that mean?

When grabbing the 14–24mm, I ask myself a couple of questions, the main one being: "Am I going to be shooting people or trees really close, and am I going to want to use filters?" The 14mm end of the 14–24mm can be not-so-kind to people, distorting features, making their nose or belly grow if you are too close to them. Since my style is often to get physically close, this can be a concern. You can zoom to 20–24mm and avoid this problem. When it comes to filters, they

ain't going to happen with the 14–24mm. The lens has a built-in scalloped lens shade. This style shade does not create a 360-degree "seal" between the lens and the filter. The gaps on the side permit light to come into the back of the filter itself. This creates ghosting and contrast issues negating any benefit of the filter. Why not just screw a filter in place, why try to hold it? There are no screw threads to attach a filter!

If the 14–24mm doesn't work for the situation at hand, the next lens I consider taking is the AF-S 24–70mm f/2.8. This is a beautiful lens in that classic focal length territory we think of as the multi-purpose lens. I've had many different flavors in this general range over my 30 years: 35–70mm f/2.8, 28–85mm, 24–85mm, 17–55mm, and now the 24–70mm, which is my favorite of all. This range encompasses what was once considered the "normal" lens focal

Shot with camera straight. Photo captured by Nikon D2Hs & AF-S Nikkor 14–24mm f/2.8 lens on Lexar UDMA.

Shot with camera tilted. Photo captured by Nikon D2Hs & AF-S Nikkor 14–24mm f/2.8 lens on Lexar UDMA.

length, with a little extra on either side. I work this lens pretty darn hard for lots of reasons. Multi-purpose is describing what this lens can do mildly. There probably isn't anything I've not pointed it at, folks—landscapes, birds, mammals, macro, planes, and trains, just to name a few—and it does them all exceedingly well, in part because the lens quality, zoom range, and f-stop throughout its range all contribute some amazing quality.

The physical size of the lens lends itself to easy transport on a second body hanging from the shoulder. Its filter size is 77mm, which means a polarizer and split neutral density gradient filter (0.6 screw-in) can be slipped into a shirt pocket and carried easily into the field. It has a really, really deep lens shade. Not that this is important when shooting the majority of the time, in fact it's a pain when using a filter, but it provides immense front element protection as the lens bounces

Tilt the camera & get close to the subject to bring depth to the image. Photo captured by Nikon D2X & AF-S Zoom-Nikkor 12–24mm f/4 lens on Lexar UDMA.

Western diamond-backed rattlesnake. Photo captured by Nikon D2Xs & AF-S Nikkor 70–200mm f/2.8 VR II lens with TC-17E II on Lexar UDMA.

along on a strap hanging from your shoulder when walking through deep brush. All these attributes make the 24–70mm the go-to lens.

Getting close to wildlife is a skill you constantly strive to improve, because once you visually see all the benefits of it, you just can't do it enough. There are times when you get close and, once there, it dawns on you that there are images to be had not so close. That's when the lens on that second body becomes very important and where the 24–70mm really shines. My photography style is to use the perspective

of a given focal length to its fullest by physically moving to get the subject size I desire, what I call "zooming with your feet." But when you've approached a subject and you're close, moving back and forth isn't always advantageous. That's when the flexible focal length of the 24–70mm once again makes it the go-to lens.

One other lens I take at times is the Nikkor AF-S 70–300mm f/4.5–5.6 VR. I grab this when I'm working birds in flight more than anything else. The AF-S speed of the lens permits quick acquisition

Santa Cruz kangaroo rat existence shot. Photo captured by Nikon D1H
& Micro-Nikkor 60mm f/2.8 lens, using a Speedlight SB-800 flash, on Lexar UDMA.

Santa Cruz kangaroo rat camera setup. Photo captured by Nikon D1H
& Zoom-Nikkor 17–55mm f/2.8 lens, using a Speedlight SB-80DX flash, on Lexar UDMA.

of the subject and maintains focus as you pan. The typical scenario is we're out shooting with the big glass and having a merry 'ol time, when all of a sudden a bird—a great subject—comes from the left or right, flying almost right overhead. Like an Old West gunslinger, the second body comes flying up with the 70–300mm attached, and a heartbeat later, that great bird is now pixels on a flash card. While a tad short for a flight lens on the FX frame, getting just a little closer makes up for not being at 400mm, and since the image quality is so sweet from this lens, it just works.

This brings up a common question, which is about shooting approach as much as gear. When I head out to a project, all the gear is in the truck ready to be used (batteries charged, cards wiped off, sensors clean). Once I arrive on-site, I take out of the MP-1 (see Appendix 1) only the gear I'm going to use in the field. For example, if that moment we're off to photograph moose (a close cousin), I will take the D3X with the 200–400mm VR mounted to the Wimberley Head and attached to the Gitzo 5560S GT sticks that will be carried over my shoulder.

Often, a second body, a D3 with either the 12–24mm, the 24–70mm, or the 70–300mm VR attached goes along. It's on a strap riding from my shoulder, turned so the lens goes behind the small of my back. If I feel I need a teleconverter, one is attached to the lens and its cap is in my pocket, so I can remove it if need be and place it in my pocket. Also I'll have a card wallet with six Lexar 32-GB cards. That's it!

The rest of these lenses are really ones that fill in the gap, you could say, for all the other types of photography I do and enjoy. It's hard to keep in mind that WRP (Wildlife Research Photography) is a business, and we have to turn a dime. This means that capital spent has to bring capital in. So the lenses that follow are just as I described: those that fill in holes in my bag, permitting me to bring back those images that make me happy and bring in the bucks.

The Nikkor AF-S 105mm f/2.8 VR and AF-S 60mm f/2.8 are micro lenses that focus from infinity to 1:1 (life-size). The primary difference between the two lenses, besides the focal length, is their minimum focusing distance (MFD) and angle of view. The 105mm VR has an MFD of 1 foot and angle of view of 23 degrees, and the AF-S 60mm has an MFD of 0.6 feet and angle of view of 39 degrees. This is important when you're photographing little dudes, for many, many reasons. One example is when I'm doing what we call "existence" shots of species.

Two Medicine, Montana. Photo captured by Nikon D3X & PC-E Nikkor 24mm f/3.5 lens on Lexar UDMA.

We've been called to come and photograph a little mammal because of its rarity. We're there to take a photo documenting its existence. The critter was captured from the wild (and is returned there when we are done), and placed into a special photo tank we've had made. I then photograph it using the 60mm and flash. The MFD of the 60mm is important, because we have the lens basically right next to the tank, so we don't see any reflection of the camera, flash, or us in the photograph. We couldn't do this with the 105mm VR because of its greater MFD.

On the other hand, when photographing a small critter like a butterfly, you want the greater MFD for two reasons: to stay further away from the critter, so as to not scare it, and so it's easier to bring in flash to light the subject. Yeah, you can use the Nikon R1C1 Wireless Close-Up Speedlight System on the 60mm, but I personally don't like that option most of the time. Using the 105mm VR, I can use the Nikon SB-900 Speedlight, which gives more power and therefore permits more DOF. I do not always have one or both of these lenses with me when I go shooting—they quite often stay

back in the office because I'm not really a good macro photographer. It just isn't something I do really well. So, I often don't go out to do macro for the fun of it, but rather, when I get the call and the work needs to be done.

> When in business, the general rule of thumb is you gotta earn five dollars for every one you spend. When you start looking at lenses with price tags of $1k, $2k, and $10k, well, you can do the math.

The next two lenses are so far out there, I'm including them only because I think they are really cool lenses and not because I think any other wildlife photographer on the planet should include them in their bags. The PC-E Nikkor 24mm f/3.5 and PC-E 45mm f/2.8 lenses are highly specialized, wickedly sharp, manual focus lenses that are truly designed for one thing: architecture photography. So, why then

Stout Grove at Jedediah Smith Redwoods State Park (2x3 pano). Photo captured by Nikon D3 & PC-E Nikkor 24mm f/3.5 lens on Lexar UDMA.

do I own these two very expensive lenses? Even more, why do I always have the 24mm PC-E with me (if not both of them)?

PC stands for perspective correction (keeping lines from merging at the top of the frame). The purpose of the PC lens is to permit the film plane to stay parallel with the subject, like a building or a tree. This prevents the lines of the subject from converging at the top of the frame. But at the same time, keeping the camera as such cuts off the top of the subject in the frame. The PC lens has a shifting front barrel. The shifting front barrel permits you to pull the top of the subject back into view without having to have to tilt the lens and converge the lines. While I use these lenses from time to time to photograph trees, their PC ability isn't why I have them.

I have these two lenses specifically for my ultra-wide panos—what appears to be a single photograph is actually six images, two rows of three, combined in Photoshop. To produce a single finished image with the same perspective as if you were standing next to me when I took it, you need to use a nodal plate. This permits you to pan on your ball head and keep the perspective across the 180-degree pan in check, but prevents the camera body from tilting up or down.

That's where the PC lens comes in with its shifting front barrel. You can shift the lens down and then up without moving the camera body and take two separate photos that, when combined in Photoshop, give you an image with the vertical perspective equal to your vertical binocular vision. Take three such panels and combine them, and you have a single image that equals your horizontal and vertical binocular vision. That's an ultra-wide pano, and why I have these two lenses.

My go-to landscape lens?
The PC-E Nikkor 24mm f/3.5.

The other lens that travels with me most of the time is the old Nikkor 28mm f/1.4 AF. There are a few times it goes into the field for your "basic" type of photography, but that's rare. I have this lens for one specific purpose: star trails. Doing star trails with digital is pretty darn simple. After taking a minimum of 40 images, one second apart, with the shutter open for four minutes, you combine all of them in Photoshop to create the classic star trail photograph. I try to take at least one star trail at every place I visit. The 28mm f/1.4, being killer sharp and so fast, makes them a snap to do.

Blunt-nosed leopard lizard. Photo captured by Nikon D1H & AF-S VR Nikkor 600mm f/4 lens with TC-14E II on Lexar UDMA.

The One Place You Can't Cheap Out!

I hate tripods. Being stuck on them takes away the freedom that makes photography creative and so much fun. With that said, they are a necessary tool that you simply cannot be without. And they are a tool you can't cheap out on.

Since day one, I've been shooting with Gitzo tripods for a real simple reason: they work. The vast majority of the time, big lenses like the 200–400mm VR and 600mm VR reside on a tripod (though handholding is done with these lenses, as well). The first test in selecting the right tripod is kinda simple: Do the legs open up wide enough, so the distance between the legs where they hit the ground is equal to or greater than the length of your rig (camera and lens)? The next test is: Does the tripod, at its maximum height, come at least up to your nose? The last one is: Does it have a thread on its base, so you can attach the tripod head of your choice? Optional questions are: How many leg segments? Center column? Carbon fiber or metal?

The answer for me is real simple: Gitzo carbon fiber 5560S GT and 3540 XLS. The 5560 is the big bad boy and the 3540 is light duty. Both of these are G-Lock, which in itself makes them more than worth their weight on any project. G-Lock permits you to change the leg length with a simple quarter-turn. You don't have to hold on to any other leg to do this. You don't have to hold a leg to lock the G-Lock back in place. One simple turn and you're good to go. When

I always giggle to myself when a photographer tells me how they are disappointed in the sharpness of their $10,000 lens mounted on a $100 pair of sticks. You want $10,000 results from that $10,000 lens—or any lens—you gotta use the best possible tripod. Bite the bullet from the start and you'll never buy another tripod (unless you leave it on the roof of your truck and drive away).

Setting up the Moose Cam. The Gitzo 5560 has no problem providing a stable platform for the DSLR rig and video at the same time—and that's with it set up in snow!

it comes to making slight adjustments without upsetting a subject, the G-Lock system paid for itself the first time out.

Neither one of these two tripod models has a center column. To get the maximum stability out of your tripod, the tripod head must rest right on top of the tripod base. If you extend a collar, and use that to get height for your tripod head and big lens, you've basically put that big lens on a monopod. Many photographers obtain sharp images doing this, but it takes work and means often the tripod is set up on a steady platform to begin with (column costs you more money and means more weight, as well). When it comes to tripod stability, you have to always plan on placing the tripod on the most unstable surface. Working in sand, mud, snow, gravel, and unlevel ground, etc., is very typical for wildlife photographers. For that $10,000 lens to do its job, the tripod must be stable.

The 5560's main job is to hold the 600mm VR, and it does it very, very well. The 5560 is called "the Giant," because it can extend as high as 8'5"! For 20 years, I worked with tripods like the 5540 XL, which only extended to 5'. Until I shot with the 5560, I didn't realize what I was missing all those years shooting with the shorter 5540. It wasn't a stability issue, it was a back and neck issue. Bending and stooping over at times to look through the viewfinder got real old. Another issue is working on a slope. The shorter legs of the 5540 made working on a slope not only uncomfortable, but hazardous. I always had to keep a hand on the tripod, so gravity didn't tumble over the rig. The 5560 made those problems disappear. To say I'm hooked on the taller 5560 is an understatement.

> What's the best tripod head for long lenses? Hands down, the Wimberley.

The 3540 is my general-purpose tripod. You could say it's relegated to landscape chores, but it does more than that. The 3540 XLS extends to 6'4", which permits me to get under it and easily look up through the viewfinder to do star trails. If I didn't do those, I probably wouldn't have the XLS version of the 3540. It can easily support the 200–400mm VR or 200mm VR, so it does get a bit of slope duty, which makes that extra leg length a real benefit.

Jake & I on the banks of McNeil River, Alaska, with our 600mm lenses resting securely on our Gitzos, which have all-day lens duty on the river.

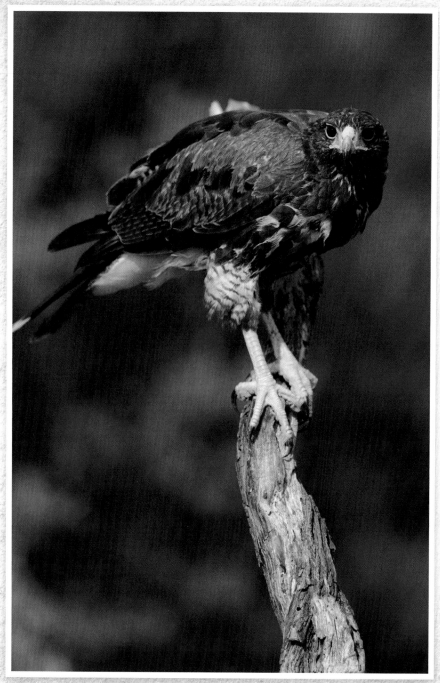

Harris's hawk. Photo captured by Nikon D3X
& AF-S VR Nikkor 600mm f/4 lens with TC-17E II on Lexar UDMA.

These sticks are the stable platform holding the tripod head, and then the lens, that permits shooting in critically low light possible. The head you attach to your tripod is just as important as the sticks themselves. The 5560 is married to a Wimberley Head II and the 3540 to the Really Right Stuff BH-55. Both are fitted with the Arca Swiss-style clamping system, whose channel groove locks into the plates attached to bodies and lenses. The 600mm VR and 200–400mm VR have had their factory tripod foot replaced with the Really Right Stuff tripod foot, which not only has a lower profile than the factory model, but has an Arca Swiss groove built into it. This system permits quick and assured mounting of the lens onto the heads. (I always double-check security when I mount a lens and/or body to a head.)

Why the two different heads? The Wimberley Head is a gimbal-style head. The gimbal permits solid support without the controls being locked down tight. One thing you want to make sure you do when you work with your tripod head is to not lock it down tight. All movement—horizontal and vertical pan, as well as rotating the lens from horizontal to vertical (via lens control)—must be loose, so you can easily follow any action. At the same time, this looseness keeps any movement from being transmitted through the head and to the lens. How loose is loose? I personally set up the tension so it takes a little force to move the lens in either horizontal or vertical motion, but not so tight there is any chattering while the lens moves. The 600mm VR with body and/or teleconverter attached is also set so it's balanced out. The goal is to be able to move the rig left, right, up, or down and then

let go, and it will stay where you left it. This gives the speed and stability you need to function as a photographer while photographing a moving subject.

The pan action is oh so important. When shooting a moving subject, the smoothness of that panning action directly translates to the sharpness of your images. Any chatter because it's over-tightened or because the action has been damaged from abuse or neglect, and you can kiss sharp images goodbye. For that reason, the Wimberley wears a Lens-Coat Wimberley WH-200 cover. And when it's transported across the country—or just going in the truck to the next site—when no lens is attached, it's covered by the LensCoat Gimbal Pouch. It's real simple: you want the best out of that $10,000 glass, so you'd better make sure everything it's attached to—that includes you—works its best.

The BH-55 is a true ball head. That means it has nearly 360 degrees of movement. When it comes to everything photography, this head just rocks. It is not an inexpensive head for a very good reason: it is a precision tool manufactured with standards that have their beginnings in the Skunk Works (the division of Lockheed Aircraft Corp. formed to rapidly develop a jet fighter during WWII). I rely on this head for doing basic landscape work, studio work, ultra-wide panos (the action is just that smooth), and at times, to hold the 200–400mm VR.

Why the exception there? Since it is a true ball head, with the main control slightly loose like I described for the Wimberley, if the 200–400mm VR is attached to the BH-55 and is not perfectly balanced, gravity will take over. The results aren't pretty when that happens. Since I can't walk and chew gum at the same time, remembering to lock down the main control when the 200–400mm VR is attached is difficult. More than once, I have forgotten, only to have the head come down on my finger and pinch me—the wildlife soon knows all the foul words in my repertoire.

Being a precision piece of equipment, anything that gets into its movements destroys that precision. Not that you have to be paranoid about it, but simple things like keeping the head covered when not in use (it comes with a cover), keeping sand out of its mechanisms, and other obvious precautions will guarantee years of service. While the

Yellow-bellied racer. Photo captured by Nikon D2Hs & Nikkor 200mm f/2 VR lens on Lexar UDMA.

BH-55 is married to the 3540, there are times (for the sake of weight conservation) it will go on a project and be used atop the 5560. While that is overkill, it works great and is solid as a rock.

The main goal is maximum stability. This means keeping the head on top of the tripod platform. At the same time, it means keeping

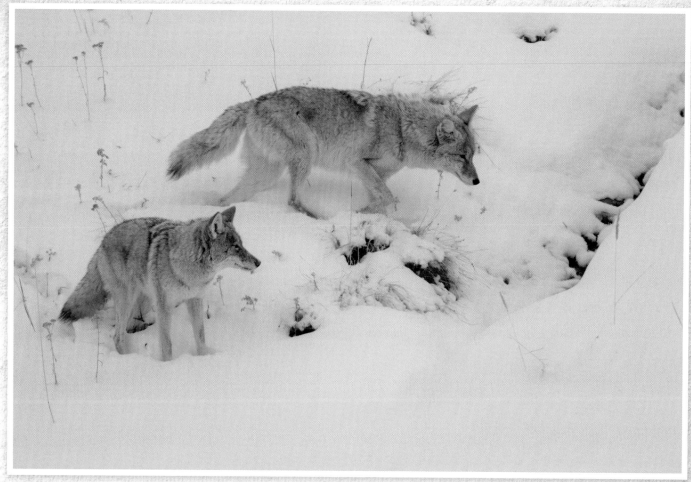

Coyotes in Yellowstone National Park. Photo captured by Nikon D3X & Nikkor 200—400mm f/4 VR lens with TC-17E II on Lexar UDMA.

the mass of the lens and/or body over that same point. It's all very physical (as in physics). Using the Really Right Stuff Arca Swiss-style plates makes this all very simple. Keeping with that, the bodies are fitted with the appropriate Really Right Stuff L-plates (only when needed, otherwise they are in a kit, ready to be attached). The L-plate keeps the camera body, when attached in either horizontal or vertical format, and its mass centered over the main base of the tripod. This brings maximum stability to your shooting.

Making 'em Work for You

The tripod is this silent miracle tool to wildlife photographers when used to its fullest. There is actually more to getting stability than simply shelling out the bucks. Let's start with setup.

When you extend the legs of your tripod, I highly recommend you extend the last leg—the leg that hits the ground—to its fullest, so it takes all the abuse of the terrain. Mud, snow, sand, and everything

Greater sandhill crane in Bosque del Apache National Wildlife Refuge. Photo captured by Nikon D3S & AF-S VR Nikkor 600mm f/4 lens with TC-17E II on Lexar UDMA.

else we set our tripod in, can take a toll on the leg joints. Contrary to logic, you're not forsaking the stability of the tripod by putting the skinniest leg to its fullest. You are guaranteeing that when you need it, the tripod is working.

Setting the length of the rest of the tripod legs can be done many different ways based on your height, the height of the tripod head, and the number of leg sections on the tripod. I would suggest that

Having a leg length routine makes good sense to make setting up and shooting faster. At the same time, shooting the same tripod height all the time is not always the best idea. Always shooting at the same tripod height will bring a look to your images that is "routine." So while you might always start with the same tripod height, be very flexible, and constantly change its height when shooting to make the most of the photographic opportunity.

you get a tripod that is 6–8" taller than you are, so the uppermost leg section doesn't have to be extended for general shooting. Setting up the tripod in this way, when you need a longer leg(s) for working on a slope or uneven surface, you can quickly and easily extend this leg(s). Being the beefiest, you have the greatest amount of stability as you reach the tripod's limit, and at the same time, limit your movement extending the leg, which might scare the subject.

When you set the tripod down, make sure it has as stable a platform as possible. If there are any little rocks around, wiggle the tripod so it settles onto solid ground and not on the little rocks. This needs to be done every time you put the tripod down, no matter the size of the tripod or the ground you're setting up on. Shaking the tripod leg is a good habit you need to establish.

Again, we often find ourselves shooting in mud, snow, and the stuff you find in marshes. These surfaces have an inherent surface tension, enough of one that despite the weight of our gear, it rides on top of this stuff. This is not a stable platform the majority of the

> "How do you have so much to write about?"
> This excellent question is a common one. My material comes from one of two places: those things I learn while I'm shooting, or questions asked by folks. Since I shoot all the time, that's where most of the material is generated.

time. So, every time you set up your tripod, along with giving it a wiggle, you'll want to push the leading leg down into the muck. The leading tripod leg is the one that normally is directly under the front of the lens barrel. By doing this, you break the surface tension and provide the tripod with a maximum stable platform.

The last thing to think about when putting your tripod down is to put it down so you're shooting between two of the tripod legs. You don't want to be straddling a tripod leg when you're shooting. Set up everything so you're ready for action, even if you're photographing a rock (you never know what might pop up from behind it), and so you can move left and right as you pan. Personally, I take this to the extreme and, when a subject moves from its original position, I will pick up the tripod and reset it, so I am basically standing in the middle of two legs all the time. There is nothing worse than having a killer subject move in such a way that you get all twisted up in a tripod leg, either kicking the tripod or doing a dance, causing the loss of a sweet image.

Walking with the tripod in the field is just something that doesn't come naturally. There are many ways you can do it, but I can only relate the style I use. The vast majority of the time, when the 600mm VR is attached to the

Jake, carrying his camera and lens on his tripod, at the back of the pack at McNeil River, Alaska (he was making sure Dad, with his bum leg, made it along the trail).

5560 and I'm off for a walk, it rides over my left shoulder. Prior to hoisting it up, I make sure everything is secure. That's because once I didn't, and I saw out of the corner of my eye the 800mm f/5.6 and brand new Nikon F4 come off the tripod and hit the ground. So, when I first connect the 600mm VR to the Wimberley, I shake the lens to double-check it is locked into the clamp of the Wimberley. Then, when I go to carry the whole rig over my shoulder, I lock down tight the horizontal and vertical pan of the Wimberley. This is so the 600mm VR doesn't swing and smack me in the back of the head (a gentle reminder to lock down the knobs). With the front element pointing toward the ground and the body up in the air, the rig is balanced, so it can ride on one leg on my left shoulder. Now my shoulder has a permanent dent in it from all the years of doing this, which helps. But at least that is how I can walk for miles with this rig ready to shoot (I've done that on more than one occasion).

I don't walk with all my gear in a photopack on my back and my tripod in hand, because if I come upon wildlife, getting it all set up and not scaring off the subject just isn't possible the majority of the time. It's all set up as described, which makes it a rather large "thing" walking toward a subject. So, when it comes time to put the tripod down to shoot the subject in front of you, you want to lower it slowly and deliberately. I tend to bend at the knees until one tripod leg is on the ground and then lift the rest of the tripod off the shoulder and set it up. We want to approach every subject as if they are shy until we know otherwise. This method, I have found, keeps our profile to a minimum while working with these tools.

Keeping the CCD clean is important. I use the VisibleDust system and, if you head to Adorama, you will find the Moose Kit containing those tools I think are important. Then head to http://moosepeterson.com/blog and look under Videos for my four videos on how to use it.

Gear Maintenance

I've been incredibly fortunate that, in all my years, I've never had my gear go down so I couldn't shoot. I'm pretty much a zealot about keeping my gear clean, charged, and tucked in at night. I want to encourage you to take the same care of your gear. When I travel, I have along a camera care kit that has just about everything in it for taking care of the gear. You'll find its contents in Appendix 2.

Working with electronics, as we do with digital, moisture, grease, and dust can be our biggest enemies. Simple daily care makes any gear going down on us a non-issue, though. The key is a clean, white T-shirt that you use to wipe all your gear down. It is amazing how this simple tool and technique keeps the vast majority of the daily grime from killing the camera. The basic regime I go through every night is best learned and observed on the four Camera Care videos posted on the Moose Library page of our website. So, rather than taking precious page space to cover that here, I'll simply say: You've gotta do it, there's no way around it, and it pays big dividends.

Working in the rain is very, very common for wildlife photographers. I tend to dive right in and not shy away from the moisture and, as long as I can handle it, I know my gear can, as well. I've tried all the covers and, while they work, they are a pain in the ass to work with. What I've been using for the last two years is not truly a rain cover, but works really well for that and just general protection of the lens (like when shooting out a truck window).

The LensCoat is a neoprene wrap that protects most of the lens barrel. It's not a complete cover, but I've found it does a great job. In conjunction with it, I use a clean, white, hand towel that I swear fell into my luggage at that hotel. This is used to *blot* the gear dry—not wipe it dry. Blotting prevents moisture from being forced into cracks and crevices of the gear, where moisture shouldn't go. So the clean, white towel is used by just pressing it against the wet gear and letting its natural absorbency do the job of drying the gear. One of these towels is in every one of my photopacks, so I always have one with me.

Working in inclement weather is really a hallmark of the diehard photographer. This includes cold—true cold, where your breath fogs up your eyepiece (which quickly teaches you not to breathe on it). Often, when this is the case, you and your gear are going in and out of the cold, which can cause, at the least, fogging, and at the most, condensation on your gear, in particular the glass. I'm suggesting you don't need to fret about all of this.

It's −40°, the Arctic wind is blasting, and while I took care to avoid condensation, this was the only time I'd had snow blown inside the front protective filter of any lens.

The key is to keep condensation from forming on your gear. The problem normally starts when you come in from the first day of shooting in such weather. The goal is to get your gear into the warmth and up to room temp as quickly as possible, so you can upload cards, clean it, and charge batteries. So, when you get to your room, take your gear out, lay it on the bed, grab a clean, white, bath towel, and instantly cover the gear. The condensation will form on the towel and not the gear. Once the gear is room temp, take care of it as normal.

Once the gear is all clean, place it back into its bag and place it in the coldest part of your room for the night. The next day, once out shooting, if possible, have the gear out and keep out what you're going to use from its bag, but under the cover of a white towel. Again, the towel will help with the fogging. The goal is maintaining an even temp for the gear as much as possible and keeping all moisture out of your bag. Take care of your gear, and it will take care of you.

Camera Bodies

I need to put this as succinctly as possible: It's the person behind the camera that counts. Just as much as lens selection determines a photographer's style, camera bodies must mold to the photographer's logic, abilities, and passion to be great. There simply is no right or wrong answer in body selection. It doesn't mean, though, for a moment that I don't know what I prefer. Ever since the D3 hit my office, I've thought it was the best wildlife photography camera body for me. For the last year, I've been shooting almost exclusively with the Nikon D3X, which is about as opposite of the camera body I recommend for most photographers. What is the best body then?

A better question is: What are the main attributes you should look for in a camera body? There are three that I feel are very important and I'd like you to consider: The first is frames per second (fps); the next would be full frame; and last is a vertical firing button.

It really doesn't matter how you get there, but you need to have at least 5 fps for photographing action. The mark, 5 fps, permits you to capture action photos without really having to think about it.

Here's the problem: by the time we see the action, tell our finger to depress the shutter release and the camera fires, quite often the action has come and gone. To make up for this lag, we hit the shutter release a tad before the action begins and let the fps take up the slack. To make this whole technique work, we need 5 fps or faster.

What if you're shooting less than 5 fps, are you screwed? Nah, you just have to be a better photographer. You have to be better at seeing when the action is going to occur. Seeing might not be the right word; predicting might be a better choice. Then, with that ability, you need to know how to use "peak of action" for stopping the action. Peak of action is best described by a dribbling basketball. When you dribble a basketball, it travels down, bounces up, and then just before it travels back down again, it stops, if for just a heartbeat. When it stops, that's peak of action, and at that point, you could photograph it with almost any shutter speed and get a sharp photograph. The thing is that you would have to push the button at just the right moment to make a sharp image of that moving basketball. That's a skill set many photographers simply have not perfected.

Full frame to me is a biggie. Seeing everything in the viewfinder that's going to be part of the final photograph is a must. Why? It's that old-fashioned thing known as photography. Photographers have composed in the viewfinder since the dawn of photography. It's part of the craft. What you see in a photo is what they saw in the view-finder. To make that work, you've got to see everything at the time of the click. This requires a full-frame or 100% viewfinder. It also means you don't depend on cropping in post to make the magic, but do it in the viewfinder. When you look at one of my wildlife images, what you see is what I saw in the viewfinder, it's that simple.

When you put the camera to your eye, so much is going through your mind before and at the moment you make that click. The goal is to remove as many variables in creating an image as possible, so you concentrate on just one thing: the subject. When looking through the viewfinder, being able to see all the elements we need

Since I got it, I've been shooting almost exclusively with the Nikon D3X.

Yellow-bellied racer. Photo captured by Nikon D2Hs & Nikkor 200mm f/2 VR lens with TC-14E II on Lexar UDMA.

Snow geese in Bosque del Apache National Wildlife Refuge. Photo captured by Nikon D3X & AF-S VR Nikkor 600mm f/4 lens with TC-17E II on Lexar UDMA.

to exclude, and at the same time, those we need to include, can only be done with a full-frame viewfinder.

The last one on the list isn't one you probably think of: a vertical firing button. Why is that important? We often work in low-light situations where good, solid handholding technique or long-lens technique is a must to get a sharp image. The vertical firing button makes it possible to do these things, but basically permits us to keep our right elbow down. Rather than having it flying up in the air, it's tucked down and, while this may seem too trivial to be important, it's on my top three list for a camera body.

What you're not reading here as important is megapixels. It's not important. Any photographer who knows their craft and practices it skillfully at the point of capture will make the most of every pixel, no matter the total. The quality resulting from that skill makes any

megapixel count on today's market more than ample to get the job done in stunning ways. If your skill set isn't up to that standard, more megapixels won't make up for it. Here's the fun thing though: if your skill set is up to that challenge, then the more megapixels, the more you can show off those skills. But don't fool yourself, more megapixels show off your lack of skill just as well.

One feature that I personally feel is important for me that I want to mention is GPS. I've been using GPS to make note of where I've been shooting since the days of film. I'm so glad the days of writing down UTMs (Universal Transverse Mercator coordinates) and later recording that info on the appropriate slide are long gone. That data is needed mainly for the projects I work on with biologists. I use it for myself mainly for return visits. Not to go back to the exact same place to shoot, because wildlife doesn't sit in one place waiting for me to come back. Rather, it's for my own trivia base of information, as

I try to better understand how wildlife use a particular area. That information is vital in how I work an area on my return visit. It doesn't make the photo any better or easier to obtain, so it's not a must to your photography.

You might be looking for settings for your body. You'll find the ones I prefer in Appendix 3. They, like everything else here, are just food for thought. While this is the gear that I depend on, and that I used to create the majority of the images in this book, they are not the only ones. Not by any stretch of the imagination. But that's what your gear—your bag of confidence—should permit you to do: stretch your imagination. If it doesn't, then you've got the wrong gear. The good, or bad, part of wildlife photography is there is always something new to explore and possibly buy. What's here just gives you some ideas. You're going to find as you continue on with the book, I really have only scratched the surface here. Because, in all honesty, this is really just a starting point.

What is always packed in my MP-1 photopack? It changes constantly, but right now it is:

- A Nikon D3X with a Nikkor 600mm f/4 VR lens attached

- A Nikkor 70—200mm f/2.8 VRII lens

- An AF-S Nikkor 24—70mm f/2.8 lens

- An AF-S Nikkor 14—24mm f/2.8 lens

- A Fisheye-Nikkor 16mm f/2.8 lens

- A TC-14E II & TC-17E II

- Speedlight SB-900 flash with SD-9 battery pack

- A Nikon D3S with an AF-S Nikkor 50mm f/1.4 lens

San Joaquin kit fox project. Photo captured by Nikon D3 & AF-S Nikkor 24—70mm f/2.8 lens on Lexar UDMA.

CHAPTER 5
And That's How You Do It

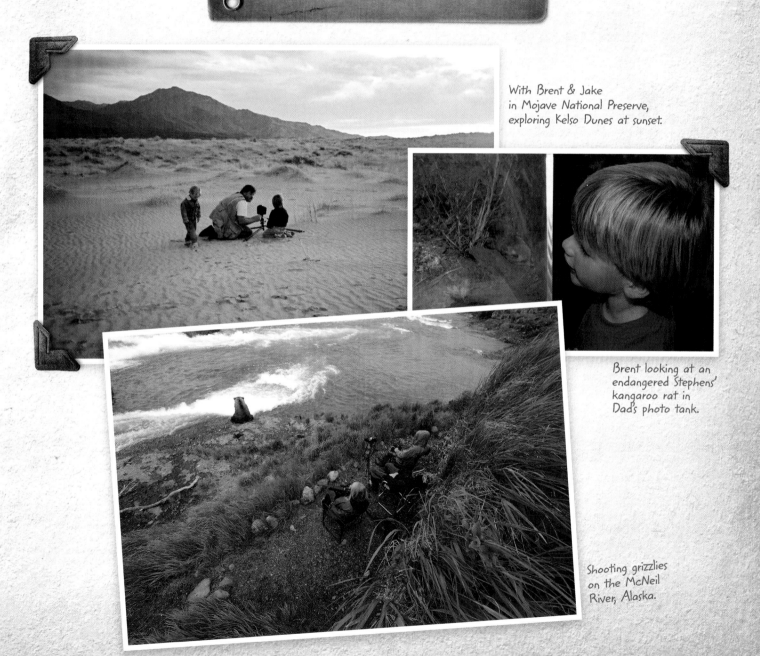

With Brent & Jake
in Mojave National Preserve,
exploring Kelso Dunes at sunset.

Brent looking at an
endangered Stephens'
kangaroo rat in
Dad's photo tank.

Shooting grizzlies
on the McNeil
River, Alaska.

Handholding the 200—400mm VR lens makes photographing bison in the Black Hills of South Dakota child's play!

Stalking a black-bellied plover in Florida.

The spring of 1993 found me in the Bitterroot Mountains of Montana, exploring both our national and natural heritage.

It's a great time of year to be in the Bitterroots, with the hillsides blanketed in yellow from the arnica, and bighorn sheep moving down to munch the fresh green forbs. The Suburban I was riding in instantly began to moan when we turned off the highway and started up the Forest Service access road. Coming from the river bottom, we headed up the side of the mountain on the dirt road into its pine-covered slopes.

What is now a Forest Service road was originally the Nez Perce trail through the Bitterroots, connecting their homes in Idaho to the vast buffalo herds in the plains to the east. Each summer, the entire Nez Perce nation ventured to the hunting grounds—families, belongings, and their vast horse herds made the journey over the mountains as soon as the snow disappeared. They would meet up with their friends, the Flatheads, and journey to the plains to hunt. All those feet, travois, and horses cut a road through the earth, creating a scar that is very visible to this day. It's the same "road" Lewis and Clark were on in 1805 when they left Ross's Hole (just a mile away from where we were), and the same road the Suburban was complaining about as we ventured up the mountain.

I had the luxury of being the passenger, so I could stare out the window, and think about what it was like being part of that mass movement to the hunting grounds. Or being the first white man to see this wilderness. I wondered if they saw this outcropping or that giant pine. I wondered what they saw that we don't see today. My mind reached back to what I'd read about Lewis and Clark's travels through this area as the Suburban took a bend in the road, crossing a small ravine. I was looking down, deep in thought, when a shape caught my attention. My mind snapped back to the present and I realized I was looking at a male dusky grouse.

Dusky grouse in shadowy light. Photo captured by Nikon F4e & Nikkor 800mm f/5.6 lens on Fuji 100.

This was a lifer for me. Lifer is a birding term that means it's the first time in your life you've seen a particular bird species. After spending time with the greater sage-grouse, I was fascinated with seeing and photographing more grouse species, so even though he was in dark shade at the bottom of the ravine, I had to get some glass on him. Where we parked put us on the backlit side of the grouse—not good. We got out of the Suburban, eased to the back and set up the gear. The 800mm lens with Nikon F4e body went onto the Gitzo tripod, and over the shoulder it all went with the vest loaded with 20+ rolls of film. We went down the road a bit and then looked over the side. There the male was—he had come up a ways and parked on a rotten log down on the ravine floor just off the road. We had immediate access to him—nothing between him and the lens. But what he did next took me by total surprise.

It was spring going into summer, and most birds had already mated, laid eggs, and hatched young. This particular male didn't seem to have gotten the memo, though. Once on his stump, he began to broadcast his availability by "booming," a process where the male inflates the air sacks in his neck and then lets the air out, creating a boom that echoes for a mile or so through the forest. I kinda felt sorry for the guy—he lost at love and didn't know when to quit. While he was busily booming, we set up, because we weren't going to pass up this opportunity. He was in great shape and displaying.

The bad thing was, we were on the wrong light side of him. Though he was in deep shade, he still had a shadow side, making photography not possible. He was a dark gray-blue blob in a sea of green—not at all attractive. Dusky grouse have a reputation for being pretty tame, or as most say: dumb. As in, you can literally walk up to them and hit them on the head with a stick (in the movie *Jeremiah Johnson*, you see them kill one by throwing a rock—totally probable!). Though this was my first encounter with one, I'd read about them, so I figured we'd test the legend. In a short time, and without a glance from him, we walked completely around the grouse and set up to shoot on the front, lit side. Things were looking up.

Once on the lit side of the grouse, we eased up to get the frame filler we wanted. It sounds like a whole lot more drama than it really was. We just walked up slowly, put the tripods down, and framed the grouse. Without any hesitation, once in the viewfinder, I fired

What's a quick way of learning about the biology of a new species you want to photograph? Watch a TV program on them. Keep in mind that some of what you're seeing is staged, but basic biology and movement you pick up can be invaluable your first time out.

off a couple of frames. It's that old adage of breaking the jinx (the jinx being where you've never photographed a species before, so you get a shot to show you've got it, and then can settle down and make real images). I then started to look at the grouse in the light and my mind started down a path that it still travels to this day.

It all started with the question, "What's my subject?" You might say it's the grouse, but that's not it. My mind quickly added, "What's the light on my subject and what's it saying?" I'd been at this photography thing for over a decade and now, with this subject, my mind asks me these questions? I didn't think about metering, I hadn't gone further than to ask where my mind's eye was going. It was stuck on: What is the very basic, but most vital, question a photographer should be asking? All I remember now is the panic sirens going off in my head with the resounding answer, "Hell if I know" flashing across my mind. Why had those questions popped up now?

I remember it like it was yesterday, because I didn't have the answers, and the photographs show that. In the midst of these questions, the light started to slowly change. The shadowy light falling on the grouse was replaced by a shaft of light coming through the forest canopy and easing across the forest floor to the grouse. And then, almost by design, a beam of light fell on just his head. One, two, and then three rolls of film were soon exposed and in the shot pocket of the vest. Then, as quickly as the light came, it left. The grouse seemed to know that shaft of light was coming, and was going to shine on that very spot, because as soon as the sun left, he stopped performing. He rearranged his feathers, looked left and then right, and proceeded to hop down from his stage and strut back down the ravine.

After that little display of wildlife and light, I was pretty darn ecstatic! The questions were

now replaced with the memory of what I thought I had photographed (a whole lot better than the actual photograph. Ever have that happen to you?). The whole event played over and over again in my mind like some *Monday Night Football* highlight. How lucky we were to have come upon this grouse not only displaying, but being in the right place when that shaft of light hit him. Oh, we were feeling mighty full of ourselves for pulling that one off. With the gear back in the Suburban, we continued up the mountain, the vehicle abuzz with the photo op we just shared.

Ten days later, the light table glowed with stacks of white boxes piled up on the To Be Edited side. Slowly, roll after roll goes by, and the piles of edited slides begin to build. I look for sharpness, and if it's there, I put the slide down in its correct pile and move on to the next slide. I get to the roll that's the start of the grouse. I move through the images taken in full shade in great anticipation of those

Dusky grouse in shaft of light. Photo captured by Nikon F4e & Nikkor 800mm f/5.6 lens on Fuji 100.

shot in that magical beam of light. I can't get through them fast enough. Then the first ones come under the loupe. I put the loupe down, the stack of slides down, and just shake my head.

What the hell went wrong? Did those stupid questions going through my mind distract me from what I was doing? Or did they change the way I was seeing? Whatever the case, the photos under the loupe didn't match what I saw or remembered. I was totally bummed—pissed off actually—that I had messed up a golden opportunity and came back basically empty handed. (Of course, it's just a photograph and, with or without them, the sun does rise tomorrow. That was a long and hard lesson to learn, too.)

The photographs of the grouse were on my mind for quite some time. They actually appeared in my first book on wildlife photography under the heading of making the subject pop. I'm a sore loser and rather than admit I screwed up, I put a new twist to the images trying to cover the moment up in my mind. It didn't work, as those questions (What's my subject? What's the light on my subject and what's it saying?) reverberated in my mind for a long time. And with time, other questions replaced some of them. I don't remember the moment the answers came to me, but they finally did come and the answers were the same. A single word for both: light!

> ◊ ...it's just a photograph and, with or without them, the sun does rise tomorrow. ◊

The quest for knowledge took me from California to the north. There were pieces of the biological puzzle missing in my home state that I hoped to find heading north to more unspoiled lands. I first went to Montana for grizzly bears in Glacier National Park. It took only a heartbeat for us to fall in love with the land and the people during our first camping trip to Big Sky country. While we didn't find any griz on our first trip, we found a whole lot more we didn't know even existed. The camera didn't have much rest. There is so much to see, learn, and explore in this secluded part of our country. And as it typically is with photography, I went looking for one thing and came back with something much bigger. I came back looking for light!

> *I can't say this enough, give yourself time to learn and grow!*

I Thought I Knew What I Was Looking For

Yup, I went to Montana looking for photographs of critters and came back with a question that opened up all sorts of new thoughts and ideas.

The subject wasn't the grouse, wasn't its performance, and wasn't even its eye (which has to be sharp), but rather, it was that dapple of light that is lighting its comb (the orange eyebrow). That bit of color—the brightest element in the photograph. Because it's what draws the eye into the grouse. If I had correctly answered the question of what the subject was at the time I took the photograph, I wouldn't have included that bright mass in the lower-left corner or the one in the upper right. They visually compete with that orange comb. I would have moved my butt and used the narrow angle of view of the 800mm lens to exclude those elements so only one element—the subject—would have visually popped in the frame. But I didn't do that, so I didn't come back with the photograph, only a giant question—an important one that goes through my mind every time I put the camera to my eye. "What is the subject?"

Photographers trip through life looking at the world a little bit differently than most folks. As my good friend Joe McNally likes to remind us, bankers, lawyers, and taxi drivers don't leave their homes and look out and wonder if they are going to have the light they need to work that day. Only photographers do that. And while the overall light of the day does affect us and our photography, I suggest it's on an even smaller scale that light starts to wind the film of our imagination. We travel along and all of a sudden we stop and think

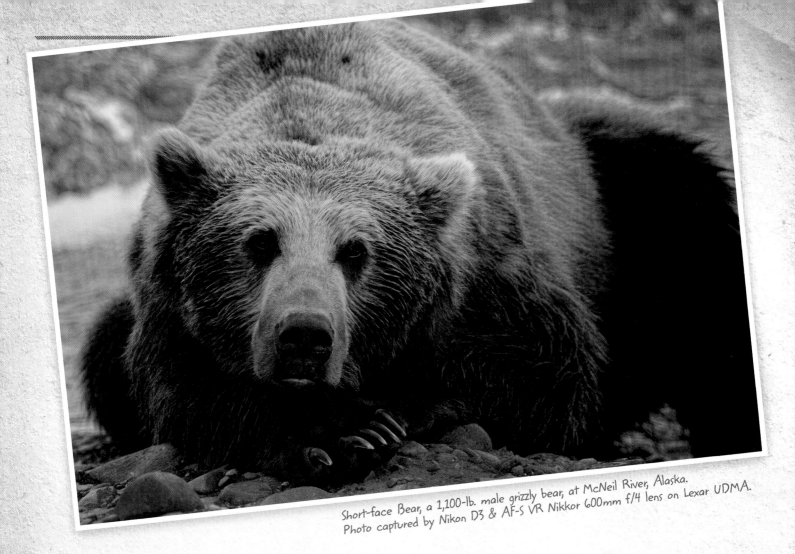

Short-face Bear, a 1,100-lb. male grizzly bear, at McNeil River, Alaska.
Photo captured by Nikon D3 & AF-S VR Nikkor 600mm f/4 lens on Lexar UDMA.

there's a photograph there. We put our camera with the right lens to our eye, the view through the viewfinder narrowing down our vision, only to say to ourselves quite often, "What was I thinking? I don't see anything there." But, yet, it is there, waiting for us.

Wildlife and landscape photographers have this problem even more so. We travel along until something grabs our visual interest, only to make us halt, think about it, play with lenses, and all the time the scene changes from the first magical moment that made us stop in the first place to when we often no longer see that magic. And what was it that grabbed us, made us stop, think there was a

photograph there? It was light, but not just any old light. It was something special in the way the light played with the land or critter that grabbed us at a subconscious level. It grabbed the mind's eye.

> Whenever you're told or you read that something is impossible when it comes to wildlife (photography, too, for that matter), realize that it's very possible. There's nothing that is impossible, except rising from the dead.

MOOSE PETERSON GALLERY SERIES

God beams & supercell thunderstorm over Oklahoma. Photo captured by
Nikon D3 & AF-S Nikkor 24—70mm f/2.8 lens on Lexar UDMA.

There's this joke floating around out there in the world about me and stumps and twigs (you can substitute dry grass stalks here, as well). Sadly, it's true, whatever version of it you've heard. When photographers start out, no matter who you are (which includes me), stumps, branches, and twigs grab our attention and photographs are made of them. While there are some classic stump and twig photos done by old B&W masters, what's created by photographers just starting out are just stump and twig photos. They suck!

Having had to critique such photography for 20-some odd years, I have more "nice" stump and twig comments than you can imagine. Every time I see one of these photos, I ask with all sincerity what the photographer saw. Of course, they instantly turn pale, and sweat pours out as they think they're going to get flamed for a crappy photo (they are crappy), but I really want to know. It's a universal thing: beginning photographers photograph stumps and twigs. Why?

Part of a forest that is submerged in a frozen Quake Lake in Montana. Photo captured by Nikon D3X & AF-S Nikkor 70–200mm f/2.8 VR II lens on Lexar UDMA.

I recently did private tutoring with a photographer who wants to become a landscape photographer (you don't just become one, you have to love to be one—it's a love affair with the land). With that in mind, we went to a locale that just screams landscapes not far from

If you look at the photographs in this book, from the first page to the last, you'll see a progression in every aspect of my photography. That's how it works, and if you were able to compare images I'll take 10 years from now to today's images, you'd see that progression continue. That's how I know I'm on the right track!

our home. It's home to what us locals call the "Dead Forest"—trees killed by CO_2 from a volcano. And just like a moth drawn to a flame, the photographer walked past a whole bunch of great photos and headed straight for, you guessed it, a stump near the lakeshore's edge.

We walked a quarter mile to get to this stump. While I knew where he was going and why, the photographer didn't. We walked up to the stump (an ugly sucker no less, not even part of the Dead Forest), the photographer put a 12–24mm lens on his camera, and he began to click. He showed me his LCD and said, "What do you think?" I said it was a stump in the sand with a lake way in the background. He kinda looked shocked at me. He liked his stump, it was a classic in the making. So, like I always do, I asked what it was about it he liked so much that he walked a quarter of a mile, in a beeline, for this stump, passing up all those other photographs. He started to list these

attributes, which while they might be true, didn't add up to a photograph. But he did start to help me form the answer to the stump-and-twig question that has plagued me for decades.

I think the universal attraction to stump-and-twig photos in the beginning is the subconscious mind latching onto the very, very, very subtle play of lights and darks in them. I'm not talking texture, or highlights and shadows, but just tones. It's a play of light that subconsciously we ingest, and consciously we force into a photograph when there is none. We say the subject is the stump or the twig, but in reality that's not the subject. It's the first recognition of light as photographers, and how it attracts the mind's eye, but we just don't know it.

Look at the grouse photos again. What are they? They're photos of a stump and a twig with a bird attached. The photo with no direct light is so much stronger than the one with the magical beam. Why is that? Ah, now we're getting somewhere when that question is asked, and more importantly, answered. Now, guess what? To get to that answer, we've got to do a little more thinking, asking of questions, and looking inside our own minds and hearts. And you know what? When you find the answer, all your exposure problems will disappear.

A real common question I hear is, "Do you use a polarizer when photographing critters?" Nope, sure don't. The vast majority of the time, I simply can't afford the loss of the two stops of light the polarizer sucks up.

One of my favorite iPhone apps? Weather Radar. This app shows you where clouds are, if any, and if they are heading in your direction. Don't have to know weather to make this sucker pay for its $2.99 price.

Where Does One Start?

Clouds are low on the horizon in the east as the sun makes its daily arrival. We're in the beautiful Black Hills of South Dakota, in Custer State Park—Disney World for wildlife photographers. We come around a bend and take the curve left that brings us smack up with a pronghorn buck standing not too far off the road. Looking at the light coming through the clouds, seeing how the clouds are blowing, I step out of the truck with the 200–400mm f/4 VR in hand and slowly walk up to the pronghorn. My approach is a beeline with one thing in mind. It's not the pronghorn I'm after, it's the light I predict will soon hit the buck.

My father, who sat in the nose of a B-29 as a navigator/bombardier and had me always looking up at the heavens, instilled in me a skill that is so important to my photography: weather prediction. It's something I can do, and do pretty darn well. I'm not talking about 67%-chance-of-rain-today-in-Chicago weather prediction. I'm talking about looking at the heavens and, in my mind, seeing where the light is going to be and when. I knew that the pronghorn was going to be in a magical beam, so closer I went. Before the light struck, I had stopped where I wanted to be and waited (the light level was ISO 200 at 1/40 of a second). A couple of heartbeats later, the light emerged, lit the ridgeline behind the pronghorn, barely grazed its side, and just kissed the grasses in front of it. Click!

In the 10 years since the grouse fiasco, I had come to say what the subject was both in my mind and in the photograph. That's where you start learning light, by understanding what the subject in your photograph is. In the photograph on the opposite page, you probably think the subject is the pronghorn. Fooled you! I didn't wait for the pronghorn. I didn't position myself for the pronghorn, I didn't select the lens for the pronghorn. I stopped, positioned, and waited for the light, because that's the subject. The pronghorn is merely the surface the light plays on to show itself off. If I was really smart, I would've taken a photo before the light kissed the scene, so you could see the difference. As it is, you'll have to look at the photograph and remove the light in your mind (which is a great exercise to do with any photograph to learn to see light).

What does the light do for us? Why do I think it's the subject and not the buck? The light does a number of things here, all arranged by where I physically placed myself, the pronghorn, and the lens I selected. The light in the foreground on the grass is the first place the eye stops in the photo, by a split-second, before going to the white on the prong. The white on the prong comes to life *only* because of the kiss of light that's hitting it. Then the eye moves through the photograph to the light on the ridgeline. Then the eye moves to the darkness in the background, which has two shades—the dividing line between the shades is a diagonal line that takes the eye where? Back down to the pronghorn to start the visual journey all over again. Yep, that was all arranged by yours truly with a prediction of where the light (the subject) would strike the pronghorn, and all contained for the eye to see using the 200–400mm lens (at 320mm, f/8, 1/40 of a second, handheld). You can do the same thing with time, training your eye and mind to see and feel the light.

Pronghorn antelope buck. Photo captured by Nikon D2X & AF-S VR Zoom-Nikkor 200–400mm f/4 lens with TC-17E II on Lexar digital film.

Keep in mind, I'm not thinking all of this when I look through the viewfinder. Rather, I'm feeling it—the passion for the play of light on the stage of life. What if we removed one element? What happens to the image? What if we take the light off the foreground or the pronghorn? The light falling on the pronghorn and grass at its feet would have the same tonality as the background. Other than color contrast (which we'll talk about shortly), the prong would meld with the background. Remove the light from the ridge, and the grass plain would not have any visual depth—it would look like some flat piece of earth rather than being a ridge. Remove the two-tone background and the visual depth again would be eliminated, as well as the line bringing the eye back to the foreground.

Shooting with a shorter lens would bring in more elements, so the eye would wander and possibly not come back to the subject. Shoot with a tighter lens, and the play between the elements would be truncated and the visual depth lost. So, for this moment in time, with these elements, this is the best that could be done to make an image. And all the decisions of lens, physical placement, DOF, and placement of the pronghorn—how all the elements were arranged (what most call composition)—were determined by the light!

> Before proceeding further, just a little reminder: I do not have all the answers. I am not an expert on this stuff. I have, at this point in my photographic life, the answers that work for *my* photography *right now*. I have no clue if these answers will work tomorrow or next year, but I have them for now, which permits me to venture forward with confidence and an open mind. It's totally up to you to use or discard what I've learned, to incorporate some, none, or all of it in your own photography.

This applies to *any* type of photography. This basic concept can be learned by anyone wanting to open their mind up to how the

> Can you make a living as a wildlife photographer? I firmly believe you can—as long as you're doing it for passion and not pay.

visual mind works and how we take in information. It won't happen overnight. We chase, console, romance, and curse light our entire photographic career. It's a lifetime pursuit, and I can't think of any better. But you're probably asking where do you start this chase, this romance with light? That's a very good question.

You start by looking at photographs. Look at your own and look at other photographers' photos. Look for images *you* like. Once you find them, ask yourself, "Why do I like this photograph?" Then start to analyze (I'd rather say "feel") the elements that grab *your* attention. Once that's done, back engineer the photograph to understand how the photographer brought them to your attention. I still do that to this day, because I know that when I recognize those elements I like in other photographs, I start seeing and recognizing them in the viewfinder. (*Note:* Not once was the word Photoshop used—this is all at-the-camera craft, which is a must to be successful!)

Another great place to learn this is in the old classic B&W movies. You look at how those are lit, how they tell the story with the total removal of color (which modern movies rely on heavily), and you will start—start—to understand *the* most important element in any photograph—light!

But, as you might guess, there is so much more to light than just this. Hell, I don't think I've even scratched the surface of all there is to understand about light at this point in my career, but I also think that's cool. Most photographers don't think about light in this way either, so you might have to reread this a couple of times for it to sink in a little. You're probably looking for a histogram lesson or something by now, or perhaps the perfect f-stop. You are going to be so disappointed; I'm not going there. Light is so much more than that.

MOOSE PETERSON GALLERY SERIES

Along the U.S.—Canada border in Montana. Photo captured by Nikon D3X & AF-S VR Zoom-Nikkor 200—400mm f/4 lens on Lexar UDMA.

What Is That Magic Mix?

The last thing the world needs is another perfectly exposed photograph. What the world needs is more photographs with passion. Getting to that end is easier said than done. It requires becoming intimate with light and thinking of it as much more than just a unit to measure. It takes time to get where I think photographers need to get to be pulling heartstrings with their images. Let's start moving you in that direction when it comes to light.

The end point we are working toward is nothing short of total manipulation of the image, so the viewer of your photograph sees exactly what, when, and how you want them to see. The viewer has no option but to see what you want them to see (don't confuse this with making a great image, it's only the beginning of that process). The manipulation we're going to do is all at the point of capture. You need to get so proficient at this that you don't even think about it, that it just comes to be in your viewfinder.

You can't forget that, in wildlife photography, anything that takes your mind away from the subject will cost you the photograph at some point. The magic mix in a great photo has to do with light, exposure, the mind's eye, and taking the viewer through your photograph using that mix, all without thinking about it. You need to forget it and have it just become who you are as a photographer. And you thought f-stop and shutter speed were your only concern. Ha!

The mind's eye is our subconscious Geiger counter, searching out light, and it's just not looking for any old light, oh no! It's funny, with all the cultural attributes triggering how we perceive the world and form opinions, that this one thing seems pretty darn universal. The first thing the mind's eye seeks out is the lightest and brightest element in a photograph (especially if high in the frame). You don't have to tell it to do so—you can't even stop it from doing so—it's just going to do it. Until you train yourself to bring that subconscious trait forward, you won't realize that's what your mind is doing. It's what the mind of the viewer of your photograph is going to do. Why is that piece of physiology important to our photography and light?

I've already mentioned and illustrated that my style of photography is anything but eyeball. The world is a stage, and I arrange the players to all have a role in that play on that stage in my photographs. The star of that stage is in the limelight, which is totally different

Least chipmunk. Photo captured by Nikon D3X & AF–S VR Nikkor 600mm f/4 lens with TC-17E II on Lexar UDMA.

than being the largest element in the frame. I'm smacking the viewer right between the eyes with the subject without demanding it with size, but instead using this one known fact about our perception, the mind's eye, and combining it with other traits to totally control the viewer's mind's eye. It loves light and bright!

You might think we're talking composition here. We are and we're not, since I'm not qualified to talk composition (I'm a simple mountain boy). What we are talking about is using light, which we know the mind's eye is looking for, and combining it with other known traits to get the viewer's attention and get them to look at our image by simply giving their mind's eye what it craves. This is total manipulation!

One of my all-time favorite images is this one of three musk oxen in Alaska (I wish it was tack sharp). It was taken in April on the Haul Road, and it was –30° at the time the click was made. We'd been photographing the herd for a couple of days, so we all felt comfortable (the oxen and I) being close physically. I was perhaps 25–30' away from them, shooting with an AF-S Nikkor 400mm f/2.8 lens (yes, I was standing out in the weather and snow, with no blind or heater). Musk ox, unless they are on the run, don't really move much. I saw this image a ways out, and just walked up to them to take it.

Even though this photograph was taken in complete Arctic coastal plain overcast (really soupy stuff), the color contrast makes the mind's

Musk ox. Photo captured by Nikon D1H
& AF-S Nikkor 400mm f/2.8 lens with TC-14E II on Lexar digital film.

Greater sandhill cranes in the Bosque del Apache National Wildlife Refuge. Photo captured by Nikon D3S & AF–S VR Nikkor 600mm f/4 lens with TC-17E II on Lexar UDMA.

What ISO do I shoot at? I'm always in the basement: ISO 100 with the D3X, ISO 200 with D3S. Do I crank it up in low-light photography? Nope. Getting a sharp image of noise serves no purpose. There are times when just watching life is more beneficial than trying to photograph it.

eye go one place. At that one place is another element that humans (doesn't apply to green men from Mars) desperately want to make contact with visually with wildlife: the eye. The only eye you can really see is the bull on the left. Whether you realize it or not, your eye goes right there, first thing.

Then, the curve of the horn, a bright element against the dark coat, takes the eye to the next bright element, and that bright element leads the eye to the next. And on this journey around and around in

> *Do you need to prep your gear, or use special gear, for working in extreme cold? I'm only talking camera gear here, but the answer is no. In the old days (prior to digital), you needed to have your gear prepped for shooting in colder than freezing. I've shot down to −42° with off-the-shelf digital gear and had no problem.*

Warning: Boring Content…

You should be forewarned: I don't do or think about exposure like other photographers. Do you know what exposure is for in photography? Do you know how to get there? I bet you think it's some silly thing that has to do with protecting highlights and opening up shadows. Or perhaps it has to do with numbers like 247 or 255 or, worse yet, a graph showing a nice valley or things piled up on one side or the other. Nah, that's all poppykash! A monkey can do that stuff (and has in a recent study).

The subtleties of exposure are our main tool for communicating emotions in our photographs—the emotion provoked by light. Yeah, exposure = emotion. How does that knowledge help your photography (because you can't graph that)? Even more, how does that help grab the mind's eye and tell your visual story? There isn't one aspect of photography that isn't intertwined with another, which is why time is such an important factor in the great image. And nothing takes more time than learning to use exposure to convey and evoke emotions.

We need to start by understanding light and how it relates to our digital camera. When I refer to light at this point, it's that coming from the sun. Flash also emits light, but we're not there yet, because we have to understand our principal light source first: the sun. We have a horrible mix to deal with in understanding light for exposure. A Stanford study says our vision can differentiate up to 27 stops of light, and in one glance, up to 15 stops (it's amazing how little is known about our vision). Whatever the number, it's vastly more than our cameras. That's the first hurdle to overcome.

The digital camera can faithfully record a five-stop range of light, and most of our printing devices like fewer. There's a huge void between what we can see and what the camera can capture. Somewhere in there, you've got to see and feel the light, so the viewer of your photograph can, as well. That is the monumental task we face every time we go click.

the photograph, you see noses, fogged breath, hair and texture, and, well, you get a sense of what it is to be a musk ox in April on the Arctic coastal plain.

Don't think for a moment that while I was walking up to make this photograph, I was thinking all that stuff. Heck no! It just is. At the time this photograph was taken, I was well over the trauma of the dusky grouse, and had learned my lessons. Arranging all the elements in the viewfinder is now second nature—it doesn't consciously come into play. If you look at my earlier images, you can see it in action, though then it was a happy accident. Probably the home I was raised in—with all the arts and crafts, and a sister who was an amazing artist sharing with me how she saw—played a part in how I saw then and see now. Where those things came together before by accident, now it is by design. But the point is that no matter how you get there, giving the mind's eye what it wants to see first—that light or bright—is a surefire way to get its attention.

> *Nothing takes more time than learning to use exposure to convey and evoke emotions.*

What then is the magical mix? A human looking at your photograph and the mind's eye getting what it wants is the magical mix. Light and bright are a great start, but not the only option we have in visual manipulation, as you'll see as we combine more and more to totally screw with the mind, so it sees only what we want to present it in our photographs. And, in doing so, we grab heartstrings.

My son, Jake, and I were up in Alaska in the summer of 2007 to work on a groundbreaking project involving the collared pika. One afternoon, we went for a drive along the Denali Highway, out in the middle of nowhere, to see what other critters were about. It was a typical Alaska summer day, where the rain had come and gone, leaving the air smelling sweet, and critters were coming out seeking the warmth of the sun. We'd photographed bald eagles and marmots, shorebirds and wildflowers. The sun set around 10:00 p.m., with sunset lasting an hour or more. There were some cool clouds off in the west, so we decided to pull out the stove, heat up some water so we could make some dinner, and just watch the light to see what would happen.

Alaska Range storm. Photo captured by Nikon D2Xs & AF-S VR Nikkor 70–200mm f/2.8 lens on Lexar digital film.

Almost like clockwork, the light started to dance on the Alaska Range. Visually, the eye could see the God beams streaming down, incredibly dramatic! If you just threw your camera up and shot, the camera would bring back the image, but it would not bring back the drama. Why? Looking at the numbers, which is all the camera can do, it doesn't realize that the mountains in the foreground need to be deep black to provide a foundation for the light streaming down and playing against them. It also doesn't see the subtle differences in the God beams themselves, the individual beams and groups of beams that create the curtain of light that so excited our vision just looking at them.

Not that the meter is being fooled, it just can't see or feel that—or doesn't understand how to expose to bring back that—visual drama. But we can. Making the shot then was real simple: shooting matrix metering, simply dial in –1 stop and shoot. That's all it took to make the image, but getting you to the point where you just know to dial in –1 stop is where we are going with all of this.

"How'd you know to dial in –1?" is the question on the table. It's a very valid one, and one that is hard to answer. My usual cop-out is simply: I've been doing it for 30 years. And while that is a true and accurate answer, really what is happening is that after 30 years, I have a feel for the light that permits me to express that with an exposure value so you can feel it. It's that dusky grouse

photo, and the musk ox photo, and the other million images coming together at that moment, taking what my eyes see, translating that into what the mind's eye needs to see, and then translating that into what the camera needs.

The range of light the digital camera can render in one click is five stops. Five stops—do you know what that means on both a technical, and more important, visual level? That's the next hurdle you must jump. Technically, five stops mean that if you were to take a spot meter reading of the scene (and I do not recommend you do this. I never do) with either the shutter speed or f-stop being constant, there would be only five stops difference between the shadows and the highlights. So, if you have a constant f-stop of f/4, using that spot meter to read the darkest shadows, they might be 1/15 and the brightest highlights 1/500. That's a five-stop range. The digital camera can hold detail for both the shadows and highlights within that range in one click.

What does that mean? This is really important, I feel, since my photography is all about subtleties. Holding detail means you can see information in either or both the highlights and shadows. In the musk ox photo, you can distinguish the hairs in the darkest part of the photo; in the highlights, you can also see the individual hairs. That's seeing the detail in the highlights and shadows. That information you can or cannot see is what you depend on in telling your visual story, and its being brought out or not by light.

Take the photo on the next page of the great egret preening. This is a lucky shot taken at North Beach at Fort DeSoto, in the mouth of Tampa Bay in Florida. This great egret was preening in a location where the sun would only stream down as the branches overhead

No matter what you read in this book, keep in mind that you need to embrace only those things that work for your own photography. Everything else, say bye-bye to!

Great egret preening. Photo captured by Nikon D3 & AF-S VR Nikkor 600mm f/4 lens with TC-14E II on Lexar UDMA.

blew in the wind. The light was filtered by the branches, so the range of light on the egret itself is less than three stops. We can see all the feathers, and details in those feathers, in the shadows and the highlights. By moving the 600mm to the right ever so slightly, I could include the distant tree trunks on the left of the frame and, since they are in shadow, even though my eye could see them clearly, they were on the dark end of the light scale. They turned out dark, because the white of the egret filled the frame. You can't see detail in the trunks because of a combination of exposure and DOF. This means you're pushing the five-stop range and sacrificing shadow detail while retaining highlight detail.

You can see this dramatic range of light from the comfort of your favorite chair. Without thinking about it, put your camera to your eye and make a click of a wall with a window. Before you look at your LCD, look at that wall and window. You can see the wall, you can see the things hanging on it, you can see things on the floor in front of it. You can also see out the window, and whatever is outside that window—a home, tree, shrub, pool, whatever. You can see all of that without doing anything special. Now look at your LCD. What can you see there? You can either see the wall or you can see out the window. But in that one click, you cannot see it all. It most definitely doesn't match what you see with your eyes. That's a range of light greater than five stops, which loses detail in either the highlights or shadows.

If you head to the extreme, outside the five-stop range that the camera can hold in one click, what are the consequences? The photo of the lesser sandhill cranes on the Platte River is a good example of this. The range of light here is beyond 11 stops, well beyond what the camera can capture in one click. You don't need a meter to tell you this. Looking at the scene, it's apparent.

The typical thought process here is to guard your highlights and sacrifice your shadows. If we were to go by that mainstream thought, we would see the sun and nothing else in the photograph. You might have a hint of the sun's beam in the river, but the main focus of this gathering of cranes would be gone, lost in the shadows. Detail in this case is lost in both the highlight (the sun) and the shadow (the cranes) and yet, the image works. Why? The mind, it does wonderful things like fill in detail when there is none, when it's prodded to do so by our visual story. And how do you expose in this situation? It was real simple for me: I dialed in –1 to make sure the blacks went black and I shot.

We need to take a step back and look at some of the mechanics of exposure before moving on. Let's start with the fact that I depend on aperture priority mode. With depth of field being such a cornerstone of photography, being in control of the aperture is a must. This means that when in aperture priority, we select the aperture we want for DOF, and the camera selects the correct shutter speed based on that aperture. Here's the main aspect of this that folks have lost sight of: the shutter speeds are stepless. That means that, even though the camera is reporting to you that you're shooting at 1/125 of a second, it could actually be 1/111, or 1/141, or any other shutter

Lesser sandhill cranes on the Platte River, Nebraska. Photo captured by Nikon D3 & AF–S VR Nikkor 600mm f/4 lens on Lexar UDMA.

The original Moose Cam in action. Running two cameras at once was possible by relying on matrix metering and aperture priority mode, so I'm concentrating on just the subject. Photo by Jeff Cable.

With DSLRs now having video capability, keep in mind there are times when still photography just doesn't work, and video might. This can add a whole new dimension to both your photography and your visual communication.

speed the camera requires to make the correct exposure based on the f-stop *you* selected.

This not only provides you with a much more accurate shutter speed than you can dial in manually, but also gets to that shutter speed one hell of a lot faster than you can physically. And, just as important, it's one less thing you have to think about, so you can concentrate on the subject. (When you dial in exposure compensation while in aperture priority mode, the camera changes the shutter speed, still in stepless fashion, to bias the exposure.)

You're probably thinking something like, "You trust your meter?!" The meter is like a best friend who loves—just loves—to give you advice, whether you asked for it or not. It's up to *you* to decide if you're going to go on that advice or not. I usually do. The advice the D3 meter is providing is based on a number of things, the biggest one is a 30,000-image database of information compiled from a whole bunch of photographers such as myself, Joe McNally, Dave Black, and others who I not only trust, but think are great photographers. That's pretty damn good free advice!

The camera's meter evaluates the scene, runs those numbers against the database, and provides its advice based on that data. (Did you know the camera knows where the sky is in the scene, whether the camera is horizontal or vertical? Pretty cool!) What still amazes me is the speed with which all of this is accomplished. It makes wildlife photography a snap compared to when I started out.

It's pretty darn cool stuff, but it's still just advice. It's up to you to say yea or nay. That's when you've got to "feel" the light and exposure, and think through how the mind's eye will zero in on what you're saying visually about the subject. Use exposure to communicate and evoke emotion and your photography will shoot to a whole new level.

Shooting a landscape, you have a little more time to think about this. Many start to chimp (look at their LCD after every shot—a bad habit in my opinion), hoping some higher source will solve the problem and come up with the answer. With wildlife in the view-

Osprey in flight.
Photo captured by
Nikon D3X &
AF—S VR Nikkor
600mm f/4 lens
with TC-14E II
on Lexar UDMA.

finder, though, or any type of action, this isn't an option, because often in a heartbeat, the opportunity to make the photograph has fled. It's either now or never, which leaves no room for second-guessing (don't even get me started on bracketing). In those instances, whom are you going to trust to make the exposure?

"Seeing" and "feeling" light is such a challenge, yet so essential. Getting to the point where you point your lens at that Alaskan Range and know how much exposure compensation to dial in takes many clicks over the years, but shooting digital cuts down the learning curve and time by lifetimes if you use it by thinking. Just looking at your own digital images, looking at the metadata, and learning from what you did in the past can greatly impact the clicks you make

tomorrow. Those images you like, how did you deal with the expo-sure? Those images you don't like, how did you expose for them? Remember both, so you can repeat the successes and avoid the failures (which are still a learning opportunity, so don't be afraid of failure).

You have a feature on your camera (available on nearly all cameras these days) called highlight warning. I affectionately call it blinkies, because that's what they do. Remember, we have a five-stop range of light that we can capture with one click (HDR doesn't work for wildlife). When you have more than five stops of light—when you have 5.1 stops of light—you're outside the range of the camera's single-click ability to hold detail in highlights and shadows.





Sandwich tern. Photo captured by Nikon D3S & AF-S VR Nikkor 600mm f/4 lens with TC-17E II on Lexar UDMA.

sake. It's amazing that your digital camera can not only teach you about the range of light, but also predict where the mind's eye is going to go in your photograph and visually show that to you. Wow!

Let's say you're photographing that great egret, an all-white bird. What if you see a couple of small blinkies on its body? Is that a good or a bad thing? The knowledge and sight of blinkies doesn't mean all is lost. In this case, the subject is all white. Is the loss of some detail in that white messing with what you're communicating visually? Is it taking the mind's eye somewhere you don't want it to? I don't have that answer, you'll have to answer those questions when you have it in the viewfinder (and on the LCD).

With the blinkies turned on, those highlight areas outside the five-stop range literally blink at you—black, then white. You have to use your LCD (a good reason to look at it), and have the highlight warning turned on in your menus and active on your LCD to see them. When trying to learn light, blinkies will teach you instantly when you are outside that five-stop range. But they can help your photography even more! They show you exactly where in your photograph you have lost that highlight information. That's big-time important!

Since the mind's eye craves light and bright first, if you look at those blinkies as not only a possible exposure problem (because blinkies are not necessarily bad), but as something the mind's eye is guaranteed to latch onto, you can make the decision if they are good or bad, not for exposure's sake, but visual communication's

Half the battle is knowing what question to ask. Your camera can help you there with blinkies. Losing some detail in a white subject I don't think is the end of the world, though, so personally, more than likely, I wouldn't worry about a couple of small blinkies. You have to make that call, but at least you now have a tool to use and a thought process to employ to make an informed decision. Just remember in this process: don't forget to ask what the subject is.

Here's another way to think about it (because you do have to think about it): If you write a paragraph of words and then, from that paragraph, take away 20% of the words near the beginning, would someone understand what you're trying to say? Now, imagine your photograph between the X and Y axes is 100%. If you don't have information in 20% of that top area (like blown-out clouds),

because it's lost information (or anything else visually distracting) and the blinkies are going wild, will someone understand what you're trying to say visually in your photograph? Don't lose sight of the fact that we are visual communicators and one of our key methods of communicating visually is with light!

When you start thinking about light (and levels of light in your photo that you control via exposure) in this way, you start to feel it in your photos. In the image of the white ibis, if you look at the butts of some of them (bird perverts), you'll notice there is *no* detail, it's just paper white. When I did a visual check on the LCD,

because white subjects in the shade are not a great light situation, I could see blinkies. Yet, the photo is in the book and the image is a favorite. Why?

The mangrove forest the ibis are standing in front of is a real busy one—*real* busy. Those roots go every which way and instantly grab the eye's attention. Standing in the water and looking through the viewfinder, they came glaring in. But where are those roots in the photograph? They are in the shade and lost because of the exposure range. What's the subject? (There's that question again.) The subject is the line of ibis and their reflection; white ibis in mixed light. It's not one individual ibis.

White ibis. Photo captured by Nikon D3 & AF–S VR Nikkor 600mm f/4 lens with TC-14E II on Lexar UDMA.

What's the light range between the background, the roots, and the subject (the ibis in mixed light)—seven, eight, nine, ten stops? How many stops do we know the camera can capture in one click? Five, right. So then, knowing the meter is going to sacrifice the shadows (because of that light and bright thing the mind's eye craves) with that kind of light range, the roots in the shadows will go black, making their busyness disappear literally in the shadows and creating a background that makes the ibis blaze off the page. That's feeling the light and letting it work for our photography. I had my normal –1/2 exposure compensation dialed in.

Normal? What do I mean by "normal" exposure compensation dialed in? How many of you shot film? Do you remember how we would take Kodachrome 64 and rate it at ASA 80? Do you remember why we did that? Because that underexposure of 1/3 of a stop saturated the colors and made the shadows go a little deeper black. For those same reasons and more (like protecting some highlights), the majority of the time I underexpose by 1/2 stop. That's all that was done in this case, but that made those roots a little darker, the red in the bills a little more vibrant, and possibly brought one or two of the blinking pixels back within five stops.

Light, mind's eye, exposure—they're all so intertwined I don't believe they can be separated. And when you think of these as ways of expressing emotions, I don't think they should be separated. For some, this "touchy-feely" approach to combining shutter speeds and apertures just won't work when it comes to making an exposure (just gotta have those numbers). I understand that, but since I don't use that method, I can't begin to address that side of exposure. As I said before, the last thing the world needs is another technically perfect photograph. What it needs are more photographs with passion.

You have to decide if the system you have brings to life the drama you see, and if it does, disregard this conversation. I bet, though, you might find some wiggle room where there is something in my images you would like to incorporate into yours. If that's the case, try feeling the light. The worst that can happen is you delete the photograph, right? And the best thing, your exposure problems disappear!

> The LCD monitor on all of my cameras is set to –1:
> Setup Menu > LCD > Brightness > –1.

Northern sea otter. Photo captured by Nikon D3 & AF-S VR Zoom-Nikkor 200–400mm f/4 lens on Lexar UDMA.

What Was That Three-Stop Stuff with the Egret?

When I'm out photographing wildlife, I look for three stops or less of light. Yep, I don't care that the camera can hold five stops, for wildlife I think that's too much visual information the majority of the time (there are always exceptions). I don't want folks reaching for sunglasses to look at my images. When you start looking at light in that smaller range, you start using other attributes of the mind's eye to lead it through your photograph. And at the same time, in lowering the range, you make light and bright even more powerful. You can play even more visual games using small subtleties that, when all added up, make for big-time drama, grabbing the viewer's attention and tugging at their heartstrings.

When you cool down the light and bright component, you can work with it in more subtle ways. This permits you to bring into play the next important mind's-eye sweet spot: sharpness. Sharpness is part of light and exposure and the mind's eye? It most certainly is. It's dang cool to be able to control so much visually with so little effort! It permits you to concentrate on the critter and making the click, leading to a stunning photograph. It really is easier than you think. How else could I do it?

The mind's eye loves sharpness. Want proof? How many out-of-focus images do you keep? How hard do you work to have a sharp image? How many techniques have you seen or read about for sharpening an image in post? Ever hear of anyone recommending an unsharp lens? Do you need any more proof? Of course, nothing beats getting it right, right from the start, which is what this book is all about.

When not competing with light or bright, the eye instantly goes to sharpness like a cruise missile (otherwise it's number two on the list of what the mind's eye goes to). Ain't that cool to know? What's the one thing that has to be sharp in a wildlife photograph (or that of a person)? The eye. Working within three stops of light, the first element in the photograph the viewer will go to then is the eye, and that's exactly what you want. Once a viewer makes eye contact with your subject, they are all yours if the rest of the elements in the photograph support it.

Bison. Photo captured by Nikon D3 & AF–S VR Nikkor 600mm f/4 lens with TC-17E II on Lexar UDMA.

Exposure compensation only works in aperture priority or shutter priority mode. I only shoot in aperture priority mode because I need more control than what one can achieve shooting in manual mode. I achieve that control using exposure compensation.

What do you do with them next, though? How do you continue the visual journey through your image? That's where DOF comes into play (an additional sharpness attribute). Depending on the rest of the story you want to tell, you select the appropriate aperture. That determines the amount or depth of apparent sharpness in your photograph, and where the mind's eye will travel to next. (Sorry, there is no magical single f-stop.)

I mentioned I generally have my exposure compensation set at –1/2 stop for color saturation and deeper shadows. Do you know how most post sharpening works? By adding black pixels along edges. Why? That thin black line tricks the mind into seeing something as sharper when it really isn't. Exposure contrast can perform the same trick. That –1/2 stop tricks the mind into thinking elements in the image are sharper than they really are. You might think that –1/2 is a miracle worker. Well, you ain't seen nothing yet.

Why –1/2 stop and not –1/3? This is strictly a personal thing, but it has to do with the fact that we're working with a five-stop range with the digital camera. For my visual taste, –1/3 stop isn't enough the majority of the time and –2/3 stop is too much. But –1/2 stop works just right for me the majority of the time, so that's why I use it. If you don't know what works best for your photography, do my teddy bear exercise (see Appendix 4), with 1/2 and 1/3 stop increments, and answer for yourself which you like better.

Now, what do we use to grab the viewer's attention if we're not depending on light or bright and sharpness to take the viewer through our photograph and speak to them? Truly, my favorite tool to use is color—in particular, color contrast. Here's where working in three stops or less light really excels (and –1/2 stop plays a big role).

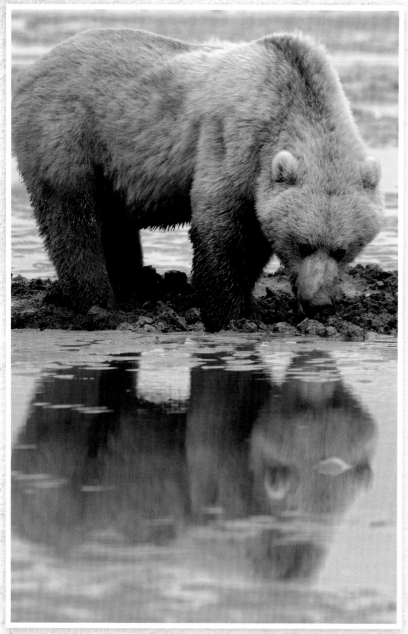

Grizzly bear. Photo captured by Nikon D3 & AF-S VR Nikkor 600mm f/4 lens on Lexar UDMA.

Alaska in the summer is magnificent. There are a couple of things you can count on then, and rain is one of them. Many shooters avoid the rain; I tend to gravitate toward it. Why? The clouds act like giant diffusion flats, knocking down shadows while the moisture pumps up the color. In this environment, the camera has zero metering problems and the colors become even more saturated with –1/2 exposure comp dialed in. Now we can add color contrast and the psychology of color to our arsenal in grabbing heartstrings.

One great reason to head to Alaska in the summer is for bears. The grizzly bear got its name from the grizzled or silver tip hair on its back. Being the part of its pelt that receives the most sunlight, it tends to bleach out, making for a very striking appearance, especially in less than three stops of light. Why? Being lighter colored, as the light levels increase to four and five stops, the hairs burn up and become blinkies. But in three or less stops, you see the golden-grizzled look that is so magnificent and makes them grizzly bears.

A big magnificent male grizzly bear is walking down the McNeil River and coming right at us. There's a light drizzle coming down. The shoreline is polished rock from an ancient glacier's passing, leaving almost no toehold for any plants to take root. It's a highway for the big bad boys to venture up to the falls to fish. A big male, known as Donnie to biologists and visitors alike, is strolling up the highway and right into the lens. There is no direct light on him, it's technically raining, yet look at how he visually pops in the frame (probably less than two stops of light). The light color of his back (light and bright, but it's a shade of brown) takes the eye right to his face. The dark legs (natural fur color) are two vertical lines taking the eyes up to Donnie's facial disk. The meeting of the light-colored back and dark

Donnie the grizzly bear. Photo captured by Nikon D3 & AF–S VR Nikkor 600mm f/4 with TC-17E II on Lexar UDMA.

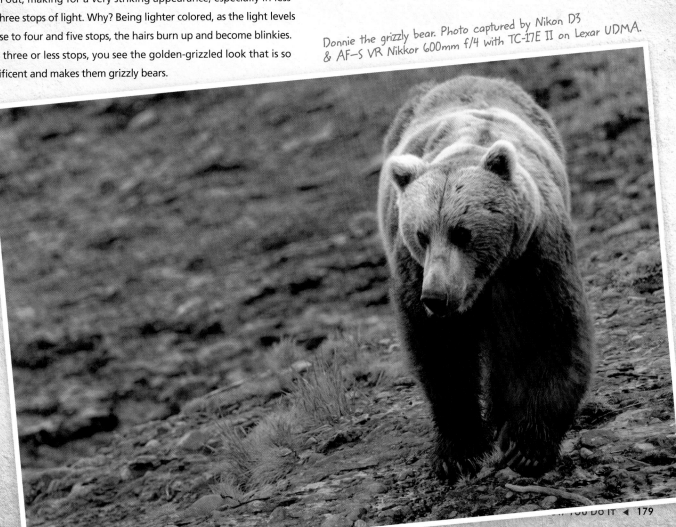

legs takes you to his face. The overall tonality of the bear compared to the background makes him pop out from it. All of these mind-grabbing attributes without five stops of light—not even three.

Take this a step further. Looking at the overall size of Donnie and Donnie's face in the photograph, how much of the photographic real estate does he consume? His body takes perhaps 20% of the entire photograph and his head (which is a big freakin' head!) perhaps only 5% of the total area. Yet, even with this small consumption of space, he dominates the photograph. And what finished it all off? What Jay Maisel perfectly brought to the photographer's attention as being so important: gesture. The slight bend in the left leg gives this giant a slight "teddy bear" look through a simple gesture. If I'd shot in three stops or more of light, that gesture would have been lost—possibly in the shadows—and then the photograph wouldn't have worked.

Another example of this is the earlier photo of the musk ox. If the light hadn't been "flat"—probably not even one stop total range in the light falling on the oxen—I would have had major exposure issues. What makes that photograph work is the play of the white against the brown and all the small shades in between that are naturally found in their fur. Introduce direct light to that and you start losing those subtle shades and the minute detail in the browns.

It's like bald eagles with their white heads and dark brown bodies. I never have understood why photographers prefer blue skies and sun overhead when photographing them. To hold the white in the head, the detail in those hackles, you have to sacrifice the body detail in that kind of light. That's a lot of the

Bald eagle. Photo captured by Nikon D2H & AF-S VR Zoom-Nikkor 200–400mm f/4 lens with TC-14E II on Lexar digital film.

bird's personality thrown away because that is more than five stops of light. Work in three stops and, wow, what you can see in a bald eagle is pretty dang cool.

With smaller critters, light is even more important, and four to five stops really is a deal killer. Small critters like squirrels, chipmunks, prairie dogs, etc., have the "cute" factor working for them. Your first responsibility is to not hurt or destroy that cute factor (which also goes for bear cubs, fawns, and moose calves). Bright light, harsh shadows, these can possibly bring too much reality to the preconceived cute factor, so you lose your viewer. Work in three stops or less and the stark reality fades, cute factor takes over, then all you really have to do is have a sharp image to be successful. Walt Disney took care of the rest for you.

Prairie dogs are killer subjects, moneymakers, and heart stoppers. Why? I don't know. There's just something about these Jabba the Huts of the prairie that grab folks' heartstrings. They are not brightly colored critters, and have no real strong markings—just kinda tan critters often in a tan world. The trick to make them stand out visually is to photograph them in the spring when there are green grasses and their pelts still have their winter, thick, pudgy look.

Black-tailed prairie dog. Photo captured by Nikon D3X & Nikkor AF-S VR 600mm f/4 lens with TC-17E II on Lexar UDMA.

For autofocus (AF) settings, this is what I do: The vast majority of the time, on the D3X/D3S, the Dynamic AF Area is set to 21 (in the Custom Settings menu, it's a3, and a8—AF point selection—is set to 51). I move the AF sensor to the element I want sharp, and shoot. When I have just one bird in flight, I switch the AF-Area Mode Selector from Dynamic-Area AF to Auto-Area AF (AAA). It's just that simple.

Green jay. Photo captured by Nikon D2X & AF-S II Nikkor 600mm f/4 lens with TC-14E II on Lexar digital film.

And shoot in less than three stops of light, so all that plumpness that makes them so endearing comes out in your photograph.

When working in three stops of light and that magical beam of light appears, guess what? It's really easy to deal with, and it makes huge drama come to life with very little effort. Check out this green jay image for a moment. This was taken in one of those magical bird blinds on the Texas-Mexico border that sucks in the coolest birds. This green jay came in just a sliver before the sun faded below the horizon. Just a moment earlier and a moment later, the jay was in complete shade.

Even including the background, the light wasn't three stops (notice how the sky is not burning a hole in the photo). When that last beam of light found a hole in the shrubs and struck the breast of that jay, look what happened! That kiss of light on the yellow sucks the eye right in and doesn't let it go. Then you've got the yellow against green combo that is so soothing to the psyche. I would have been much happier if the jay had turned his head a tad more, so the dark blue on the cheek and eye were better lit, but as you can see, I didn't throw the image away.

Is the amount of light striking the breast enough to change the shutter speed from the prior shadow exposure? Nope, it's not that much light—perhaps 1/3 of a stop more. If that's the case, why does it stand out so? Because the elements around it are darker and so by association, it is brighter. It means no pixels were harmed in the creation of this photograph. It's pure light magic and I just happened to be lucky enough to be there to make the click. It sure didn't hurt to be shooting with the 600mm with the TC-14E to narrow down the angle of view, so darker elements surrounded the jay. But that's the magic of light when you work in less than three stops.

Taking this a step further, let's talk about bunnies. The photos on the next page of the eastern cottontail were taken with the AF-S 600mm f/4 VR with the TC-17E. There's a spot in Custer State Park by the airfield where you can typically find them early in the morning in the spring. I love photographing small critters, so we check that locale often. On this morning, a couple of kids were out. You can see

how soft the light is, you can see right into the shadow it casts to its right. That means we're working well within three stops. Look for a moment longer and you'll see the light is skimming over the back and is a little brighter on the head. That's sweet light in action! Which of the two photos do you think I think is better?

Yeah, one is better than the other in my opinion, and it's because of what the light is doing. It's subtle, but it's what I look for in the viewfinder when making the click. The image with the bunny smaller in the frame is the better of the two. It's not the head gesture that does it (it doesn't hurt), but the light on the grass in the top-right corner that makes the difference to me. Cover it up with your hand, and look what happens to the photo. Look at the other image where that grass was cropped out when I moved closer to the bunny. That lit grass brings not only visual depth to the photo, but also continues the cute factor—the Peter-Rabbit-in-the-briar-patch feel to the photo. Don't discount the importance of those preconceived notions about wildlife for a second. Use them the best you can in every click. It's all part of the mind's eye and the path to the heart.

Lastly, did you know that with three stops of light or less, your meter is nearly always 100% right? Yeah, find three stops of light and your metering problems practically disappear. That in itself makes you want to find that light.

Eastern cottontail. Photos captured by Nikon D3X & AF-S VR Nikkor 600mm f/4 lens with TC-17E II on Lexar UDMA.

Oh Man, Do We Love Color!

The range between highlights and shadows, what we were just talking about with the five-stop range of light thing, is also referred to as exposure contrast. Contrasty images can be a good or bad thing. But there's another kind of contrast that's just as important that I want to make you aware of—color contrast. Where exposure contrast has a very finite range we can measure, color contrast is not readily measurable and ranges the entire visual spectrum of light—a vast spectrum of possibilities to grab the mind's eye in a whole other way without worrying about blowing out pixels. The beauty of color contrast is we're not limited to three mere stops, but have the entire rainbow at our disposal for communication.

> Color contrast is the deliberate use of complementary colors on a conscious level in a very blatant way to make the subject smack the viewer right between the eyes.

The psychology of color, which is the way our mind interprets and responds to color on a subconscious level, is something we tap into when using color contrast. Color contrast can be used to communicate many subtleties in nature and in our subject that otherwise might be lost. Rather than depending on just exposure contrast to make things visually exciting, you might want to incorporate more color contrast.

El Capitan, Yosemite National Park, California. Photo captured by Nikon D2Xs & AF–S Nikkor 14–24mm f/2.8 lens on Lexar digital film.

I Could Be Just Blowing Smoke Here

While there is science to prove the psychology of color, this color contrast thing is something that just kinda fell in my lap. I think of color contrast as the conscious counterpart of color psychology. We're playing on the mind's natural acceptance of color(s). Using a lens' angle of view, depth of field, and lighting, we deliberately use associated colors to, again, grab the mind's eye and lead it through our photograph. In many ways, this is harder to do because we just can't add a color we think we need, we have to work with what's provided to us. It just seems to fit into shooting in three stops of light so nicely that we've gotta take advantage of it.

Rocky Mountain bighorn sheep. Photo captured by Nikon D3 & AF-S VR Nikkor 200mm f/2 lens with TC-17E II on Lexar UDMA.

The very subject we're focusing on, nature, is an essential element in our use of color contrast. Mother Nature presents us with such a rich palette of colors, each so very unique yet blending with each other. Not taking advantage of that in our photography would be downright criminal. I would hazard a guess that it's these colors—be it in birds, mammals, flowers, or landscapes—that drew many of us to photography in the first place. We just need to refine our vision and photography to find, see, and make use of this natural contrast.

Color contrast works its magic to make the subject pop the best when exposure contrast is at its least. Strong light tends to create sharp edges between colors (black shadows), which in a dramatic sense is great for

photographs. And I'm not suggesting for a moment that this be ignored in your photographic pursuits. What I am suggesting is a different way of looking at color and taking advantage of a light source many photographers don't utilize, by relying on color contrast to communicate.

Overcast light, whether it's one stop or three stops (or no stops in pouring rain), allows the natural colors in a scene or subject to come to life. This quality of light can, and often does, bring out the saturated colors that many of us seek in our images. (Of course, this light source has a bluish tint our camera records, as well.) It's the very subtle nature of this kind of light that I love as it permits us to take advantage of nature's color contrast and communicate its beauty.

Warning: Boring Content Again

There is a little scholarly thought to support my hypothesis on color contrast, but it's normally taught in formal art and graphics classes. Color theory in the context of color contrast involves the color wheel, which is divided up into three categories: primary, secondary, and tertiary colors. The three primary colors of the color wheel are red, yellow, and blue. They are thought of as the basic foundation of the color wheel, because they are used to create all the other colors of the wheel. If you combine two of the primary colors, the three secondary colors are formed. They are orange, green, and violet. Combining a primary color and an adjacent secondary color creates the six tertiary colors. These colors are red-orange, red-violet, yellow-green, yellow-orange, blue-green, and blue-violet.

I'm not suggesting that a color wheel be taped to the back of your camera or committed to memory, we just need a starting place and this fits. Color contrast works off the color wheel and the very basic concept of complementary colors. If you select a single color on the wheel and then move directly across the wheel in a straight line, the corresponding color is complementary. For example, if you select red, right across the wheel is green, and so it goes for yellow and purple, blue and orange, and so forth. Complementary colors "complete" each other. Complementary colors, when used together in a photograph, make each other seem brighter and more intense. Ah, a lead back to light and bright and the mind's eye.

You can also use analogous colors (there's a new term for you). An analogous or harmonious color scheme involves understanding the color wheel even better. If you select a single color on the wheel and then move just one spot (or color) to the left or right of that color, you have its analogous color (we're not talking hues here, that's totally different). Where complementary colors make each other stand out, analogous colors create a harmony within an image. You actually have tons of photos with analogous colors in your files, yet you probably didn't know they had a name. A field of grass, a sunset, and an animal's fur coat are all examples of analogous colors.

Complementary colors are directly across from each other on a color wheel.

If you're a little weak in your color theory or on the color wheel, you're not alone. You can search the word "color" on the Web and find tons of good info.

How Might You Apply This Concept?

It's not like we can go out and, with the wave of a magic color wand, make color contrast appear (no, we can't use Photoshop either). While we're still in the chapter on exposure, we're really dealing with those elements of light we can use to visually communicate. Color is a huge component of light that most tap by accident, not design. I encourage you to start thinking about your color photography as *color* photography. Recognize the colors

you're seeing and make use of them, along with all the other tools available. The masters of photography today nearly all have a formal educational background in art. There's a connection, and it doesn't have anything to do with f-stops, composition, or any of that stuff. It has to do with color and using it to grab the mind's eye.

Color contrast goes hand-in-hand with great light. If you're shooting on a bright day, trying to take advantage of color contrast is pointless. Shooting in mellow light (three stops or less) is when you want and need to take advantage of it. Using a long lens with a narrow angle of view helps in selecting a background, for example,

with a complementary or analogous color for your subject. You might use flash to "clean up" the subject's color in the bluish tint of overcast light and bring it back to 5500K (something that comes later in the book). You might start underexposing more, starting at –1/2 stop, but moving down even more with time. The more you start seeing color, the more you'll start seeing ways to make it an essential part of your photography through different techniques.

Back in 2005, my shooting bud Kevin Dobler and I floated down the Kongakut River in the Arctic National Wildlife Refuge, in Alaska. Every time we hauled out at night and set up camp, we had company:

Moose. Photo captured by Nikon D2Hs
& AF-S VR Nikkor 200mm f/2 lens on Lexar digital film.

the arctic fox. In the summer, their pelts turn a motley grayish-tan, a far cry from their winter fluffy white. But their summer coat is a natural for their world. Looking at the photo, you can see the colors of the background are analogous colors with the fox, centering on that greenish-blue. Green (or shades thereof) is one color away from the complementary brown of the fox. Color, rather than exposure contrast, makes the fox pop out.

One of my all-time favorite images (which doesn't mean the best in the world) was taken on St. Paul Island (yeah, of Discovery Channel's *Deadliest Catch* fame). I spent an incredible month there—great photography abounds on that island. The red-faced cormorant can only be photographed in a couple of places on the planet, St. Paul being one of them. Why is this image one of my favorites? I know the downpour of rain I stood in to make the image, and I vividly remember

Arctic fox in summer. Photo captured by Nikon D2X & AF–S VR Zoom-Nikkor 200–400mm f/4 lens with TC-17E on Lexar digital film.

standing on a grass-covered cliff, leaning out to make the shot, the ocean pounding 600 feet below me. Of course, the final image speaks to me all those things. The image has no exposure contrast whatsoever. The light is flat, flat, flat! This black bird against the slate blue-gray Bering Sea works because of the black against the blue-gray—color contrast. And because of the lack of exposure contrast, we can see great detail in all of the black feathers of the body and tail. It's the small patch of red on the face that draws our attention right to its eye. This is using color contrast to its fullest.

Do I mentally look for these colors in the world of the subjects and wait until they are perfectly placed in the frame to shoot? I wish I had the time and ability to do so, but such is not the case. Rather, I look for those colors within the viewfinder and use the lens to isolate and combine them when available. If I can move left or right, up or down a little to bring these colors in, I do so. I make the most of what I have at hand at the time I fire the shutter. It's one of those things that when it all comes together in the viewfinder, you strike photographic gold.

We're still talking about manipulating the viewer by using all the tools we can to exclude some elements while including others, so we take them on a journey. It's a visual journey that we create in our photos with light and bright, sharpness, exposure for emotion, color contrast, and so much more, creating a visual map with a pot of gold—our subject—waiting at the end. While many folks put so much weight on the rule of thirds for composition, just giving the mind's eye what it craves is much more powerful. Color is what dictates much of our composition more than any conscious thought about some rule!

Color contrast, while having its basis in the color wheel (a tangible thing we can see), in practice is not a tangible technique we can put into rules and apply in the field. It's another one of those things that one must start to see along with the quality of light. You have to go through a few levels of photography and mature to where you start seeing the elements that really make a great image great. Color, though obvious, truly isn't.

Red-faced cormorant on St. Paul Island, Alaska. Photo captured by Nikon F5 & AF–S II Nikkor 600mm f/4 lens on Agfa RSX.

Some of the best photography is taken in some of the worst weather!

Manipulating the Mind with Color

The psychology of color plays an overwhelming role in the ability of an image to communicate. It gives the mind a place to start, finish, and often find solitude in an otherwise information-overloaded world. It's used every day in the advertising we are bombarded with, so why not put it to good use to tell a story in our photographs?

Arctic ground squirrel. Photo captured by Nikon D1H & AF-S VR Zoom-Nikkor 200—400mm f/4 lens on Lexar digital film.

There's an age-old adage that when photographing birds, if you don't have a good background, find something green to put behind them. Why is the color green so important or pliable that it's a universal cure-all for backgrounds for birds? What is it about color that grabs our attention in a scene and gets us to photograph it in the first place? What are we doing technically right or wrong in our photography to exploit people's natural draw to color?

The human brain is able to distinguish over 200 shades of white and see the same color no matter the light source, so saying color is essential to our perception is no exaggeration. When viewing a black-and-white scenic, full of all the shades of gray that a good paper and photographer can bring to light, the emotions just those shades of gray can evoke is tremendous. But that's just a small sampling of the potential a full palette of colors can bring to a photograph.

With that in mind, thinking about light and the range of light the digital camera can capture makes you think a little more about the importance of exposure—exposure not for technical perfection, but in communicating passion. Knowing white is such an important color to our vision that we can see over 200 shades of it, light and bright take on a whole new meaning all of a sudden.

When photographing wildlife, you'd be surprised by the emotional response color can evoke, and how color, especially the color of the background, can emphasize and enhance that emotional response. We can't change the color of a subject to any great degree, but we can definitely alter the colors of the world around the subject to some degree, using various technical tools at our disposal. (If nothing else, this will help you understand what images to send or not send to editors.) But which colors communicate what? Let me give you some very basic descriptions of colors and how we subconsciously perceive them. (It's very important to realize that we are talking about psychology of colors here; folks don't see certain colors, then rationally think about their emotional response to them.)

Yellow is the color nearest to "light" and leaves a warm and satisfying impression. It's lively and stimulating, and in many cultures symbolizes deity. Dark yellow can be oppressive, while light yellow is breezy. Yellow's stimulating nature and high visibility to the eye is the reason why many road signs are bold yellow (contrasted by black text). Yellow birds, flowers, and skies are sure to be eye-catchers just because of the way the mind and eyes work!

Blue represents temperature, sky, water, and ice. It is the second most powerful color, and it obviously represents coolness, mist, and shadows. In some applications, it can represent peacefulness and calmness. And as pink represents femininity, blue represents masculinity. Blue is often associated with somber emotions like sadness, gloom, and fear. Blue is a contemplative color, meaning intelligence and strength. It is one of the most politically correct colors there is, with no negative connotations of it anywhere on the globe.

Green is the most restful color for the human eye. It's the universal color of nature, and it represents fertility, rebirth, and freedom. (That answers the question of why it's the best background for birds.) Bright green

Yellow leaves a warm & satisfying impression. Horsetail Fall, Yosemite National Park, California. Photo captured by Nikon D2X & AF-S VR Nikkor 200mm f/2 lens on Lexar digital film.

Blue represents ice and coolness. Snowy owl. Photo captured by Nikon D2H & AF–S VR Zoom-Nikkor 200–400mm f/4 lens & TC-14E on Lexar digital film.

Green is the universal color of nature. Ho'opi'i Falls, Kauai, Hawaii. Photo captured by Nikon D3X & AF–S Nikkor 24–70mm f/2.8 lens on Lexzar UDMA.

can be uplifting, while dark green evokes a mental picture of a pine forest. Street signs are painted with a metallic green background contrasted with white letters because the combination is believed to be the easiest to read and recognize for the human brain. However, as with most colors, green also brings forth some negative connotations. The phrase "green with envy" also gives way to guilt, ghastliness, sickness, and disease.

Orange is a good balance between the passionate red and the yellow of wisdom. Orange is symbolic of endurance, strength, and ambition. It can represent the fire and flame of the sun. It's said to also have the cheerful effect of yellow, but is intensified in its closeness to red.

Red is a bold color that commands attention. Red gives the impression of seriousness and dignity, represents heat, fire, and rage, and is known to escalate the body's metabolism. Red can also signify passion and love. Red promotes excitement and action. It is a bold color that signifies danger, which is why it's used on stop signs. Using too much red should be done with caution because of its domineering qualities. Red is the most powerful of colors.

Pink is the most gender specific. Pink represents femininity and has a gentle nature (which is not a bad thing). It is associated with sweets like candy and bubble gum. It also symbolizes softness. Because it's so "feminine," the use of pink should be well planned. Pink and blue combos are most associated with babies, soaps, and detergents.

Orange can represent the fire and flame of the sun. Sunrise in the South Dakota Badlands.
Photo captured by Nikon D3 & AF–S VR Zoom-Nikkor 200–400mm f/4 lens on Lexar UDMA.

One of the most predominant hues in nature, brown gives a sense of familiarity. Bison bull & calf. Photo captured by Nikon D3 & AF—S VR Zoom-Nikkor 200—400mm f/4 lens on Lexar UDMA.

Gray can enhance and intensify any other color it surrounds. Scissor-tailed flycatcher. Photo captured by Nikon D2Xs & AF-S II Nikkor 600mm f/4 lens on Lexar digital film.

Purple is a mixture of somber blue and active red. Like blue, it can represent coolness, mist, and shadows. It symbolizes royalty and dignity, and can be mournful, yet soft and lonely. Purple is described as an "unquiet color," being mysterious and mystic in a cultural sort of way. A study revealed that purple, the color of mourning among many peoples, meets with disapproval in six Asian countries.

Brown is associated with nature, trees, and wood. It represents conservancy and humility. Next to gray, brown, in one of its many shades, is one of the most neutral of the colors. It is useful in balancing out stronger colors, and because it is one of the most predominant hues in nature, it gives a sense of familiarity. Light brown confers genuineness, while dark brown is reminiscent of fine wood and leather.

Gray gives the stamp of exclusivity. It's the color "around which creative people are most creative." Gray is a neutral color that can enhance and intensify any other color it surrounds. It can enhance the psychological response of the other colors it supports.

Black is associated with elegance and class (as in a black-tie affair). It is the traditional color of fear, death, and mourning. Look at the many terms using the word black to understand how it is perceived: black sheep, black heart, black and blue, and black mark. Despite the negative imagery that black brings, it is a preferred color in many designs, since

it contrasts with most colors quite well. If used correctly, it promotes distinction and clarity in your images.

White symbolizes purity, innocence, and birth. It's closely associated with winter and can also represent surrender or truth. In the color spectrum, white is the union of all the colors. Its neutrality and conservative nature is widely accepted. Its simplicity and subtle quality makes it an ideal color for establishing clarity and contrast in your images.

What is my favorite color? Brown.

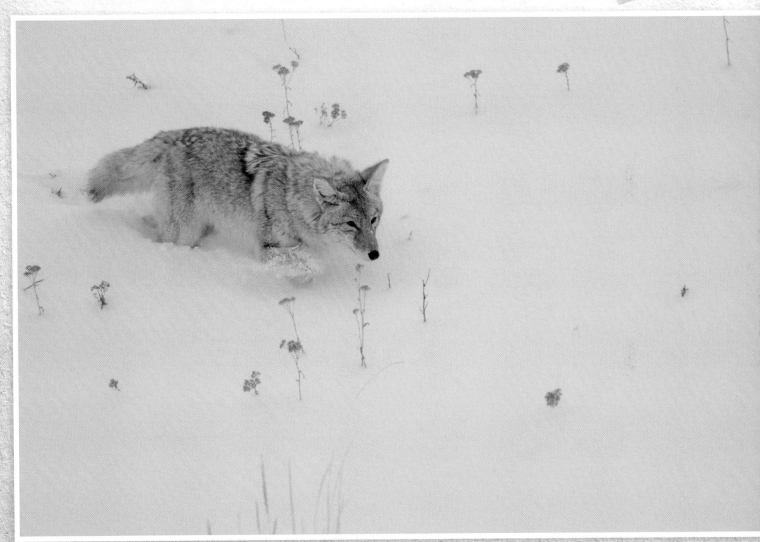

White is closely associated with winter. Coyote in Yellowstone National Park. Photo captured by Nikon D3X & AF-S VR Zoom-Nikkor 200-400mm f/4 lens with TC-17E II on Lexar UDMA.

If you're like most folks, you've probably never thought about color in this way. That's partly why it's called the psychology of color. It's truly a powerful part of communicating. You're probably saying, "This is all well and good, but what does it really have to do with my photography?" Well, why not use the same principles to help sell your message, your photograph, or your photography that are used to sell you things? I bet that if you look at your favorite photographs—your own or someone else's—and look at the colors and read the color definitions, you'll discover just how important color really is.

Many ask what's going on in my mind when I make a click. What am I seeing, what am I thinking, and how does that make the click happen? When asked this in conjunction with exposure, I truly have a hard time providing the two-line answer most seek. To answer that question, for my own photography at least, requires more than a couple of lines. It's hard to believe I think about all of this when I click. And that's just it—it's not thought about, not anymore. My mind is on just one thing—the subject—and all the rest of this stuff just falls into place subconsciously now. It just is.

That copout answer of, "I've been doing it for 30 years" is so accurate and, at the same time, so useless at the moment the question is asked. What is your exposure? How much comp do you have dialed in? When I answer those questions by just saying –1, I want to hand folks a book with all the caveats I just wrote here for the sake of full disclosure. But I don't, because that's not practical. What you have here, then, is the long-winded answer.

This is what it all comes down to: When I'm out shooting, I look for the subject (be it a bear, bird, boulder, or brick), and when I see it, I select the lens to use and walk toward it. As I do, everything my eyes and heart can see gets processed. I look at the light direction, quantity, and quality, I look at the subject's color and the colors surrounding it, and based on all the input and how I want to depict it, I will make the decision as to what exposure compensation I'm going to dial in.

San Joaquin antelope squirrel. Photo captured by Nikon D1 & AF-S II Nikkor 600mm f/4 lens with TC-14E II on Lexar digital film.

Be it 0 or –3, my starting point is decided in my mind and dialed in before the camera is ever put to my eye. Exposure is based on what I see, feel, and want to communicate to you, the viewer. I reach up and dial it in (sight unseen if the camera is on a tripod). Then the camera is put to my eye, all the elements are arranged in the viewfinder, and at that moment just prior to the click, I will make the final call on the exposure and make the final adjustment to it (remember, my baseline starts generally at –1/2). After the initial clicks, if there is a question in my mind about the highlights, I will look quickly at the blinkies, otherwise I won't chimp, just keep on shooting. And as the events in front of the lens unfold, a change might or might not be made to the exposure. That's it—just shoot and enjoy the moment. And that's how you do it.

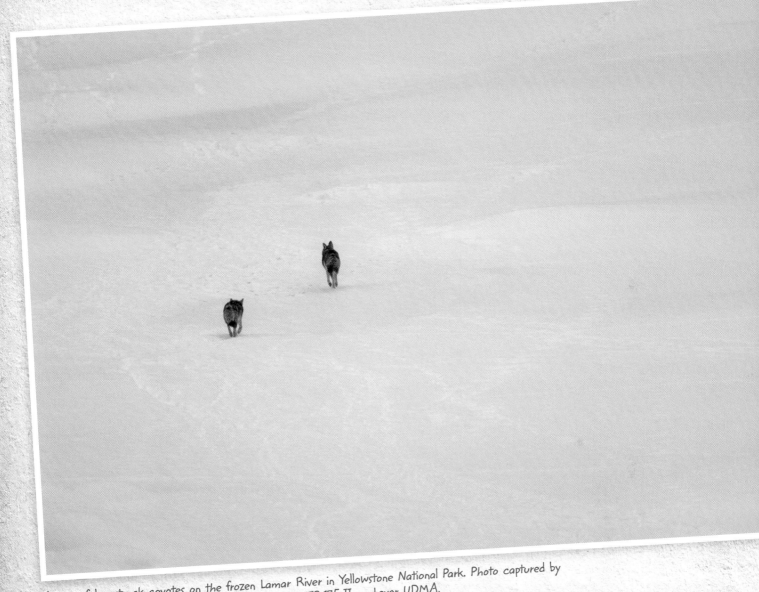

A pair of lovestruck coyotes on the frozen Lamar River in Yellowstone National Park. Photo captured by
Nikon D3X & AF-S VR Nikkor 600mm f/4 lens with TC-17E II on Lexar UDMA.

CHAPTER 6
It's Just That Essential to Success

After our first outing to see and photograph the greater sage-grouse: Brent, me, Sharon & Jake.

The "compound" on Homer Spit, Alaska, where you could literally walk with the eagles. When you get this close, photography is a no-brainer!

Photographing the shaggy dogs of Custer State Park, South Dakota.

Grizzly bear with fish at Brooks Falls, Alaska. Photo captured by Nikon D3X & AF-S VR Zoom-Nikkor 200–400mm f/4 lens on Lexar UDMA.

Out following polar bear tracks in the Alaskan Arctic. Photo by Laurie Excell.

The fog is so thick it collects on the Fresnel lens of the Better Beamer flash extender, causing it to rain on the barrel of the Nikkor 600mm f/4 lens. The cliffs where my gear and I are precariously perched disappear 600 feet below into the fog and waters of the Bering Sea. The summer of 1996 finds me on an amazing journey, starting about as far east as you can go on the continent and ending about as far west as one can travel and still be in the U.S.

Over 300 rolls of film gave their lives to document the adventure. From the mosquito marshes of Churchill, Canada, that seem so long ago, I now stand on the cliffs of St. Paul Island. I've been on the road for three weeks by the time I start my month-long exploration on St. Paul, with a short stop on the Russian River, Alaska, for salmon fishing prior to the flight to the island. While I've been basically at the same latitude the whole time, the world couldn't be more different at each of my stops as I chase birds.

The light is as soupy as the weather in the summer in the middle of the Bering Sea. What little light squeezes in between all the moisture molecules is pretty much worthless, barely providing a bluish 1/30 of a second exposure. I'm going nuts because in the viewfinder are the birds I've so long dreamed of photographing: horned and tufted puffins; parakeet, least, Cassin's, and crested auklets; northern fulmars; and red-faced cormorants in their best breeding brilliance, colors cutting through the gloom like a fog lamp. (These days, most people know of St. Paul Island because of Discovery Channel's *Deadliest Catch*, but back in the summer of 1996, only birders knew of and came to this remote outpost.) I'm bundled up against the dripping cold that cuts right through even me, and only what is on the other side of the lens brings any warmth to my soul.

Horned puffin. Photo captured by Nikon F5 & AF-S Nikkor 600mm f/4 lens with TC-14E on Agfa RSX 100.

> *Where's one place I want to revisit and shoot so bad it hurts? The tundra marshes of Churchill, Canada.*

Gotta shoot; gotta shoot; gotta make an image! The frustration of not having even an ounce of nice light has me bouncing around like a mad man in a very dangerous spot. The birds aren't holding still; the shutter speed is so slow; the light is so blue and gray—yuck! There are hundreds upon hundreds of birds in sight, but only a couple can be photographed. Only a few are within reach of my flash. I'm with my good friend Artie Morris, and despite just getting zapped with 510v from his flash (Canon units don't like rain), he's trying to get in position to shoot down the cliff face as I am, looking for targets close enough to work.

You might think that 1/30 of a second is fast enough for perched bird photography, and in normal conditions I would agree, but these conditions are anything but normal. The heavy fog has the color temp well above the 5500K of the Agfa film. Photographing a black-and-white bird with an orange bill in this light will return an image of gray sludge.

The Nikon SB-26 Speedlight, with the SD-8 battery pack connected to it, is dripping wet and, after what just happened to Artie, I'm very nervous every time I touch it. But I have to hold it to wipe off the moisture on the Fresnel to shoot. Without wiping the Fresnel, the light is cut down two stops, rendering it useless in these conditions. With every click of the shutter, I look at the ready light in the viewfinder, hoping it will just go on and off.

The SB-26 might be plugged into a Quantum battery, but it's working really hard to get light to the subject. With each confirmation there is enough light hitting the subject, I fire, but I have doubts in my head. Finally, I get a horned puffin within distance with no obvious fog between it and the lens. I wait, making each

Horned puffin. Photo captured by Nikon F5
& AF-S Nikkor 600mm f/4 lens on Agfa RSX 100.

blast of flash count, because each could be the last from either moisture killing the unit or the batteries going dead. Finally I see the gesture in the viewfinder, I hit the shutter and the ready light says all is good.

The flash does its job. Its light strikes the puffin, piercing through the weather and exciting the colors, which bounce back at the speed of light, where they are recorded on the film. In a couple of weeks, I'll know my calculations were correct and the combination of being in that place with that subject with that light and exposure made the image in my mind a reality.

Light is so important to our photography, be it ambient or from the flash or a combination of both. With the sun being the main light source we depend on and chase, it is nearly always the first light we use for wildlife photography. But there are times when the sun doesn't want to play with us. It's those times we need to grab a flash and meld in our own light to make the image. It would be great if we could do a Joe McNally flash setup—having a critter wait for us to set up all those lights would be outstanding—but I've yet to meet a critter willing to let us set up multiple flash units around it. Our use of flash, then, has to be a stealthy, simple, and elegant affair, so in the final image, its use is not even detectable. All very much something you can do!

Horned puffin. Photo captured by Nikon F5
& AF-S Nikkor 600mm f/4 lens on Agfa RSX 100.

Don't let flash scare you. I've only heard
of it killing one photographer. (Kidding!)

Before Going Any Further

Using flash is a royal pain in the ass! Seriously. When I left school, I was clueless about flash. Yeah, I sat in the lecture, I worked in the studio, but the math and application of flash just didn't worm its way into my head. It frustrated the crap out of me for a couple of years, and then one day—literally—the light came on. Shortly thereafter, I was hiring out as a lighting assistant, doing things like flash-filling the Queen Mary while fireworks were being shot off. By the time that Allen's hummingbird nest came along and I was soldering together SC-12 cords, I had more than come to terms with flash. And to this day, I still think using flash is a royal pain in the ass.

Why? We work in an incredibly fluid shooting situation all the time, with critters who move (when will they hold still?) and a sun that does its own thing, and then add in batteries, flash arms, cords, computers, let alone exposure, and it's just a pain to set up, carry, and apply. When I watch my friend Joe work his flash magic, I not only really appreciate the art he brings to flash photography, but I'm thankful I'm not the one jumping through all those hoops.

I'm not going to go so far as to say I hate flash, I'm just saying I pull it out only when the light forces me to and not one second sooner!

Wait, I've Got to See Light to Use Flash?

The first concept you have to wrap your head around when it comes to flash is when you must use it. Yeah, there are times when you might *want* to use it rather than *have* to use it (you flash sicko), but you must know one before venturing to the other. Flash photography has as many applications as there are disciplines in photography.

In wildlife photography, we apply flash (in the grand scheme of things) pretty darn simply. We use flash basically for two deficiencies in the ambient light: quantity and quality. To be successful in applying flash, then, you've got to become fluent in the language of light. Without that, you won't see those deficiencies in the light and have the answer on how to apply flash to deal with them (another of the many round robins in wildlife photography, but one you can overcome).

Working with flash successfully with wildlife (success = no one can tell you used flash) requires you to understand ambient light. As we've already explored, we seek many things in the light coming to our subject, not the least of which are quantity and quality. Yeah, we can use tools like blinkies to help, but they don't help much. That's because we're working with the dark side of light rather than the bright side. Moreover, you've got to get a feel for light and how it's playing in your image to know when to apply flash and how much. I'm always amazed how often I see photographers apply flash to situations where it does no good and quite often hurts the light that is present.

On the second day of a workshop in Yosemite National Park, we walked across the road from the lodge to Lower Yosemite Fall to photograph the rainbow in the spray that occurs in the afternoon. Most brought a 70–200mm and wide-angle lens, and that was all. I had just received the newly released AF-S VR Zoom-Nikkor 200–400mm f/4 lens, which naturally I had to take on the walk where a wide-angle was the perfect lens (who can put down a new lens?).

It was December, when the light is great on the falls, so we spent quite a bit of time there shooting. One habit I have, no matter where I am in the world, is constantly looking around for wildlife. It's just this thing I do. We were standing on the bridge at the base of the falls when, out of the corner of my eye, I noticed movement, flight, and a small shape near the top of the tree that wasn't your basic, normal bird form.

I instantly called Sharon's attention to the shape perched in a cedar. She got out her bins and glassed it, and about the same time, we both said it was an owl. But it wasn't any old owl; it was a northern pygmy owl. Smaller than a dollar bill, they are so tenacious they take on

quail as prey. We watched it for a few moments and then it flew across the creek formed by the falls. We alerted the rest of the group to the owl's presence, but there wasn't much they could do—they all had short lenses. About the time everyone was looking at it, it flew again. This time, it came right to us and landed atop a snag no more than 15 feet away and in a magical beam of light.

It was sheer luck that this little guy landed at point-blank range and I had along the 200–400mm VR. Within a heartbeat of its landing, I was shooting. The moment stands out for two reasons: The main one is it's one of my favorite photographs (I couldn't have had the elements all fall into place any better if I had conjured them up myself). The other reason is because of a question. The owl was not around for long—I only captured 41 images of it before it took off again (it was looking for a meal). Once it flew off down the wash, I was asked why I didn't use flash on the photograph.

To the uninitiated, it's a very valid question. Many photographers seem to have the impression that shadows are bad and technically correct exposures are a must. Standing there looking at the owl, the group saw both of those things and determined that flash was the answer to making the photograph. With your naked eye, you could see all the busy forest in the background and you could see the bright portion of the stump the owl was perched on. The owl was lost in all of that, but as you can see in the final photograph on the next page, the forest in the background is gone, the bright stump isn't bright (exposure compensation), and the owl is anything but lost.

This is a prime example of when the feel of the light can't get any better, so you don't want to screw it up with flash! There are no deficiencies in the light—not quantity or quality—far from it.

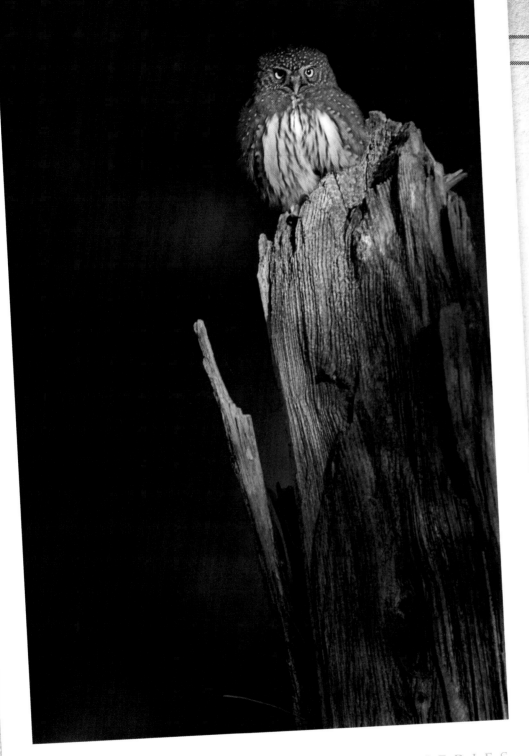

What's the subject? It's the stare of those yellow eyes. They are lit and piercing. The stage for those eyes is the rest of the owl, which gives gesture to the entire photograph. And, even though they take up almost no real estate in the photograph, you can't help but see them. There is drama in the light, brought out with the exposure. That's what talking with light is all about. Flash would have just messed that all up. So the first and the biggest challenge I think to using flash in wildlife photography is knowing whether to use it or not.

So Where Does One Start with Flash?

You start out by first not thinking of it as an enemy (not the same thing as thinking it's a pain in the ass). You start by simply plugging the flash onto the camera's hot shoe and making a click (a click of whatever) and looking at your LCD. Becoming familiar with just the mechanics of how it all works is a big step. An example is the Nikon SB-800 Speedlight. Calling up the menu on that puppy is a royal pain in the butt! Depressing the center button and holding it for at least two seconds to call up the menu you need for setting it to Remote was a learning curve all by itself. So just getting used to your piece of flash gear is a great first step.

Northern pygmy owl. Photo captured by Nikon D2HS & AF-S VR Zoom-Nikkor 200–400mm f/4 lens with TC-17E II on Lexar digital film.

Then comes learning how to program your camera for flash. You need to wrap your head around the fact that your camera and your flash both have a computer. This is important to learn and remember. The exposure computer in the camera affects both the camera and the flash. The exposure computer in the flash affects just the flash. As you'll come to see, understanding this makes working with flash exposure a whole lot simpler. We should start with the camera's computer, since it affects so many aspects of flash photography.

> The best way to learn flash? Photograph someone, anyone, and move the flash in an arc around their face. Then, look at the lighting pattern. The face is a great surface to start seeing how light affects curve and form.

Me at Dead Horse Point, Utah. Photographing someone's face is a great way to learn how light affects curves. Photo by Joe McNally.

Warning: Camera Technical Stuff Follows

Sync. You've probably heard this term before when speaking about flash. Most photographers aren't sure what it means and, more importantly, how to make the most of it. It is a confusing topic, not made any less so by the instruction book that you need to have a handle on to make the most of the computer's ability to make your life better. I apologize in advance; this is kinda dry stuff.

The shutter curtain is not a solid curtain, but rather, is made up of a number of "blades" that, when all closed, block light from striking the film plane. These blades move en masse, in a group, or one by one, depending on the shutter speed. You need to know this trivia to understand the camera's sync options and some flash operation.

Most cameras on the market today have a number of flash sync options. For example, the Nikon D3 has available front-curtain, slow, and rear-curtain sync. These three syncs determine when the flash fires and how it behaves with ambient light exposure. There are two things you need to remember about these syncs: available shutter speeds and when the flash fires.

With front-curtain sync, the available shutter speeds to sync with the flash are 1/250 to 1/60 of a second. The flash fires when the first shutter blade starts to move (the low-end shutter speed can be affected by the Flash Shutter Speed setting [e2] on the D3's Custom Settings menu).

With slow sync, the available shutter speeds to sync with the flash are 1/250 of a second to 30 seconds, and it fires the flash when the first shutter blade moves.

Bald eagle. Photos captured by Nikon D3S & AF-S VR Nikkor 600mm f/4 lens with TC-17E II on Lexar UDMA.

Using rear-curtain sync, the available shutter speeds to sync with the flash are 1/250 of a second to 30 seconds, and the flash fires when the last shutter blade finishes its travel.

So, cutting to the chase, we mostly use rear-curtain sync in wildlife photography. That's because of two factors: ambient light exposure blending with flash, and the subject's movement. We work, more often than not, in low light levels where we require shutter speeds slower than 1/60 of a second—often it's more like 1/15 of a second. At the same time, since our subjects like to move (bastards), if we want to incorporate that movement in the storytelling, then the movement has to have a logic to it.

With front-curtain sync, the movement would appear after the subject. The subject would be sharp, then a blur would continue beyond it in the direction of its movement. We see movement (and we get this from cartoons) as happening and then the subject "standing still" or sharp after the movement. So even though we can work with slower shutter speeds with front-curtain sync with custom setting e2 (Nikon users), we don't get the right blur to communicate movement.

You're Getting Me Excited Now

Yeah, with the first piece of techno mumble jumble out of the way, we move on to the next. Our job is to take technology, physics, imagination, and passion and bring it together in a flash and a click. Our modern TTL technology makes it simple to do while blowing by much of the manual stuff we had to know and work by years ago. I want to encourage you, though, to embrace a little of the old mechanics, so you can make the most of the new.

Start by understanding that when flash exposure is being set manually and not by the camera's computer, we use shutter speed to manipulate the ambient light exposure and the aperture for the flash (flash-to-subject distance, as well). In this manual world, we need to know the flash's guide numbers (GN) and use a chart for exposure calculations.

Moving to the modern age, knowledge of a flash's GN and looking at the chart has been removed from the exposure equation for us with TTL. We select the aperture we desire for DOF and the computers give us the blast of flash we need to achieve that exposure in what is nothing short of magic. The easiest way to think of i-TTL (intelligent through-the-lens flash) is that it's like a light switch on the wall: i-TTL turns the flash on and off for just how long you want it to.

In aperture priority mode, we select the aperture we want for DOF and the camera selects the right shutter speed. This is just like working without flash—it's basic exposure stuff. But once the flash turns on, the camera adds in the flash exposure to its thinking. In rear-curtain sync, we have a top-end speed of 1/250 of a second (unless you have a focus point option selected in the Custom Settings menu, which you should turn off when in rear-curtain sync) and if you've selected an aperture that the camera feels needs a shutter speed higher than 1/250, the camera will say HI. When you see HI rather than a shutter speed displayed, the ambient light exposure will be underexposed.

In this scenario, if you see HI, one option would be to close down the aperture until you see a shutter speed appear (1/250 being the first speed to appear). When you close down the aperture to make

Black bear on the move. Photo captured by Nikon D3X & AF-S VR Zoom-Nikkor 70–300mm f/4.5–5.6 lens on Lexar UDMA.

San Joaquin antelope squirrel. Photo captured by Nikon D1H & AF-S II Nikkor 600mm f/4 lens with TC-14E II on Lexar digital film.

the shutter speed sync happy, you not only sacrifice the DOF you felt you desired for the photograph, but you cut down the effective range of the flash (you can see this on the LCD on the flash—it's the inverse square law at work). This is where sync and shutter speed come into play in another way in our photography.

The vast majority of the time in wildlife photography, we're combining flash with ambient light, better referred to as flash fill. This is so bloody easy nowadays with i-TTL and digital. Seriously, you could blow through most of this discussion and set the camera and flash to auto and get a fairly reasonable overall exposure. That's just darn cool compared to when I started and we had to use matches to light subjects. But the melding of flash with ambient light so no one can see flash takes more than just simply setting everything to auto. While flash exposure is taken care of for us, we still need to think about shutter speed and, for myself, flash is when I concentrate on shutter speed more than any other time. You're going to have to think and feel to make it happen.

So Darn Hard to Learn from Just Reading

Let's talk this thing through by looking at an image. The photos of the tricolored heron were taken at Fort De Soto Park's North Beach, Tierra Verde, Florida. I was shooting with a Nikkor 600mm VR lens and 1.4x teleconverter with a D3 attached and an SB-800 doing the light duties (1/60 of a second at f/8). From the background (which is water), you can tell it was an overcast morning. To make the lighting on the heron worse, it was under a tree. That gave the light a somewhat darker, yet directional, feel. The light is coming in from the left.

We have a few options here to make the click. The first is what you see here, a straightforward click with –0.5 exposure compensation dialed in to the camera to deal with the gray nature of the light. Without the –0.5 exposure compensation, the background would blow out and be one nasty eye-grabber. The second option many take (and it's your call, not mine) is to take this same image you see here and fix it in post. It would be pretty simple to do. But, I'm not a fixer kinda guy,

got to get it right in the camera, so that means going with option three: flash fill (there's also an option four: don't take the photo).

We turn on the flash and we take a click. With −0.5 dialed in the camera body, and the flash at 0 exposure compensation, both the ambient light and the flash are being underexposed by −0.5 stop. In this scenario (not shown here), the heron looks like it's being lit by car headlights. It's not a pleasing light by any stretch of the imagination.

If you're new or not good with flash, how would you know this by just seeing the pop of the flash? This is one aspect that makes flash amazingly difficult to learn. In the days of film, your past experience is all you had to know if the flash fill worked or not. Today, you can hit the monitor button on your camera and look at the flash fill exposure, the light you've added, on the LCD (keeping in mind the LCD is not 100% accurate for exposure) and make a judgment call. Digital is a great tool to help you learn flash. So you look at the LCD and look at the heron, and you don't like what you see on the LCD. What do you do?

We need to meld the light from the flash with the ambient light. We need to decrease the amount of light from the flash that's striking the subject to make this happen. How do you accomplish that? You actually have a number of options. For the sake of a quick discussion, let's just say the aperture is fixed and we can't change it. With manual flash control, to underexpose the flash you would have to physically move the flash backward, away from the subject. Working with wildlife, that is just not an option (besides, we'd need a third arm). If we continue the manual exposure thought process, we could also close down the aperture, but when we do that, what has to happen to the shutter speed? We would have to increase our shutter speed, taking it down to perhaps 1/15 or 1/8 of a second. Ouch!

But we're not working manually, we have a computer—two, in fact. The camera's computer is underexposing the camera's and flash's exposure, the ambient light, and the flash light by −0.5. We don't like that, so we use the computer in the flash to decrease its exposure by dialing in −2 into the flash. When we dial in exposure

Tricolored heron with −0.5 exposure compensation dialed in to the camera. Photo captured by Nikon D3 & AF-S VR Nikkor 600mm f/4 lens with TC-14E II on Lexar UDMA.

Tricolored heron after dialing in −2 exposure compensation on my flash. Photo captured by Nikon D3 & AF-S VR Nikkor 600mm f/4 lens with TC-14E II, using a Nikon SB−800 Speedlight flash, on Lexar UDMA.

compensation into the flash, it only affects the flash exposure and not the ambient light exposure. By using exposure compensation, we've still not touched the aperture, so we're still in control of the DOF. That's exactly what I did with the heron and the results are what you see in the photo here.

The question here should be: "Why did you dial in −2 on the flash? Why not −2/3 or −1? Why as much −2?" We're using the flash to fill in detail subtly, not obviously. It's a dance to kiss the subject with just enough light to tell the story while not making the flash look obvious (though it's obvious here for educational purposes, see the red eye?). The flash has to be less light than the ambient light, and it's just a matter of how much less to make the image work visually. When the flash is equal to the ambient light, it's called a 1:1 ratio. We very rarely use that ratio in wildlife photography (since the light is over the lens axis) because it "flattens" our subjects—they no longer have any visual dimension or depth. That much flash fill will fill in all the shadows, which is the last thing we want.

An example of this flat lighting is the photo without any flash. Other than some light on the left side of the bird, there is no shading suggesting it's anything more than a cardboard cutout. Shooting at a 1:1 ratio would produce the same flat look, but in reverse: all lit rather than nothing lit. Neither works when communicating the beauty of our subjects.

As we start to dial in exposure compensation on the flash, we change the ratio of the light and minimize the shadows, bringing back detail. How much shadow detail you "reintroduce" into the photo as we program in exposure compensation is up to you, the photographer. If the subject is really cooperative, you can take a whole bunch of photos, each with a different flash exposure compensation dialed in. But we both know that's not a good or viable solution. Which still leaves the question, "Why −2?" It's real simple: it's what I like. In film days, with the F5 body and SB-28 flash, my favorite was − 2/3 exposure compensation, and with the D3, it's −2. That's a pretty simplistic answer to a rather complicated question. Sorry.

Turning Day into Night

Let's get back to that shutter speed thing, because it's important. One of my mini-passions within wildlife photography is small critters, especially endangered ones. The biologist we worked with on the sheep capture back in our earlier days (Vern) did small critter work in his early school days, and one of the species he worked with was the Amargosa vole. Listed as endangered in 1984, not much later it was thought to be extinct—until Vern rediscovered a small population. After the sheep capture, Vern and I did a number of other projects together. One of them was to find an Amargosa vole to photograph. The only known photo before our project was of a vole in Vern's hand (from his earlier work).

Don't have space to describe all the fun we had traversing the bulrushes in the marsh to set traps and check them in 100+ degree heat during multiple trips to the locale (just outside of Death Valley), but after more than 5,000 trap hours, we finally caught one. It was a pregnant female, so we know there were at least two in the world at that time. It was a very exciting moment. With it in hand, it was time to take what we call a "record of its existence" photo. That brings us back to this shutter speed thing.

The Amargosa vole is a nocturnal critter, which means it's active mostly at night. To create a biologically accurate photograph, we needed to do it at night. It was bright daylight when we caught the vole and waiting until night was not an option. How do we then make day into night? You don't crawl under a blanket when the temp is 100+ degrees—

it would kill the critter, and you wouldn't be too happy either. A better option, you guessed it, is shutter speed. When you look at the photo here, you can see right into the background, because the combination of shutter speed and aperture is the correct combo to properly expose for the ambient light. And just like the tricolored heron, the flash is merely filling in the shadow detail to a degree, so you can see into the fur of the vole.

To make the background disappear and create the illusion of night, all we had to do was change that shutter speed/aperture combo, so we weren't properly exposing for the ambient light. Our goal was to make day into night and we accomplished that by simply underexposing the ambient light (see the photo on the next page). There are a number of options to accomplish this, and most require you to think while shooting. I want to suggest a method that puts the power of TTL and camera/flash computers to work for you.

Amargosa vole. Photo captured by Nikon F5 & AF Micro-Nikkor 60mm f/2.8 lens, using an SB-24 Speedlight flash unit, on Agfa RSX 100.

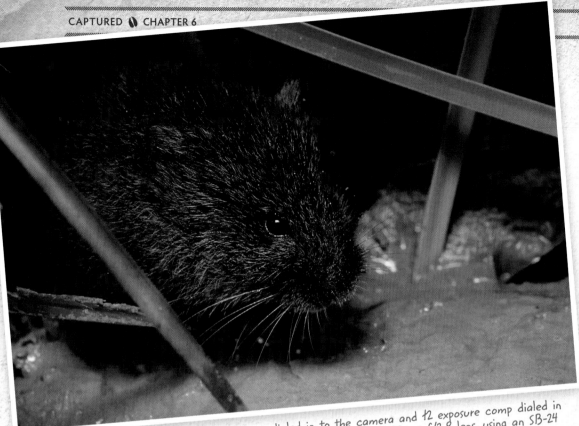

Amargosa vole with −2 exposure comp dialed in to the camera and +2 exposure comp dialed in to the flash. Photo captured by Nikon F5 & AF Micro-Nikkor 60mm f/2.8 lens, using an SB-24 Speedlight flash unit, on Agfa RSX 100.

We never touched the aperture, because we needed a predetermined DOF and because it wouldn't affect the ambient exposure. We did it by changing the shutter speed, altering it by dialing in an exposure compensation of −2, which increased the shutter speed by two stops. All you needed to know was to dial minus exposure comp into the body and plus into the flash.

Now, the minus exposure comp you dial into the body might not necessarily be the exact plus exposure comp you dial into the flash. You might want to create some other ratio of light or bring a drama to it that the exact plus and minus exposure comp don't create. That's just fine. As long as one is minus and one is plus, you can make day into night. We're messing with that shutter speed and ambient light exposure to make the flash work to our desired effect, all with the simple turn of a dial. Darn, technology is cool!

We normally underexpose the ambient light when no flash is attached by dialing in minus exposure compensation. Well, with flash, nothing changes. We still dial in minus exposure comp, so let's go −2 stops. Now what happens? The ambient light is underexposed by two stops and, because we've dialed exposure comp into the body, the flash will be underexposed by two stops, as well. That's not a good thing; we need flash to bring up the detail.

What happens if we dial in exposure compensation on the flash, say +2 stops? That's the exact opposite of the camera body. The computer in the flash only affects the exposure from the flash. So with −2 in the camera and +2 in the flash, the exposure from the flash that hits the vole is 0, or the vole is properly exposed by the flash and the ambient light is underexposed by two stops, turning day into night.

How do you find your favorite exposure compensation? The fastest way would be by doing my teddy bear exercise (Appendix 4) and adding flash to it. After that, it's just a whole bunch of shooting in the field. Create a folder called Flash Fill, copy images to it you take with flash fill, and refer to it over time. You'll start seeing patterns that work and don't work. You learn from your own images what works for your photography. Simply put, flash just takes time to master!

One Other Note on Shutter Speed

When we say "sync," we mean exactly that, we are syncing the flash's burst of light with the time that there is nothing obstructing the film gate opening. When a camera says its top shutter speed is 1/250 of a second and we try to use a shutter speed faster than that, in film days we would see a black bar in the photo. That's a shadow of a shutter blade. Why is that?

Using the SB-900 Speedlight as an example, it has a flash duration of 1/880 to 1/38,500 of a second. Those speeds are pretty darn fast, faster than the camera's flash sync speed, faster than the shutter blades can get out of the way. It has to do with light physics and mechanical science that we don't need to know. We just need to understand that 1/250 is our top shutter speed. Or is it?

Most cameras these days have the ability to do auto FP (focal plane) high-speed sync. When that is active (on the D3, it is set under e1 on the Custom Settings menu), the camera can sync with shutter speeds up to 1/8000 of a second (the camera should be set to front-curtain sync, and you should be using an SB-800 or SB-900). With that, you can tap into these kind of flash speeds out of the SB-900 while working at shutter speeds much faster than 1/250:

- 1/880 sec. @ M(anual) 1/1 (full) output
- 1/1100 sec. @ M 1/2 output
- 1/2550 sec. @ M 1/4 output
- 1/5000 sec. @ M 1/8 output
- 1/10,000 sec. @ M 1/16 output
- 1/20,000 sec. @ M 1/32 output
- 1/35,700 sec. @ M 1/64 output
- 1/38,500 sec. @ M 1/128 output

You might be wondering about all that earlier discussion about shutter speed sync when you read that. I did, too, the first time I read it at the SB-900's introduction, until I read the fine print. Oh wait, there isn't any fine print in the manual, so upon asking, I was told that you lose about one stop of light output from the flash for each one stop jump in shutter speed. That translates to light from the flash falling off faster and faster with a constant f-stop, from say 35 feet, to 24 feet, and then to 17 feet if we go from 1/250 to 1/1000 in auto FP.

Great Basin pocket mouse. Photo captured by Nikon F5 & AF Micro-Nikkor 60mm f/2.8 lens, using an SB-24 Speedlight flash unit, on Agfa RSX 100.

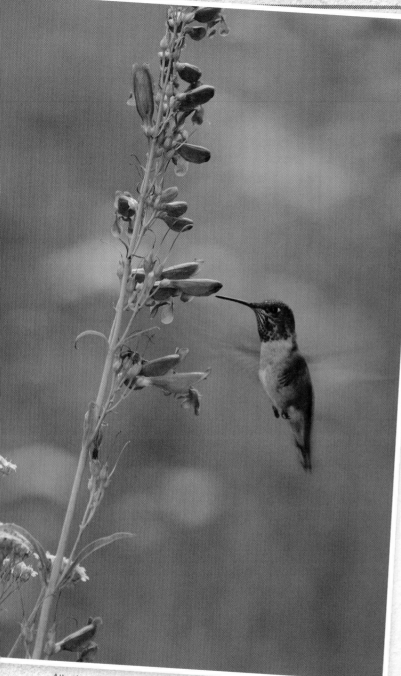

Allen's hummingbird taken with simple flash fill. Photo captured by Nikon D3X & AF-S VR Nikkor 600mm f/4 lens with TC-17E II, using an SB-900 Speedlight flash unit, on Lexar UDMA.

The way this thing works is the flash fires off a bunch of small bursts of light that is perfectly timed with the shutter blade movement across the film gate. It's really a fancy light painting operation. The burst of flash is timed so, as the slit in the shutter blades travels past, the film gate receives exposure from the flash. It's amazing technology that just costs us flash power. All those bursts from the flash for one exposure drain the capacitor, so the total output power from the flash is less than regular operation.

This does provide us the opportunity to do high-speed flash work without the incredible expense or hassle of the big flash units. An application for this would be photographing hummingbirds in flight. You've probably seen photographs of hummers frozen in midair in amazing body postures with every minute detail tack sharp. It appears as if it's a photo of a live mount the way everything is frozen in time. Those images are done with four or five flash units, some costing as much as $4,000. Using what we just learned, I think we can do better with less.

The first photo of an Allen's hummingbird coming into a flower was taken using simple flash fill. There is a single SB-900 with a Better Beamer attached shooting at 1/125 with the flash at –2 exposure comp. Personally, I kinda like this photo because it shows the life of the hummer in action. They evolved their amazing flight for the sole purpose of feeding on nectar. I think that should be incorporated in the photograph of a hummer, but I've gotten off the topic.

Using the settings in the table I just gave you, we can obtain some amazingly fast flash speeds from our little SB-900. It's pretty darn simple: you just dial into the master flash (or SU-800 Wireless Speedlight Commander) M 1/16 and you've got that flash duration. Next, it requires a camera capable of doing FP mode. Lastly, it requires a number of flash units, because we're reducing the power from each unit dramatically by going to FP mode. You do not double the flash output by simply using two flash units. It doesn't work that way. Generally speaking, it requires four units to double the output of just one.

The other photograph (right) of the Allen's hummingbird was captured with five SB-900s being fired by an SU-800 commander.

The camera was set to manual (M) exposure mode and the shutter speed set to 1/1500. The aperture was set to f/6.7 and the SU-800 was set to M 1/16 output. The combination of 1/1500 shutter speed and 1/10,000 flash duration freezes the wings. Determining the correct exposure for the ambient light and flash will require a few test firings before the hummer comes in (the flower is sprayed with sugar water—a 1:4 ratio of sugar to water—to make sure the hummers come in time and again).

We're not using i-TTL to determine the flash exposure when we set the flash to M 1/16. We're using simple flash-output-to-subject-distance. Looking at the setup photo, you can see there are two flashes lighting the backside of the hummer, two lighting its head, and one coming in from overhead. Look at how close they are to the single blossom to make the exposure. That's what was required to get 1/1500 at f/6.7. These photos were taken in broad daylight—full sun—another requirement to get that exposure for the background. The trick, if there is one, is the ambient light exposure. Every time you up the shutter speed one stop, you reduce the power of your flashes by basically half. You have digital; it's easy to do. And this setup is only $1,000 for everything (compared to the big rigs).

This is just another example, though, of how flash, shutter speed, and modern technology can make photography possible that, truly, not too long ago was locked away for nerds with big wallets.

Allen's hummingbird with action frozen by flash. Photo captured by Nikon D3X & AF-S VR Nikkor 600mm f/4 lens with TC-17E II, using five SB-900 Speedlight flash units, on Lexar UDMA.

We used five SB-900 Speedlight flash units & an SU-800 Speedlight Commander unit to stop the action of the hummingbird's wings.

What, Do You Memorize All This Stuff?

I did once, only so I could forget it and just apply it. In the old days, I took tons of notes when shooting with flash and film—the only way I could teach myself to improve. You don't have to do that anymore, though. You just have to look at the metadata (you've got to have a program that shows *all* the flash info to you, though. Not all do). While I remembered correctly, I did, for example, double-check the exposure info on the tricolored heron by opening the NEF file in Nikon Capture 2. There, it displays camera exposure and exposure compensation, flash exposure compensation, and the exposure of various flash groups (if they were used in making the photograph). This information is invaluable when learning and mastering flash.

One other thing I can't stress enough is to take photos of your flash setup if you're shooting with multiple flash units (like the one for the hummingbirds). It took a number of flash arrangements to get what I liked. The flash on the gorget (neck) was the hardest for me to get right. I don't want to have to reinvent the wheel, so I refer to these photos all the time.

Let's Get to the Heart of the Matter

This theory and technical stuff is all well and good, but applying flash is where we need to be, so let's get there. Like anything photographic, there is the boring background info that has to be gotten out of the way, so you can get to the heart of the matter. In this case, it's the

> What about the falling snow? It's all about shutter speed again. To show the snow falling, you need to take into consideration the speed of the snow falling and shutter speed. Use too fast a shutter speed, and it just looks like someone sneezed on your image. Use too slow a shutter speed, and it's a ticker-tape parade on Broadway. Another reason I love digital: one click and you can look at the LCD to figure out what is the best shutter speed.

> What rechargeable AA batteries do I use? Maha PowerEx 2700mAh NiMH.

melding of two light sources so well, we communicate what we desire and the viewer just says, "Ahhh!"

We skirted around the first deficiency in light so far, the quantity aspect of it. What we're talking about is shadows. When shadows hide details that we feel are important to our photograph, the method used most often to bring out that detail is flash fill. Just as the name suggests, we're filling in the shadows, lessening them until we reveal the detail we desire. As we've discussed, this is really done to personal taste. There is no technical standard for this in wildlife photography like there is in portraiture with its many options for shadow control.

The photographs of the Cassin's finch on the antler are a good example of what we're talking about. The antler is attached to a tree branch that's attached to the rail of our deck (the tree branch also holds a suet feeder). It's all set up for one thing: photography. While it's storming outside, cold and nasty, I'm inside the warm office shooting out. I take this stuff very seriously. To understand what makes this photograph work, we need to talk about a number of its components. First is the shadow.

You can see that it's snowing, so the light is obviously overcast at the very least. Even so, it has a direction to it, so the eye of the finch is in a dead zone. While not a believer that every critter needs to have a catch light, in this case, the dark socket and area around the eye is objectionable (it could be solved without flash if the bird just tilted his head up a little). Flash fill is needed to bring up detail in the eye and side of the head. You can see instantly the most important aspect of a wildlife photograph now: the eye. The flash light is coming in from the left and slightly above the finch. Why is the flash fill coming in from that direction?

Cassin's finch. Photo captured by Nikon D3 & AF-S VR Nikkor 600mm f/4 lens on Lexar UDMA.

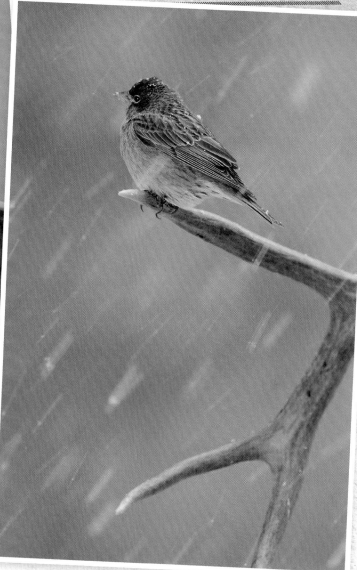

Cassin's finch with flash fill. Photo captured by Nikon D3 & AF-S VR Nikkor 600mm f/4 lens, using an SB-900 and Lastolite Ezybox Hotshoe, on Lexar UDMA.

In this scenario, where I had complete control, I could light as I wanted, not how I was forced to by the subject. How was I in control? The birds were coming to a predetermined spot, the antler perch I set up. The antler was set so the background was one I desired based on where I would stand in the office. You could say I set up a bird portrait studio, not an uncommon method of shooting and something that makes bird photography possible no matter where you live. Since I had a studio setup, I used a studio light. On an Avenger C-stand with an extension arm, I had a Lastolite 15x15" Ezybox Hotshoe with an SB-900.

Shooting with a 600mm VR lens on a Gitzo 5560 tripod, the D3 was connected to the SU-800, which triggered the SB-900. The exposure comp dialed into the camera was –0.5 and the flash was –2. Whoa Nellie, you're probably saying. An Ezybox on a C-stand? All that to just fill in a shadow?

Red-shafted flicker feeding young. Photo captured by Nikon D2Hs & AF-S VR Nikkor 200mm f/2 lens on Lexar digital film.

True, 99.9% of the time the flash for us wildlife photographers remains on the lens axis. But since I had complete control over the situation, and the Ezybox and C-stand didn't mind being out in the snow, I took advantage of the gorgeous light created by the Ezybox. Just look at the second shot of the Cassin's finch—you can't tell flash is the light source. What made me think of this kind of light in the first place? It would be easy for me to blame my friend Joe McNally, but that's not the case. Look at the photograph. What's a big part of it that would really go nuts with a straight-on flash burst? The antler. It's a highly reflective surface, and if I used direct flash, your eye would never see the finch. With that very soft side light, though, the light wraps around the antler and just lets it be what it should be—a stage for the finch.

Obviously, this is not how we get to use flash fill in the field. The setup I depend on in the field is as simple as I can make it. The red-breasted sapsucker photograph is a good example of this setup in action. Using the Gitzo 5560 for sticks, a Wimberley Head II has the 600mm VR lens attached. Also attached to the Wimberley head is the Wimberley F-9 flash arm (with the back screw removed on the arm, so it can be tilted down). Attached to the flash arm is an SC-29 off-camera cord (which I personally shortened to 28 curls). The flash connector end of the SC-29 has a Wimberley FA-11 adapter attached to the bottom of it, so there's no way the flash can spin once attached (without the FA-11, it spins when you carry the rig over your shoulder). The SB-900 is slipped into the flash connector end of the SC-29 (after St Paul's Island, I've embraced using the WG-AS1 Water Guard on the foot of the SB-900) that is atop the flash arm. The SB-900 has a Better Beamer attached to it (more on that in a moment). The last thing is an SD-9 battery

pack connected to the SB-900 and held into place on the Wimberley head with a Velcro strap. And you thought the Ezybox was overkill.

The main beauty of this system is that the flash is always above the lens, so the beam of light from the flash is always on the lens axis, whether shooting horizontally or vertically. This is for shadow control—not shadow from the ambient light, but any that might

You want to protect the Better Beamer's Fresnel lens from scratches, so get the LensCoat BeamerKeeper case for it. The case also makes it easy to carry and easy to pack, and that means you'll take it with you more often.

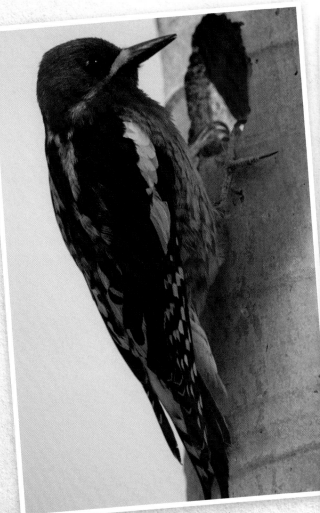

Red-breasted sapsucker without flash fill: Photo captured by Nikon D2Xs & AF-S VR Nikkor 600mm f/4 with TC-17E II on Lexar digital film.

Red-breasted sapsucker with flash fill. Photo captured by Nikon D2Xs & AF-S VR Nikkor 600mm f/4 with TC-17E II, using an SB-900 Speedlight flash unit, on Lexar digital film.

be created by the flash. I'm often asked if we need to go to the expense of buying these brackets like the Wimberley flash arm. All I have to do is put the flash in the camera's hot shoe and turn the rig vertically and folks get it. When you go vertical with the flash in the camera's hot shoe, you're going to get a shadow on the background, either to the left or right of the subject, rather than behind the subject where we can't see it. Also, when the flash is in the hot shoe, we're introducing a new light pattern that is different from the sun, making it look like we live on the planet Zorg with two suns. Now, back to the sapsucker photograph.

Looking at the photograph with no flash fill, what are the deficiencies we see? (If you don't see deficiencies, then this is a good lesson for you.) The obvious one is the head—that gorgeous red is in shadow, so it doesn't blast off the film. Remember what we learned about red

> Shooting with a flash and you just don't have enough light? If you're shooting with a teleconverter, take it off and you'll gain a full stop of light.

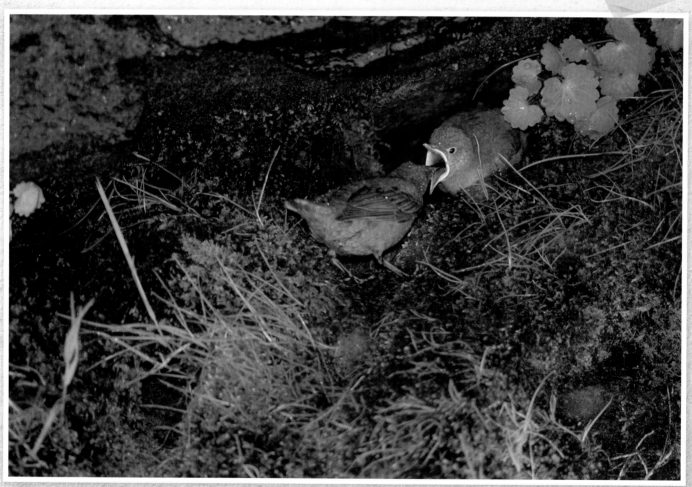

American dipper feeding chick. Photo captured by Nikon D3X & AF-S VR Nikkor 600mm f/4 lens with TC-17E II on Lexar UDMA.

and our vision in Chapter 5? When you've got it in a photograph, make the most of it. The unobvious reason is the fact that the adults were coming in to feed the kids. The last couple of days in the nest, the kids stick their heads out the hole to feed. That hole's dark, and if a kid stuck its head out, it wouldn't be lit and very cute, but dark. So the head of the adult and head of possible kids are the two main reasons to apply flash fill here.

Let's step back from the photograph for another moment to talk about that Better Beamer. We're setting up a shot, hoping to capture the kid sticking its head out of the hole (never did get that at this nest—see the red-shafted flicker photo to see what I was after). In order to make the shot work, depth of field is real important here: both the kid(s) and parent need to be sharp.

The SB-900 zoomed to 200mm without any aid can give you f/4 at 60 feet (ISO 100). Even when we go to f/5.6, we still have a flash beam that travels to 49 feet. Go to f/11, like I was with the sapsucker, and you're down to 24 feet. While it might reach the 24 feet, each time that flash goes off, the entire capacitor of the flash will be drained. Recycle time is then at its max (even with an SD-9 attached, it slows down shooting). The Better Beamer's role is not to throw light the length of a football field, but rather to permit us to have more DOF when using the flash. In this scenario with the sapsucker, I could shoot at f/11 and f/16, not drain my capacitor, and still have all the light I needed for flash fill.

You've probably already guessed the exposure I used with the sapsucker: –0.5 in the body, –2 in the flash. That pretty much covers most situations for me. You might be looking at the two photos

A little flash will add color to my feathered friends, king parrots I was working with in Australia (until they went on strike).

carefully now and notice that the light coming from the flash seems "warmer" than the ambient light. If you did, most excellent! It was early morning when I worked this nest, because the rest of the day the light was hard and from the wrong direction for the only place I could set up. Adding "white" light to warm sunrise color would stick out like a sore thumb. So I gelled the flash with a Kodak 81a gel filter. This gives the slightly warm-light look to the head of the sapsucker and hole, suggesting early morning light. What you can do with flash is amazing when you just think light.

The American dipper photo (left) is another classic example of the need for and application of flash fill. This nest, which has been active for more than 20 years, is a favorite of ours. We visit it every year—some years we can photograph it, and some years we can't. Why? Water. It's on the opposite side of a creek at the base of a waterfall, and we can only get as close as the water permits. In normal years, there is so much water we physically can't get close, but other years, like this one, we can get just close enough.

> When using the Better Beamer, be careful. The Fresnel lens will burn the paint off your camera lens and melt the rubber focusing ring if sun strikes it.

I'm shooting with the 600mm VR lens with the TC-17E II attached, and even when we get as close as physically possible, this is as big a subject as we're going to get in the frame. The nest is referred to as an "igloo" because it's made of moss in an igloo shape under the ledge of rocks along a waterway. What you see here is a textbook example: under a rock ledge next to water. That's a pretty dark scenario, light-wise. The only option is flash fill with a Better Beamer. The flash went in, kissed the two dippers, and the photo was made. The parent is on the left and the kid is on the right. How can you tell? That big orange target of a throat for the parent to shove some lovely bug down. Wondering to yourself why that color is so vibrant? Now we're getting to the heart of what flash is all about in wildlife photography.

American oystercatcher. Photo captured by Nikon D3S & AF-S VR Nikkor 600mm f/4 lens with TC-17E II on Lexar UDMA.

In for an Ounce…

Everything in this chapter up to this point has been about the obvious attributes, troubles, solutions, and uses of flash—a great place for you to start mastering it. Where we're going next takes you further into feeling light, which we started in the last chapter and will continue now with flash. That's because the second deficiency in light that we need flash for—quality—is all about color.

You probably missed it, but when I talked about the problem photographing the puffins on St. Paul Island, I mentioned color. If you look at the photos of the tricolored heron or the Cassin's finch, you'll see that in the photos where flash was applied, the color of the subject is a whole lot more vibrant. These are prime examples of why, more than for shadow detail, I use flash for color.

Let's get back to the photo of the American dipper (great birds by the way). Without flash, we couldn't discern the birds from the rock face (we're working with gray birds nesting in gray rocks), the greens of the foliage would look pretty sickly, and that open mouth would not stand out. Why? It's not just the lack of light in quantity, but

If you're shooting in rain, fog, or by splashing waterfalls when the water is between you and your subject, remember the flash will light it all up and make it a visual eyesore the majority of time.

also in quality. The temperature of the light is at the high end of the spectrum, so it has a high concentration of blue.

Our cameras work generally in the 3000–8000K range, and in this scene, we are well above that 8000K mark. So, the combination of the quality of the light falling on the scene and our cameras inability to deal with it gives us a flat, bluish-looking photograph. That's until we add flash fill, not for exposure, but for color. Once flash fill is added here, the greens are perky, the grays separate from each other, and that big mouth takes the eye right into the story of the photograph.

There's one added obstacle to making this image you don't see: the falls roaring by splash here and there as the water crashes down the rocks. Those splashes fly up in every direction at their own whim, without any prior notice or pattern. When photographing the dippers, a lot of great images of feeding and interaction were deleted because of these splashes. When they flew up, they were physically closer to the flash than the nest, so the water hit by the flash turned into white orbs. Not totally different than the problem I had shooting in the dense fog on St. Paul Island.

While obvious, most never think about why, biologically, birds are so colorful. It's to make identifying one's species possible and, in the spring, for easy identification of the males. For this reason, the birds' feathers are designed to reflect light. When they are out in the sun, they are a blaze of color, and when they go into shade, they just disappear. It's all about survival and sex. It's pretty cool if you think about it, and as a wildlife photographer, you need to think about it.

You're probably wondering how I get these before and after photos where it appears the subject hasn't moved. Flash is very important to my photography, and I'm always experimenting to see if I can take it to the next level. For me, taking before and after photos is very much a part of that process. To this end, I have the Function (Fn) button on the camera programmed so, when depressed, it shuts off the signal to the flash to fire. Reaching up to turn the flash on and off is not only a pain, but often is not advisable when working with a shy subject. Depressing a button right next to the lens can be done easily and without alarming a soul.

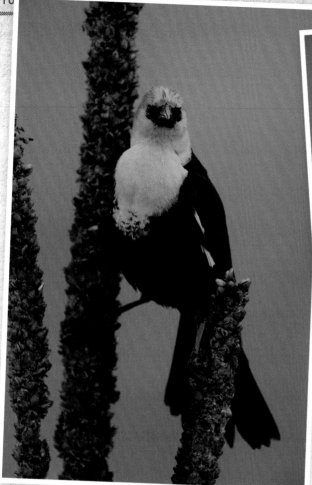

Yellow-headed blackbird. Photo captured by Nikon D3X & AF-S VR Nikkor 600mm f/4 lens with TC-14E II on Lexar UDMA.

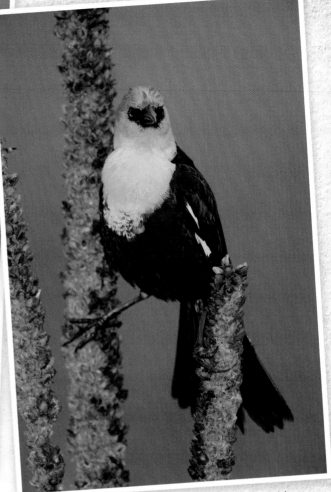

Yellow-headed blackbird with flash fill. Photo captured by Nikon D3X & AF-S VR Nikkor 600mm f/4 lens with TC-14E II, using an SB-900 Speedlight flash unit, on Lexar UDMA.

When birds go into shade, they disappear. Hmm, do we have a tool to make that color come to life when there is no sun? Heck ya—flash. And when I'm photographing birds, I normally have the flash in place for just this reason.

It was a typical summer afternoon in Montana: the thunderstorms started to form early, so by 9:00 a.m., the skies were gray. In the middle of nesting season, a favorite place of mine to go is

Lee Metcalf National Wildlife Refuge. On this visit to the refuge, the yellow-headed blackbirds were at it in full force, the males broadcasting at a feverish pitch to attract the females. It was easy shooting, working on the dirt road, using the open rear hatch of the Sequoia for a rain shelter. It really doesn't get much better!

Yellow-headed blackbirds are as handsome a bird as you're going to find at that time of year. Their yellow and black, with a speckle of

white, make them easy visual standouts. On this day, though, with the gray overcast sky and thunderheads, that yellow wasn't so vibrant and the detail in their black disappeared. I wanted that color, so the yellow needed to be kissed with the 5500K of the flash and not the 9200K of the ambient light. The key words here are "kissed" and "5500K" (okay, one's a number and not a word).

With the flash set up as described for the red-breasted sapsucker (minus the warming gel), I adjusted the flash rig so the light would just skim off the top of the blackbird—a technique called "feathering the light" (I'm not making that up; it's not some bad bird pun). This is where you use the outer edges of the flash beam, rather than the whole beam, to light your subject. It's the softest part of the light, even when using a Better Beamer.

What I do is determine the approximate distance I want to be from my subject, then get that far from a stationary object (in this case, I used the taillight of the Sequoia), and take a picture. I look at the light on the LCD and then adjust the Wimberley flash arm up or down, so the flash is lighting up just the top half of the photo. I rarely blast a subject with the whole flash. With that alignment done, I went to some stalks where I saw one male always going to display, and set up to shoot.

When he wasn't on the stalks, I took another test shot. (Sometimes I don't tighten the flash arm enough, so it moves when I walk, and sometimes I can get closer than I originally thought I could. So when afforded the opportunity, I do another test firing.) Then I simply

waited for the male to arrive and, as you can see, he did, doing that crazy thing yellow-headed blackbirds do. Straddling a couple of reeds or stalks, he stood there and called for a mate. I just clicked away.

Looking at the two images on the previous page, the first thing you should notice is, in the photo with flash, the yellow is brighter and the breast looks much more puffed out. You will probably then notice the color difference in the stalks and the background, and finally the detail in the black body. All of this is the result of the flash, which, like before, was set to –2 stops while the body was set to –0.5. The color temperature of the flash, and then the camera automatically switching to the Flash white balance, warmed up the overall image, while the flash just kissed the bird to make it pop.

While I like the flash fill photo over the photo shot in the overcast, don't forget that, for me personally, I prefer not using any flash. The last photo here of the yellow-headed blackbird was taken with no flash, and with the sun just starting to come out in a crack in the clouds. That quality of light blows away what the flash is producing, and is a whole lot easier to work with. But you don't always get it when you have the subject in the viewfinder, so you go with flash.

Yellow-headed blackbird with natural light. Photo captured by Nikon D3X & AF-S VR Nikkor 600mm f/4 lens on Lexar UDMA.

Does flash fill for color work with mammals? The one big issue with that is mammals aren't really colorful in general. They aren't meant to reflect color like birds. Take a gander at these images of the desert cottontail. You do see a warmth brought to the pelt, and the overall image, for the same reason it happened with the yellow-headed blackbird. What else do you see in the photograph? You see red-eye. So, to make it work, you'll need to deal with red-eye (which we will in a moment). Personally, I don't use flash with mammals for color.

> What's the best time of year to photograph mammals? In the fall, when they have gotten fat over the summer and have grown their thick, winter coats.

Desert cottontail. Photo captured by Nikon D3X & AF-S VR Nikkor 600mm f/4 lens with TC-14E II on Lexar UDMA.

Desert cottontail with flash fill. Photo captured by Nikon D3X & AF-S VR Nikkor 600mm f/4 lens with TC-14E II, using an SB-900 flash unit, on Lexar UDMA.

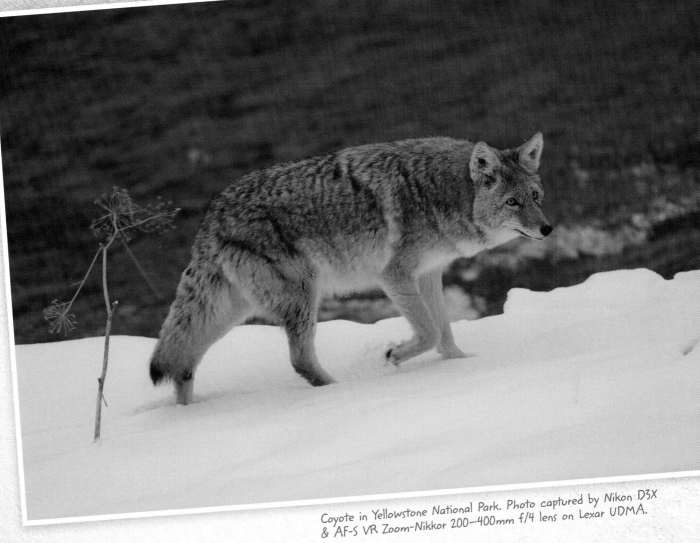

Coyote in Yellowstone National Park. Photo captured by Nikon D3X & AF-S VR Zoom-Nikkor 200—400mm f/4 lens on Lexar UDMA.

Are There Any Pitfalls?

You might begin to think that once you own the flash and get over the nervousness of attaching it to your camera, that it ain't all bad. I have to admit that it can do a real sweet job for being a pain in the ass. But even with that knowledge, there are times and places that flash fill simply doesn't work for me. Let's talk about mammals.

Where birds have feathers, designed in part to reflect light, mammals for the most part have hair designed for a number of things, warmth being a big part of it. The hair on big mammals like deer, moose, elk, bears, and the like is made up typically of two types of hair: ground hair and guard hair. The ground hair is the short stuff that you typically see when a mammal has shed its winter coat. The guard hair is the longer hair that is typically shed, and which grows long and makes a critter look magnificent in the fall. Those two types of hair directly affect how and when I use flash fill with mammals.

Big game animals, because of their two types of fur, don't look good when flash filled. The guard hair is highly reflective by nature. When hit with flash, you end up seeing that flash a thousand million times in the critter as small specular highlights. Do you know what

a specular highlight is? It's that shiny spot on the hero's tooth that sparkles at you in a bad movie. It's not a good thing to see a gazillion times all over the coat of your subject. And while the guard hair is creating all these specular highlights, the ground hair is doing what it's meant to do, sucking up light. The ground hair is what keeps the critter warm by absorbing light. If you carried around an Elinchrom Ranger and 74" Octabank, then you might have a prayer of flash filling a deer, but you have no prayer with a small Speedlight. That ground hair sucks up all the light you can throw at it and asks for more.

Are there pitfalls when it comes to photographing birds with flash? There's one big one: branches. Birds perch, and they typically perch on branches in trees. When you look at the bird perched, your mind does a great job of filtering out distractions like branches that are in front of and behind the bird. What your mind dismisses, the flash brings radically back in often-horrible ways. This happens in a couple of ways.

The one thing you typically don't notice are the branches that are between you and the bird. Those branches are physically closer to the flash and receive more light than the bird, so they often are over-exposed. If that's not bad enough, twigs and branches are typically white and bright, so they reflect back even more than just being overexposed. They are a pain.

Ghosting can be a pitfall or a good thing, depending on whether it is by accident or planned. What's ghosting? When shooting with flash and a slow shutter speed, and the subject moves, the blurring that occurs is called ghosting. The blurred wings of the Allen's hummingbird in the flash fill shot is ghosting—the wings moved during the slow shutter speed, so they blurred. Quite often, you get ghosting by mistake because you haven't noticed how slow the shutter speed has dropped, and you end up with throwaway results. But if you're photographing a woodpecker and you want to communicate its drilling action, a blur of the head driving toward the trunk, with it sharp when it makes contact, would be a cool image. I bring that example up, because it's an image I'm still trying to make, and is a prime example of ghosting working for you.

In the Dead of Night

One of the places where flash is at home is at night. Nocturnal critters are way cool to photograph, and with today's technology, it's easier than you can imagine. In fact, that's exactly what you need to do nocturnal flash photography—imagination.

When we switch to shooting at night, the one thing we remove from the discussion we've had so far about flash is the ambient light. So, when you attach that flash, it is no longer fill, but the main light. When we switch from fill to main light, we have to change the way we think about light. You might make it easier for yourself by thinking of the main light as the sun, because at night, the single master flash is like the sun.

No matter where you place that flash, when you think of it as the sun, nocturnal photography becomes a lot simpler. Let's just work with the idea that the sun is going to be connected to the camera's hot shoe. "What?" you're thinking. "The camera's hot shoe? I thought that was the last option." You might find when you first start working with nocturnal critters that in the hot shoe is a great place to start, and with time and more equipment, you might move it out of the hot shoe. So, assuming nocturnal photography is new to you, let's put the flash in the hot shoe. The master flash and the camera need to talk, so let's get that set up first.

Setting up the camera for nocturnal flash work is different than setting it up for flash fill. The first thing we should set is the camera to manual (M) exposure mode and the shutter speed to 1/250 of a second. This is for a couple of reasons: First, when working at night, DOF doesn't play as big a role as during the day. The reason is that the only thing we'll see in our photograph is what we light with the

What's one of my best-selling photographs? A photo of the Great Basin pocket mouse.

MOOSE PETERSON GALLERY SERIES

Great Basin pocket mouse. Photo captured by Nikon F5 & AF Micro-Nikkor 60mm f/2.8 lens, using an SB-24 Speedlight flash unit, on Agfa RSX 100.

flash, and light from flash falls off quickly. The DOF is limited to what we light, so being in aperture priority mode to vary the DOF while shooting is kinda pointless.

The other reason is we're still working with the concept of the camera working as fast as possible, so we can, too. We go to manual mode and 1/250 of a second so the camera operates as fast as it can. The motor drive advances faster at 1/250 than 1/60 and that permits you to be ready for the next shot sooner, which can be critical in nocturnal photography (you gotta have external power for your flashes working with nocturnal critters!). You also might want to set your

flash sync to front-curtain, but that's not really important. Lastly, you want to set this main flash to 0.0 exposure comp to start with. The flash exposure is still i-TTL, and we very much depend on that for exposure.

One other camera setup you might want is for the AF illuminator on the flash. The SB-900 has the best one of any flash, so you might want to take advantage of it. To make it come on, you need to set the camera's AF operation to single servo (with focus priority set in the Custom Settings menu [a2 on a Nikon D3]), the camera's firing mode to shutter priority, and the AF illuminator turned on in the flash. With all that done, when you're working at night, the flash projects a red beam the camera can use to auto-focus on. This is the system that, when it first came out, wowed the kangaroo rat biologist, and that I've depended on more than once shooting at night.

With this basic camera setup, it's time to think through the light. We have the master flash in the camera's hot shoe. That's our sun. If we think back to the tricolored heron, what was the problem we needed to solve? We had a flat light source—no light giving visual depth, shape, or texture to the bird. So, we added some flash fill, not eliminating all the shadows, but enough to give us that form and detail. With nocturnal critters and with the "sun" sitting in our hot shoe, what kind of light are we going to have? Not much different than that icky light hitting the heron that we added flash fill to fix. We're going to do the same thing with our nocturnal shooting.

The first photo I ever had published in *National Geographic* was of a giant kangaroo rat. When it was selected, I asked the photo editor why they selected my image from all the others. The answer was brief and right to the point: "The shadow!" The photo had been taken with two flash units—one in the hot shoe and one to the right at 45 degrees out and up. The flash in the hot shoe was the main light and on the right was the fill. Being fill and to the right, it created

Giant kangaroo rat. Photo captured by Nikon D1H & AF-S Nikkor 300mm f/4 lens, using two SB-80DX Speedlight flash units, on Lexar digital film.

a slight shadow behind and to the left of the kangaroo rat. More importantly, it created shadows on the kangaroo rat itself, showing its cute, chubby nature that caught heartstrings.

The photo on the left of the giant kangaroo rat (not the one used in *National Geographic*) depicts what I'm talking about, the lighting pattern of your basic two-flash nocturnal critter photo. You can see the shadow showing it's chubby nature, and how they sit with their front feet folded up under their chin and hind legs, which is how they got the name kangaroo rat. The slight shadow behind the critter makes it pop out from the background.

Speaking of the background, notice how it's lit? You see the light falling off and it getting gradually darker the further the light has to travel. That's the inverse square law in action. Since I was so close to the kangaroo rat—about three feet away—the flash has enough power to light up all you see in the scene. For a record of existence photo, that works. For telling the story, it doesn't work at all! That brings up the other GKR photo.

I've been photographing this particular species since 1987, so to say I have a few in the files is an understatement. The photo here is one of my all-time favorites. It was made using just one flash. If you look at the shadow, you can figure out how the photograph was lit. The one flash was off-camera, on a stand above and behind the subject. Why behind? The shadow! Shadows are incredibly important in photography.

The story I wanted to tell in one click was the plight of this endangered species. To do that, I needed to incorporate the loss of habitat by man's building on it. How would you do that with a nocturnal critter? I thought lights would work, but where there is man, there is no kangaroo rat. If you look in the background, you see a glow, that's the glow of Bakersfield, California. Using a long shutter speed, you can see that glow. By putting the flash up high and with that shadow in front of the kangaroo rat, it kinda speaks of how alone in the big, bad world they are. All this storytelling was done with one click and one light.

Giant kangaroo rat. Photo captured by Nikon D100 & Nikkor 14mm f/2.8 lens, using one SB-80DX Speedlight flash unit, on Lexar digital film.

It's Like Shooting in the Dark

There are a couple of issues shooting nocturnal critters to watch out for. The first is known by most: red eye. Simply put, nocturnal critters have lots of cones in their eyes so they can see in the dark. Flash, because the angle of incidence (the angle at which the light hits the surface) equals the angle of reflection, lights up them cones and the camera sees them. The color might be red, purple, or green, but whatever the color, since eyes are so important and are perceived as being black, red eye is a bad thing.

Getting rid of red eye at the camera is real simple: break that basic law of light (the angle of incidence equals the angle of reflection). There are two ways to do this, and both involve moving the light from the hot shoe. You can go straight up 14" or more from the hot shoe, which changes the angle so you don't see red eye. Looking at the photo of the raccoon hanging in the tree, you can see the normal green/red eye of straight flash is gone by using the second method, moving the flash up and out of the hot shoe. What else do you notice when you do that? When the flash is moved up and left from the hot shoe, you lose the red eye, but you gain a nasty shadow behind the raccoon. Using a second fill flash would help this, but I use the raccoon as an example here for two reasons: the first was the red eye solution; the second comes back to that fill of light.

Ricky Raccoon—ever heard of him? That cute little critter is why the world thinks of raccoons as being such adorable creatures. Look at the photo taken using flash. That's not very cute. Why? The quality of the light is anything but cute—it's hard and factual. Even with the pose and body gesture, which is cute, the hard light just blows it out of the water.

Raccoon at night, without red eye, but with flash creating harsh shadow. Photo captured by Nikon D1H & AF-S VR Zoom-Nikkor 70–200mm f/2.8 lens, using an SB-800 Speedlight flash unit, on Lexar digital film.

Raccoon at high noon. Photo captured by Nikon D3X & AF-S VR Nikkor 600mm f/4 lens with TC-17E II on Lexar UDMA.

Take a gander at the other raccoon photo, taken at the opposite end of the light spectrum—high noon in Florida's Corkscrew Swamp (killer place!). Even with hard light coming in from the right, the raccoon is totally cute. Why is that? Because the hard light photo has shadows in all the right places to make the body gesture stand out. The moral is: just because you can take photos at night doesn't mean you should.

The Old Movie Trick

When color films were first being produced for the big screen, and still today at times, the night scenes were a bit of a problem to create. In B&W days, they shot them during the day and just underexposed the print, but that didn't work for color. We all know there is no color in the black light of night. What filmmakers did to fool the mind is to still underexpose, but add a blue gel to the camera. Adding bluish light to an entire scene makes you accept that it's night. Dang, give us humans the right color and you can lead our minds just about anywhere.

I've used that same approach with some of my small critter shots to bring out the feel of night more in a photo. The image of the montane vole is a good example of it. You get a Roscolux gel swatch book from Adorama for $3.95 (as of the writing of this book) and grab the lightest blue one you can find in there. Slip that gel into the gel holder of the SB-900 and just shoot. Keep in mind that if we wanted to be truly biologically correct when photographing nocturnal critters, the photograph would be all black and you wouldn't see them—it's nighttime. But we want to see them, which is the point of photography. So with this simple idea, just like that, you're shooting like they do in the movies!

Montane vole, taken using a blue gel over the flash. Photo captured by Nikon D2Xs & AF-D Micro-Nikkor 60mm f/2.8 lens, using an SB-800 Speedlight flash unit, on Lexar digital film.

And the Sun Still Shined

A personal mission of mine for the last decade has been to see for myself what's happening to the planet with its warming. To that end, in October 2005, my good friend Roger and I headed to Alaska to observe and photograph polar bears. It was a few weeks prior to the sun setting 24/7 for winter. The light was killer. Knowing this, and the remote location we were flying into, I packed light and took just one SB-800 with no external power source, as I would only use the flash for a portrait perhaps. We arrived in Alaska and flew into the location only to find that because of some disturbance, the polar bears (which were coming to feed on a whale carcass) had switched from feeding during the daylight to all-nocturnal activity.

That's right, I traveled all that way to photograph polar bears, and they were coming out only at night. Holy shit! And what did I have with me to deal with the situation? One SB-800. Worse, I had only one AAA LED flashlight to work by at night. Well, those were the cards I was dealt, so I played the hand.

> If you're using remote flash out in the cold, prolong your battery life by holding chemical hand warmers around the battery compartment with an old sock.

The first thing was I had to make the flash work at night. When it's −10° or −15°, a flash hanging out in the cold air loses battery power really fast. I went to the trading post and, while they had no flashlights or AAA batteries, they did have chemical hand warmer packets. I secured those to the outside of the flash unit with wool socks cut down to fit, keeping the battery chamber warm, so the batteries had a normal life.

To make the light from that single flash do the most work for me and keep me a safe distance from the bears, I needed to shoot with

Polar bears feeding on a whale carcass. Photo captured by Nikon D2Xs & AF-S VR Zoom-Nikkor 70–200mm f/2.8 lens, using one SB-800 Speedlight flash unit, on Lexar digital film.

a fast, light lens. I settled on the 70–200mm f/2.8 lens and shot almost entirely at f/2.8. You see, I didn't stay inside the safety of the vehicle to shoot; I got outside with the bears the majority of the time. With only a AAA LED flashlight, I tell you a couple of times I jumped into the van really, really fast with my heart a pumping at full speed. Not that I learned better and stayed inside, it was just part of the experience.

There were a couple of things that made the images work, technologically and photographically speaking. The i-TTL and AF-ILL systems (auto-focus assist illumination, which illuminates the subject to help the camera focus in low light situations) made the images happen, literally. I can honestly tell you that my mind was firmly locked onto the subject. Man, was it locked onto the subject! The camera's technology, a majority of the time, had to focus for me, and the i-TTL did all the exposure for me. It worked great, even in that cold world.

The other giant factor in success was the fact the subject was white. That was a huge lifesaver! The camera had no problem locking onto that white subject for focusing, and the i-TTL was very happy to work with reflected light from a white subject. At the same time, that white subject made the black world even blacker. With those two visually important colors in the photos, the red from the blood really stands out, helping tell the story.

Looking at the images, you might notice one with a slightly yellowish tint to it. If you look even closer at that photo with the yellowish tint, you'll see the bears look a little fatter, and they have a little more character to them. That color tint, that very small shadow

> Do you change your camera's clock? Changing the time zone in your camera can be a big help after the fact. From making filing your images easier to going back a year later and seeing what time the light was great can be done easily when the clock in the camera is set accurately.

Polar bears feeding on a whale carcass. Photo captured by Nikon D2Xs
& AF-S VR Zoom-Nikkor 70–200mm f/2.8 lens, using one SB-800 Speedlight flash unit, on Lexar digital film.

helping to make them plump, is thanks to the van's headlights. Whenever possible, I used the headlights as my fill. I had to lower my shutter speed to 1/30 of a second to make it work, so some images were deleted because of movement—things were too out of focus. But I got a few that did work.

Packing light, I had an off-camera TTL cord with me (the SC-28), but I did not have any kind of bracket or flash arm. When the flash was attached to the camera's hot shoe, the light would head out and quite often light more of the background than desired. The only way to deal with this was to raise the flash up above the camera. That also helped with the red eye (which is a whitish-blue in polar bears). After a night of shooting, my arm felt like it was going to fall off from holding that flash up.

The moral of the story is this: you *gotta* know flash! Even in this situation, where I was working with the bare minimum of flash gear, knowing how to make the most of it saved the day. Could a better image have been made with more gear? Oh, heck yeah. But since that wasn't an option, the one single flash worked.

So, in a Blast of Light

Heading out to shoot, it's time to get the gear out and set up. The smart photographer takes a moment and does a 360 of the sky. What's your prediction for what the light is going to do? With that in mind, what's the subject you're focusing on for the shoot, and where do you think you'll find it? In checking and asking yourself those questions, if even for a heartbeat the thought of flash comes in, then the flash should be set up and taken along. I usually mumble at myself when I think I need flash. I mumble even more when I think it and don't act on it, because then I normally do need it.

So, the flash rig is gotten out and readied. On the Gitzo 5560, a Wimberley Head II with a Wimberley F-9 flash arm is attached, along with the SC-29 AF TTL cord. The SB-900 Speedlight flash unit is then slipped into the flash connector end of the SC-29 with a Better Beamer flash extender attached to it. The last thing is an SD-9 battery pack connected to the SB-900 and held into place on the Wimberley head with a Velcro strap. The sync on the camera is set, and a quick meter check is done so the camera isn't being friendly and saying HI (go back to the technical stuff on page 206 if you don't get this). With that, it's off to shoot I go, knowing that a very important tool—flash—is ready to go. And while I still think it's a pain in the ass to use, I wouldn't go out shooting without it. It's just that essential to success.

CHAPTER 7
They Set the Stage

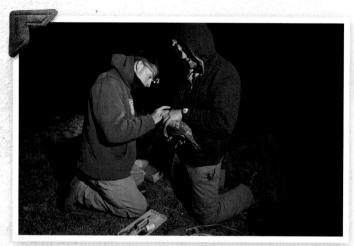

Processing a female greater sage-grouse. Photo captured by Nikon D3 & AF-S Nikkor 24–70mm f/2.8 lens, using two SB-900 Speedlight flash units, on Lexar UDMA.

Moose kissing a moose

A Moose with a salmon.

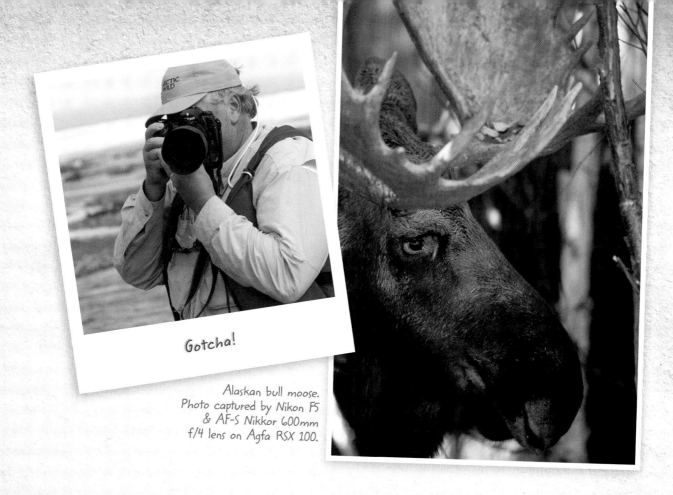

Gotcha!

*Alaskan bull moose.
Photo captured by Nikon F5
& AF-S Nikkor 600mm
f/4 lens on Agfa RSX 100.*

I was hungry for moose. On my way to St. Paul Island, I fished in the Kenai River for the first time and pulled in my first— but nowhere near my last—salmon, and had my picture taken with a moose, which really got my wheels turning (ironically, the photo of me having a photo taken with a salmon and a moose won someone else a photo contest. Small world).

When I got home, I started snatching up all the material I could find about moose biology—where to find them and when. I was in my basic search and destroy mode when I hunger to photograph a new species. It just so happened that, during this quest, a *National Geographic* special came on PBS about moose. I turned it on to see my good friend Joel Sartore lying on the ground, camera up to his nose, with a 15mm mounted to it pointing straight up, shooting into the face of a bull moose!

The next day, I was on the phone to Joel asking the five W's (I wanted to be that close to a moose). Joel, being a great guy and trusting me, provided me with his contact at the Alaska Department of Fish & Game. With a couple of calls, I had the director of the Kenai Moose Research Center on the phone. Sharon and I were going to be in Alaska shortly after this, as it happened, working on a piece about moose for Audubon (it never ran), so I made an appointment to meet with the director. He had no clue who in the world I was, so without the meeting, I wasn't going to get anywhere.

A month later, I nervously sat in an office in Soldotna, Alaska, waiting for our appointment. This was a first for me. I've always met biologists for the first time in the field on their research site. I never had to "interview" before, but this biologist had had a bad experience with a photographer, and all photographers since have

had to go through this (including Joel). I was shown into the office, we made our introductions, and started a conversation. When it got to my reason for visiting the research center to take photos, well, let's just say my answer ("Because I want to") wasn't embraced with open arms. The conversation went downhill—there was no further reason for him to talk to me. They weren't going to let me in.

I turned the conversation from photography to biology. I was going to at least leave with some answers. I think it was obvious I'd done some homework, knew enough moose biology to be dangerous, and that I wasn't just some photographer on vacation. Then the biologist made a comment about antler growth. I said I'd heard of the same problem with an introduced population of tule elk in California, and that they'd found the problem was a copper deficiency.

This got the biologist's attention. He gave me a look that said, "Maybe he isn't that dumb." He asked if I had a contact name I could provide him. I said sure, it was the same biologist I had done the sheep capture, Armagosa vole, and so many other projects with. With that answer, the biologist just stopped and looked at me. It was a very uncomfortable stare. What he said then shook me to my core.

Young moose recovering from a broken leg at the Kenai Moose Research Center. Photo captured by Nikon F5 & AF-S Nikkor 28–70mm f/2.8 lens on Agfa RSX 100.

"You're *that* photographer, aren't you?" In my mind I was saying, "What the hell does that mean? What photographer?" The biologist then asked, "Did Vern ever tell you about his Ph.D. defense?" I had done a bunch of photography for Vern for his Ph.D., which he got by bravely going back to school late in his career. I owed (and owe) Vern a lot, so it was the least I could do. He went up to UAF (the University of Alaska Fairbanks) for a year to finish his Ph.D., armed with a ton of research and the photos we had gone out and made. While I've never personally done it, I've been told that you have to go in front of a panel of peers, professionals, and professors, and defend your Ph.D. dissertation—a rather nerve-wracking experience to say the least. It was for this defense I'd made the photographs for Vern, and this experience the biologist was referring to. I simply said, "No."

The biologist told me this story: "At the very end of Vern's presentation (I've never asked Vern if this is true or not), the oldest, wisest, crustiest member of the panel, who makes the room nervous just when he shifts in his chair, paused and cleared his throat. 'I don't know much about your science, but those are the damn finest photographs I've ever seen!'" With the telling of that story, I was welcome at the Kenai Moose Research Center.

There Is a Reason for All of This

It is a very, very small world. It started with my mom "helping" with the first intros that led to the next with the least Bell's vireo, which led to the sheep capture, and that led to an elk and Ph.D. project, which led to moose in Alaska. It is an amazingly small and rewarding world.

Biologist conducting research at the Kenai Moose Research Center. Photo captured by Nikon F5 & AF-S Nikkor 28–70mm f/2.8 lens on Agfa RSX 100.

Young moose being bottle-fed at the Kenai Moose Research Center. Photo captured by Nikon F5 & AF-S Nikkor 28–70mm f/2.8 lens on Agfa RSX 100.

It is very easy to get involved in wildlife photography, which is a really good thing. If you're really fortunate, like I am, you don't even have to leave the comforts of your home to photograph critters. An extension of this is the neighborhood pond or marsh. Taken even further are the great adventures we are so fortunate to take to locales like Yosemite or Yellowstone or Alaska, and across the seas to Africa, Australia, and New Zealand. Wildlife photography is the grandest of photographic pursuits!

As photographers, and wildlife photographers, what is it we seek? In the grandest sense, to move those who view our images with the magic we witnessed the moment we made that image. And, for

Bison in Yellowstone National Park. Photos captured by Nikon D3S & AF-S VR Zoom-Nikkor 200—400mm f/4 lens on Lexar UDMA.

many, that is reward enough for our efforts. I'd like to suggest there is another reason for what we do, one even more selfish and with even greater rewards: knowledge.

You might have bought this book to see some beautiful images, which I appreciate. But more than likely, it's in the quest of knowledge. You wanted to learn more about your craft, improve your photography, and find a new camera toy or two you could add to your bag.

> The challenges of wildlife photography can easily be found in our pursuits, from our home to the wilds of the world. I can tell you, though, that you won't challenge yourself, or your photographic skills, until you're working with a biologist. Working within the confines of not upsetting data collection, but being a part of that effort, in itself will improve your photography. Going beyond that and finding answers to biological questions with your camera is immensely satisfying.

Us photographers, we're cut from the same cloth for better or worse. There's even more you can learn, greater knowledge to be gained, that will further your photography, and with it, make you hunger for even more. That's working with biologists (or any professional in your photographic passion).

The quest for knowledge should lead you naturally to working with biologists. I've never been fortunate enough to take a single class in wildlife biology or management. All I know about biology comes from reading and working with biologists (and a fair amount of field time to see it unfold). I've never been shy about the fact that my success is directly attributable to the biologists we've worked with over the decades. We have photographed 127 threatened or endangered critters during our career, thanks to biologists. The men and women who have shared their hard-earned knowledge with us so willingly are the reason I have the knowledge and skills I do to share with you.

You can make a difference in this world with your photography. You can go beyond the mere goal of grabbing heartstrings—you can change minds! You can take your quest for knowledge to new levels,

taking your photography with it to make a difference. You've probably at some time seen the National Geographic Channel or read a *Nat'l G* and said to yourself something like, "I wish I could do that!" Well, I'm telling you that you *can* do that, and a lot more. This is not limited to a fortunate handful of photographers, not by any means. It is limited to only those with the imagination and ambition to go after it.

How Do You Go After It? Where Do You Start?

You start with your heart. The best place to start is with a critter or cause that not just interests you, but tugs at your passions. No matter how big or small a critter, they can all benefit from your skill and craft. So start there. Just remember, you're starting something that will take time. You won't get the shot the first time out. Like all good things, it takes time, which is why it needs to be something you are passionate about. You should add to that some practicalities that life forces upon us.

Heading to the middle of the Gobi Desert for your first project isn't really smart. Starting simple and close to home gives you a number of safety nets, permitting you to grow as you go. Keep in mind that when you take on working with a biologist, you're making a commitment to time as well as your craft. I'm not saying you're going to be with a project for 23 years, like I've done, but it could be a whole season or year. (That's until you get hooked, and then the time seems to just slip away.)

Say you have a passion for small things like bugs. How do you find an entomologist (bug biologist) and project near home? These days, with the Internet, it's pretty easy to get started. Google Scholar Beta (http://scholar.google.com) is an amazing resource where you can type in a species' common or Latin name and a flood of information comes flying out. You can also tap into BIRDNET (www.nmnh.si.edu/BIRDNET), a doorway to a number of scientific journals for ornithology.

These are just a sampling of the Internet resources you can use to search for the critter you want to work with. You research your critter

What's the mammal ID book I recommend? I wish I could recommend just one, but there isn't just one. I literally have a library containing (right now, because it's always expanding) 27 mammal ID books.

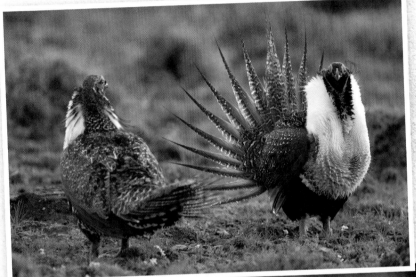

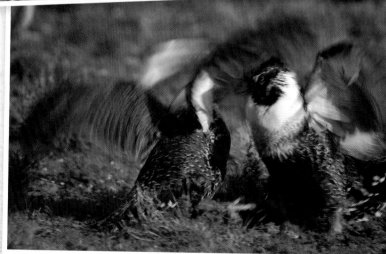

Male greater sage-grouse fighting. Photos captured by Nikon D1H & AF-S II Nikkor 600mm f/4 lens on Lexar UDMA.

by looking for papers that have been written about it, because that's where a treasure trove of information awaits. Besides the basic biology you need to read about, you need to learn the name of the person who is doing work on that critter. With a couple of clicks and some reading, the whole world opens up for you.

> The first time you meet with the biologist in the field, do yourself a favor and leave your gear in your vehicle to start. Take time to get to know the biologist, their project, and how they go about collecting data. You should have a body hanging on your shoulder with like a 24–70mm lens attached, but start off by being a really good listener. Make sure you take notes when you're listening—notes can help you have the perfect gear for the project and information to write about your experiences later. Being a professional from the get-go garners more from the start than I can ever communicate.

Biologist performing an ultrasound on a moose at the Kenai Moose Research Center. Photo captured by Nikon F5 & AF-S Nikkor 28–70mm f/2.8 lens on Agfa RSX 100.

Do you just call up the biologist? Yeah, you do! No matter how old you are, or your years of experience or lack thereof, you can do it. I know this for a fact because of all the photographers who have already followed my suggestion and are now out there doing it, making a difference. Now, do you call up a biologist and say, "Hi, I'm a photographer and I want to photograph polar bears"? No. When you make that call, think of it as forming a partnership. In any partnership, each partner brings something to the enterprise, so, as a whole, it can succeed. You need to be able to explain to the biologist what you're bringing to the partnership when they bring you on board. You'd be surprised how doors open when you simply say, "I want to photographically document your project."

What can you bring to the partnership? Your skills as a photographer have to be tops. I'm not saying you have to be the best photographer on the planet, but rather, the best you can be at that point in time. You have to understand that there is no pay involved— you are a volunteer. Your pay is much greater than money and is something you can take to the bank over and over again: knowledge. You will be part of a team whose main goal is data collection. When you approach the biologist with that knowledge and attitude, you'll do just fine.

What Gear Do You Need to Get Started?

Like all things photographic, it starts with the camera. You want to be confident with your camera gear. You want to be confident with your photography before you take on a project, as well. Confident is not the same as expert. Whether you own one lens or five, possessing the skill to make them work for you is what you need to get started. You're taking on the responsibility of more than just making pretty critter pictures—that's really the least of your worries.

What's a good basic setup and skill base to possess when working with biologists? There are a couple of factors affecting the answer to the question. Are you thinking of working on a project about whales, or one about butterflies? Are you thinking about heading to the Arctic, or to the end of the LAX runway? These are the extremes, but

certainly not out of the reach of anyone. The bigger the project, the bigger the bag of gear you need and skill set to use it. As you're about to read, I might take the entire locker of gear with me or simply a body, lens, and flash.

In researching to find the biologists, take a little extra time to read through the paper. You can blow past the science part, but be sure to read the methods or methodology section. This will help you think through the gear you'll need. There is no special gear required, but you'll find flash is pretty much indispensable. The main use will be for flash fill when photographing the biologist at work. We're not talking annual report portraits, but a professional working in the field—working with gear, working with critters, working at their profession. These photographs can be as challenging as getting photos of the critters.

One thing that has always helped me is showing up mentally prepared on the first day. That's reading everything I can about the critter. I know that much of what I'm reading is not 100% accurate or up-to-date, but it's like reading an instruction book prior to working with a new camera body. It gives you a place to start, something to fall back on, and creates questions that can be filled in with accurate info once you dig in. You'll find biologists love to tell stories, so give them that chance.

If there is one skill you should have at least a basic comfortableness with, it's shooting portraits with a wide-angle lens. I should refine that even more: wide-angle portraits with flash fill. Refining that even further: wide-angle portraits with flash fill done on the run. Yeah, that's the skill you need. Probably the one thing wildlife photographers don't know is the "Joe move." This is the name I've given the basic flash fill pose Joe McNally does in a pinch. Your right hand has the camera, and the left hand has the flash (a TTL cord connects them). The camera and right hand go up to your left shoulder to hold it still, the left arm goes underneath and sticks out to the right as far as you can stretch, pointing the flash at the subject. This simple off-camera flash, handholding style works killer when photographing biologists at work.

Just What Can They Do for You?

Getting down to brass tacks, what's in it for you? They put you in front of some of the most exciting, rare, and never-before-photographed critters on the planet. At times, this will happen at locales no one else can get into. That ain't too shabby. They will teach you more about biology than you could ever expect to learn anyplace else, knowledge you can use when working with other critters to get close physically while knowing you are doing nothing that could possibly harm them. They give you the confidence to take on any project, any place, with any critter.

I went and counted, and I've worked with 217 biologists over the course of my career, so far. Only two didn't become friends of mine. These are some of the nicest, friendliest, and smartest folks I've come to call friends. They are also the finest teachers I've learned from, which brings us full circle as to why I work with them and why I'm encouraging you to do the same. Making better photographers of ourselves while in the quest for knowledge is incredibly satisfying.

Attaching a radio pack to a greater sage-grouse. Photo captured by Nikon D3 & AF-S Nikkor 24–70mm f/2.8 lens, using two SB-900 Speedlight flash units, on Lexar UDMA.

What seems like a lifetime ago, the spotted owl was on just about everyone's tongue. An endangered species whose plight was horribly handled by science and government, they became the battle cry for old-growth forest protection. In the midst of this, I decided I needed to learn the facts for myself, so to the field we went.

The entire Peterson family met the biologist early one morning, high up on a mountain, to be taken to an undisclosed site. (Until the boys went off to college, they were pulled out of school and went on most projects.) We got briefed on what would happen that day. Everything centered on mice. Live mice—ones used for medical research, so they were healthy and biologically clean—were popping around in a cage, perhaps knowing their fate. With some gathered up and placed in a pouch, up the hill we went. The biologist had to learn that day if the pair of spotted owls in the territory had paired up, and if they had, if they had a nest, and if they did, if they had eggs or kids. All of this would be discovered with the help of a single mouse.

I walked up the hill with an 800mm f/5.6 lens with a Nikon F4e body attached, a Nikon F4s with an 80–200mm f/2.8 lens on my shoulder, and a 20mm f/2.8 lens, an 85mm f/1.4 lens, and a flash in my vest pocket. Within a heartbeat, we came up to the first owl. On this, and a long list of other projects, I wish I'd been a better photographer back then when I look at the opportunity and photographs. The owl wasn't that high above us, the 200mm easily filled the frame with it as it stared down at us. I made a couple of clicks as the mouse was brought out. Moments later, the mouse was offered to the owl and it happily snatched it and winged off. What the owl did with the mouse told the biologist a lot.

If the owl just ate the mouse, it would mean it wasn't paired up yet. It didn't, it winged off with the mouse. So, now we knew it was a mated pair. Also, if it ate it (really don't know if it was the male or female at that point), then there was no nest. When it winged off with it, we needed to get running up the hill to see what it did with the mouse. A few moments later, we were staring into the nest with two new hatchlings. That one mouse told us a lot about this pair.

It was a great day watching the owls be owls. Since we were there, the owls got a couple more mice than they normally would have, as I asked questions that the biologist wanted to find the answers to. Normally, the mouse is thrown for the owl to capture, but I wanted to know if their desire to catch it would outweigh any fright. The biologist offered one up at arm's length, and the owl came down after a little thinking about it and took the mouse from the biologist. It took it a short distance and landed on a downed trunk, ate the mouse, and just looked around. I asked if I could approach it to photograph it. The biologist said sure, and if the owl didn't like it, it would just fly off.

Me doing the "Joe move."

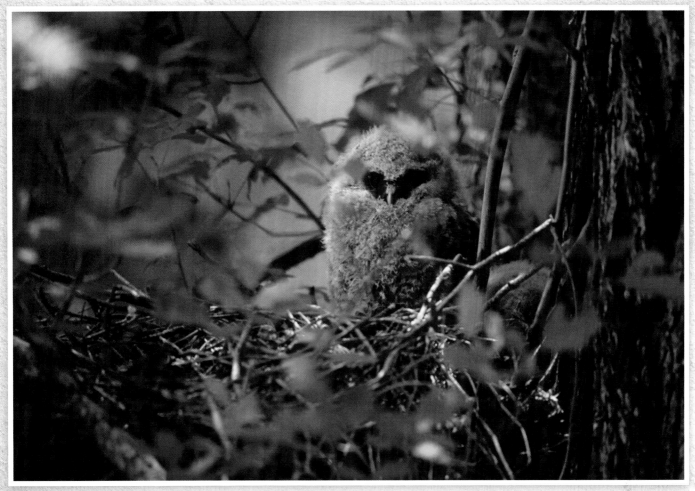

Spotted owlet. Photo captured by Nikon F4e & Nikkor 800mm f/5.6 lens on Fuji 100.

The way I work with biologists—always—is to just let events unfold. I do not direct things or set up shoots. I work as they work, photographing the project as it unfolds. I never lose sight of the fact that they are in the data collection business, and I don't want to do anything to mess with that. That's why I asked if it was okay to approach the owl. Armed with the 80–200mm, I slowly approached it. It was perched on a vertical broken branch on this downed trunk. The trunk's diameter was slightly greater than my stride, so my feet

didn't touch the ground. The only decent background to be obtained was a direct approach, shimmying down the trunk.

Have you ever tried to stalk an owl while shimmying down a trunk that's giving you splinters in a very sensitive place? What I won't do for a photograph. I kept sliding down the trunk, the owl watching me either out of amusement or bewilderment, but whatever the case, it just watched. I kept easing closer, until all of a sudden, I lost my grip

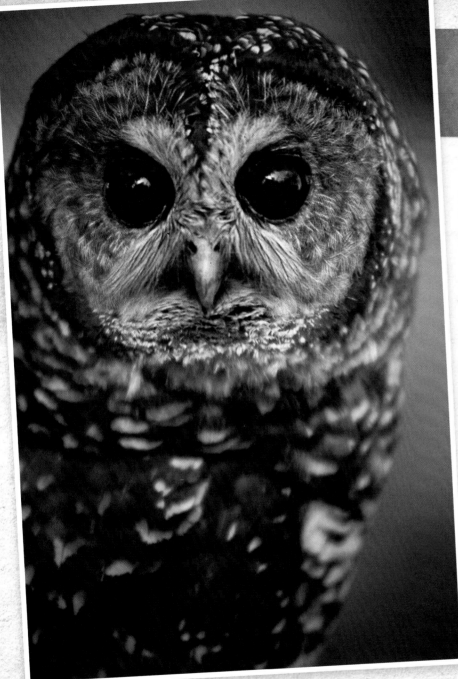

Spotted owl. Photo captured by Nikon F4e & AF Nikkor 85mm f/14 lens on Fuji 100.

What family of birds do I wish I could spend one heck of a lot more time photographing? Owls. They are so cool, so full of character, and they grab an audience's heartstrings faster than any other critter.

and went down the trunk like one of our boys on a slide. Between me and the owl was another broken branch about five inches long and pointing in a direction that made my eyes get really wide.

I'm watching the owl, watching that branch as I try to stop myself, and like some Monty Python movie, I stop only at the last moment before real damage occurred. I look up and the owl is still staring at me (like you see here), about as wide-eyed as could be. I'm about five feet away from it. The camera is not at my eye but in front of my chest. I ease it up and put it to my eye only to see I'm physically too close. I can't focus. I slowly lean back, trying to get a sharp image, and just as I hit the shutter, the owl decides it has had enough and flies off. I turn around to see the audience still rolling on the ground laughing.

We ate our lunch on the slope across the ravine from the nest. From our perch, we could see right into the nest. The afternoon was slipping by, the light not really coming into the nest, but that didn't stop the shooting. The owls had had a couple more mice by now. We were seeing if they would eat them or take them to the kids. One adult perched right over our heads, within easy shooting range,

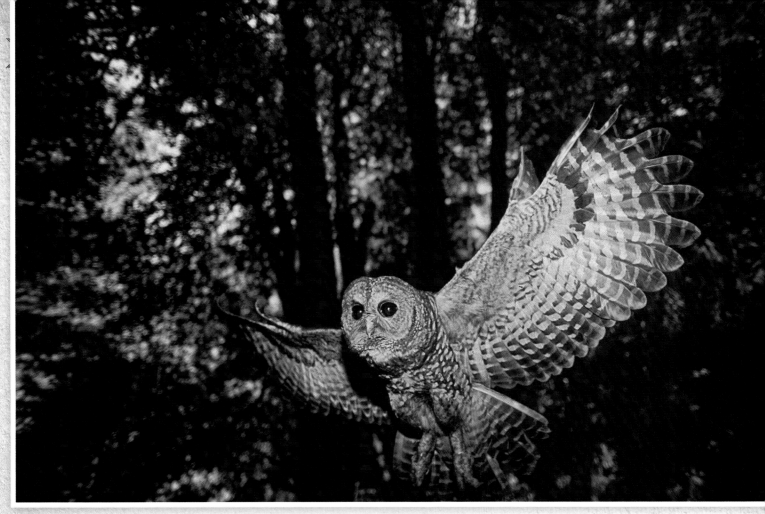

Spotted owl about to snatch a live mouse off my head. Photo captured by Nikon F4e & AF Nikkor 20mm f/2.8 lens, using an SB-16 Speedlight flash unit, on Fuji 100.

watching for another mouse offering. It was then I asked if we could offer the mouse so I could get a flight shot. The biologist was up for it, but figured the only way to get the owl close was to put the mouse on my head!

That's right, put the mouse on my head—the owl would have to snatch it from there for me to get the shot. The biologist figured that he could pull the mouse away at the last moment and the owl, seeing this, would pull up and fly away. No one had ever tried this before, so who knew what would happen. There's a famous

> *That's right, put the mouse on my head— the owl would have to snatch it from there for me to get the shot.*

article, "An Eye for an Owl," (and a later autobiography, *An Eye for a Bird*) about a photographer who lost his eye to an owl. That was going through my mind right then.

So, here I was, lying down, the F4e loaded with a fresh roll of film. The 20mm f/2.8 lens was attached and prefocused in my hand, predetermining the distance I thought the owl would be when the mouse was pulled away from my head. The flash was attached in the hot shoe, set up to be the main light. With everything set, the mouse was put on my head, and without a heartbeat in time, the owl

> *I'm nothing special. I've just earned a reputation of being a professional. You could earn that reputation, too, with time spent working with biologists, your own professionalism, and of course, your photographs.*

Trapping a San Joaquin kit fox. Photo captured by Nikon D3 & AF-S Nikkor 24–70mm f/2.8 lens on Lexar digital film.

swooped down to snatch it. The biologist pulled the mouse away and the owl turned on a dime and winged back up to its perch. It never got close to me. We tried it again with the same result. We tried it a third time with the same result. We put the mouse on my head, but this time, the owl just looked at it and didn't move.

"If it flies back in, it has to be rewarded with the mouse" the biologist said. "*Do you want to continue on with this?*" Of course I did, which meant I had to let the owl take the mouse from my head. Spotted owls have the skill to snatch a flying squirrel off a tree trunk right after they land, so I knew they had the skill to take the mouse and not my hair. The question was, did I have the nerve to put losing my hair aside and make the image? You can see the result on the previous page, and I still have my hair. I never felt a thing!

You Can't Do It on Your Own

Something that's really important for you to understand is you can't do this on your own. You do your homework, you read the papers, and you not only learn the name and contact info for the biologist, but you might also learn where they are working and how. Don't think that with this information you can bypass the biologist and go it on your own. I say this for many reasons, the main one you need to be very aware of is the legalities.

No matter whom the biologist is or who they work for, they have to have federal and state permits to do what they do. Permits are required for everything when entering particular areas, from trapping, to handling, to marking critters. This is not to be taken lightly. One of the huge benefits of working with biologists is your actions come under their permit, allowing you to be there shooting. There is no way you could get your own permit, so in most instances, this is the only way in.

The reputation I've earned and have in the biological community is greater than that I've earned in the photographic community, and means much more to me. That reputation is based on my simple mantra that no photograph is worth sacrificing the welfare of the subject, along with my willingness to put the camera down to help. It has allowed me to do many things that would normally require a permit.

You will have to prove yourself. There might have been a photographer before you that burned the bridge, or there might be a biologist who has never worked with a photographer before. Whatever the case, you have on your shoulders more than the weight of making the image, but also that of making a reputation for yourself as a photographer who can be trusted and whom biologists want to work with. If you thought selecting the right f-stop was a white knuckler, wait until you take this one on.

Have You Ever Been Told No?

I've been incredibly fortunate that only one biologist ever said no to our request to work with them. I reminded them of that when, later, after working with the species with another biologist, they called requesting images for their article in *Nature* scientific journal (it is a small world).

We've been incredibly fortunate to work with the some of the top biologists and scientists in the world on various projects. From creepy crawlies, to slimy things, to plants (I really don't like doing plants. I should never have to get that low), to just about everything in between. Many of the biologists I work with are involved with more than one species, and quite often are involved in entire ecosystems. The work I did with giant kangaroo rats took me to the San Joaquin pocket mouse, blunt-nosed leopard lizard, riparian woodrat, riparian brush rabbit, and then to the San Joaquin kit fox. That work honored me by getting my name added as a contributor to the largest endangered species recovery plan ever written, and later by being made an associate with the Endangered Species Recovery Program.

I'm going to tell you about three of our projects, pretty important ones, to provide you with a little better understanding of what it's

Processing a San Joaquin kit fox. Photo captured by Nikon D3 & AF-S Nikkor 14–24mm f/2.8 lens on Lexar digital film.

I was once told when I started out that I would never make it as a wildlife photographer, especially one specializing in endangered species. I guess that, in a sense, I was being told no. I didn't listen very well— I went on and made it all work after all. You can too.

all about. Earlier, when I made a reference to *National Geographic* kind of work, it wasn't a very accurate analogy. The glamour most project on those articles is not what you're going to experience. Everything doesn't turn out perfect in the end; the great photograph isn't always captured. There are no big bucks involved, no TV cameras—it's just you, the biologist, and fieldwork. But if the images stir you, grab your imagination, then you know the potential and the rest, well, is up to you.

What You Can Accomplish in Three Days

The Attwater's prairie chicken (APC) is one of the most endangered birds in North America, with a wild population ranging between 40 and 60 birds in 2006. That's all. They were listed as endangered back in March 1967 amongst an infamous group: the timber wolf, California condor, San Joaquin kit fox, black-footed ferret, dusky seaside sparrow, and other imperiled critters (some of whom are now extinct). Since being listed as endangered, the APCs have become even more endangered, if there is such a thing, as their

Collared pika. Photo captured by Nikon D2Xs & AF-S VR Nikkor 600mm f/4 lens with TC-14E II on Lexar digital film.

Did you know that I put out a quarterly publication called *BT Journal*? In it I share my latest projects, what I've learned behind the camera, and the tools and techniques I'm working with and on to improve my photography.

numbers have continued to drop. In the '80s, there were about 500 APCs (whereas in the 1850s, there were nearly one million!). A drought in the '90s caused the population to crash, leading to the number found in 2006.

In 2006, a long sought opportunity finally came through. "So," an email from the U.S. Fish & Wildlife Service in Washington, D.C began, "what's happening with those Attwater's?" I replied to the email. Two weeks later another email came, "So, what's up with the Attwater's?" The hint was pretty darn clear—I needed to find out what was happening with the Attwater's and do it now. It's a species I'd wanted to get involved with for many years, but the opportunity never came—their numbers were simply too low to take the chance of any failure. Out went the email to a biologist who I had been in contact with for a number of years: "What's up with the Attwater's?"

The reply was that it might be the year. We arranged to get in touch in a few months. When the time came, I emailed the same question. The response was very encouraging. Then the winter rains came, the weather making it hard for man and beast, and the outlook started not looking good at all. The weather was adversely affecting the Attwater's breeding. The appointed dates came and went. Finally, at the end of April, I sent off one last email. I had no real hope. I figured another season would slip away without getting out with the APC. Then the response came back: "Things seem to be late because of the weather, might be able to make it all work the 2nd week of May." I was off to Sealy, Texas, and finally going to work with the Attwater's prairie chickens. Hot damn!

As soon as I purchased the plane ticket, my mind began to race. I would have three days to photograph the biology and biologist. What tools would I need? How would I get them there safely? What techniques should I experiment with before arriving? What plan of attack should I previsualize for three days of hard-core photography? What photographs do I *have* to get on this trip? What story lines should I set up to get and come back with? Will I have a second opportunity to work with the APC, considering how long it took to get my first? My heart was pounding with excitement, my mind racing with questions. Life is good!

Trip Prep

The first thing I did was a literature review on the APC. That took about a heartbeat, because there is very little out there. Fortunately, my good friend Joel Sartore had spent some time with the APC and did a piece for *National Geographic* on them. Joel sent me some of the info he had gathered during his time with the APC (he really is a good guy!). I looked at his outstanding images and did some back engineering from them to further think through the gear I needed. I also went through my images and notes from photographing the greater prairie chicken (a close cousin). While photographing the APC on their booming grounds was a very small part of my photo coverage, I wanted to get it right.

After all was said and done, I took a whole lot of gear. I started a list weeks before departing, jotting down an item every time something came to mind. I started setting gear aside a week before, so nothing got forgotten. I ended up shipping 115 lbs. of gear to Texas in a Pelican 1640 case. I shipped a spare D2Xs, a 200–400mm VR lens, a 200mm f/2 VR lens, a 28mm f/3.5 PC, six SB-800 Speedlights, an R1C1 wireless close-up Speedlight system, an Epson P5000 multimedia photo viewer, four SD-8a battery packs, light stands, flash brackets and cords, a GPS unit, Justin clamps, Lastolite panels, spare batteries and chargers, Kenko extension tubes, a fanny pack,

A newly hatched Attwater's prairie chicken. Photo captured by Nikon D2Hs & AF DC-Nikkor 105mm f/2 lens on Lexar digital film.

and a blind. This was in addition to the gear I took with me on the plane: my full MP-1 complement (See Appendix 1), including the 600mm lens. Amazingly, there were only a couple things I didn't use, like the light stands and large Lastolite panel, during the three days. Everything else got a workout.

The last thing was to take care of travel and lodging plans. Sealy, Texas, is truly rural, so a drive after landing was a given. With that knowledge, I planned to fly in a day early and out the day after my last day of shooting. With all of that dealt with, I just had to count the days until I was with the APC.

The Shoot: The Beginning

It was 4:30 a.m. when I pulled out of the hotel parking lot, everything wringing damp from the humidity (great thunderstorm the night before). I arrived at the refuge a half an hour before my meeting time. With the light just becoming a hint on the horizon, I started looking for images. The moisture in the air was incredibly thick, which made getting a sharp image with a two-second exposure iffy at best. I got my bins out and scanned, looking for any life out and about that would make a good image. I saw a pair of white-tailed hawks perched on power lines in the distance. I made note of where they were, so I could come back later to get them in the viewfinder, since they are a predator of the APC. It was nearing time to be at the headquarters, so I got back in the SUV and headed down the road.

At 5:30 a.m., I met the Attwater's Prairie Chicken National Wildlife Refuge manager, Terry, at the refuge headquarters. First, he introduced me to the business of the refuge. It was established in 1972 for the sole purpose of recovering the APC by protecting a small

remnant of the gulf coastal prairie that was home to the APC. So, after a quick tour of the headquarters itself (so I would feel at home), out to the refuge we traveled. I loaded my MP-1 in the truck, along with a handful of SB-800 Speedlights, the 200mm f/2 VR lens, Lastolite panels, and Gitzo 5540LS tripod, and off we went.

As we traveled, I listened to all that was said. I had my camera in my lap ready to work. I traveled with the 200mm f/2 lens at the ready, the D2Hs (my main camera) with a 12–24mm DX lens attached, and an SB-800 on an SC-28 remote cord plugged in, turned on, and ready to go.

While every APC wears a transmitter so their location is known, we started our search the old-fashioned way, using our eyes and ears. We made a turn in the road after driving a ways, and up ahead was a male APC, standing right in one of the dirt treads on the road. It stood kinda out of place in relationship to where the booming grounds were located, and where it should have been at that time of the day. It was kinda hunkered down and paying absolutely no attention to us. As is typical with the tall prairie, getting elevation to see is a must, so Terry hopped out of the vehicle to look around and see if other APC were about.

> I feel sorry for folks when I tag along in that I ask a million—perhaps two million—questions. On all my projects, I tend to have questions that are rather specific and often take my hosts by surprise, since they are not your average "How's the weather?" kind of questions. But, with limited time, I need specific answers to be as prepared a photographer as possible to capture the images. At the same time, I need to be as accurate as I can be in my reporting, so getting the facts brings all the loose strings together in my own mind.

When Terry hopped out to take a look, I hopped out with camera in hand to start working. With the very blown-out background caused by sunlight coming through the overcast, without even taking a shot, I instinctively dialed in minus exposure compensation in the body, plus exposure comp in the flash, and started shooting. The flash was held out as far to the right as it could go as I leaned over the hood of the truck. After quite some time, because we couldn't proceed as long as the APC stood in the road, I asked if I could walk up and photograph the male.

I proceeded to mount the 600mm on the tripod and walk up to the APC. Its body posture didn't change as I got closer and closer. The light was pretty soft and gray from the morning overcast as I began to shoot. I've learned never, ever pass up an opportunity because, well, you may never get another. I've been on many a project where the first time out on the project, I never saw the subject, let alone got a shot off. So I continued forward and kept shooting, even though the photo was okay at best. I got within 30 feet when the male finally seemed to take note of me. All he did was turn his head and look at me. I shot some more frames, then with nothing new in the viewfinder, I just watched him. After a while (perhaps 15 minutes) the male

Terry looking for Attwater's prairie chickens. Photo captured by Nikon D2Hs & AF-S DX Zoom-Nikkor 17–55mm f/2.8 lens, using an SB-800 Speedlight flash unit, on Lexar digital film.

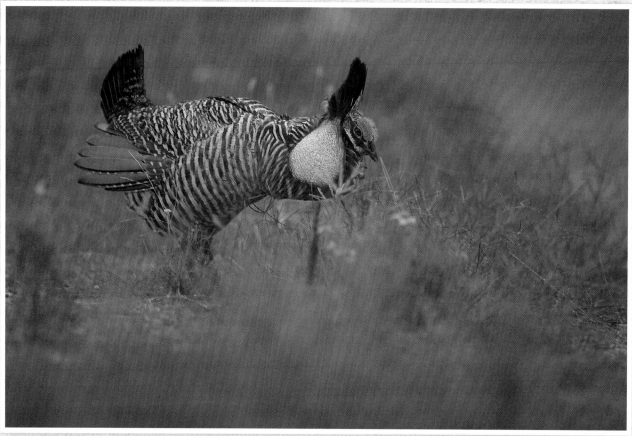

Male Attwater's prairie chicken performing a mating dance. Photo captured by Nikon D2Xs & AF-S II VR Nikkor 600mm f/4 lens on Lexar digital film.

began to feed, walking ever so slowly in my direction. After a little longer and a few more frames, he simply flew off down the road.

We finally arrived at the booming grounds. It was covered in water, not resembling a prairie, but rather a wetland. We saw a number of bobwhite quail off in the distance and a mess of jackrabbits, but at first, no APC. We got out of the truck and stood on it to scan the horizon when we first heard the distant booming. If you're not familiar with the sound, it probably wouldn't register with you. Using our ears as crude radar, we narrowed down our visual search

until finally, we found the maker of the sound. We saw a lone male off in the distance on a little rise where he was half-heartedly performing. Then we saw a second, and then a third male, all three seemingly not sure if their efforts were worth their time or not.

It was the end of the mating season. It was later explained to me that there are times when a nest will fail and the female will again venture to the booming ground to mate. If successful, the females will double-clutch, or lay a second set of eggs (fewer eggs than the first clutch). These males, I guess, had hopes of that happening, though

their efforts were a little on the pathetic side. For my project, and photographing the biology of the booming ground, this location wasn't going to work unless I could figure out a way of not sinking in the mud. So we traveled on to the other active booming ground. At least, it was active the week prior.

We arrived to see that, in that week, the prairie here had grown into a jungle. The grass was so high you couldn't see the watering trough for the cattle (used to graze down some of the growth, replacing the bison that historically were here). This dense growth also meant there was no place for the APC to perform. We got out, scanned the horizon, listened, and seeing and hearing nothing, drove down the road, which made a giant curve to the left.

Being in the passenger seat, I could see a little further than Terry. After a short distance, I could see an APC in the road track. We stopped, got out and looked about. Sure enough, it was a male APC performing in the road. Off in the distance, we could hear another. After a little time, we found three males performing in the road. Not performing any more vigorously than the other males, but they were still perform-ing and at a locale I could set up the blind and photograph their behavior. We parked and watched for a little over thirty minutes, until the males finished and flew off in different directions into the depths of the prairie.

After we'd been out for nearly five hours, we started back to the headquarters. In that time, we'd seen eight APC, which equaled nearly 20% of the current wild population. That fact went through my mind as I said it out loud. Terry's face reflected the depressing fact that that was the truth.

At the headquarters, I switched vehicles and began learning the daily activities of the refuge personnel to preserve the APC. Throwing my gear in another truck, in a heartbeat I was with Stacey heading out in a radio truck to locate all the female APC on the refuge. I was in the good hands of an intern who had really taken the APC and their plight to heart. This trip was not going to be as fast as the last one. In fact, I wouldn't be back in until dark!

How sharp is sharp enough? Did you know that images that can easily be printed in a magazine and look great don't always meet the standards needed for a 24x30" print? Knowing the difference might just keep you from deleting so much. How do you learn the difference? Time. Putting in your time.

Stacey listening for Attwater's prairie chickens. Photo captured by Nikon D2Hs & AF-S DX Zoom-Nikkor 12–24mm f/4 lens on Lexar digital film.

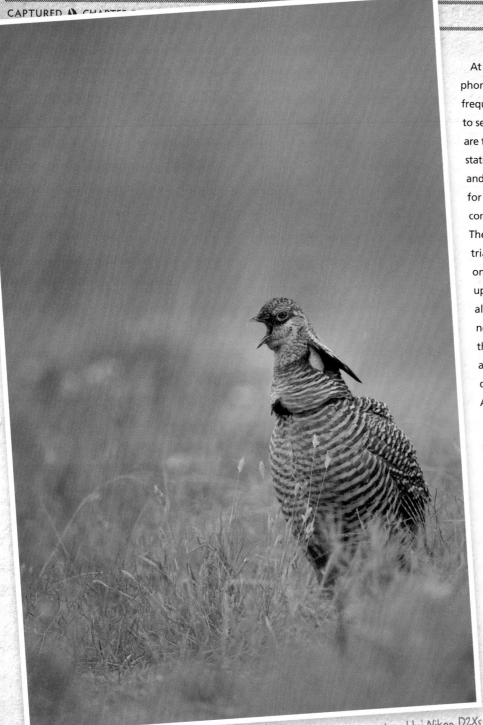

A male Attwater's prairie chicken. Photo captured by Nikon D2Xs & AF-S II VR Nikkor 600mm f/4 lens on Lexar digital film.

At preset intervals, the truck stops, the headphones go on, and the listening begins. The frequencies for all the females are run through to see who's nearby. If there are any hits, notes are taken and then we travel to the next listening station, just a couple of heartbeats down the road, and the process begins all over again. We did this for a few hours. The point is to find signals that come from the same locale for 24 hours or more. The listening stops are set so the signals can be triangulated and the females who are sitting on a nest can be located. The female will lay up to 12 eggs, one every 30 hours or so. Once all the eggs are laid, the female sits on the nest and incubates them all. It's at this point the telemetry tells the biologists there is an active nest. Active nests mean lots of different things, the main one being more APC to increase the population.

Once we covered the whole refuge and found all but one female, it was time for Stacey to take over feeding duty. To understand this, let's step back for a moment. Once a nest is located, the refuge personnel make their first visit to the nest after dark. They locate it and construct a predator fence around it. The fence is one we can step over, but snakes, raccoons, opossums, and skunks (the main nest predators) can't get through. The fence encompasses about 400 square feet around the nest.

Knowing the date the female started to incubate, the date the chicks should hatch is calculated. About a day before that date,

the nest is checked to determine the status of the eggs. Once the chicks hatch out, that night (again, after dark, because the female will have all the chicks under wing), the refuge personnel make another visit, this time to put a brood box over the APC family. This box further protects the entire family from predators, and permits the personnel to make sure the chicks are getting fed lots of insects. This is the feeding we're about to do all afternoon.

The Shoot: The Heart of the Recovery

Every other hour, the APC family gets fed—over 100 live insects for the chicks, and forbs and berries for the hen. The live insects are collected by the refuge personnel from the refuge every day for the entire nesting period, which goes on for weeks. So, with our radio duties done, we headed to the first nest. There were four active brood pens, so we stopped near the first one in that day's order (the order gets flipped every day). With all the biological and photographic gear in hand, we walked out to it. It's a mere shadow way the heck out in the prairie. Stacey looked at my feet and said, "We should have told you to wear knee boots." That's because the prairie, which should be a dry, tall-grass place, was really a mud pie. One nest had been lost the previous week because the rains raised the water level, flooding it out. We trekked across the prairie to the predator fence.

I was told to wait outside, then come in on the same path walked by Stacey. She went into the brood box to make sure all was fine for me to walk in. Once she gave me the high sign, I walked over, got down on my knees to look in, and saw the APC hen and little, couple-day-old chicks bouncing about. I instantly made mental notes of the APC family's reaction to our presence and the direction of the light

Stacey checking the location of the Attwater's prairie chicken hens. Photo captured by Nikon D2Hs & AF-S DX Zoom-Nikkor 12–24mm f/4 lens on Lexar digital film.

(then calculated where it would be later on). I noted what Stacey was doing, and asked questions about what she was doing and why. She counted the chicks to make sure all were well, while I took a couple of "comp" shots to look at in the truck as I formulated a plan for the rest of the afternoon, and then we were off. Very little time is spent with each APC family—probably not even five minutes.

An Attwater's prairie chicken hen in a brood pen. Photo captured by Nikon D2Hs & AF-S DX Zoom-Nikkor 12–24mm f/4 lens on Lexar digital film.

incredibly boring, laborious, and vitally urgent task, you can't grasp what these folks do to keep these endangered species from slipping away. On the weekend, to take care of the four broods, an estimated 280,000 insects were needed. Can you fathom the time to collect all those insects? Go and try to catch one—just one—grasshopper in your yard and then multiply that by a whole lot. With a couple of bags filled, it was back to rounds.

In the midst of our third round, Stacey said she needed to check the status of a nest to see if the eggs had hatched. Looking for the nest of a bird the size of a chicken in the sea of prairie grass was like looking for a gray needle in a dump truck full of silver needles. We had the "advantage" of knowing it was inside the predator pen, so we limited the search area to 400 square feet. We knew the nest was in the "middle" of this area, but even with the aid of the telemetry telling us exactly where the nest was, it was impossible to see. Making it even more complicated, the hen didn't leave the nest, even when I was standing just a foot above it, trying to get a photo of the single eye staring out at me. After seeing this, I could only wonder how a predator spots one of these chickens out in the grasses to pick them off. We confirmed the eggs were still in the nest, and back to rounds we went.

And so it went for the next couple of brood pen visits. It was the last brood pen, the last APC family of the four, that is still the most memorable. All the families reacted differently to our presence. This last family was the home of the "Hen from Hell." The hen earned that name because she is a great mom. When the brood pen was visited for any reason, like feeding, the hen rushed the door as it was opened, and viciously attacked the hand that was literally trying to feed her. At the same time, she trained her chicks to hide, and hide they did. I made lots of notes on this visit, as I knew this was the pen to photograph. The Hen from Hell would turn out to be my photography friend.

And with that, we drove back to the beginning of the feeding rounds and got ready to start all over. We had a couple of minutes before we needed to start the rounds. So the nets came out and sweeping began. Sweeping is when you take a large bug collection net and brush the grasses to collect insects. Until you've done this

During the first round of brood box checks, I made the long walks to the pens and just watched what was happening. I made a photo every now and then, but the light was hard and I wanted to get in the flow of the procedure and the different hens' reactions to us. It was in the last round, with the sun heading toward the horizon, that I went into action. I walked out with the D2Hs, 12–24mm DX lens, SB-800 Speedlight tethered to the SC-28, and memory cards in my

> There is a common problem that causes images to not be sharp: heat shimmer. Grass, blacktop, sand, and snow are just some of the earthly (and non-earthly) elements that reflect heat, creating waves that will kill image sharpness.

pocket, and started to make images. Then a simple dance began between the light, the subject, the screen of the brood boxes, the APC, the work going on, and the camera to create the images. My pants were already soaked from the standing water, so I just sprawled out the best I could to get down to the APC's level and record what their life was like as we, man, tried to undo what we had done to put them in this box.

Stacey did a whole lot at once as we made the rounds. Some of it was the math from all the telemetry work to determine if any of the females not previously on a nest were now nesting. She also read over notes of biology to be investigated. One of the hens who'd had a stationery signal for some time was due to have her eggs hatch. So, on our final round, Stacey took me out to check on this hen. The nest was inside a predator fence and Stacey knew where it was located. She walked right over to it as I stayed outside the fence. You cannot see

An Attwater's prairie chicken nest with eggs hatching. Photo captured by Nikon D2Hs & AF-S VR Micro-Nikkor 105mm f/2.8 lens on Lexar digital film.

the chicks when they're hiding in the grasses, so I waited until given the sign, then I walked the same path.

Stacey called me over to see a nest with one egg, two wet, newly hatched chicks, and six little squirts, bouncing about. She needed to get some gear being driven out to us, so I had about 10 minutes to photograph the chicks. I got down on their level (which meant my butt was sticking way up in the air) and, with the 105mm VR micro lens, began to watch them. Within a short period, they came over to me and I began to shoot. In a couple of heartbeats, I had to stop shooting, because one of the chicks climbed into the lens shade and I couldn't see a thing. I waited until the adventurous chick went about its travels. It was magical! It was over way too fast, and was time to continue with the feeding. With the knowledge the chicks had hatched, the team set a time that night to go in and install a brood box, once it was dark and the hen had gathered her young.

We had one last feeding to do for the day: the Hen from Hell. We walked out just as the sun hovered above the distant horizon. On cue, as Stacey opened the door of the pen, the hen was right there to express her desire for us to leave. I went down to the side of the box and she instantly came to me, which made Stacey very happy, because now she could work. I put my lens up to the mesh and the Hen from Hell instantly pecked at it. With her hackles up, she sat right in front of me with a very defiant attitude plastered on her face. She couldn't have been a better model to communicate the plight of the APC if she had been trained to do so. There she stood, defending the next generation of APC, indignant about the help she was getting and didn't want, and frustrated with the situation in which she found herself. Click!

❝With her hackles up, she sat right in front of me with a very defiant attitude plastered on her face. She couldn't have been a better model to communicate the plight of the APC if she had been trained to do so.❞

The Shoot: The Management

I was anxious to get to the refuge the second day. The first day had been incredibly productive: I had learned a whole lot about the APC, and I had a real solid foundation of images. I had, of course, gone through all the images the night before. They had been edited, filed, and backed up. I made written notes of what worked, what didn't, what story elements I had, and what I needed to still capture. I thought of a couple of article tracks, so I needed a number of images still to make them work. All of this excitement was racing through my head and dancing in my heart as I stood at the headquarters. I arrived quite early to get more images. Besides, I was too excited to sleep. That all faded away when Mike drove up.

Mike, the lead biologist, drove up and, after a brief greeting, I asked how the night's work of placing the brood box went. "Not well. Not well at all," he said. Then he pointed to a blue cooler he was getting out of his vehicle.

The hen for the newly hatched chicks I photographed the day before had been killed sometime in the afternoon. When they went out that night to place the brood box, they got a mortality signal from the hen way off in the distance. They searched as long as they could and found only eight of the nine chicks, who were now staying warm in the blue cooler (a custom structure to keep the chicks warm). The chicks were being rushed to the Houston Zoo, where they would be taken care of as part of the captive breeding program that has been established for the APC. It was a real downer to start the morning. No time to dwell on the reality of nature and endangered species work, brood box changes had to be accomplished—and fast, before the days' heat was upon us.

Every other day, the location of the brood box inside the predator pen has to be changed because, well, those chicks put out a lot of crap. This procedure, like all others, was done quickly, quietly, and with biological efficiency to assure the welfare of the APC. The whole point of the brood box, a technique that had only been in effect for a couple of years, is to maximize chick output. They have lots of chicks because lots die—that's part of the system. Until the APC are recovered as a species, the recovery tool is to increase nature's productivity odds.

We headed out, four biologists and myself, to the pens. With lightning speed, Mike got inside the pen and had the hen secured, pulled out, and placed in a dark box, where she waited quietly. Then the chicks were gathered up, which was no small feat. First, they had to find them, which was not easy. Then, they had to catch them very gently and place them in a pillowcase. Once that was done, the pen was moved just slightly, so it contained all new earth, and was set back in place.

The chicks were "processed" and valuable information gathered. First, all hands that might handle a chick had to be sterilized. The most important data, being gathered for the first time, was the growing weights of the chicks. For example, was the bug production on the refuge enough to maximize the number of chicks that survived the first couple of weeks of life? The biology was complicated by the

ramifications of this and other questions that the new information gathered might answer. It could be very important. So the chicks were placed in a small plastic coffee tin, which was placed on a scale inside a white bucket (so the wind didn't affect the scale), and weighed. After weighing, the chicks were placed into another pillowcase. Once all were weighed, the chicks and mom were placed back into the pen and off we went. The whole process didn't even take 10 minutes.

In gathering the chicks for this pen, we were one short. It wasn't found until the pen was moved; then its lifeless body was discovered. It was underweight. They didn't know why; it's one of the answers they were trying to find, and it's just the way of the APC.

This was one of the few projects where I didn't get my hands dirty, as it were. Terry had designed my visit and everything to be done, so I had only one job: take pictures. He had all the staff needed for every project, so I didn't have to put down my cameras and help. This planning and forethought is why the APC is still with us—they are in the hands of folks who truly, truly care about them!

My main photographic tools were the D2Hs and 12–24mm DX lens, with an AF-S DX 17–55mm f/2.8 lens in my fanny pack. I had an SB-800 Speedlight tethered to the camera via an SC-28 remote cord. The vast majority of the photography had to be done up close and personal (moving about and creating new scent trails for the chicks just wasn't smart). A vast majority of the time, it worked out that all the action was backlit. Flash fill was a must, so I relied on the ol' minus exposure comp in the body and plus in the

An Attwater's prairie chick. Photo captured by Nikon D2Hs & AF-S VR Micro-Nikkor 105mm f/2.8 lens on Lexar digital film.

Newly hatched Attwater's prairie chickens. Photo captured by Nikon D2Hs & AF-S VR Micro-Nikkor 105mm f/2.8 on Lexar digital film.

The "Hen from Hell" in a brood pen. Photo captured by Nikon D2Hs & AF-S DX Zoom-Nikkor 12—24mm f/2.8 lens, using an SB-800 Speedlight flash unit, on Lexar digital film.

flash for the lighting. For the photos taken of personnel working with the APC, the flash was often rested on my knee while shooting. If I wasn't doing that, I was using the "Joe move" I mentioned earlier in this chapter to light folks.

We left the Hen from Hell for last. Just as always, as soon as the door opened, she charged. Mike, being so good, basically stepped back in time for her to walk right into the holding box. The entire

time she was in the box, she talked to us, and it wasn't a friendly conversation. None of the other hens did that, just her. The processing of the chicks went smoothly and it was time to put everyone back into the pen. This was when I wanted to get the photos I had in my mind—I knew the Hen from Hell would perform.

I got in one doorway of the pen, had Terry put the Hen from Hell in the other door and then had him stare in to get her to move

toward me. I pre-focused the 12–24mm DX, shooting at 12mm, and placed the SB-800, which was on the SC-28, on top of the pen and pointing down. As soon as the Hen from Hell was placed in the pen, she marched right over to me and pecked on the filter. She just stood there, staring at me. When she started to march toward me, I started shooting, ending up with 12 photos taken in eight seconds. As I write this, I'm cycling through the images, laughing as I see this little hen with all that attitude march up to the camera right on cue.

Our last chore for the morning was somewhat depressing. We went out to recover the remains of the hen killed the prior evening. With telemetry in hand, we followed the signal. We walked quite some distance when we came across a small smattering of feathers. That was all that was left—a few feathers, the bands, and the telemetry. The distance we were from the nest meant the predator must have been avian, because a mammal wouldn't have carried the hen so far to eat it. That's why seeing a male on a fence post the morning before seemed so odd. It was an easy target. But then, that's why the APC have such a short life span, I guess.

The Shoot: The Last Day

Arriving at the refuge on the last day, I was greeted with good news: no new fatalities. The chicks that were taken to the Houston Zoo made it through the first night, though one was iffy. In the previous 36 hours, six mortalities were enough. Terry had done a great job of scheduling my visit with the activities of the refuge. In two days, I witnessed and photographed basically all the biology and recovery efforts that occur in the spring at the refuge. There was only one thing left: the males on the booming ground. The previous afternoon, Terry and I had gone back to the second booming ground, where we'd seen the three males in the road the day before, and set up my blind.

At 4:30 a.m. on the third day, Terry drove me out to my blind. By 5:50, I was in the blind. He left me with a radio and headed back to the headquarters to get caught up on paperwork. The

> I got a new blind for this trip—a Grizzly G-20 Pop-Up Blind by Ameristep—from Cabela's for $50. It worked great! It had a huge interior, so moving about and standing up without hitting the walls was easy to do.

afternoon sun the day before had turned the blind into a green-house, and the cool of the night condensed the moisture on the walls of the tent. It was dark out, so in the blind with the windows up and a flashlight on, I got set up in the "rain." I picked up a $5 chair from Wal-Mart when I first arrived, which I set up first so I had a dry surface to work on. Then I laid the blind case out on the ground and placed my MP-1 on top of it. Within minutes, I was all set up, so I could open the large windows and get some air moving around inside to dry things out.

I'd set up the AF-S II 600mm f/4 lens on the Gitzo with the Wimber-ley head. The GPS unit was hanging on a window just outside the blind. All the windows, except the one I was shooting through, were closed so I wasn't silhouetted. I wanted to be able to shoot as soon as an inkling of light hit the ground, so I cranked up the ISO to 800, something I very rarely do. I had *no* clue if I would have any males, and if I had any, if they would perform or fight. I wanted to be ready for anything. Being in a blind, if the males flew in behind me, I wouldn't see them. So listening very carefully for their heavy wing beats just prior to their landing was essential. Staring out the west-facing window, I heard wing beats behind me.

At 6:05 a.m., the first male flew in—I could only hear it, couldn't see it in the dark morning light. Within about 15 minutes, all three males were present, and with a shutter speed of 1/8 of a second (remember, I'm at ISO 800), the males began vigorously dancing. The one right behind me was literally on my blind side and was so close I could have grabbed him with my arm out of the blind. The other two males landed in front of my blind, but around the bend in the road. I could

only see them through the grasses. By the time the light levels got to where I had a shutter speed of 1/30 of a second (at ISO 100), the males had stopped performing. The male that was behind me walked right past the blind and up the road just far enough I could fill the frame with him. While he puffed up his air sacks a couple of times, no dance was performed. Why? Probably because he had no audience. The three males stuck around until nearly 9:30, when they flew off, back into the grasses they came from.

There was one very humorous, if depressing, incident that occurred during this time. A mottled duck male flew into the area and walked over to the road for a short time. The male nearest it got real excited—I mean, real excited. It started to perform for the duck as if it were a female APC. The duck just looked at the male as if he were nuts and proceeded on its way.

Terry picked me up because he had one last activity for me to photograph. A high school science class was coming to spend the afternoon at the refuge. Doing what? Collecting bugs, of course. The number of bugs needed on a daily basis is enormous once all the hens are with chicks. Adding stress to the situation is once the bugs are caught, they only stay alive a couple of days, and the chicks only seem to eat live bugs (probably have to see the motion to trigger feeding). So, capturing bugs is an ongoing, daily process. The goal for the high school class was a mere 80,000 insects. With the 200mm f/2 VR lens attached to the D2Hs,

Male Attwater's prairie chicken. Photo captured by Nikon D2Xs & AF-S II VR Nikkor 600mm f/4 lens on Lexar digital film.

I photographed some of the sweeping, then I took up a net and started collecting, too. I would stop, take a couple of shots, collect insects, and so on. I did this for a few hours, until the biggest photographic challenge of the entire trip confronted me.

How do you photograph hundreds of Ziploc bags full of thousands of insects to show there are hundreds of bags of insects? I tried all sorts of ways: with flash, without flash, flash here, flash there, bags here, bags there. The one shot I had complete control over, the one that really summed up what recovering the APC is all about, was by far the biggest challenge. The high school kids thought I was nuts as I spent an hour playing with those bags. And with that, it was time to head back toward San Antonio for my early flight out the next morning.

The success I had during these three days came from the same formula that has always served me so well over all these years. First and foremost was the cooperation and teamwork with the biologists. I can't thank Terry enough for having me—not only inviting me to the refuge, but also setting up the time so I could experience in three days basically all that's being done to recover this endangered species. Mike did a tremendous job, including me in all the recovery efforts that were in full swing. The other part of the formula was all the past experiences I had, both with biology and photography, which prepared me to make the most of the experience and do my best on behalf of this really cool species. I was physically dog-tired, emotionally pretty tapped, but mentally totally hyped by the whole experience. I think the Hen from Hell is what made the difference for me. I'm not sure why, but this experience and this species grabbed my heartstrings and didn't let go.

A high school science class collecting bugs to feed the Attwater's prairie chicks. Photo captured by Nikon D2Hs & AF-S VR Nikkor 200mm f/2 lens on Lexar digital film.

Ziploc bags filled with insects to feed the Attwater's prairie chicks. Photo captured by Nikon D2Hs & AF-S DX Zoom-Nikkor 17–55mm f/2.8 lens on Lexar digital film.

Alaska marmot. Photo captured by Nikon D3X & AF-S VR Nikkor 600mm f/4 lens with TC-20E III on Lexar UDMA.

Found Up on a Rock Pile—History!

The American pika will probably be the first species to be listed as endangered because of climate change. Its cousin, the collared pika will probably join it. In 2007, Jake and I were very fortunate to be a part of a groundbreaking project documenting and assessing a species change caused by climate warming. It's a project we will never forget, and are still very active with. There is no way you can't be changed after experiencing things like this!

Jake is flying up the steep slope, his cross-country skiing legs the perfect tool for blasting up the talus slope, so he reaches the ridgeline with ease. I come up from behind, photographing him and the vast Alaskan landscape stretching for miles and miles in every direction, while looking for our subject. I see little wisps of movement out of the corner of my eye. I hear their "eek, eek" call, but I'm moving too

fast trying to catch up with Jake to spy anything concrete. As I near the top, one of the researchers appears on the opposite ridge, so I grab the 200mm f/2 VR lens out of my daypack and make a couple of snaps. Jake calls me, so I scramble up to the top. The view is spectacular, simply breathtaking!

We get the bins out and, in the distance, we can see a grizzly out on the taiga (a subarctic coniferous forest) going after ground squirrels. A gyrfalcon rockets past us as it cruises along the slope. Then, a collared pika pops up just down slope, looks at us, calls, and darts off back into the talus slope. Simply magical!

How did we get here? In February 2005, the office phone rang. It was a photo buyer looking for a photo of a northern water shrew for an exhibit. Sharon did her normal great job, getting more than just the sale. After talking for a while with the person on the other end of the phone, we had a new contact for working in the field with biologists in Alaska. Moments later, an email arrived: "Moose's interest in photo documenting 'critters' is right in line with ours. My job as curator is to document mammalian diversity in the state, and we have several projects to do just that. If you're serious about working with us on projects, let me know. Currently we're planning specific field projects on pikas, marmots, and water shrews, but we're routinely involved in general mammal inventory work throughout the state."

Fast-forward a couple of years to July 2007 up in Alaska on the Denali Hwy. Jake and I are in our rental Hummer H3, bouncing down the dirt highway, looking for the turnoff for another dirt road that

leads to camp. Sharon did a great job, not only putting Link and myself in touch, but also getting me in the field on a real cool and important project. What might appear to be a simple scientific sampling has much greater ramifications, as you'll soon read. I'm the first one to admit that, not until we'd reached camp and spent time on the mountain did I comprehend just how remarkable and fragile this ecosystem at the top of the world truly is, depending on the cold that defines it.

What Jake and I were in for was anything but dramatic. In fact, it was quite the contrary. We were invited to take part in a pure science project that was, for the most part, looking at questions from the ground up and reinforcing the foundation for the work to come. Sitting on a talus slope, literally in the middle of Alaska, looking out over the Alaskan Range, there was plenty of time to think about how the collared pikas are telling us a story we need to hear!

A collared pika momentarily resting on a talus slope. Photo captured by Nikon D2Xs & AF-S VR Nikkor 600mm f/4 lens with TC-14E II on Lexar digital film.

The Collared Pika

There is probably no cuter critter on the planet than a pika. I've never met anyone who didn't instantly fall in love with them after seeing one. While their southern cousin, the American pika, is literally in our backyard, I'd never spent time with the collared pika until this project. On a good day, when the tourists are gone, you can drive right up to Savage Rock in Denali National Park and Preserve and see a couple of these guys bolting through the rubble. They are also around the rest stop at Polychrome Pass. There is no way that, once you see one, you won't fall head over heels for them. They are characters, filling an incredibly unique and highly specialized niche.

Pikas live in talus slopes. What the heck is a talus slope? Talus is a pile of big rocks on steep hillsides, found only on select mountains. Because it's a habitat on the move and consists of boulders, there is limited, if any, plant growth within it. There are islands of stable earth in the talus where plant growth can take root and there are the talus edges, otherwise it's a desert. It's this very fact that makes the pika inhabitation unique. In order for the pika to survive here, they have to be harvesters, spending much of their summer collecting, drying, and storing "hay," which is another word for lots of different plant matter. They do this because,

A collared pika near the edge of the talus slope. Photo captured by Nikon D2Xs & AF-S VR Nikkor 600mm f/4 lens on Lexar digital film.

while they live only where there is snow in the winter, they do not hibernate, but are active all winter long.

Roger Smith, at the Alaska Department of Fish & Game described pikas as having stocky bodies, short legs, and being almost tailless. How big are these pikas in relative terms? They are the size of a tennis ball— a tennis ball! They are small, dang small, and yet those little legs propel them over, around, and seemingly through this rocky world with a speed that makes your head spin. They are colonial, living in small colonies. On the mountain we were working, the colony only numbered 26 individuals (and it was a big-ass mountain). They are territorial, defending their territory from their neighbors normally with calls, although "fights" have been seen. And while they defend their territory, they have no qualms about stealing hay from their neighbor. At the same time, when a predator appears, the call goes across the colony to warn all the inhabitants. So, just like any critter, while things look simple at first glance, pikas are a complex species.

The life span of a pika is only about three years, with the odds of seeing its first winter real slim. Only about 50% of the kids make it to their first birthday. Their main predator is the weasel, although when you see a pika just sitting on top of a rock, you might think a bird of prey would pick it off. That's until you see

A collared pika gathering "hay." Photo captured by Nikon D2Xs & AF-S VR Nikkor 600mm f/4 lens with TC-14E II on Lexar digital film.

A collared pika carrying hay to his haystack. Photo captured by Nikon D2Xs & AF-S VR Nikkor 600mm f/4 lens on Lexar digital film.

how fast the pika goes "underground" and realize that if a bird of prey attempted to take one and missed, it would become rock art. Splat!

The collared pika lives in a very defined belt through Alaska and the Yukon. While some of the science is still being analyzed, I'm sure it has to do with temps. Pikas are sensitive little critters. If there isn't enough snow cover to insulate their homes, they freeze to death. On the other hand, they easily get heat stressed, which also leads to death. This very defined band of temperature in which they can exist is why some think the pika are endangered due to global warming (they are not listed officially by any government as such). A 2003 *Los Angeles Times* article, prompted by a study released at that time, noted that pikas had disappeared from nearly 30% of the areas where they were common in the early parts of the 20th century, and that 80% of the population in the Yukon had recently died out after extremely warm winters.

Pikas are most active during the morning and late afternoon. They are mostly vegetarian, feeding on the stems and leaves of various grasses, weeds, and small shrubs (our pika friend we spent the most time with just loved fresh willow sprouts). They are remarkable for their highly developed haymaking behavior. Males start the haymaking process first. By early July, they begin periodically clipping or pulling up stems and twigs, which they carry back to the colony in their mouths and store under overhanging rocks, in crevices, and along the edges of boulders. As summer advances, haymaking becomes the dominant activity, and the haystacks become progressively larger. During this time, the pikas become less tolerant of their neighbors and defend their feeding territory more and more vigorously.

Each pika may make several haystacks within its territorial boundary, but usually concentrates on a single main stack, which by late August may be up to two feet high and two feet in diameter (the

hay piles we saw weren't this big yet). The piles are often partially exposed to sunlight, allowing successive layers to cure. They use the same sites for their haystacks year after year.

The females typically begin haystacking after the males, because they're caring for their young. The peak of the breeding season occurs in May and early June, as snow begins to melt and the first green plants of the season appear. We were too late to see any of this going on. In fact, we saw juveniles out and about. The young are born blind and nearly hairless, and are cared for by the females alone. Young

pikas reach their adult size after only 40 to 50 days. The juveniles we saw alone and with nothing to compare to side-by-side looked adult-sized. One aspect of pika life not well understood is how the young disperse and find new homes.

Little is also known about what pikas do in the winter, although they are sometimes seen sunning themselves on large rocks on clear days. Presumably, they divide the rest of their time between feeding, chasing off other pikas trying to raid their haystacks, and resting up for the next haying season.

Collared pika gathering hay. Photo captured by Nikon D2Xs & AF-S VR Nikkor 600mm f/4 lens on Lexar digital film.

Studying the differences in collared pikas with fresh study skins.
Photo captured by Nikon D2Hs & AF-S Nikkor 14–24mm
f/2.8 lens on Lexar digital film.

So, what was the project we were a part of looking at? Scientific studies are showing that the pika is making some radical changes to survive in a warming climate. Moving upslope to where it's cooler, while important to their survival, isn't the real amazing thing. Rather, it normally takes a millennium or two for critters to evolve. The pika seems to be doing this in only decades! The research (sampling, collection, measurements, data analysis and review, publication) isn't all done, but the preliminary findings are damn mind-boggling.

The lead researcher we worked with is in the process of doing all of this. For the last three years, she has looked at previously collected pika specimens, collected new ones, and gone to sites where they were collected 50 years ago. She told me that while going through the Smithsonian collection of collared pika, she took 60 measurements of just the cranium! You have any clue how much data is collected for each specimen that has to be entered into a computer and then analyzed to even start to get a handle on all of this science? It is truly a daunting task. And it's showing the pikas are changing in size in response to climate change. That's bloody radical!

Believe it or not, this pretty much sums up the science we know about the collared pika. We had another researcher with us from Canada who was recording the calls of all the pikas she found. She just didn't work with the "easy" ones (if climbing a 3,000-foot mountain is considered easy), but hiked across the valley plain of the Alaska Range in a day to record pikas she found on the other side. Both researchers made the trip across a couple of days to sample pikas and calls. Truly, these are incredibly dedicated and thorough investigators, leaving literally no stone unturned in their quest to find answers. After this, what Jake and I had to do to get our photos seemed downright easy.

Photographing the Project

The goal of our work was simple: photograph and document the project, as well as the summer biology of the collared pika itself. It sounds so simple 4,000 miles away in the comfort of my office. In practical terms, it turned out to be pretty much that. This was a very special project for me for many reasons, the main one being that I had my son Jake along. Jake is a photo major at Montana State University, Bozeman, and is an excellent photographer (as well as being very talented in understanding wildlife). This was our first project together where we were both on the clock as shooters.

The other reason this project was special was working with some really neat folks in the middle of nowhere, Alaska, and with an incredibly photogenic critter. I was excited to be, in a small way, a part of a project with pretty lofty goals. Lastly, was where we'd be staying during the project. To make this all come together took a bit of forethought and planning, and it all went flawlessly.

Our two weeks were spent staying in the finest accommodations in Alaska, our Sierra Designs tents out on the open taiga. There is nothing like getting out of your tent in the a.m. to view the incredible expanse of the Alaska Range right out of your netting. Getting tents to Alaska safely—without the poles being bent or broken, or material

Jake & I taking a break in camp. Photo captured by Nikon D2Hs & AF-S Nikkor 14–24mm f/2.8 lens on Lexar digital film.

ripped—when you're flying is a challenge (learned about that the hard way). To get all our important gear to the site, we shipped it in a large Pelican 1690 Transport Case. Along with the tents, the case also carried Therm-a-Rest camping mattresses, a camp stove (Jetboil—killer stove), and extra photo gear, like a small mammal tank, 200mm f/2 VR and 60mm micro lenses, extra flashes, batteries, chargers, Lastolite panels, and other gear (110 lbs total). We shipped it a week in advance by FedEx Ground for pick up in Anchorage—once we got off the plane in Anchorage, this was our first chore.

With the Pelican case picked up and secured (it filled up most of the back of the H3), we stocked up on supplies. We were staying out in the middle of nowhere, so we had to have everything from food and water to chairs and toilet paper. After getting dinner, we were off. Around midnight, after a long day of travel (we'd left home at 1:00 a.m.), we stopped for the night. Up early and well rested, off we went again, and a couple of hours later, we pulled into camp.

> Our Pelican 1690 Transport Case has seen a lot of use in a short time. It's watertight, crush proof and dust proof, and does one heck of a great job.

As we drove along the Denali Highway, we saw a large mountain looming on the horizon on the south side of the highway (we knew our camp was on the south side of the road). We made some sort of snide comment about that probably being the mountain we'd be working. Of course, we were hoping that wasn't the case, because it was one big-ass rock! Well, as you might have guessed, our camp was at the base of that big-ass rock. The mountain has no name, but did

> The Denali Highway is a really cool drive. It's for those either really comfortable camping with bears, wolves, and no creature comforts, or those in the well-packed RVs. All but 40 of its 120 miles are paved. Shattered front windshields are common. But the views, landscape, wildlife, and adventure make it a spectacular drive. It was the original way to get to Denali National Park and Preserve before the Parks Highway was created. I've done it twice now, and look forward to doing it again.

appear on the topo map. The first thing Jake and I did when we got out of the H3 was look up, up, up the mountain and there we saw a speck way in the hell up there. It was the Canadian researcher working the slope. Oh my, it was going to be one heck of a time going to work!

Once we recovered, we met the researchers we'd be working with. For the first time ever, we were joining an "all-girl" camp. After introductions and a rundown of the day's work on the mountain, Jake and I set up our tents, got moved in, and then went to work ourselves. We grabbed a PB&J sandwich, got our gear packed into our daypacks and headed out and up.

The first thing we needed to do was explore the mountain to get a handle on where the pikas were on the mountain, and find the most active ones that would make good subjects. So, up the mountain the search took us, and up, and up. We saw some pikas, and heard more, and a weasel periscoped in front of me briefly—our only sighting of the main predator of the pika. Above us on the mountain, we saw researchers looking for pikas, as well. The Canadian researcher was way the heck up the mountain, not too far from the peak. Slowly we made our way up toward her.

We lucked out and caught up with the Canadian researcher, and were able to make some really cool images of her at work at the top of the world. Near the top, Jake and I stopped for a while, and just looked out across the landscape. Off in the distance, we could see a moose cow foraging. We saw a griz out digging up what appeared to be Arctic ground squirrels. There were lots of ponds and lakes, some with resident pairs of loons. A gyrfalcon went speeding by as it rode the wind. It was quite a place to sit and watch the world spin. As it turned out, this was our only trip up the entire mountain during the project.

Canadian researcher listening for collared pikas. Photo captured by Nikon D2Xs & AF-S VR Nikkor 200mm f/2 lens on Lexar digital film.

On the way up, but nearer the bottom of the mountain, we were introduced to #16. The Canadian researcher arbitrarily numbered the pika that she recorded, so we used those numbers to talk about the individual pika on the mountain. Pika #16 was a male who had just started to collect hay for the summer. They knew he was a male by his pelt color, combined with the fact he was collecting hay already. Jake and I spent the next two weeks getting to know #16 real well.

There are a number of challenges in photographing pika. First is their really small size. Grab a tennis ball and focus on it with your 600mm lens, and you'll see how close you have to get to make an image. (That's a great way to practice photographing them, by the way.) Then have someone bounce it down the driveway and photograph it. Pikas are fast—bloody fast! They streak through the talus with incredible speed, some of the time above rock, and the rest, below rock. They have very defined routes through the talus that you'll start to get a feel for if you spend enough time with them. While they are not real shy around people, their very nature—constantly moving through the talus on their daily routines—makes it seem as if they want nothing to do with you.

The second day, Jake and I set up our gear on the edge of #16's territory and just watched, and started to get a feel for how he went about his daily routine. We quickly discovered three large rocks in his territory where he liked to just stop, sunbathe, and watch the world go by. We named the rocks, so when #16 was on them (or near them), we could communicate to each other where he was. The last big challenge about photographing pika is the world in which they live.

Collared pika #16 on the talus. Photo captured by Nikon D2Xs & AF-S VR Nikkor 600mm f/4 lens with TC-14E II on Lexar digital film.

There is no way when you're way up the side of a mountain this high to not stop and look around. Not knowing if you'll be that high again, you take all the images you can. The views around the mountain were spectacular. We photographed everything within a 360° view of the top.

The colorization of the rocks isn't a whole lot different from the pikas. They blend in all too well, and with their small size, you might hear them calling, but it takes some time to locate them visually.

Having ID'd those three rocks the first day made our work just a little easier. We also started to get a feel for when #16 was active and not active. There were definite periods in the day when we wouldn't see him, like around noon, and certain weather conditions when he

Collared pika #16 leaping between boulders. Photo captured by Nikon D2Xs & AF-S VR Nikkor 600mm f/4 lens on Lexar digital film.

would be less active. He didn't seem to want to be out when the clouds came overhead and it got cool. It's Alaska, so we had rain basically every day but one (we had five to six rainbows every day, though). At the end of our second day on the mountain, we knew #16 would be perfect for us, so all we had to do was be at the rock pile every morning around 9:00 a.m., wait, watch and shoot.

The rest of the week, you'd find Jake and me up with #16 when weather permitted. Jake was shooting with a 200–400mm VR lens with a 1.4x converter on a D2X body, and I was working with a 600mm lens and 1.4x teleconverter on a D2Xs body when photographing #16. On the third day, we found the first of the three places #16 was

leaving the talus slope to gather his "hay." We kept working at getting closer and closer to him while he was gathering his hay. After working that opportunity for a while, we decided to take on the challenge of photographing him running—literally running—back to his hay pile to cache his hay. That's the challenge we worked the rest of our time on the mountain (and what practicing photographing a bouncing tennis ball gets you ready for).

Ol' #16 had one principle route for running through the talus to and from his main hay pile (he had started two hay piles). We were able to identify that route pretty quickly. It took us days, though, to come back with the images we wanted. That's because #16 played games with us.

While we knew the route, he would vary the rocks he used above-ground and below. This guy was like greased lightning, even with those willow boughs sticking out of his mouth. He could also fly—no, seriously. He would be going over the rocks, and when he wanted to get across the gaps between the boulders, he would leap and fly across them with ease. Getting this all on film was a huge challenge and consumed a lot of our day.

Pika #16 also had a distinct route to the hay gathering area. When either Jake or I saw that, we would say something to each other like, "He's heading down," which was the signal to get to the camera.

There were a couple of spots where #16 would pause and look about. Depending on the light, we would pre-focus on one of those rock perches and wait to see if he popped up for a photo.

Once he made his way down, if we could, we would photograph him in the process of gathering hay. There were trips where he would go deep into the willow stand to gather and we couldn't see him. Other times, he would be right on the fringe, so shots were simple to capture. Then, we would pre-focus on one rock where he always perched with his mouthful of hay before heading up the slope again.

Collared pika #16 taking a breather. Photo captured by Nikon D2Xs & AF-S VR Nikkor 600mm f/4 lens on Lexar digital film.

Once he left there and started his run, it was a mad chase with the lenses panning to keep up with him. When we were able to keep up with him, we would capture one series of images of him on the move. There were certain boulders he would momentarily perch on as he ascended the slope, where we could grab a shot or two. He would do

Preparing study skins of the collared pika in the warmth of the science tent. Photo captured by Nikon D2Hs & AF-S Nikkor 14–24mm f/2.8 lens, using three SB-800 Speedlight flash units, on Lexar digital film.

this for perhaps 30 minutes, and then next thing, we would see him on his Flower Rock, Sunning Rock, or Glacier Point Rock taking a rest. He would typically hop on those rocks and look right at us, a look of self-satisfaction. All in all, it was one of the funniest shoots I've done.

Jake and I would constantly move about the slope when #16 was active, trying to get the best vantage point of his path, looking for shots of new activity, his interaction with other pikas (which we never saw), and new hay piles. We had to be careful walking about the talus slope and setting up the tripods. Twisting an ankle or falling with your big lens over your shoulder was a real concern. Working on a slope of about 20–25 degrees, we made sure that our tripod legs not only were on very firm ground, but also that they leaned into the mountain. The wind was a constant factor (it helped keep the bugs down some of the time, though, since they were annoying the majority of the time), so we didn't want our tripods going over because a gust helped gravity.

In between the periods of greatest activity (my notebook was full of times by the end of the project), there were huge voids of no activity. Once we carried our gear upslope to #16's territory, and parked for four to six hours. Keep in mind that this was July in Alaska. The sun went behind the mountains in the west around midnight but it never got dark. When it came to shooting, we had a whole lot of hours in the day to be on the mountain and with #16. But we wanted to minimize the number of trips we had to carry all our gear up and down the mountain. So, during the slow periods, we made ourselves as comfortable as we could and watched the rocks for the next active period. For this reason, I always have my small Therm-a-Rest seat with me. Those rocks get real hard after a while.

In the evening, around 8:00 p.m. or so, we'd head back down the mountain for dinner and uploading of images. We had with us all the 12-volt chargers for notebooks, cameras, and flash batteries, so we could operate by just using the electricity in the H3 (a nice feature of the H3—it didn't require a key in the ignition to power the accessory outlets). This is also when the researchers would come in from their all-day fieldwork and start working with what they collected during

The lead biologist on the collared pika project recording her field notes. Photo captured by Nikon D2Xs & AF-S Nikkor 14–24mm f/2.8 lens, using one SB-800 Speedlight flash unit, on Lexar digital film.

the day. So, after a yummy dinner of Chili Mac or Teriyaki with Rice (Mountain House freeze-dried food), we'd leave our notebooks working at uploading inside the vehicle and head into the main research tent to watch, listen, learn, and photograph the project. This is where the flash came out.

It was great to have Jake along, since he's great with light and was the perfect VAL for the work (VAL = voice-activated light stand, a Joe McNally term). Jake has been working with biologists since he was literally able to walk. With that knowledge, combined with his understanding of light, he was able to position a second and/or third light to fill in the lighting of the main flash running off the camera.

The lighting was an SB-800 Speedlight flash being shot through a Lastolite panel. The flash was never in the hot shoe, but rather off to one side or the other and connected to the camera (D2Hs) via an SC-28 remote cord. It was the master with no compensation, while the two slaved SB-800s typically would be set at –1 or –1.5 stops. The tent itself was huge, and made of a material that lent itself to being a flash diffuser, so I played with that a lot, as well. The goal was to photograph the activity and teaching going on in the tent at night without being in the way. As you can see in the images, it all worked out really well.

The photo here of the head researcher out with her collections, notebooks, and traps was one she actually set up. She was outside on a nice day with no bugs, catching up on all the field notes she had to record (a monumental task). She set up as if setting up for a photo. She had morning light on her left and the pika mountain in the background. The photo was real easy to capture. Jake held a Lastolite panel on the right, just out of the frame, with a single SB-800 firing through it to fill in the light on the right. The magic of Nikon's iTTL did the rest.

Eek, Eek

Unlike many of the projects we work, this one didn't have tons of technical obstacles to work through to be photographically successful. It was basic photography, not that different from photographing birds on the wing. We just had to apply the technique to an earth-bound subject. Putting in the time, using proper long lens and panning techniques, and learning how to ignore the bugs was all it took.

The subject itself, the collared pika, isn't endangered, nor in imminent threat of going extinct. There was no in-depth story to illustrate either—I still haven't found a way of photographing global warming in a single click. And the science being conducted, the collecting process, isn't any more than a critter in a trap. To many, this would be a boring photographic project with no real challenges, and without creature comforts to make up for that. Compared to most of the projects we write about (we work a lot of projects like this, we just don't write about them), this seems out of place. So then why did I write this piece?

There are many reasons. The main one is to make the public aware that there are changes going on in our environment that are as dramatic as polar bears drowning because they're losing their ice, just not on as grand a scale. But they are just as important. There are many scientific endeavors going on with these small and non-glamorous critters, as scientists work toward getting more answers and possible solutions to some serious problems facing the citizens of planet Earth. These projects are going on

without being photographically documented, or their stories being told outside the halls of science. These projects could use your skills, talents, and passion to advance their work.

I speak for both Jake and myself when I say we felt different when we left pika camp. Nothing profound, but perhaps a little saddened, because we had experienced something quite unique that had taken hold in our consciousness. Our "office" for the two weeks was the wilds of Alaska; there is no way to remain unaffected. We felt very fortunate to have the opportunity to spend real quality, concentrated time with our subject—a real treat. We had four amazing ladies we could turn to for assistance and information, as well as some great laughs, to make our photography that much more meaningful.

These are the types of opportunities awaiting you and your camera. I hope I've given you the itch to get out and head north and explore with your camera. Hopefully, at some point, you'll find yourself on a talus slope on a warm, sunny day and you'll hear the call of that unique critter, and you'll chase down the "rock rabbit" with your lens.

Literally in the Backyard

It's 8:00 p.m. as I back the truck out of the driveway. There's not much camera gear loaded—a D3, a couple of lenses, and three flashes. It's April and there is most definitely a chill in the air, so I have my heavy Nomar jacket and gloves packed. I only have a 15-minute drive to the rendezvous point, most definitely the closet project to home in my career. I arrive at the Green Church 15 minutes early (I want to watch the eastern horizon at sunset—there's always something in the air). A shooting star lights up the sky and, as it fades, headlights from a vehicle just coming off the highway light up my truck.

It's an old, faded California Department of Fish & Game (DFG) Game Warden truck that was later described as being held together

> Alaska is a great place to shoot! But, just because you're in Alaska doesn't guarantee you'll get the great shot, or even get to shoot in the first place. Like any location, homework is a must to make the most of the locale. I've been skunked shooting in Alaska just as much as any other locale in North America.

by duct tape and baling wire. Inside are the biologists I will work with for the next couple of years. The lead biologist, a master's degree candidate from Idaho State University, has already earned a heck of a reputation. The quiet guy in the back is a Ph.D. candidate from Georgia (the country, not the state) working on black grouse (there's a bird I want to photograph!). The first thing he says to me after introductions is, "I have your book!"

When my gear is transferred over to their truck, we head down the road. The location we're heading to is nothing new to me—I've been going there since 1989—and the species we're going to find is no stranger either. But the project is totally new and I'm very excited. In the slight glow of a new quarter moon, the headlights go off, the engine shuts off, and we don our gear. We head through the closed gate and we start what will turn out to be a six-mile walk through the sage in the pitch black darkness of a Sierra night.

Leif, the lead biologist, did a practice run with his field tech Ben, so I'd know the drill when the time came. While it isn't new to me, I was new to them, so there is at first some initial shyness with a stranger in the mix. We venture further into the meadow, heading to a known roost area. Then, Leif comes to a halt, points something out to Ben, the boom box comes to life with the recording of an ATV roaring down a trail, and the pace turns into a frantic near-run, as we're less than 50 meters from the prey. Then, the spotlight quivers. Ben flares right, then left, and back again, making a question mark of a path. Within a heartbeat, the hen is in the net and we're on the ground next to a greater sage-grouse (GSG).

This project is trying to better understand the survival rate of the GSG young and how they utilize their habitat. My being here was an extension of my own project photographing what many consider an endangered species (though it doesn't have that designation). I've been photographing bits and pieces of the GSG biology since 1989, but hooking up with biologists working on the population on my own doorstep was hard, because no one was doing much other than monitoring. Then came Leif and a whole new opportunity.

A greater sage-grouse. Photo captured by Nikon D1H & AF-S II Nikkor 600mm f/4 lens with TC-14E II on Lexar digital film.

The method I just described is how they catch a GSG. In total darkness, the noise and light basically puts the grouse in a trance. With skill, the researcher pretty much just walks up to them and catches them. This technique, called spotlighting, is used on a number of species and has been used on a number of the projects we've been a part of. It requires total darkness to work, which means no moonlight. The bright, clear, starry nights of the Sierra are almost too bright without the moon. For this reason, flash can't be used to document spotlighting, so over the last two decades, I had no images of that technique. This first night out with the biologists, though, I was more excited about the technology than the subject.

When they did their test run to show me how they would go about catching the grouse and where they wanted me to stand during that capture, I shot with the D3 at ISO 6400 to see if, with that new, high ISO, I would get an image. As you can see, I did! At the first conference where Leif presented a paper on his projects illustrated with my images, the image with the biggest impact was the spotlighting—it had never been seen before. This first night out, that was really my main focus, getting the spotlighting on film, and by 2:00 a.m. when we wrapped, I was quite excited to see what I got.

Spotlighting to catch the greater sage-grouse. Photo captured by Nikon D3 & AF-S Nikkor 24–70mm f/2.8 lens on Lexar UDMA.

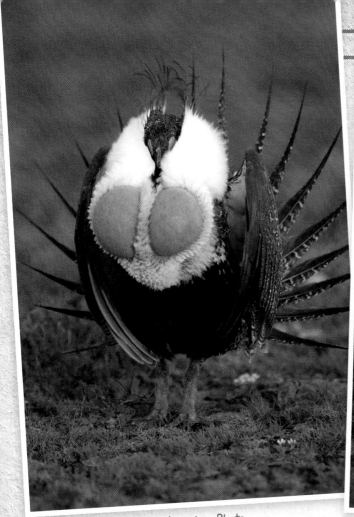

A male greater sage-grouse booming. Photo captured by Nikon D1H & AF-S II Nikkor 600mm f/4 lens on Lexar digital film.

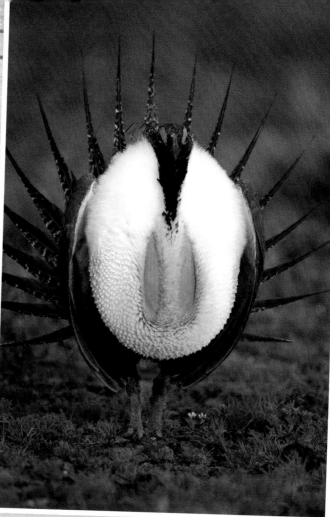

A male greater sage-grouse performing. Photo captured by Nikon D1H & AF-S II VR Nikkor 600mm f/4 lens on Lexar digital film.

The next night, we did the whole thing all over again. I went through my images from the night before. I decided to shoot ISO 6400 for spotlighting with –1 exposure compensation dialed in the second night. I also went through my images of the biologists processing the captured females. I gelled the SB-900 flashes with a blue gel, because white light at night just doesn't look right. I thought it was too dark, so I dialed +2/3 exposure comp into the flashes for the second night. I also decided I needed two background flashes rather than one. And I decided to work more with

just their headlamps as a light source, letting the inky blackness of night fill in the rest of the photo. The trick was to remember to change the ISO when I turned the flashes on, and change it again when I turned them off.

While walking and looking for the grouse in the dark, I did my usual thing and asked questions. I asked things like, "How much do they weigh?" Leif replied quietly, "Females: 3 lbs. Males: 7 lbs." After jotting that down, I asked how many chicks they have. "First clutch, up to 10 typically. Second is four to six,"

he answered. "How old are the chicks when they fly?" "You ask a lot of questions. They can fly at 14 days, short distances." The pace quickened and I took that as a sign to be quiet. Leif is a really good guy, a great biologist, and I have a lot of respect for him. And, he answers all my questions.

The locale we were walking is called the Long Valley caldera, the second most active caldera in North America. It has a very gentle slope to it, covered in this funky alkaline grass plant stuff (I know my egetation really well). We were actually walking on a lek, that being the place where the males gather at first light to dance and

boom, hoping to attract a female so they can mate (the males having nothing to do with the nesting or rearing process). I was just thinking about that when we all heard the most amazing, haunting, resonating moan come from below our feet. It was really cool!

The biologist had captured, marked, and attached radio packs to all the hens he needed for this population, so after the second night, they were done. Then the waiting process began, and much like the Attwater's prairie chicken project, daily monitoring of the females began to determine who was nesting and the nest locations.

Processing a captured female greater sage-grouse. Photo captured by Nikon D3 & AF-S Nikkor 24–70mm f/2.8 lens on Lexar UDMA.

Checking for a signal from the radio packs on the female greater sage-grouse. Photo captured by Nikon D3 & AF-S VR Zoom-Nikkor 70–300mm f/4.5–5.6 lens on Lexar UDMA.

Three weeks later, we were up in the Bodie Hills when the old, green, retired warden's Bronco stopped with a lurch. The door swung open out of my hand—the truck was pointing down a steep grade. "The road is washed out beyond here. Gotta walk the rest of the way." I got up at 2:20 a.m., drove 30 minutes to meet up with the biologists, and then drove with them another 40 minutes to get to this point. The sun was a rumor on the horizon when I grabbed my camera gear and headed off while attempting to keep up with the 24-year-old springbuck biologists I was working with. We went down at an alarming rate and speed in the darkness, alarming because we'd have to hike back up the same grade to get back to the truck.

A mile down the grade, the antenna went up and the signal was found. Cross-country we went, hurdling sagebrush in a marathon race with the sun. First down a gully and then up a hill, my guides moved like pronghorn sheep and quickly pulled away from me (oh, to have young legs). Our route was precarious at best, as we zigzagged, following the signal. We reached a rise and got another sounding. I looked over my shoulder to see the road, way below us.

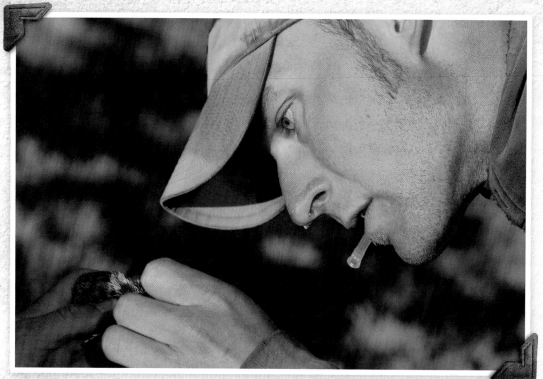

A biologist processing a greater sage-grouse chick for his study. Photo captured by Nikon D3 & AF-S VR Micro-Nikkor 105mm f/2.8 lens on Lexar UDMA.

at a little less feverish pace, and worked our way back to the truck. The three-mile jaunt netted all of us nothing: the biologists weren't able to collect any data and I didn't get a photograph. Mother Nature still rules the roost and, for the moment, the greater sage-grouse had five less chicks to boost its falling numbers.

We had done this exact same thing the morning before, with the only difference being the chicks were still present. The hen had gathered them all under her for the night, so they could stay warm. That's why we had to find them prior to sunup. With them safely gathered up, without saying one single word (which meant I had to ask my questions later), they were pro-

Not even able to catch my breath, we were off again, still cross-country, but now following the ridgeline we had climbed to. The biologists came to a quick halt. The signal had exploded, which meant the quarry was less than 10 meters away. This routine was familiar—we just did it the morning before—so I froze. Spotting the object of our quest, the biologists crouched down, and walked very slowly toward the tan-colored lump at the base of a sage. Less than a meter away, it exploded into the air and down the slope, and the biologists froze. When they stood up and I saw their faces, they looked like they'd just swallowed a lemon.

"There's none here. Must have been predated upon between 5:00 last night when we last checked and this morning." "She's broodless." With that, we headed cross-country again, at least

cessed and released. The hen was just a stone's throw away, clucking at us as we hurried to move away. That was the whole point of this project: to find out how successful the clutches are, how many chicks make it to the first winter, and how in all of this, the GSG utilizes the habitat in their win-or-lose battle with life.

When they had that four-day-old chick in hand and the first light of day lit it up, the click of the camera meant more than just recording the moment. It was a 20-year quest for me, one more answer for Leif, and a little hope for the species.

One year later, I was at Photoshop World when my iPhone vibrated in my pocket. After the session, I listened to the voice message: "Moose, I have a nest you can photograph. Give me a call!" It was Leif

with news I'd waited nearly two decades to hear. I instantly called him back. The nest had only a few days before it hatched out. The day I got home would be the only opportunity to photograph the nest. That afternoon, Leif guided me up the ridge, through the sage, and to a little outcropping of rock. We hadn't spoken a word since we left the truck. Leif took a new route every time into the nest, so no predator could follow it. He pointed, and there before us was the nest. We could barely make out the hen, staring back at us, holding tight, hoping we wouldn't come any closer. I made a couple dozen clicks and, minutes later, we were back at the truck.

I'm close, but I don't have the whole story of the greater sage-grouse yet, on film or paper. It's one of many projects, all involving biologists, that we are still working on. When will I feel I have finished these projects? When I have fulfilled the quest for knowledge with the answers captured on film.

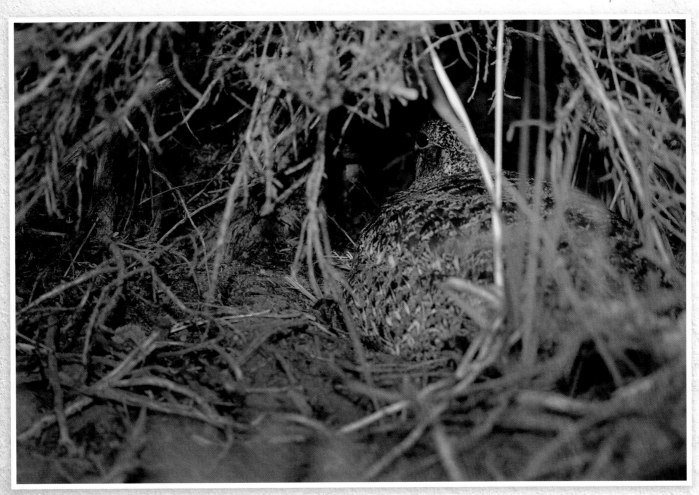

A greater sage-grouse hen on her nest. Photo captured by Nikon D3X & AF-S VR Nikkor 600mm f/4 lens on Lexar UDMA.

MOOSE PETERSON GALLERY SERIES

A greater sage-grouse chick. Photo captured by Nikon D3 & AF-S VR Micro-Nikkor 105mm f/2.8 lens on Lexar UDMA.

One of the first riparian brush rabbits to be captured to establish a captive breeding program. Photo captured by Nikon D1H & AF-S DX Zoom-Nikkor 17—55mm f/2.8 lens on Lexar digital film.

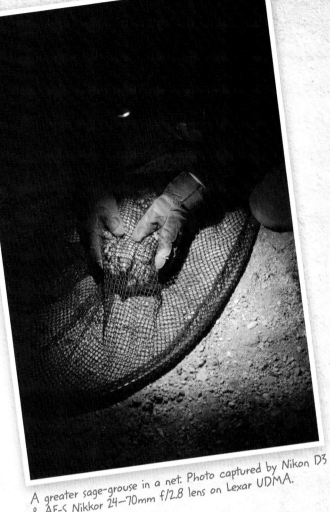

A greater sage-grouse in a net. Photo captured by Nikon D3 & AF-S Nikkor 24—70mm f/2.8 lens on Lexar UDMA.

It's Just an Extension of Our Passion

Our exploits with biologists will easily fill volumes when I'm finally put in the dirt. This is just a small sampling, just 17 days out of the nearly 30 years we've had the honor to work with this gifted, talented, and dedicated group of people. This is what's waiting for you!

Making that one image—a sharp, perfectly composed exposure reflecting the emotion of the moment—is so rewarding

and satisfying. Yet it pales when compared to accomplishing the same thing while working on projects such as these. And topping that is having the opportunity to share these stories with others. I thank you for that, and I hope they move you to action. I'll say it again, I wouldn't be here without the many biologists we have worked with over the years. I thank each and every one of them. When it comes to my life, I can honestly say they set the stage.

CHAPTER 8
It's Not Over by Any Stretch of the Imagination

Jake & I unloading our gear in the McNeil River State Game Sanctuary.

High up the slope off the Kongakut River in Alaska, the gorgeous spring flowers were a must to photograph, despite all the critters about.

Sharon & Jake at the OP overlooking the massive Kodiak grizzly bears, taking a moment to photograph the bear about to eat Moose. Nah, just kidding.

Greater sandhill cranes. Photo captured by Nikon D3X & AF-S VR Nikkor 600mm f/4 lens with TC-17E II on Lexar UDMA.

Sharon & me at the bottom of Norris Geyser Basin, Yellowstone National Park on a brisk −20° morning.

The floats skim across the lagoon's surface as we come in for a landing. The flight would have been a white-knuckler for most not used to flying in Alaska. The clouds were kissing the pass, leaving the tiniest of openings through the mountains to the coast. It's the first time Sharon and Jake have flown to the coast from King Salmon, so they're wide-eyed. Oh, they've flown through other parts of the Katmai and Kodiak, but no two places—no matter how close—are the same in Alaska.

We motor across the lagoon until the engine is cut in the shallows. Having flown with our hip boots on, we hop out into the lagoon and help secure the plane so we can unload. As we turn the plane, we're greeted by a legend, Larry Aumiller, manager of the McNeil River State Game Sanctuary. Before we know it, a thousand pounds of gear is off the plane, we're at camp, and our plane is heading back into the clouds and over the pass. We're home, at least for the next four days, at McNeil River.

We had a blustery first night there, and woke up to wetness and cold. During the night, a grizzly came through camp—perhaps five to seven feet from our tent—and stopped to munch on greens. I woke Sharon and said there was a griz outside our tent. She said something like, "That's really neat" and went right back to sleep. So did I.

Ah, Dusty! Just 20 feet away is my all-time favorite bear. I know, you're not supposed to get attached to your subjects, but I can't help it; I do so all the time and none more so than to Dusty.

There is NO room in a float plane, so be very careful with the weight of you and all your gear. Want to shoot during the flight? Have the body and camera in your hand when you board—there's no other way of working. I prefer the AF-S 24–70mm lens in these situations.

There's a briefing each morning with the biologists. At ours the first day, we found out that, because of the high tide, we'd be taking the long route around Mikfik Creek. Since we were the first to the falls for the season, we'd be carrying the folding chairs with us that will be used by all visitors to the falls during the season and secured away each night there. We also learned that, because of the timing of the tides, we wouldn't be able to make it back by foot, even using the high tide Mikfik trail, so the "navy" would be picking us up. The "navy" is an old net tender boat they have at McNeil just for such a need. There are supposedly two weeks during the season they need it, and this was one of them. With my right ankle swollen (limping along with flesh-eating disease [FED]) and already not happy about having to be in hip boots, having three miles of this day's walk removed was a good thing.

Since this was our first visit to the falls, I took the 200–400mm VR lens and left the 600mm VR back at camp. The 200–400mm VR is my primary big-mammal lens. My original plan was to put the 200–400mm VR in the dry sack on Sharon's back and 600mm VR in mine, but once we had the basics in the dry sack and I heard we'd each be carrying a chair, that idea went out the window. As planned, Jake and I were taking our MP-1s fully packed. This was really the easiest part of getting ready—it took only minutes. Next, it was time to put on my hip boots. Oh man, it did not go well. If I'd thought it was difficult putting my right hip boot on the day before, this was even worse. After what seemed like a lifetime, and just in time to join the group, it finally slipped on.

In the misting rain, we started out. If my ankle bothered me, I don't remember. If rain was a problem, I don't recall. All I remember is walking the 20 yards from the cook shack, getting on the main trail, and starting the incredible journey to the falls. I'd been waiting nearly 20 years for this moment and it couldn't come fast enough. You start out along the high water mark of McNeil Cove and skirt it for a while, then venture up the mudflats of Mikfik Creek. At this point, you reach the sedge flats.

The sedge flats are a very important and major food source for grizzlies early in the season. Prior to the salmon run up Mikfik Creek (which begins and ends before McNeil River), the bears munch on the

sedge flats. Once the salmon start to run up Mikfik, the bigger males tend to just go for salmon and eat sedge only as they travel through the area. This is especially true once the salmon start up the McNeil. Once the males are occupied with salmon, the sedge flats tend to be utilized by just the sows with cubs.

We worked our way up the mud on the edge of the sedge flats as we took the high tide trail around Mikfik. The hip boots are a must, because you are constantly in the mud, water, or a combination of both up to your ankles. The high tide trail is especially muddy—slippery mud that just sucks up every step. Your energies are divided

Wake up to rain and think you should cancel your day's shoot? Don't do it! The rain does stop, and when it does, critters come out of the woodwork. You want to be there to capture that.

between watching where you're stepping, the actual step, and watching for bears. Since they can easily be hidden by the sedge grass and the tidal creeks that run through it, they can literally pop up right next to you.

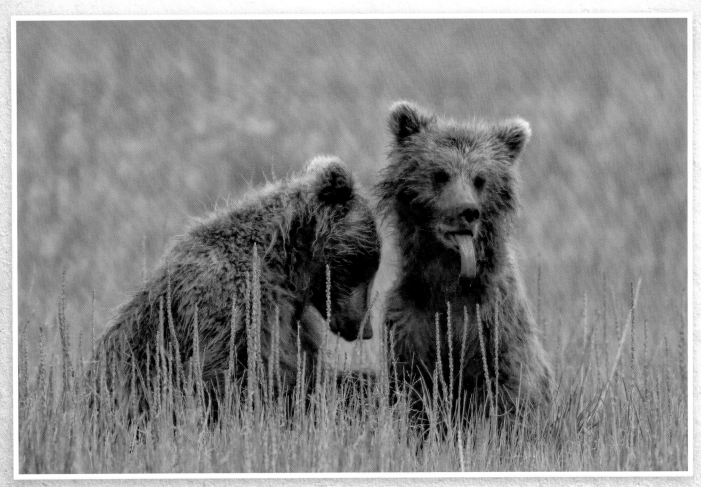

Grizzly bear cubs. Photo captured by Nikon D1 & Nikkor 800mm f/5.6 lens on Lexar digital film.

We finally came to the high tide crossing of Mikfik, just below small falls the bears were hanging out at a few days prior. Once across, we headed back down along the sedge flats. We hadn't gone too far when we came up to our first grizzlies. Two cubs were up on the small hillside, taking a snooze. They barely raised their heads at our approach and didn't budge, even when we were a few feet below them. After taking a few clicks, we proceeded down the trail, around a bend. There, right next to the trail, was a sow. We walked up to her, then stopped to watch and photograph her. She was perhaps 20 to 30 yards off, pulling up and munching on the grasses, with a sound like someone tearing up paper. Then, another sow and cub appeared in front of us.

Since seeing the two cubs, I had the 200–400mm VR mounted on the tripod over my shoulder. So when this opportunity came up, I just lowered the tripod and began to shoot. At first, I fell back into old habits of zooming in tight on the bear. Looking at my 36,000 grizzly bear images prior to going to McNeil, I knew I didn't like this tight scenario, so I zoomed back to 200mm and shot the general biology of munching. I came to McNeil knowing I wanted to visually tell the whole story of our adventure. Thankfully, our group all wanted to "watch" bears, so there was never any hurry to do anything other than that. When the sow and cub slowly munched away from us, we ambled down the trail.

Going around the corner and up a small waterfall slope, we came to the "freeway." They built a boardwalk a number of years ago that takes you above the thick growth and muddy trail and prevents further erosion—it really speeds up your progress. You're in real tall and dense vegetation from there on, with bear signs everywhere you turn. Almost as soon as you hear the river, you see it, and there

> The McNeil River is so powerful, it can sweep you away with your first step. The bears, on the other hand, have no problem with it.

before you are McNeil River Falls and the bears. It was 12:30, cloudy, cool, and absolutely spectacular when we first saw them.

We got our briefing (the "lay-of-the-land and etiquette" talk) and sat down in our chairs for truly the best show on the planet! There are two "platforms" at the falls: upper and lower. The upper is at the top of the bank, and the lower is on the river's edge. Both are really cool to be at and both have bears walking right through them. If you're not careful, they will knock over your tripod—they are that close. It's schweet! It was a slow time for bears at the falls, as we saw a max of 10 bears at one time the first day. That wasn't a problem.

The biologists don't mark the bears, but they are studying them, so they distinguish individuals by noting behavior. They look for unique characteristics that make an individual stand out, and then give them a name. I find this fascinating, because they know so much about each bear. We saw Otto, with the bad jaw from an earlier fight, and Donnie, who had a unique way of holding a salmon up against one leg to eat it while standing in the middle of the river. There was Luther, Rocky, Elvis, Jordan, PH, and our favorite, Dusty. You knew Dusty for many reasons, but his distinguishing mark was a bad claw on his front right paw. We fell in love with Dusty instantly.

Dusty was parked "Dusty-style" in the #2 spot for catching fish at the falls when we first arrived at the river. He sat, lay, ate, crapped, and just about everything else, just feet in front of the lower platform. Seriously, you could reach out and touch him at times! Dusty is a big ol' boy, 10–12 years old, and weighing in at just over 1,000 lbs. He's one of the bad boys at the falls; few other bears messed with him or tried to get his spot. Many of the photographs you see here are of Dusty. He's quite the character!

What's Dusty-style? Well, as the salmon fight up the river—and it is a fight—they come to McNeil River Falls. On the west side of the river, right below the platform, is a small rock shelf that the salmon must jump over before going up the other shelves of the falls. This first shelf, because of the strong current, tends to make the salmon not real accurate jumpers. They jump and often hit the rock, which dazes them. Well, Dusty sits hunched over at this spot, his back to

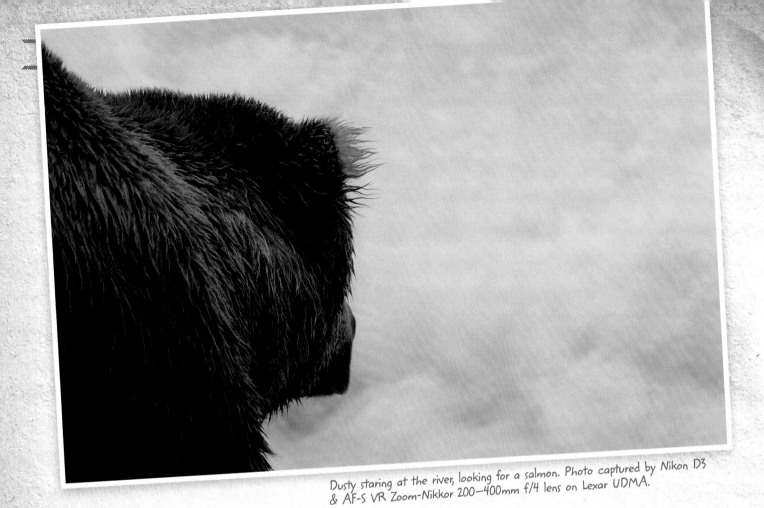

Dusty staring at the river, looking for a salmon. Photo captured by Nikon D3 & AF-S VR Zoom-Nikkor 200—400mm f/4 lens on Lexar UDMA.

you, totally ignoring your presence, waiting for that unfortunate salmon. When it hits wrong, Dusty does no more than simply take his paw, nail the salmon with his long claw, and eat it. You gotta keep in mind that all the bears have only one thing on their minds—getting fat. The way they do it is real simple biology: eat a lot and sleep.

I stayed on the upper platform all day (my ankle simply wouldn't let me go down the steps to the lower one). There is non-stop activity, with little time to eat, drink, or even contemplate a nap. Bears come and go at the falls, especially goobers. What's a goober? It's a young bear in the 3- to 4-year-old range that has just been kicked out by its mom and now has to make it on its own. They are scared of their own shadow, but they have to eat, so they venture to the falls, where Mom taught them that food can be had. All an older

bear has to do is sneeze and a goober craps and runs for its life. They are very funny to watch!

The photography was stellar. What's interesting is that the cliché shot of a bear catching a salmon in its mouth never came to my mind. There was so much more to photograph—images I hadn't seen before, so that's what I went after. Dusty was a favorite subject, as I explored other ways to say grizzly bear photographically. A portrait of Dusty scratching his head with those five-inch-long claws is a favorite. Or the tufts of hair coming off his ear as he stared out over the river, looking for a salmon. I just love this more intimate look at a griz. After all my experiences with grizzlies over the past decade, I still have a hard time thinking of them as man-killers, but after several people were mauled by grizzlies in downtown Anchorage, you can't forget that fact.

At 6:30, we left the falls to meet the navy and get our ride back to camp. That boat ride felt real good to my ankle—it was pissed off when I took my hip boot off. Some characteristic FED boils had formed from getting hot and rubbed all day. That, along with the one med I had to finish off that week, pretty much zapped any energy I had. Nonetheless, when we got back to camp, Jake and I made a water run—he drove the wheelbarrow with 20 gallons of water, while I walked along trying to look useful and looking out for bears. We ran into one that we had to talk to and convince to go left as we went right, but no big deal. Then, it was out of my hip boots and back to work.

While Sharon heated dinner, Jake and I uploaded images—3,200 for me this first day. We finished the process in the tent that night. At the same time, I uploaded Sharon's images to the Epson P7000 (which she fell in love with). All the images were put onto a Buffalo Technology 500-GB external drive and then, before falling asleep at midnight, a backup was made onto another Buffalo 500-GB external drive. While this was going on, I wrote in my journal, which I keep every day I'm shooting. Too many things going on to trust to memory, so down on paper they go.

> When it came to telling the story of our week, I wanted to grab heartstrings from the get-go, and the only way I know of doing that is to make every single click as powerful as I can, as if I only have one click to convey it all.

I woke up with the inside of my ankle looking nasty—it had to be drained before doing anything else. It was hard to concentrate, in part because of the meds (it was my last day of phase 2 meds, and I was looking forward to being off them) and in part because my mind was racing with how I was going to photograph the grizzlies that day. So, between dealing with my ankle, the meds, and the photographic side breaking through, my head was spinning.

I used up some of my precious battery time and went through the prior day's images just to see where I was, what I had captured, what I liked and didn't like, and just what I needed to do to take my photography to the next level. It was a fight to wrap my mind around why I was here—in this place I had waited so long to visit, a place that is so magical, and so special—and to bring that back in just one click. Why just one click? When it came to telling the story of our week, I wanted to grab heartstrings from the get-go, and the only way I know of doing that is to make every single click as powerful as I can, as if I only have one click to convey it all. For many, this would be a huge pressure on their photography. I took it as a massive challenge to push me, and my photography, to places that hopefully I'd never gone before.

Our eyes greeted the dawn at 8:00 and we had a 10:30 departure time, so I had plenty of time to get my hip boots on if nothing else. I managed, then rethought the gear I was going to carry to the falls. After looking at my images from the day before, I wanted to be even more intimate optically with the bears, so the 200–400mm VR was left behind and the 600mm VR got packed. At the same time, I took out the 24mm PC-E and 105mm VR, SD-8a, SB-800, SC-28, and some other accessories I wouldn't need. My ankle wasn't going to support that weight and the long walk, so I took just what was needed.

We started off with a huge treat: Larry was our guide for the day. Larry knows McNeil and its bears like no one else. Our departure was later, so we could take the "low" tide trail to the falls, saving us time and saving my ankle wear. When we got to Mikfik Creek, the tide had been slipping out for only a few minutes, so Larry went across to see how high it was. Our limitation was the height of the shortest pair of hip boots (if you get wet, there is no getting dry). We lucked out and by going real slow (so as not to create any wake) and staying in the shallowest portion of the creek, we just barely got across. This instantly put us in the sedge flats with the bears. Actually, bears had been with us since leaving the camp, but once across Mikfik, we started to watch and photograph them.

We saw Dakota, a beautiful 6-year-old female, and her cub the majority of the time. Her pretty, light coat and very mellow disposition made her a favorite of almost everyone. With Larry beside us, we got right up with her as she grazed. I borrowed Sharon's 70–300mm VR

(great, great lens for here) and photographed Dakota for some time. After a while, she moved on to graze another patch, so we took that as a signal to wiggle on our way, as well.

We'd left the camp in the rain and when we arrived at the falls at 1:30 p.m., it was downright cold, cloudy, damp, and there were only four bears present. For the longest time, it was quiet, with no salmon running, and no bears coming to the falls. We had a new goober show up, named Braveheart. He was no ordinary goober, and I predict that someday he'll be one of the bad boys of the falls. Braveheart did all the usual goober things, except he constantly tried to get in the best positions—those held by the current bad-boy gang. He would get in the best fishing spot and stand his ground the best he could, until he dropped a load and ran like a bat out of hell when a bigger bear just looked at him. As soon as he felt the coast was clear, he would be right back in that spot again. At the very least, he was entertaining!

Another new bear that day was Custard, who got his name because he was the color of custard. He was funny and didn't really seem to be into eating. He was a big boy, but was easily pushed around by

Sharon, me & Jake photographing grizzlies.

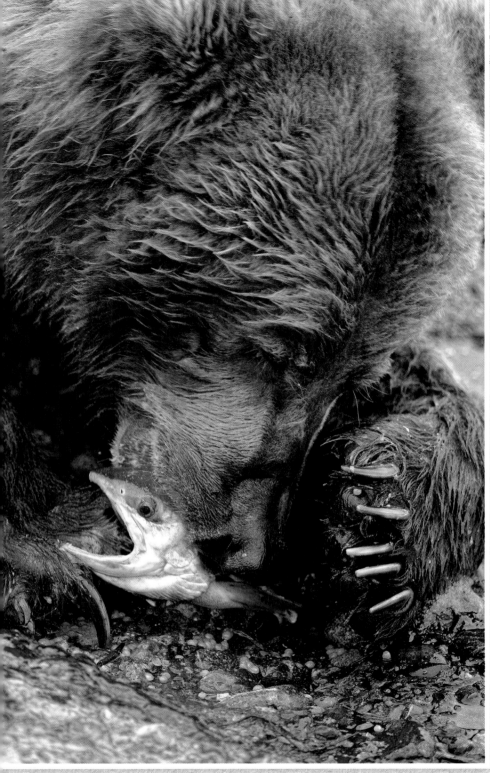

Dusty eating a salmon. Photo captured by Nikon D3 & AF-S VR Nikkor 600mm f/4 lens on Lexar UDMA.

younger bears. His efforts to catch a fish were half-assed at best. He was gorgeous, though, and regrettably stayed on the other side of the river in a spot where there was no photograph to be made. That is one of the cool things about McNeil, there really isn't a bad place to photograph bears, except the one where Custard stayed. Every other bear in every other place on the river made for a good-to-great photo. It's a shame this was our only time with Custard during the week—he was one handsome critter!

It was so cold, damp, and slow that Larry offered to take those who wanted to go on a "warm up" walk, so all left except Dan (a fellow bear-watcher), Jake, and I (my ankle wasn't letting me go anywhere). Over the next 90 minutes, a small run of salmon made it up the river, and with them came the bears. How do the bears know a run is coming up the river? Do they hear or smell the salmon? Does the gathering of gulls or bald eagles signal them? Nature is so cool, how does it all work?

Otto and Luther started to catch salmon. Dusty came to the falls for the first time that day at 6:00 p.m., parked in the Dusty spot, and instantly caught a salmon. With salmon in mouth, he turned to face us, and lay right down. He was point-blank range, perhaps 23 feet away, making short order of that salmon. Jake and I were loading in CF cards, just like in the old days, the way we would with rolls of film. One of those "one-click" images came from this feeding and is one of my favorites of all time. The salmon—survived only by its head, since the rest had been consumed—in its last defiant act grabbed onto Dusty's claw, as if biting him at this point might secure its release. Its roe had squirted out all over the rock, Dusty's big paw and claws gently holding

it in place, and with precious small bites, he consumed these tasty morsels. Wow! Even as I write this, the whole thing, which probably took only minutes, plays in slow motion in my head and heart, still taking my breath away. This moment with Dusty was worth the 20-year wait!

By 7:00, we were heading back to camp. The ride from the navy had us back in a heartbeat and we got into the cook shack to find Tom had started a fire. We'd only been at McNeil for 36 hours, but it already felt like home. With only five of us in camp, we were able to spread out in the cook shack, so the camera gear and computer were stored inside all the time. This made the task of uploading cards while preparing dinner a whole lot easier.

The cameras were always left set up and easily accessible, because bears are always wandering about. That night, we had Dakota and her cub, and Simba and her cubs, go through and across the spit to the mud flats. We ventured out to the spit and photographed Dakota nursing her cub, then playing in the sand with it. It's hard to describe what it's like living in a world where you are not king, not even a player, but an observer at best. We were guests of the griz and they were amazing hosts, permitting a window into their daily lives and, at times, sharing it with us. There was nothing physically between us and the bears (a nylon tent doesn't count for much), yet nothing needed to be. If you had to put it into terms, a mutual respect or right to life existed. I've spent a lot of time with grizzly bears, but nothing like McNeil. Nothing! At 11:00 p.m., with all cards loaded, cleaned off, and backed up, the cold and damp drove us to the comfort and warmth of our sleeping bags.

> *Are grizzly bears to be feared? No.*
> *Are grizzly bears to be respected? Damn straight!*

I didn't know it when I woke up, but this was the day that all my experiences with grizzly bears over the last decade had prepared me for. My leg was just not right, and even after draining it, I wondered if it would get me to the falls. We rose at 8:40 and had a departure time of 10:30, which gave us plenty of time. I was quite happy with my gear selection the day before, so I wasn't going to change up anything for day three. We took the lower crossing of Mikfik Creek and went right over to the sedge flats, where we were greeted again by Dakota and her cub. After 20 minutes, we took a vote, and went straight to the falls. We arrived there at 12:30, and only three bears were present. But we didn't have to wait very long before they started to stream in. We had new bears, like Short-face, Holden, Bwog, Derek, and a couple others—a total of 13 bears at any given moment.

I have to be honest with you, even with my journal in front of me as I write, even with the 5,000 images I took that afternoon, it's still a blur to me. Even combining my images with the 3,000+ Jake took, there are holes in my memory. I do remember Jake saying, "Dad, look right. Dad, look left. Dad, look down," and my saying the same thing to him constantly during the afternoon. We could have had 10 shooters on those platforms and still could not have recorded all that was going on.

There were bears everywhere! Keep in mind this was a "slow" time at the falls. Oh lordy, what is it like when it's normal or above normal? Lexar was very good to us, and had sent eight 8-GB loaner cards. This day, we needed them. All three of us were madly shooting. We'd no sooner arrived, than Dusty walked up to his spot, grabbed a salmon as if it were waiting there for him, and started eating. Short-face was on a big-ass rock out in the falls, fishing and catching fish. He ate with his back to us, which I took personally until later. Elvis was out in the middle of the river, standing there waiting for a stunned salmon to float back to him (how did he stand out in that current and never move?). Goobers ran in here and out there. Luther, Rocky, Jordan, Otto, and Donnie were back and forth, either catching salmon, checking out what others had caught, or doing the second thing bears do best—sleep!

We had one bear, name unknown, sit about 30+ feet from us for half an hour, just watching the bald eagles fly back and forth. He just sat on his ass, his head twisting back and forth, as if watching a U.S. Open match. Another unknown bear just sauntered up and, as if getting in his easy chair to watch his favorite TV show, parked himself on his butt, leaned up against the bank, and took in all the activity. The bears were scoring salmon and making a feast of it for nearly two hours—it was non-stop activity.

It started to warm up a tad, and it was siesta time. For the bears that is, surely not for us. First, Dusty (how I love that bear) curled up right next to his fishing hole. You can see him in this image right there on the edge of his rock with the water crashing right behind him. The 24–70mm came out. Then, after a while, this calm came over me and I started to think about what it was about this scene that really grabbed me. It's what I've tried to explain about grizzly bears for a long time. I put the 1.7x on the 200-400mm VR and framed up that sweet muzzle of Dusty, along with those powerful claws, and made another all-time favorite click of mine. In fact, I shot a lot— horizontal, vertical, with converter, and without. Shooting down at just the right angle was all sheer luck. If I'd been lower or Dusty higher, the photograph would not have worked at all.

And just when I thought it couldn't get any better, Jake made me aware of Short-face out in the middle of the river on the rock. He'd been pretty rude all day with his back to us. There hadn't been any shot really between his back and the bright, white rapid behind him. That had all changed.

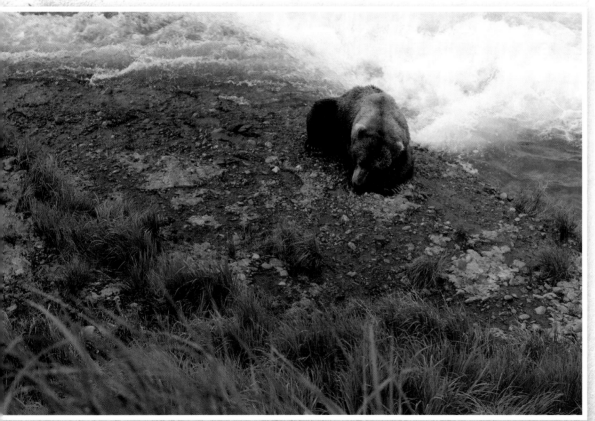

Short-face was now lying down and facing us, staring at us eye-to-eye. He was perhaps 30 feet away and at the exact same level when lying down as our lenses. It was the shot of shots, and Jake and I both ripped them. It is nearly impossible to explain the excitement of the shooting. It's the kind of shooting you do with someone that every other second you want to high five from the thrill of the images you're capturing and the experience being lived. There were smiles all around. It was really great being there with Jake and shooting with him. It added a whole new level of pleasure to photography for me.

The shooting continued that way until 5:00 p.m. That's when, and this rarely if ever happens

Dusty napping next to his fishing hole. Photo captured by Nikon D3 & AF-S Nikkor 24–70mm f/2.8 lens on Lexar UDMA.

at the falls, there was an option. The navy would be making a run over to pick up a person and we could all go back with the navy, or we could walk down the freeway to take the folks back to the boat (because no one can be left at the falls for that long by themselves), then walk back to the platform for a few more hours, and then walk back to camp using the high tide trail. There was no way my ankle was going to let me do all that walking—it was already pretty messed up. So Sharon and I hitched a ride with the navy back to camp. Jake decided to go back to the falls and was royally treated. The late afternoon sun finally came out over the river (but not at camp) and the bear activity increased. Jake came back with images that still bring tears to our eyes—they are beyond words. They just scream grizzly, McNeil River grizzly!

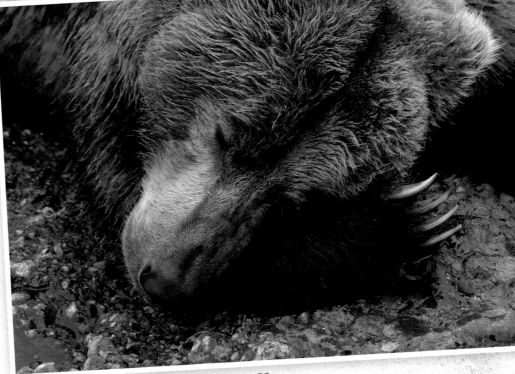

Dusty, the grizzly bear. Photo captured by Nikon D3 & AF-S VR Zoom-Nikkor 200–400mm f/4 lens with TC-17E II on Lexar UDMA.

Sharon and I took care of some camp chores, and I had to do some medical work on my ankle. After all that was done, I went over to a nearby fox den for a while to watch and shoot. I'd never had a day like this with grizzly bears—never. We were so excited, it was hard to sleep, and we woke up sadly knowing it was our last day—weather permitting, we would be flying out. The thought of leaving was hard to swallow. At our 9:00 meeting, we found out that Larry would take folks out to the mudflats. There was no way my ankle was going to let me do that, so I stayed in camp to finish taking it down. Jake stayed back to help. He still had cards to upload from the previous afternoon and wanted to make sure Dad and his leg were okay. It was a great morning: I talked with Tom, the biologist, for an hour and a half, and we went out to photograph the male red fox coming back with a ground squirrel, three voles, and a muskrat. Sharon went to the mudflats, where they spent the morning with 13 bears clamming. Yeah, that's the kind of experiences you can have at McNeil without even going to the falls!

The Dreams of a Wildlife Photographer

I truly wish that all photographers have the opportunity at least once in their lifetime to be in the presence of grizzly bears. Their effect on people who let them into their soul is amazing. Once they are in, you just can't spend enough time with what I've come to admire as gentle giants.

Starting out in photography is a struggle on every level, from knowledge to gear to time to practice your craft. It was no different for me starting out. "You've gotta go to McNeil River," I was told long before I ever contemplated working with grizzlies. A photographer I knew told me it was the place to go. "You sit out in the open, the bears surround you and just do their thing, and all you have to do is click." It sounded so impossible when I first heard about it back in the '80s that I blew it off. I mean, really, sit amongst the grizzlies with no barrier between me and the bears? How could it be true?

Then I saw the photos. I saw the bears up close and personal, taken with a 50mm lens. I saw photos of a sow nursing her cubs

Pronghorn antelope. Photo captured by Nikon D2X & AF-S VR Zoom-Nikkor 200—400mm f/4 lens with TC-17E II on Lexar digital film.

over 42,000 grizzly bear images (you could say I love 'em) and yet I still spend way too much money just to be in their presence. Why? Our experience at McNeil sums it up pretty well. It's at the heart of my photography and wildlife photography. It's really what this book is all about.

Presenting my griz adventures to the public is great fun for me. When I rise and get in front of the audience, the first thing I see people doing is counting my fingers, looking at my arms, and checking to see if I have a limp. I've been with grizzly bears, surely I've been attacked at least once, right? "Let's hear about how you've been scared and chased; let's see them fight pictures; how about that snarly face you see in magazines?" Then I throw up a shot of a cub, tell a little story about their fight with bumblebees, their fight for survival on a daily basis, and slowly the myths slip away and you can see the looks of anticipated fear change to admiration and adoration. It's the same look and feeling so many photographers experience when they're out shooting and the myths slip away, and the enjoyment in the viewfinder is recorded.

with a photographer sitting right next to her. I saw the photos of the bears with salmon in their mouths. In my mind, it was the quintessential locale for a wildlife photographer to prove he'd made it. At that moment, though, I didn't have the means to fly up to Alaska, I didn't have the support gear, and I certainly didn't have the skill set. That was incredibly frustrating and, at times, ate away at me. It would have to be something I worked toward unfolding in the future. It did get me to thinking, planning, and dreaming.

It took me 24 years to experience firsthand the magic I saw in someone else's photo of McNeil. It took me 11 years just to get to Alaska and see a griz, but the majority of those early images are kinda, well, they just don't say griz when you look at them. Looking back on it, I'm glad it took that long in one sense, and wonder how it would have changed me if I had done it sooner. I currently have

Life slowly prepared me for the opportunity to be at McNeil, and not until I was ready did I go to make images that I now hold so dearly, images I couldn't have made just a year before. It is no different for any of us: life has to unfold, time has to click on past for the knowledge to sink in and meld with who we are, so others can feel that in our images. It was not until that realization came to me on the bank

of the McNeil River, shooting beside our son Jake, that I decided to write this book. I was asked how we inspired Jake to become the great photographer he is on track to be. It wasn't so much what we said, but what we did, and that was to make sure both our boys experienced our wildlife heritage and wildlands in their many glorious varieties. Luckily for all of us, photography was the vehicle taking us on this magical journey. It's there, waiting for you too!

It was this realization of the work and dreams leading up to that moment on the McNeil that determined how this story you're reading would unfold. Every day behind the camera prepares you for the next day behind the camera, and the wise photographer realizes this, and gives themselves and their photography the time to make that ever-unfolding journey. The mechanics of making a click, as we've explored, is truly the easiest part of this photographic proposition. Coming to feel the light—be it ambient, flash, or their combination—

is the next big challenge, which simply takes time. But we've left the biggest challenge for last, and it's one I hope always challenges you. At least, that's my hope for myself.

I learned the hard way there is so much more that goes into making that great bear image (or any image) than the proverbial "f/8 and be there" mantra leads you to believe. The biggest challenge in photography is knowing your subject. No matter what the subject might be, no matter where your photographic passion takes you— be it people, sports, landscapes, or wildlife—that knowledge permits the rest of your talents to shine. In this case, the knowledge is often wrapped up in the blanket called biology. In the past, I've tried to communicate this required acquired knowledge simply labeled basic biology, but I now understand it must go way beyond that to create the images with impact, with passion. It takes more and it's within everyone's grasp if they let it in.

Grizzly bear fishing at Brooks Falls. Photo captured by Nikon D3X & AF-S VR Nikkor 600mm f/4 lens on Lexar UDMA.

Intimate Biology

Back in 2007, we did an Alaskan photo excursion with a group of really nice photographers. Of course, it wouldn't have been complete without photographing grizzly bears. Previously, when we did grizzly bear photo safaris, we took just five shooters. Any more and it just makes it really hard for us to not have an impact on the wildlife's daily routine, which in turn impacts making the shot. On this excursion, we had two freakin' buses of shooters. Holy crap! Get 40+ folks close to a wildlife subject, let alone a grizzly bear, when most had no more than a 300mm lens? Who comes up with these nightmares? I'm good, but really, that's stretching it.

We were outside of Haines, a place I'd never been before. We were told that grizzly bears are sometimes seen up Lutak Road, heading up the south side of Lutak Inlet to Chilkoot Lake. While folks mean well, I learned long ago that such stories coming from the paperboy of the third cousin of the neighbor's hairdresser usually don't pan out. The only reason I decided we should go that way was that there was supposed to be a bear with an injury. If that were true, and if we were to find it, and if it was a safe distance away (you don't mess with an injured bear!), we might just get to see it. Any possibility of getting

Pine grosbeak. Photo captured by Nikon D2H & AF-S VR Zoom-Nikkor 200—400mm f/4 lens with TC-17E II on Lexar digital film.

glass on it never even crossed my mind. I just wanted folks to be able to see a grizzly bear, which would make them (and me) happy.

Up the road we ventured in two old school buses on a lackluster drive with no photo ops. Just to add to the fun, it was overcast. Two busloads of anxious shooters and nothing to shoot—I hate that pressure as the leader, but on we drove (you probably think this whole chapter is just about grizzlies. Hang in there; I might surprise you). This is when you get on the mic and tell stories, ask questions, and try not to show you think you're photographically screwed. I was on the mic doing just that when we made a bend in the road and, off in the distance on the edge of the water between two buildings, I saw a familiar shape. I told the bus driver to stop, grabbed Sharon's bins and glassed the shape. It was a grizzly bear, and it had a limp!

After saying a little thank you under my breath, I quickly glassed the entire area to get the lay of the land. I've always gotta have that in my mind (why I have a GPS loaded with topos with me). By this time, the bus was listing 30 degrees starboard, as everyone was on the right side trying to see the bear. No one else saw it, how could they? They didn't have my eyes connected to my experience, but they at least gave me the benefit of the doubt. I quickly ran back to the other bus, told them what I saw, braced for the starboard list, and told the bus driver our plan of attack.

You're making deposits into your knowledge bank that you can make withdrawals from anytime.

When the buses started up the road, I saw nothing but confusion on some faces, disappointment on others, and some expressing all too clearly that they thought I was an idiot to be moving. I don't really run a democracy when I'm leading a workshop, so up the road we drove, where I knew we could make something happen. How'd I know that? Where we were heading, I didn't know—I'd never been on this road before. I'd never seen this bear before, so I had no knowledge of its personality. I knew by what I saw in the lay of the land, and I know bear behavior, so we kept driving up the road slowly.

As we followed the inlet, the road and its shoreline slowly got closer and closer to each other. We came to a bend and it took us right up to the inlet's shore. We had about a 40- to 50-foot buffer of grass between the shore and us. There was a log there, which I knew was a good thing, and the bear was nowhere in sight.

We got everyone out of the bus and gave them the instructions, giving them no options—play my way or sit in the bus. Everyone was to be at the back end of their bus. They were not to venture away from that spot—not move forward or backward, just sit. I'm always amazed in situations like this when folks have paid really good money to learn from me and, after giving them the best sound advice I can, they think I'm nuts. Why did you come then? (Inside words!) So, there we sat for a while—to some, for much too long.

Unless that bear found some easier source of food, he would be along. Even if he found an easier source of food, he would just be delayed in getting up to us. About 30 minutes later, he first appeared limping up the shoreline. I knew that the first moment he spotted the wildlife paparazzi would be the make-or-break moment for our photographic opportunity. If everyone held as instructed, he would just keeping walking right up to us. (I only had to kill one person and, after that, no one moved.) The griz stopped for a second, looked us over, and kept walking up the inlet shore as he had been doing. We were in.

I watched both him and the group. I told them to hold off shooting, wait until he got closer. He kept walking up as I watched him through Sharon's bins. I watched where his eyes were looking and his nose pointed. I instantly knew what he was doing and where he was going. It was then I yelled out, "Focus on the log. He's going to step up on the log and walk across it, giving you the perfect shot!" I saw the looks coming from the group. How do you know that? You don't know that. You're bloody nuts! A couple of minutes later, the silence of the forest was shattered by the first barrage of shutters, as the griz got up on

Injured grizzly searching for an easy meal. Photo captured by Nikon D2Xs & AF-S VR Nikkor 200mm f/2 lens on Lexar digital film.

the log and walked right across it, just like someone predicted. I became a hero, for an instant.

Was it a great shot? Heck no, it was okay at best, but that wasn't the point. Forty folks were just 50 feet away from a live, wild grizzly bear and, not only were they alive to talk about it, but most of them got their first really nice grizzly photos (they were abuzz with the story that night). More important to me was that, because of my years of experience with griz, the whole group got up close to a griz and had the opportunity to let it into their hearts. We actually were able to spend more time with it, and got even closer, because once the bear decided we posed no threat, he didn't care about us, which is how it should work.

"How did you know the bear would walk up on the log?" It was a really good question that was instantly posed to me, and one I regret I didn't answer fully to everyone. By the third time I had been asked it, I was mentally moving on, so I gave the simple answer of "Experience." The full answer is a mixture of biology, hydrology, and experience. The biology: the bear was injured and looking for easy food that wouldn't tax its limited abilities. The hydrology: the water was bringing dead, spent salmon down the inlet, and a carcass would get caught on the inside of a log where the water flow slows down. The experience was knowing the biology, the hydrology, and combining it with photography to be in the best spot to get the best possible shot. That's intimate biology.

Developing the Skill Set

Getting close physically and isolating with optics, the combining of biology and technology, and adding in your passion to make the photograph come to life for the viewer—that's the recipe always in my mind when I'm out shooting. That is so much easier said than done in the beginning. But you, too, can come to this point if you just start putting the pieces together that you collect from your experiences. That's what creates intimate biology.

Where do you start? It's a great question and, to be quite honest with you, I don't have the answer. I've been asked a million times and never found one answer that works. This is, in part, because I know what I went through, and I surely don't want anyone to have to repeat all of my mistakes. I've also seen very talented shooters, after a couple of years, hit the wall of frustration and hang it up. That's the last thing I want for any shooter.

> ❝I am totally convinced, from what I've seen, that you can do what I do if you're willing to put the right foot in front of the left foot, and continue that day after day, on good days and bad days.❞

What if you start by taking an inventory of what you've got? Is there an answer for you there? How much camera gear do you own? What's your longest lens? Where do you live? How much time do you have? What are you goals now and for the future? Ask yourself where you would like photography to take you in five years. Perhaps the most important questions are: where do you want to go, and how much passion do you have to get you there? I am totally convinced, from what I've seen, that you can do what I do if you're willing to put the right foot in front of the left foot, and continue that day after day, on good days and bad days.

Putting this into practical terms, let's say you have one body, a wide-angle zoom lens, like a 16–85mm, and a telephoto zoom lens, like 70–300mm, you work a 9-to-5 job, are on a limited budget, and live in a city. Where do you begin? If it were me, I would point my lens right out the window. You'd be surprised just how much you can learn right from the comfort of your own apartment or home. The roadblocks to your learning are only those you throw in the way, because if you want to succeed, you've got to master the can-do philosophy. I've either experienced or heard all the reasons you can't do this or that, and I've either experienced or heard how you can do it. It's totally up to you. So, let's explore the first possible place to start: your own home.

You need a subject. We're going to step past bugs and rodents for the time being, and focus on birds. You have a limited focal length of 300mm, and if you're shooting on a DX body, you have an effective focal length of 450mm. These are doable if you get the birds physically close, which is more than doable. There are two main things you can offer birds that will bring them in close: food and water. So that's the biology and technology we need to get started toward success—attraction and focal length.

Now, I'm probably not the best example to follow here, because I literally have attached to the home/office railings, walls, and any other strata I can reach, feeders and birdbaths. It's a bit much for the sane. You need to do some biological and photographic research before you put out food and water. With a 300mm lens, you know you'll want the attractant no farther than 12 feet from the camera to get a good image size. If you're wondering where that number came from, focus on someone's fist with your 300mm lens and see how far away you can be and still have a good image size. Keep in mind that, in the beginning, subjects coming to your food or water will be shy, so when shooting from your window, it might be better if the feeder is farther from the house (you can always move it closer as they become more accustomed to you).

Once you figure out the distance, you need to determine location. This is where your photographic skill starts to get honed. The feeder or birdbath is the attractant, not the location where you'll be taking the actual photo. The perch is what you'll be focused on. You need to design your shooting gallery thinking of light, background, and

Hairy woodpecker. Photo captured by Nikon D2X & AF-S II Nikkor 600mm f/4 lens on Lexar digital film.

subject. You want to place your attractant so the birds will come to it only after they land on the perch you put out first. Before going to the feeder or birdbath, birds tend to stop someplace to check things out, and be sure they're safe. That's the role of the photographic perch. To make this all come together, you have to do your homework to the best of your ability.

Think through how the sun moves across your yard, and where the best light is in the morning or afternoon. Are there trees that provide open shade you can take advantage of, and perhaps permit you to use flash to your advantage? Look at the light that's going to hit the perch and the background behind it. Stuff a colored sock, making it the size of a bird, attach it to a stick, and take pictures of it. As long as your neighbors don't see you doing this, it's a good way of seeing the little annoying details that the eye otherwise blows by: a telephone pole in the background, a white corner of the garage, little distractions we otherwise dismiss in our daily routine. Once you have a location determined, it's time for construction.

Keeping in mind what you learned about location and background, put up your feeder or birdbath during this process. Be real picky about the perch you select, be it a natural bush or one you've collected to put out. You want not only some biological authenticity, but photographic character, as well, in your perch. A perch with character can make the shot in an otherwise sucky location. Little dicky birds (sparrows, finches, jays, etc.) should have a perch that is no more than a pencil's thickness in diameter. The perch is a mere player in the drama—you don't want its size to upstage the subject. You might have someone move the feeder and perch around while you're looking through the lens, just to be sure they don't get in each other's way in the photograph. It's *your* shooting gallery. You can set it up any way that works for your photography.

With everything set up, it's time to get out the camera and dial in details—from focus point to f-stop to exposure compensation to time of day—to concentrate on your craft. While this is the *Field of Dreams*, where if you build it, they will come, they won't come as fast as in the movie. Make a daily journal of what and

*Bullock's oriole. Photo captured by Nikon D3X
& AF-S VR Nikkor 600mm f/4 lens with TC-17E II on Lexar UDMA.*

who you see that includes the date and weather. This is a great way to start learning bird species. Over time, you'll see a pattern of who comes when and how long they stay. For example, the evening grosbeaks come back to our feeders the end of March and head out the first of September. This is important to me because the rarities, like the rose-breasted grosbeak, only appear briefly about 2–3 weeks after the evening grosbeaks first arrive at our feeders. I haven't gotten glass on that rose-breasted yet, but my journal keeps me on my toes, looking for it when the time is right.

Now it's up to you to watch, learn, and shoot. Start by watching how the birds get to your feeder or birdbath. They tend to make a few stops on the way, places where they feel safe and can look out for predators. One species might enter a bush on one side and pop out the other. Another might go in high and come out low, and then fly low over the ground to the next bush, then appear at the top of it. Notice how the branch vibrates when a bird lands on it—it's not the same as how the wind affects the branch. These are all incredibly important observations you need to ingest and take with you into

Pine siskin. Photo captured by Nikon D3X & AF-S VR Nikkor 600mm f/4 lens with TC-17E II on Lexar digital film.

the field. You're making deposits into your knowledge bank that you can make withdrawals from anytime. And it's only the start of what you'll learn from the comfort of your home.

You know anything about the hierarchy of birds? In late summer, we have tons of pine siskins, a plain little finch not much bigger than your thumb. There can be a hundred in one feeder at one time. When the Stellar's jays come in, the siskins explode from the feeder in an "announce" flight pattern. When the northern pygmy owl, sharp-shinned hawk, or goshawk comes in, though, the siskins explode in a "don't kill me" panic flight pattern. Understanding and recognizing this difference in the flight pattern of a prey species is a huge tool to take into the field. How do you think you get close to those raptors? You gotta find them first, and this is a great way of doing it.

The first click you make of a bird on your perch is a big high. As you make more and more, the high wears off, and you get pickier and pickier. This is a good thing, not bad. It means you need to start

pushing your photographic skill set to match what you're learning biologically. What can you do? Move the perch closer to the lens. Introduce on-camera flash, and then move to off-camera flash. To be really honest with you, you only stop where your imagination ends. Keep pushing and you'll be surprised how, in a relatively short time, with relatively limited means, you're making really sweet images.

I've seen eyebrows raise and expressions glaze over when I present this basic concept to an audience. Really, how could an experience at home translate to what "real" wildlife photographers do in the field? The lens I started with wasn't a 600mm VR. Remember what it was? A 400mm. My first "big" shoot? A hummingbird nest in the backyard, where I spliced together TTL cables so I had light. Years later, we flew 4,000 miles to sit in chairs next to falls because the salmon were there bringing in the grizzlies. Oh man, this world is so intertwined—the biology, the technology, the business—you've just gotta let it in!

Next Is the Left Foot

I'm quite serious when I say I make a lot of money shooting out my office window. It's a win-win no matter how you look at it. There are no travel costs, I can shoot whenever I have the time, I can experiment when it doesn't really matter, I can practice new techniques or try new gear, it's a tax write-off—any way you look at it, sitting, watching, and shooting in your own yard makes you a better and more successful photographer. And you can take this basic concept even further.

There is a great place in Texas I love to go to: the Dos Venadas Ranch. Steve Bentsen has created a photographer's Shangri-la. In the hottest and driest part of the state, along the Rio Grande River, Steve has built "water features" that are accompanied by photo blinds. This is the ultimate in backyard shooting. This takes what you've already learned to a whole new level, with much greater photographic rewards, all built on the basics we just talked about.

You have two basic scenarios at Dos Venadas: either a ground blind (your butt is on the ground, so the lens is only as high as your eye), or a sunken blind (the lens is basically at ground level). There are variations on this: depending on the particular blind, you have

Northern flicker. Photo captured by Nikon D2X & AF-S VR Zoom-Nikkor 200–400mm f/4 lens with TC-17E II on Lexar digital film.

no background or you have the natural habitat for a background. After that, you sit incredibly still and very quiet in the 100-degree heat and fill up flash cards like a mad man with some of the most amazing birds North America has to offer.

What makes this all work? Why does this concept take things at your home a step further? First, you're leaving the comfort of your home and dedicating part of your yard to the pursuit of wildlife photography. That's a whole other level of commitment, and a good thing. You'll have to learn how to build a ground-level water feature that not only attracts critters (because mammals come, as well as birds), but is also photographable. It's gotta look like a real pond, even if you're in the middle of suburbia. And, you're going to need a longer lens—a 300mm, or DX 450mm effective focal length, ain't going to be enough. With this bigger investment in time, knowledge, and gear comes not only the potential for better images, but a better understanding of biology and how you can apply that knowledge to producing better images. (If you're thinking of taking it to this next level, I highly recommend heading down to the ranch yourself to see how Steve does it. It will save you tons of time and dough.)

The crested caracara is a species I'd wanted to photograph ever since I saw it in the bird ID book. It is one crazy lookin' bird—black, white, orange, and legs that look like it's waitin' for a flood, if you know what I mean. You see them in Texas on telephone poles and hay piles, but if you stop to photograph them, off they fly. When I got into Steve's raptor blind for the first time and he told me they would be flying in to the perches in front of me (along with Harris's hawks), I was a bit of a skeptic. That's until the first one landed just 30 feet away and I was taking headshots. Yeah, I was shooting with a 600mm with a 1.7x teleconverter, but I was seeing in the viewfinder an image I'd always wanted. That's the reward you have to look forward to every time you take it up another notch. With intimate biology, you know not just the subject, but yourself, as well.

Crested caracara. Photo captured by Nikon D2X & AF-S II Nikkor 600mm f/4 lens with TC-17E II on Lexar digital film.

Painted bunting. Photo captured by Nikon D3X & AF-S VR Nikkor 600mm f/4 lens with TC-17E II on Lexar digital film.

This is *the* most important lesson you'll learn in this process, so listen closely and write this down: The best images are made when the wildlife *comes to you*. The green jay is a big bird as perching birds go, and the painted bunting is the size of your thumb, maybe. The only way to make an image of either is to get physically close (hell, that's true for the crested caracara too, for that matter, or a moose, or griz, or whatever). The only way I was going to get close was to go to their habitat and have something that would draw them in to the lens. The way you learn and master this incredibly important principal is by doing it, and there's no better place to do it than at home. The best way to get physically close is to have the bird or any critter come to you—intimate biology!

And Now the Right Foot, This Time in the Wild

Your evolution as a photographer comes when you constantly apply what you've learned to the next project. Some wait until they master one concept before moving on. I've done that, worked to master one concept, and more often than not, that concept, once mastered, tended to be abandoned or folded into some other concept. So, like a bull in a china shop, I tend to just charge forward before mastering any one thing. With that in mind, forward we charge. Let's go to the beach!

Shorebirds are great to photograph, and I don't get enough time shooting them myself. Don't let the family name lead you to think they can only be found at the beach. One of my favorites is

Snowy egret. Photo captured by Nikon D3X & AF-S VR Nikkor 600mm f/4 lens with TC-14E II on Lexar UDMA.

the upland sandpiper, which I photograph mostly in the middle of the Black Hills in South Dakota. But, we're going to head to where you think you'd find shorebirds—the shore—and in this case, the southwest coast of Florida.

Shorebirds come in two basic flavors: drab and spectacular. Regrettably, we most often see them in their drab state, which biologically speaking is in their winter plumage. I've seen many a birder who knew shorebirds by their winter plumage only become totally frustrated trying to figure out the species in their breeding plumage—there is that much of a difference. Either way, they are great fun to photograph.

So, the first thing we're going to do is go prepared with gear. Being a public area, the next thing we're going to do is *not* stick out like a sore thumb. You're going to the beach, so dress accordingly. I've found, for example, these cool shoes called Five Fingers that are killer for working in the sand and mud of the coast. You'll understand why they are important in a moment, but the concept here is real simple: you're sneaking up on little birds, and Murphy's Law states that when doing this in the sand, you're going to step on a sharp shell that will make you jump, say a bad word, and make the bird fly away. So, to foil Murphy, wear shoes.

You're going to get wet. Wear clothing that permits you to get wet, and take a towel. The towel serves the obvious purpose of drying yourself off, but there is actually a more important reason to have at least a small hand towel with you, as you'll soon discover. The clothes should be good for getting muddy, as well, so they should be expendable. They also should keep

> *Be very, very careful when you get out of your vehicle, assemble your gear, and walk toward the beach. Sad to say, but you need to look around and see who is looking at you. There are those who would love nothing better than to lift your gear while you're not around, so take precautions when leaving your vehicle. If at all possible, have everything ready to go before you park, so once you park, you just have to grab it and walk away.*

you from getting sunburned. You have no idea how badly you can get burned until you've found that one great subject and work it for a couple of hours, not realizing how much time has gone by or that you're the color of a stop sign. Sunblock, a broad-brimmed hat, and an SPF shirt are must-have tools for working the shore.

When it comes to photographic gear, keep it real simple. I recommend heading out with nothing less than a 500mm or 600mm prime and a 1.4x or 1.7x teleconverter. You want to head out with the teleconverter already attached, and its caps in your pocket. A pair of bins is a great idea—I prefer 12x, the big boys, which makes finding the small peeps faster. Your lens should be on its normal tripod with the last leg extension fully extended to keep the joints of the tripod out of the sand. I also highly recommend you have a panning plate in a Frisbee with you. Lastly, take lots of flash cards.

Once you hit the beach, you need to look at the lay of the land (not what's laying on the land). You're looking for subjects (of course), where the birds seem to be congregating, and the flow of life on the beach. Apply what you've learned from your own yard and experiences. The shorebirds are going to be one of two places usually: at the waterline feeding, or up in the sand sleeping. Both are opportunities.

What else is happening at the beach? People are sunbathing, playing ball, and walking the surf. This can be a plus and minus to your photography pursuits. Try to make them a plus as much as possible. For example, if folks are walking the surf, can you use them

as they walk to slowly "herd" the shorebirds to you? I'm always surprised how many photographers don't use that tactic. Of course, once the shorebirds feel they are getting corralled, there is the real possibility they will just fly, but with practice, you'll learn to see this communicated in the bird's behavior, so you can minimize or avoid it.

Lastly, look at the light. Look first at its direction. You'll be shooting sooner and with less hassle if you walk the beach so the sun is on your back. This means the subject will be front-lit. The time of day isn't as important as you might think, because you have that great, natural fill card working for you—sand! Personally, I'm not a huge fan of first light, because it can be so orange with the bounce off the sand, but being early does often mean you have the beach to yourself. That is a benefit. But, with all that natural fill, what do you need to think about as far as metering? Personally, I know I'm going to be –0.5 and never think about it again. I sure don't need to lug along the flash. F-stop? I'll probably be at f/8 to f/11 the majority of the time, depending on the size of the subject. With that, it's time to get on a bird.

The most common mistake first-timers make in this situation is shooting at eye level, shooting down on the birds. Yeah, you can make an image that way, but what you see mostly in your photograph is sand. What's your subject? Constantly ask yourself that, because with the answer comes the photograph. In this case, it's small birds dancing on the sand. The answer to make the subject pop and minimize the sand is to get down on their level to shoot, which is where the panning plate comes in.

The panning plate is a great tool that lets you get down on the same level as your subject. Why is that so great? When you get down on the same level, the background disappears. The DOF band runs perpendicular to the sand, so only that area where the subject is standing will have any focus. It becomes a wash of colors, which is a great stage for your subject to pop visually. Even better, you can vary the color of the background. Rather than having it all sand color, you can pick up the blue of water or green of some far off shrubs. The background might be something a half mile off with only a splash of color, which is just downright sexy. Speaking of

which, be sure the background isn't some sunbather or the next tap on your shoulder might be the cops (no, I'm not speaking from personal experience).

Why should there be a Frisbee attached to your panning plate? For the same reason you're wearing shoes, for sneaking up on the subject through the sand. Here's the drill: You're going to find your subject and approach it with your long lens on the tripod. You'll make sure you have that small towel with you (tuck it into your pocket or tie it to the tripod, keeping it out of the sand. Golf towels work great). You'll end up lying on the ground, so make sure items like your caps and flash cards aren't in pockets, which might get filled with sand, but are where you can still have access to them.

When you get to a comfortable distance to work, but where you're not impacting the shorebirds, take your long lens off the tripod and attach the panning plate, which is inside the Frisbee. Then, very slowly, lower yourself to the sand. Why slowly? Where

Did you know that I've created a whole bunch of videos? You can head to www.kelbytraining.com or to www.moosepeterson.com—there are nearly 200 videos on everything from birds, to mammals, to landscapes, to finishing.

and how would predators be coming at these shorebirds? How does a cat approach its prey? Putting yourself in your subject's shoes should start to become a natural course of thinking.

At first, you're going to be on your hands and knees, scooting up on the birds. Your long lens will be attached to the panning plate so be sure you take care not to nosedive it into the sand or let it tilt back, putting the camera body into the sand. Now comes the painful part. When you get close enough to start shooting, you've gotta lie in the sand. We're just not made to bend at the neck in the way required when in the sand to look through the viewfinder, but that's what you've gotta do. You continue to move forward, real slowly, by digging your toes in and pushing yourself forward while sliding the camera rig forward. Imagine the pain of doing this when a shell gets lodged between your toes!

The sharp image comes from pressing your left hand down on the lens barrel and pressing the camera body against your eye. This is while your head and neck are cocked in a way that soon brings discomfort. Don't be surprised if your right hand, pressing the camera hard against your forehead, begins

Using a Frisbee to keep the sand out of my panning plate while stalking birds in Ft. Myers Beach, Florida.

to cramp up from the isometric exercise. At the same time, continue to dig your toes into the sand and slowly propel yourself up to your subject. It will take a little bit of time, but the final results are stunning.

That white towel now becomes really important. Your hands will undoubtedly be sticky, from either the sea air, sweat, or both, and sand will stick to them—you do not want to use your hands to move in the sand. Use your elbows, keeping your hands clean to take care of the lens and operate the body. When you go to stand up from lying in the sand, you've got to avoid getting sand on your gear. Check the wind direction, so it doesn't blow on your gear. Don't use your hands, if at all possible, to get up. Use that towel. (Keeping a can of air in the car is a good idea, to blow off sand before putting your gear back in its bag.)

Why did you carry the tripod along if you're using the panning plate? Two reasons: The main one being it provides the platform for your lens as you go down and then back up from the sand. The other is there will be other images of terns, gulls, and pelicans flying by or diving for food, where you don't want to be on the ground trying to photograph.

How many times will you be getting up and down? Let's just say you'll get your daily workout in the process of shooting. You'll try this bird and that bird, getting down on the sand and just starting to approach, and they will fly for one reason or another. That's the way it goes, but want to know what will increase your odds of shooting? The birds are looking for what? Food. Use your bins to see where the greatest number of birds is foraging, and you'll have the best odds of getting the shot. And, of course, whenever possible, find a spot where their natural foraging behavior of walking the shoreline brings them to your lens.

I rely on the Epson P7000 for field backup, image review, teaching, and image transport. It's a tool that, if you're serious about your wildlife photography, you should be serious about having.

Reddish egret. Photo Captured by Nikon D3 & AF-S VR Nikkor 600mm f/4 lens with TC-17E II on Lexar UDMA.

One of my favorite images using this technique comes from Fort Myers Beach, Florida. There was a black-bellied plover that was intent on foraging a little eddy. I approached as I just described, and walked up as close as I could, which was about to where the sand met the muddy sand/water. It was then I went to the ground and imitated a beached whale sneaking up on a bird the size of your fist.

Through the wet sand/mud I slithered, watching the plover the whole time. When it stopped and looked at me, I stopped. When it went back to foraging, I went back to getting closer. Finally, I was at the MFD of the 600mm lens. I put my chin down in the mud and looked through the viewfinder, and there was this really clean shot of the plover. I shot and shot, being conscious of the background and the horizon line, constantly making small adjustments (the tripod collar is loose, so you can easily level the image).

Then the plover turned its back to me and tilted its head to watch the passing of an osprey. Knowing my intimate biology, I knew it would cock its head to get a better look at the osprey. At that point, I tilted the lens a little to emphasize the gesture and clicked. When I look at that photo now, it just makes me smile.

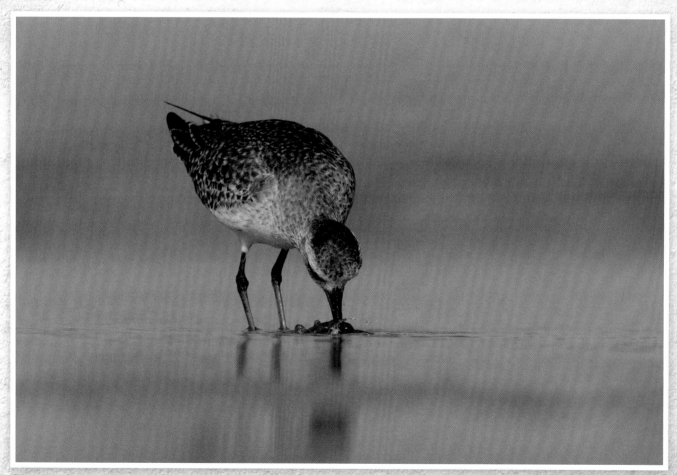

Black-bellied plover foraging. Photo captured by Nikon D3X & AF-S VR Nikkor 600mm f/4 lens with TC-17E II on Lexar UDMA.

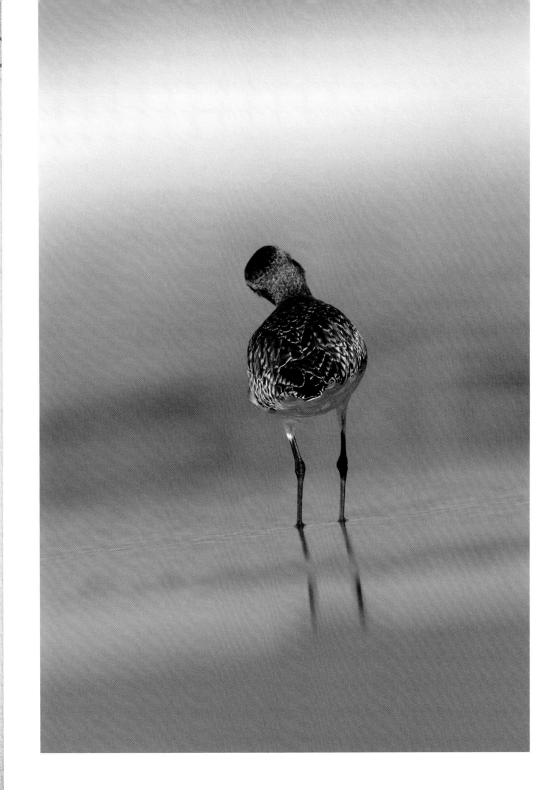

Black-bellied plover
watching a passing osprey.
Photo captured by Nikon D3X
& AF-S VR Nikkor 600mm
f/4 lens with TC-17E II
on Lexar UDMA.

Can You Go Lower?

By now, you know that's a loaded question, because of course you can, there are no limits. An example of this is the photo of the black-tailed prairie dog. I've already talked about how much I love photographing them. The vast majority of the time, you end up photographing them from eye level, mainly because prairie dog towns have the potential for fleas (and are covered in bison pies). So you don't need your panning plate here. But like the beach, the foreground/background of either nothing but dirt or grass just doesn't make the subject pop. You only need a couple blades of grass or a little dirt in focus around the subject for the viewer of the photograph to get the idea of place. So then, how did I make the photo you see here where obviously I'm lying on the ground? Or am I?

Back to the lessons we've learned from our yard. Critters come to food and water, and other times they seek the safety of a shrub, tree, or the like. In this case, prairie dogs seek the safety of their burrow when not foraging. You find an active burrow, and there is the possibility of getting the photo.

In getting close physically, you're going to have to deal with the pickets first. What are pickets? It's an old military term, applied here to those prairie dogs spread around the dog town, acting as sentries on the lookout for predators. They are standing up like a picket and sounding the alarm call when a predator comes near. Don't take it personally, but they consider us predators. Upon your approach, the alarm call goes out and most of the dogs will scurry to head underground. No worry, with time they will come back out to feed—you just have to watch and find that locale and you'll have a subject.

In this case, the dog town is a favorite of mine at Wind Cave National Park. The road goes right through the dog town, and this burrow is right next to the road, so this particular dog is used to humans. Even better, the road dips down to a creek crossing, so I'm shooting at ground level. I'm standing with the tripod set up at its normal height, but we're in a hole created by the road cut. Other than the lens and my head, most of me was below ground and out of sight of the prairie dog. It had no problems being out and about, because it didn't see much. And when you think about it, this really isn't any different than what the birds at your feeder see when you're in the house photographing them.

The photograph of the roseate spoonbill sky pointing is another favorite, and was taken with the same basic technique, in principle. The photo was taken in Florida, out in Tampa Bay—as in, *out*

Black-tailed prairie dog in Wind Cave National Park, South Dakota. Photo captured by Nikon D3X & AF-S VR Nikkor 600mm f/4 lens with TC-17E II on Lexar UDMA.

Roseate spoonbill. Photo captured by Nikon D3 & AF-S VR Nikkor 600mm f/4 lens with TC-14E II on Lexar UDMA.

in the bay. A boat took me out there, but I got out of the perfectly fine boat and shot in the water at water level. This meant the water was up to my waist.

The tripod has long sleeves on its legs so the water isn't soaking them (it isn't a big deal if it does). Wearing my Five Fingers again, with the 600mm with a 1.4x attached, I got out of the boat and slowly walked toward the spoonbill (you have to be careful to slip along in the water, not splash). The entire time I was walking toward it, I watched it and its reactions to my approach. At the same time, I was watching

the background—the green reflection of plants on the shore. When I got within shooting distance, I put the tripod down, pushing its front leg into the muck underwater, creating a stable shooting platform.

I put my eye to the viewfinder, looked first at the background, and then at the spoonbill. The subject and the background dictated a move closer and to the right. So I picked the tripod straight up, raising it four to five inches as I slipped forward and over. I put the tripod down again, pushing its front leg in as before, and with the image fine tuned—click, click, click.

There is an adage in portrait photography that you shoot up on men and down on women. It has to do with the general visual perception of masculine and feminine. While it might be a dated concept, it's still one that plays a role in producing drama in a photograph, especially when photographing wildlife. Getting down on the same level as shorebirds, or prairie dogs, or other critters increases their visual presence more than just popping them from the background.

One of my all-time favorite grizzly bear images is of Short-face at McNeil River. We're talking 1,100 lbs. of wild grizzly bear, fat and happy and sleeping in the middle of the river. He was perched on top of a rock that was exactly eye level with the lens. So when he lowered his head to his massive paws and looked at me, he was looking right down the lens barrel. The 600mm with 1.4x brings that expression of ears forward (so bloody important in mammal photography), staring down the nose like a puppy lookin' for love, and smacks you right between the eyes with it. Not what most think of when they think of a man-eater.

Getting on the same level is part of what brings that power to the photograph. Next is the narrow depth of field of f/8, so basically only the eyes are sharp. The contrast in the strands of hair fool the eye into thinking more is in focus, which is why the stare is so enlightening. Lastly, and most important, is the background. It's limited to just his body and a little of the riverbed. That is really what this is all about. Background control.

Short-face, the grizzly bear, at McNeil River. Photo captured by Nikon D3 & AF-S VR Nikkor 600mm f/4 lens with TC-14E II on Lexar UDMA.

Soapbox with a Background?

I want to step back for a moment and emphasize something that is very important to my style of photography, so you can decide if it should be incorporated in yours—the background. I mentioned it when I spoke about lenses and want to make sure you understand that, in all honesty, it dominates what I do in the field.

Bird, mammal, bug, rock, tree, or mountain—whatever the subject—the background is what makes me do what I do behind and in the camera. I've mentioned I'm not an eyeball photographer, but rather, I let as much of the critter's world into the frame as needed to tell the story (without saving their homes, there will be no critters to photograph). You might think that since the critter

isn't filling the frame, worrying about the background isn't that important, because really, percentage-wise, all you see is background. But the opposite is true: the background is even more critical if you're going to see that subject.

When I walk toward a critter to make a photo, I've already decided what I want for the background by looking at what I have to work with. I walk in a deliberate path, so when I put the camera to my eye, all I have to do is make a small adjustment by moving up or down, left or right, by only inches to make the photo. At this point, there is no guesswork, just fine-tuning once I'm at the distance to get the image size I desire.

Northern hawk owl. Photo captured by Nikon D1 & AF-S Nikkor 600mm f/4 lens on Lexar digital film.

Playing into this is, of course, the light, the exposure, the body gesture, the lens, and most importantly, the heart. But the background is what makes or breaks this entire assembly of natural parts in the viewfinder. I more than understand that, for many, the challenge is first getting an exposure, then getting a sharp image, and then getting close physically, and that's after finding the money to buy the gear and the time to shoot. I've been there. I understand that, and having walked that path, I'm telling you that pushing through that and getting to this point in your photography is more rewarding then you can ever imagine. It's what you have to set your sights on.

A common question is, "How many images do you keep?" When I say my average is 90%–92%, I see either disappointment or amazement. When I go click, it's because I like what I see in the viewfinder.

The subject and background work. If I don't like it, I don't go click, and perhaps that's why I am "skunked" so often. At the same time, I don't throw away an image just because it's not perfect. Just because I might not show it to the public or sell it for a million dollars doesn't mean a photo is a failure, and neither are you because you took it or saved it.

Background selection is about storytelling, for sure. The editor of this book had to muck through my grammar, my spelling, and my style of presenting words (not going to go so far as to call it writing) and eliminate those parts that just don't resonate, polish those parts that do, and clean up the rest so you get my drift. It's no different than what you're doing with the background and the final success of your image.

Bison in the snow. Photo captured by Nikon D3 & AF-S VR Nikkor 200mm f/2 lens with TC-17E II on Lexar UDMA.

You have to eliminate those elements that are distracting, while including those that tell the story, all while watching the subject for the right moment to go click. What's the story? What's the role of the subject in that story? What lens do I use, aperture do I select, or exposure compensation do I dial in? You're the storyteller, you tell me. You tell the world through your photograph. Ever heard one person tell a joke and it flops, but another person tells the same joke and it's hilarious? What's the difference? Presentation—one is more polished than the other, and that's simply what you're doing with a camera, making a presentation and polishing it.

In the pursuit of the perfect background, did I have some failures? Yeah, but you ain't goin' to see them. Do I have them in my files still? Yeah. How do you measure what's good if you don't have the bad? Do I still make mistakes today? Yeah, but not as many and normally not when it counts, and you still ain't going to see them. So, when I compare my images of today with those taken when I started, have I gotten to where I want to be? Does all of this go through my mind when I'm behind the camera? It does, but on such a subconscious level, I'm really not thinking about it, though it is dictating my actions.

Whatever the subject of your photograph is, it must smack the viewer right between the eyes if you're to be a success at being a visual communicator and puller of heartstrings. There are many roads to get to that place. The straightest and fastest I know of is the use of background.

Eagles in flight; a slow shutter speed blurs the wings. Photo captured by Nikon F5 & Nikkor 400m f/2.8 lens on Agfa RSX 100.

Pointing the Lens Up

Photographing birds in flight is the challenge that comes up about now in one's pursuit of wildlife photography. You have really only a couple of things you have to combine for success: you've gotta have a subject, you've gotta have at least 300mm, and you've gotta have a background. After that, it's just practice, practice, practice.

Great panning technique is a must for getting a sharp image. If you go out shooting and you find your camera always searching for focus, it's a sure sign your panning technique sucks (okay, the gentler answer is your panning technique needs practice). Panning is when your camera body moves in relationship to the subject. You're keeping the film plane parallel with the subject, which is how you maintain focus. When your camera is keeping pace with the subject, shutter speed doesn't come into play, because when done correctly, the subject isn't moving in relationship to the film. The wings, which are not parallel with the film plane, are where shutter speed is important. Slow shutter speed blurs pumping wings; fast speed freezes them.

Eagles in flight;
a fast shutter speed
freezes the wings.
Photo captured by
Nikon D2Hs & AF-S VR
Zoom-Nikkor 70–200mm
f/2.8 lens on
Lexar digital film.

Keeping the film plane parallel with the subject is the goal. You have two techniques to perfect: handholding and tripod. First, employ proper handholding technique (gravity forcing the lens down into your hand, the camera pressed against your forehead, elbows in against your sides) to keep a lens of at least 300mm rock steady. You plant your feet and twist your trunk at your waist to follow the subject. The key is when you start and stop firing the camera. You start firing as the subject comes into the frame, at which time you start twisting at the waist. You continue to twist as you follow the subject, firing as appropriate. You continue this until you are no longer twisted or the subject is exactly in front of you. At this point, you stop firing, but continue to twist until the camera is no longer making any noise. This is essential. Stop prior to the camera stopping and you'll have images out of focus. You have to continue to follow the subject in the viewfinder until the camera is silent.

It's basically the same thing with a tripod. You want to set up so you're working between two tripod legs. Use the proper

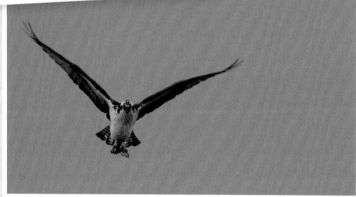

Osprey in flight. Photo captured by Nikon D3X
& AF-S VR Nikkor 600mm f/4 lens with TC-17E II on Lexar UDMA.

long lens technique (rest your hand on the lens barrel, press your eye against the camera body) and follow the subject in the same way, continuing to follow after you stop firing, until the camera no longer makes any noise. Why do you stop firing when the subject is in front of you? Because up-the-butt shots are rude!

The best way to practice this hasn't changed in 30 years. Grab your best friend, some unbuttered popcorn, and head to your

nearest duck pond. Have your friend throw out the popcorn for the gulls. Now, make a sharp image of them! I guarantee you, you will master panning doing this over and over again.

Photographing birds in flight is typically easiest and best when the light and the wind are hitting your back. Why? As I said earlier, if the sun is on your back, your subject is front-lit. If the wind is hitting your back, the birds are flying into the wind, so they're slower, making it easier for you to track them and get a sharp image.

Now, there's a saying in bird flight photography that, summarized simply, states: when it's overcast skies, don't shoot! Photographing birds against an overcast sky is a no-win situation. I don't care about any exception you want to think about, it's a no-win scenario, so just don't go there. I know you will, though, and when you see the results, you'll never do it again. But think through the exposure and you'll know why it's just not doable. With this being true, what about photographing birds on water on overcast days? I'll let you think that one through.

A common and very good question is which AF (autofocus) sensor, pattern, type, or flavor should you use? That really depends on your camera and your skills. Photographing the gulls will help you find that answer for yourself. Keep in mind that the breast is a bigger and easier target to find and lock onto, so use that as a starting point. As you move on with your skills, you'll probably pick a left sensor for birds flying left to right, and a right sensor for

birds moving right to left. Most start with the center AF sensor. You can tell—it shows in their photographs.

You don't need to worry about keeping your camera level with the earth when you're photographing birds in flight. In fact, turning the camera to emphasize the flight path is a smart thing to do. And while you're doing that, put the bird in a part of the photo that emphasizes this even more. This would be done in concert with the background. Yeah, backgrounds play a part in flight photography, as well. Oh man, is there no end to the compounding of all we have to think about when we're shooting? Hell no! Ain't that cool? Another challenge.

> There are so many techniques in photography, and probably none more important than panning. There is only one way I know of to become a proficient panner—practice!

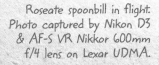

Roseate spoonbill in flight. Photo captured by Nikon D3 & AF-S VR Nikkor 600mm f/4 lens on Lexar UDMA.

You can take this a step forward by intentionally shooting at a slow shutter speed to blur the motion. Communicating action in still photography is an art, and doing blurs is taking art to artsy fartsy. Basically, you'll be shooting around 1/15 of a second with a rock-solid panning technique, so the eye is sharp, but everything else is a blur. You have to really watch your backgrounds, because any element that is even 1/2-stop brighter than the rest is a visual sore thumb. You will delete a lot of images to get the one, but it's worth it.

Expand Your Backyard

There comes a point where the backyard photography, no matter how productive it is, gets old. You might live in area like I do where, seasonally, the feeders get slow as birds head either south or north. Whatever the reason, you want to stretch your wings and find other places to work your craft. But, where?

Taking your lessons from your backyard and expanding them to answer this question is pretty simple. Find food and water, and you will find subjects. The problem might be that you don't like the subjects you find, the surroundings in which you shoot, or the proximity to your home. One real issue can be that the location doesn't have any romance or technical challenge. When you start to factor in those requirements, shooting locations become slimmer and slimmer.

Speaking as a photographer who has sat for days in a Bakersfield sump (a hole in the ground where trash and dirty water runoff from the streets collects) just to photograph San Joaquin kit fox pups, you should be suspect about my ideas for where to go shooting. We're talking about parking a couple of blocks away, acting like a burglar, sneaking to the locked gate (my camera and 400mm f/2.8 lens at my side, along with a chair and water), checking all directions before inserting the key, and entering the smelly compound in summer's 102° heat, with Bakersfield's lovely orange air to breathe, and sitting in two inches of water. I was in pig heaven, sitting and staring at a sandy bank for three days. In all seriousness, I'm incredibly fortunate to have worked in some of the worst and most incredible places this planet has to offer, and they all await you and your lens.

I contemplated writing an appendix with just names of places to go, but that wouldn't really help you. If you follow my son Jake's blog (and you should), you know how many days a year he spends in Yellowstone National Park, which is literally his backyard, looking for wildlife. You've also

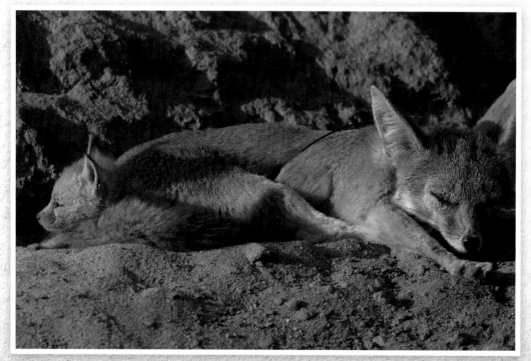

San Joaquin kit fox and pup. Photo captured by Nikon D1 & AF-S II Nikkor 600mm f/4 lens on Lexar digital film.

read how many days go by with nothing but a lonely bison up on the ridge being all he's found. And he's damn good—if he ain't seeing it, it ain't there. So if I listed Yellowstone, yeah, you could go there and, at the right time and the right place, find amazing wildlife. That's just not an everyday happening. It's a big-ass place, so it takes more than just saying Yellowstone to find a subject for the lens.

It only takes one cooperative subject to make any location a killer one. If you think about the size of your own yard and searching it for just one subject, it might take some time. Expand that to anywhere in the world and, well, you can see that we're all up against the same challenge. We can quickly narrow it down, though, which gets to the point of where to take your craft next.

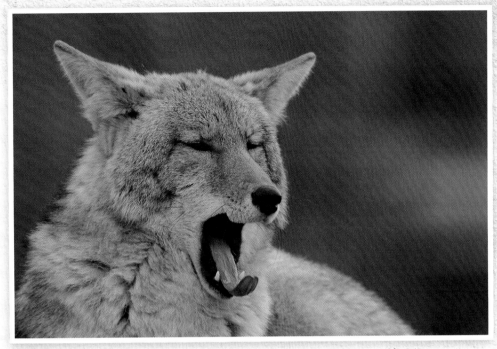

Coyote. Photo captured by Nikon D3 & AF-S VR Zoom-Nikkor 70–200mm f/2.8 lens with TC-17E II on Lexar UDMA.

Whenever in a new area, the first thing I check out are regional, state, or national parks, or wildlife refuges. The reason is very simple: these protected spots offer wildlife food, water, and shelter. Those key ingredients we learned about in our yard apply to anywhere in the world, so seek them out. The additional benefit to these locales is that wildlife in them tend to be habituated to human presence. This is a *huge* benefit, and lets you get down to shooting in a short time. Time is the most precious factor in this pursuit. Never forget that.

There are a number of ways to work a new area. Generally speaking, I find a locale that offers food or water, and then I park and watch. I realize this "passive" style of shooting doesn't work for some and that's okay. It's just that with the years, I have come to find that watching, listening, and understanding the flow of a location produces more,

better-quality images in a short time than a panic approach of searching every nook and cranny. The reason? Wildlife come to us on their terms, and this is always the best way to get the best images.

Now, if you go and camp in the middle of a parking lot, obviously you're not going to get any shots except, perhaps, a gull (though we had a coyote once, in Yellowstone, lay in the middle of a parking lot and we photographed him for quite some time). We're talking about looking at a location where there is food and water, and if you see signs of animals coming through—most typically scat—then there is a good probability they'll be back. Does this technique work every time? Not even, but that's okay. The one thing you have going against you when you venture to a locale for the first time is you just don't know the pattern.

Alaska marmots. Photo captured by Nikon D3X & AF-S VR Nikkor 600mm f/4 lens with TC-20E III on Lexar UDMA.

There is an amazing place just north of Salt Lake City called Bear River Migratory Bird Refuge. The vast majority of the year, you'll find your basic great blue heron or gull, and on good mornings in winter, you might find a bald eagle on the ice, but generally you wonder why anyone recommends the place. Then, from late October through November, the place explodes and there are more birds than you have pixels to photograph. Many locations are like that.

This is when an important component of intimate biology kicks in: the homework. It's so easy now compared to when I started, since most of the information is just a click away. Do a Google search on your area, or the area you want to explore, and find a location. Once you have a name, do another search on the name of the specific location and add the word "photographs." If it's a viable place to shoot, photographs will be posted. Get yourself an EXIF reader (for Firefox on my PC, I use Exif Reader, because with that, you can Right-click on the photo and you'll see the date the photograph was taken). So, with just a couple of clicks, you have

a location name, possible subjects, and the date those images were made. To me, it's how you do your research to make the most of a new location or find one in the first place. Knowing your resources is a very important part of this process.

There's the Critter, Now Get Close to It!

No matter your style of photography, be it eyeball photography or leaning more toward my "environmental portrait," you've got to get close physically. "How close is getting close physically," you ask? The vast majority of the time, I am no further than 60 feet from my subject. When it comes to LBJs (little brown jobs), I'm going to be at the MFD of my 600mm, which is 16 feet, whenever possible. If I'm working with moose—the other end of the spectrum—60 feet or closer makes me very happy. Okay, you say, "What about grizzly or polar bears?" What I do here, I never advise others to do, but I'm just as close, if not closer, to them if I know the individual. "Well how the hell do you do that," you ask? That's a great question.

I truly wish I could remember and write about every possible scenario I've come across and how we solved them all to give you a leg up on this very important aspect of wildlife photography. Heck, walking up to a perfect stranger on the street and asking them to model scares the crap out of me, where my buddy Joe McNally does it without a second thought. Yet I sleep with bears right outside my tent.

When it comes to understanding biology, and using that understanding to get close and predict a critter's actions, the talk will always be in generalities. The main reason is each critter out there has its own personality, just like we do. Approach me wrong and you'll not get a word out of me. The right word and you can't shut me up. It's no different with wildlife, except if they don't like you, they just leave. Grizzly bears are pretty simple, as they do one of two things when they see you: walk away and leave, or not give you a second thought and go about their business. So, as we go on with this discussion, keep that in mind, each and every individual critter is totally different in their reaction to you.

Let's start with the very basics, just what we're presenting to wildlife. When we were in Yellowstone, filming the Kelby Training Yellowstone class, at the very first stop, I told our cameraman Jason (a great guy) that what we both had to do was get out and roll in the bison pies, so we were scented and could get close to the wildlife. Jason's eyes got real big as I opened the door of the vehicle to get out. He didn't know if I was kidding or not, and the possibility that I wasn't scared him. I quickly let him off the hook because we had work to do.

When I head out to shoot, I wear basic neutral colors and a smile, and that's it. Wearing camo (you or your lens) isn't going to hide the fact you're a person with a lens coming to take a critter's photo. We're not talking about sitting in some deer stand all night here, we're talking basic wildlife photography. I always work under the assumption that all critters are shy until I'm proven wrong. For that reason, I wear neutral colors.

Besides your clothes, you're also wearing camera gear, and how it's presented is important, too. Now some of this is going to sound

> Have I ever been scared or afraid for my life photographing any critter? Not once, never, not with grizzly or moose or wolf or anything. Knowing basic biology prevents you from ever getting in that situation.

Bison. Photo captured by Nikon D3X & AF-S VR Nikkor 600mm f/4 lens on Lexar UDMA.

petty and anal, but it's what I do and think about when I go out. While I've never witnessed it personally, I've been told that white lens barrels bother wildlife. I've shot with many a Canon shooter beside me and never saw a critter bolt away screaming at the sight of a white lens barrel. On the other side, I've not seen critters flock to those with a black lens barrel, either. So, I honestly don't believe the LensCoat cover color is important, but knocking down the shine or reflection off the lens barrel or chrome parts might very well be, which is why I advocate LensCoat covers.

A reflected shine of a chrome piece might be enough to scare away a shy subject, and if it does, we'll never know that was the reason. At the same time, that giant front element staring at the critter might look like a giant eyeball blinking if you keep putting your eye to the viewfinder and taking it away. I'm very cautious when working with a critter at first. If I take my eye away from the viewfinder, I block the light coming into it in some way, with my body, hand, viewfinder shutter, or by turning the lens. Until I know the subject is comfortable with me, I take nothing for granted.

Long-tailed weasel. Photo captured by Nikon D3 & AF-S VR Nikkor 600mm f/4 lens on Lexar UDMA.

One of the great things about digital, I feel, is our ability to ditch the photo vest. The bulk of the vest modifies our profile/outline in ways I always felt made some critters, especially big game, shy away from us. They wouldn't run, but they would never let us get as close as we wanted.

When going to a shoot, the gear is in the MP-1 photopack in the truck. When I get to a location, only the gear needed for that shoot is taken out. If birds are the target, then the 600mm with teleconverter (with its caps going in my pocket) is mounted on the tripod. Going after big game, the 200–400mm is mounted on the tripod with the teleconverter in the back pocket. The CompactFlash card wallet goes into a side pocket in the pants (Carhartt pants are great for fieldwork). Lastly, a second camera body with a "landscape" lens usually goes over the shoulder (mounted so the camera comes into the small of your back). You gotta look at where you're heading and make the best judgment about what you might come across and the lens required to capture it. Generally, that's it. The gear is minimized, so what we present to the wildlife is minimal.

The majority of the time, the critters we're "stalking" are prey species, species on the bottom of the food chain—they are someone else's meal. This is why they tend to be nervous. You can generalize that the predator is either going to be coming from the air or the ground. Since we can't fly, photographers are lumped in the ground predator category. Have you ever watched a predator slink through the grasses toward prey? They tend to be low to the ground, and the grass parts around them in a very deliberate way. The movement of those vertical lines—the grasses—is one thing prey species are very sensitive to. Can you think of any vertical lines that sway that are part of our camera gear? Yeah, those straps you have hanging from your lens barrel and camera body (not the one on your shoulder, which melds into your profile). I've seen many times how those straps sway-

> *You gotta look at where you're heading and make the best judgment about what you might come across and the lens required to capture it. Generally, that's it. The gear is minimized, so what we present to the wildlife is minimal.*

ing as the gear is carried, or with a gust of wind, has sent a subject back into the bushes. For that reason, you don't see any straps on my gear, except on the body going over my shoulder.

This is all about looking at ourselves through the subject's eyes. We have two other appendages that we need to keep tucked in at first, our arms and legs. Keep in mind the predators coming at ground level—they're going to be low. Your feet, believe it or not, can make or break your stalking of a shy critter. Keeping your feet low to the ground, and not raising them as high as you normally would when walking, can make a huge impact. Your arms and hands waving away from your body can give you grief, too. Learning to "slide" them up and down your body in front of your chest will make a difference.

Lastly, there is noise. Camera bodies now come with the motor drive built in, so even if its noise is an issue, you can't take the motor drive off. I haven't ever had noise from the camera be a problem in the field. Does it startle critters? I've not seen it, but I've seen them look up at me when the camera goes off. Is that from the noise or something else associated with making the snap? I don't know. Have I seen this more when using a flash? Yeah, the combination of flash and motor drive can at times make a critter look up. But I've never seen it alter their behavior, or send them running into the woods.

Yes, these are the extremes, what we do when we don't know the subject and if it's shy or not. There's always the other extreme, where you could blow a foghorn and not get the critter to give you the time of day. And, of course, the biggest compliment a critter can pay you is to fall asleep in your presence. Nothing says you're doing everything right like that. But, of course, you ain't getting no photographs either. It's like our camera settings always being set for action, even though we might be photographing a rock. With wildlife, we're working on the assumption it's a shy subject until we know otherwise.

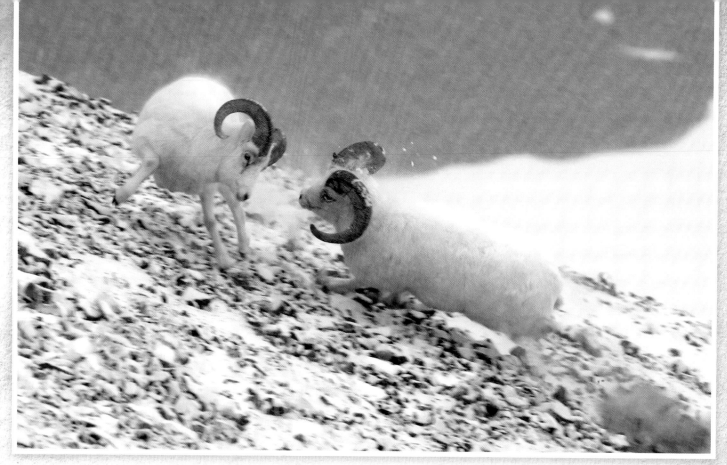

Dall sheep rams fighting. Photo captured by Nikon D1H & AF-S II Nikkor 400mm f/2.8 lens on Lexar digital film.

Working the Tripod

Quite often, you'll find yourself heading off into the field with your big lens attached to the tripod—the quintessential wildlife photographer in action. And while this might be true, it's a point of frustration for many photographers, getting the tripod out into the field and then working with it once they're there. So let's go over a couple of the finer points of tripod field etiquette.

You want to head out with your rig ready to rock-and-roll. When you put the tripod down, all you want to do is fine-tune the framing and fire. This means that, before you even put the tripod on your shoulder, you've turned on the camera (and it remains on), set the f-stop where you'd like it, dialed in any exposure compensation,

and focused your lens on something that is about 60–80 feet away. The precept is pretty basic: be ready for action. With this, it's time to lock down the controls on the head. It doesn't take too many times of the big lens swinging and bashing your brains before you remember this.

We all have a slight variance on the carry method because of our personal builds, but this is how I make it all work: First, the tripod/long lens/camera ride on my left shoulder. Why? That's where it has for 30 years, and the trough is well formed to accept it. I set the 600mm or 200–400mm when I lock down the head, so the length of the rig goes parallel with two of the tripod legs rather than

perpendicular. I do this so when the rig is riding on my shoulder, the front element points to the ground and the camera body is up in the air. Then, the rig is hoisted over my shoulder, so one tripod leg is on my shoulder, the lens/body are next to my head, and the other two tripod legs are out to my left side. This is how I carry the rig when I'm walking from point A to point B, covering some ground. This style of carrying gets changed up once we're getting close to the subject.

The tripod legs sticking in front of you is not what makes critters nervous, it's the movement of these straight lines from pointing straight out to going near vertical that bugs them. It's just too many lines moving in too many directions, and it will make a shy subject bolt. So, when you start getting at a distance where you might be working a subject, change up the tripod so it's now exactly as if it's sitting on the ground, but it's resting on just one shoulder. From this position, it's real easy to simply lower it off your shoulder, going straight down on the ground. You can simply bend at the knees and lower yourself (not bending over, but going straight down) to put the tripod down, and then slowly stand straight up behind the tripod.

Over the years, we've done a number of tests to figure out why this works this way, but we've never found an answer. Wildlife, for whatever reason, make that tripod into their own personal wall of protection from us. Stay behind it and they are happy. Walk beside or in front of it, and they are out of here. The lines of the tripod legs are diagonal and never move. It could be they register this as a log or something. Whatever it is, take advantage of it and stay behind it.

Pronghorn antelope. Photo captured by Nikon D3X & AF-S VR Nikkor 600mm f/4 lens on Lexar UDMA.

San Joaquin kit fox and pup. Photo captured by Nikon D1 & AF-S II Nikkor 600mm f/4 lens with TC-14E on Lexar digital film.

This means that when you're working your way closer to a critter, you have to stay behind the tripod, so no lifting it up on your shoulder. Rather, you're going to "bench press" it in front of you. It's all arm strength, baby, lifting the entire rig up, and only by a couple of inches. You raise it just enough to clear any obstacles on the ground and that's it. You then lower it with as much ease and grace as your muscles will permit. What I do is step up into the tripod legs as far as I can, then lift the rig up and set it down, step into it again, lift and move, until I'm at the distance I want to be. I'm watching the subject the *whole* time, so if there's any indication it's not happy with my movement, I stop.

You can't put the tripod down just any old place, either. It's creating the support for that big, expensive lens. You want to make sure all three tripod legs are on terra firma. You don't want any little rock, twig, or other obstruction underfoot. What if you're working in snow, sand, mud, or something not all that firm? You've gotta give that front tripod leg a firm push, setting it into the surface. Breaking that surface tension between the three legs is the goal. You're going to be working between two tripods legs, not straddling one, so push the leg right in front of you into the ground.

Most mammals are sensitive to high-frequency noises—noises like those made from squeaky tripod legs. You know the squeak. If you have one, you'll need to lose it. Some of the nylon leg wraps and rain covers (not the neoprene that LensCoat uses), when rubbed by your hands, on each other, or against another piece of nylon, create a noise we can't hear, but a critter can. This goes for some of the nylon camera bags out there, as well. I discovered this when I was photographing a kit fox, and every time I made a small move, it looked straight at me. It took some doing, but we figured it out and tested the hypothesis. Nylon and critters don't work.

The Approach to Your Approach

Whether you're using a tripod or handholding, if you're approaching a subject, don't be in a hurry to get nothing. I'm not saying that slow and easy wins the race, because that's not always true either. What I'm saying is, as you physically move closer to your subject, be it by foot, car, boat, float, or crawl, you've got to watch them.

They will visually tell you if you're doing things right or wrong—coming too fast or needing to hold. You've just gotta watch for the signals. With mammals, their ears tell you tons. Both ears back on a moose and you'd best be on your guard, they aren't too happy. Both ears back, but cocked so they are pointed sideways, and they are listening to a possible predator (or mate, if it's fall) off to the side. Watching the ears and tail on a deer tells you even more. Again, these are generalities, but that's all we've got to go by.

Birds have other signs you can watch for. The best known is the raptor defecating before taking off. But they don't always do that, and they can defecate and it means nothing more than they had to drop a load. But if you watch their tail, it can tell you tons. The tail shake-out is often a sure sign they're out of there. Watch their feet, as well. They do a little foot-to-foot shuffle when they're thinking about splitting.

Some birds, like the mockingbird, are always pumping their tail. Birds like the American dipper and spotted sandpiper naturally bob up and down. So, while in some species, these signs tell you they're leaving, in others it's just part of their natural biology.

The key is to watch these signs and start learning them. As you approach the subject, watch it, don't take your eyes away from it. When there is a change in its behavior, stop, watch, and figure out if you or some other influence is messing with its mind. With that information, you know if you can proceed or need to hold tight. Seriously, don't be in a hurry to get nothing. How long have I taken to get close to a subject? The longest I can remember is 40 minutes to approach a nesting Pacific loon—a photo later used by Nikon and made into a poster. Patience does pay off.

Red-shouldered hawk (Florida race). Photo captured by Nikon D1 & AF-S II Nikkor 600mm f/4 lens on Lexar digital film.

Since I brought it up, what about this patience thing? This is such a common comment: "You must have a ton of patience!" You might call it that, but truthfully, I'm so curious about what I'm seeing, so challenged to get the image, and so excited by the possible rewards, time just flies by. If that's patience, then I've got it, but to be honest with you, I don't think of myself as a patient person.

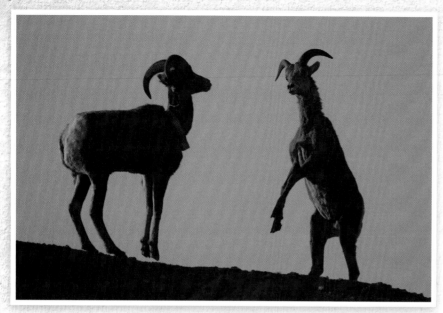

Rocky Mountain bighorn rams preparing to fight. Photo captured by Nikon D3 & AF-S VR Zoom-Nikkor 200–400mm f/4 lens with TC-17E II on Lexar UDMA.

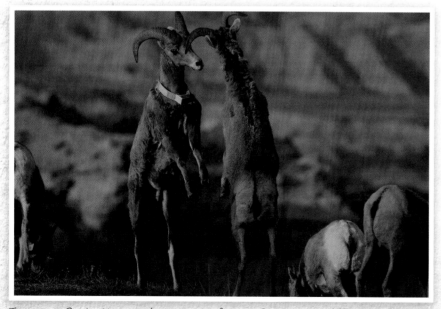

Two young Rocky Mountain bighorn rams fighting. Photo captured by Nikon D3 & AF-S VR Zoom-Nikkor 200–400mm f/4 lens with TC-17E II on Lexar UDMA.

You Can't Underrate Sex!

It's one of those clear sky mornings over the Badlands. The air is clear and crisp, and you can taste the minerals as they float into your senses. You know the light will be hard as nails before too long, so the panic sets in to find a subject while the light is still sweet. Walking the road, trying to make a landscape happen at the very least, the first Rocky Mountain bighorn sheep are spotted coming over the ridge. They are silhouetted by the rising sun and they are "kids," not big rams, but no matter, they are a subject that just needs some light. They walk the ridgeline and, as they do, you map their path and start thinking where they will come down and where you should be to make an image at that spot. You start to move in that direction, watching their progress as you walk. Then one stops, turns around, and squares off with the other.

You stop, watch their body gestures toward each other, and then hurriedly set up the camera and get glass on them. Shooting with the 200–400mm, the lens is zoomed to take in just the two sheep. In the light levels, you know to dial in –1.5 stops. Then, right before your eyes, they rise up and attempt to air dance on the spine of the ridge. The light is pretty near nonexistent, only the slightest of rim lighting from the sun, but no matter, the motor drive starts to whirl. They only attempt it twice on the ridge before continuing down the path. They come down to your level and go about being sheep, munching spring grasses.

The rest of the herd comes over the ridge, walks down the same path, and joins the two young rams, who are now grazing on the side of the road. The Badlands off in the background starts to glow with

the morning light, so you move to take that into the photograph, trying to make the image happen in the viewfinder. It's a hard day to make things click: sheep on the side of the road with hard light—right elements, wrong proportions. No matter, you keep working the situations.

Then the two rams bodies get ridged, each step of their walk more pronounced. They are thinking about going at it again. This thought no sooner comes to the forefront of your thinking and you back down the zoom to take in the upward movement when they launch skyward and start to paw at each other. You get off a couple of frames and they're done. The herd continues along their path, which takes them down the side of the hill and into one of the Badlands' deep, steep ravines where you can't follow. With that, the 20-minute encounter is over.

Spring is a great time to be out shooting, because one the best tools we have to get close physically is in the air—sex. These two rams were affected by it. They weren't fully under its trance yet, but enough that they had to push each other around. It was the first time I had air dancing displayed close enough to get glass on it, so I was incredibly excited to capture it. The telemetry collar on the one's neck doesn't bother me (I've put a few of those on in my day). Having an *Audubon* magazine cover of a banded California gnatcatcher, knowing most photographers either don't take such photos or Photoshop out the collar (which I *never* do), is not only a great experience, it's money in the bank. All because of sex!

The Badlands of South Dakota, right outside Wall, are a great place for bighorn sheep in the spring. There's always something going on, from rams butting heads, to them just munching grass, to ewes with spring lambs. The common denominator is spring sex, and when that is in the air, the last thing wildlife thinks about is someone approaching them with a big lens. Bighorn sheep are a great subject for learning this lesson: they are pretty easy to find and work with, and are rather forgiving of our mistakes without any real risk to their welfare. One of the best locales for photographing bighorns is Custer State Park, South Dakota. And, these lessons can be applied to almost any sheep species.

I have a real love affair with wild sheep, so I've spent a lot of time photographing them. Even for the beginner, they are a species with little homework. Using sex to get close physically, it takes little camera gear or experience to make some sweet images. North America has six species of wild sheep, broken down into two types: thinhorn and bighorn. Thinhorn have horns that are widely curled, and smaller cranial and body measurements (a smaller diameter base). Bighorn rams often have broomed horns (the ends broken off) because of their bigger, thicker mass. Neither shed their horns—they grow a little each year and you can actually age sheep by their annual rings. While there is a biological difference between them, I've seen Dall sheep with broomed ends and massive horns and bighorn rams with really wimpy horns.

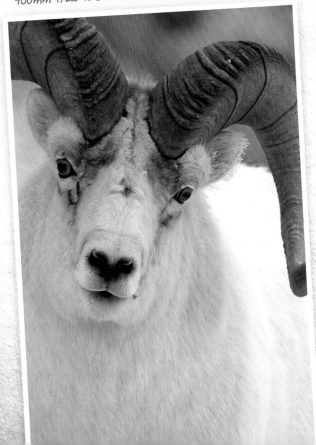

Dall sheep. Photo captured by Nikon D1H & AF-S Nikkor 400mm f/2.8 lens with TC-14E II on Lexar digital film.

Sheep scream wilderness, which is why when most folks think of wild sheep, they think of some creature way atop a ridge that, even with a spotting scope, is a mere speck on the horizon (a disheartening site when you want to photograph them). Sheep do live on slopes, some so vertical you wonder how they stick to the rock. This feature of their lives and habitat is important to their survival. Predator avoidance is why sheep live on precarious slopes that can slow down the photography. And their food source is mainly the grasses that cling to the rock crevices on the slopes.

Sheep don't live in a daddy, mommy, and kid arrangement. This is important to know, because it's how the sex works in your favor. There are only certain times of the year, primarily generalized as fall, when ewes and rams come together, and that's during the rut (though there is evidence that bonding occurs in the spring, as well). Other than this brief period, rams form ram bands and go one way, and ewes create ewe bands and go their way. While they might come together for brief periods, they are basically separate except for the rut.

In the spring, when the ewes drop their lambs, most often, the ewe leaves the ewe band to give birth alone further upslope. So in regions that have even nastier topography than the slopes where you might normally see the sheep, they give birth. A day or two after the lamb is born, the ewe and lamb rejoin the ewe band. After all the spring lambs are born, these groups can be quite large.

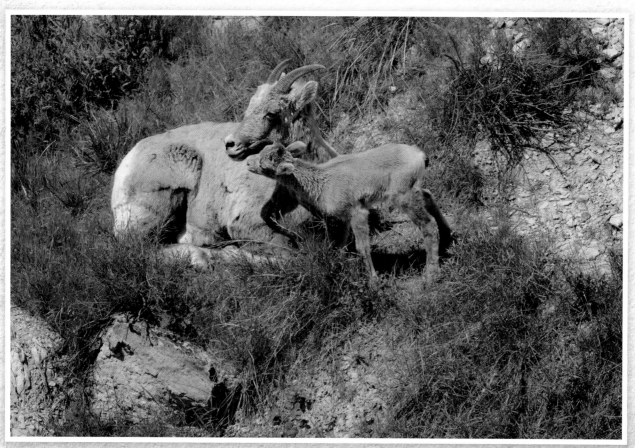

Rocky Mountain bighorn ewe and lamb. Photo captured by Nikon D3X & AF-S VR Nikkor 600mm f/4 lens with TC-17E II on Lexar UDMA.

The fall is when rut begins, and where the age-old urge for survival takes hold, and the world of the wild sheep crashes in spectacular form. When the ram and ewe bands come together in the fall, the rams battle to be the studliest, and thereby have the right to mate with the most number of ewes (don't fret, some of the smaller rams get in on the breeding action). Of course, this is all a biological generalization, as each region's wild sheep react to the weather as much as their own biology. If there's one thing I've learned in two decades of working with sheep, they don't read the books, so they don't know exactly what they are supposed to be doing all the time.

The rut period might last four to five weeks. Prior to the rut, the animals look their best. Their winter coats have come in, the rams are their fattest, and photographically and biologically the sheep are spectacular. After the rut, though, that's not quite the case. Rams have lost fat, coats are often muffed up, and some animals have gained battle scars.

Since sheep by are pretty easy to approach, it takes very little positive human contact to habituate them. When you're working sheep, you've got to think like them in some aspects. The main one I must stress is predator control. You can never forget that sheep are always looking for an upward escape route. When they have one, they are basically calm. Cut it off and they're gone. This means that you need to always approach sheep from below, slowly, and with the thought always in your mind not to get between them and their escape route. It is very wise to glass a mountainside with this in mind before approaching sheep. Look at where they are grazing or resting, and search the hillside, looking for their possible escape routes. Then plan your ascent, avoiding those escape routes. Taking the time to do this can only bring you photographic rewards.

Rocky Mountain bighorn sheep with a shadow area for the background. Photo captured by Nikon D3X & AF-S VR Nikkor 600mm f/4 lens on Lexar UDMA.

Two essential photographic elements you've got to keep in mind when photographing wild sheep are background and light. Neither one of these are easy when you're already working against gravity, weather, and nature.

One reason background control is challenging is because moving around, which would be the normal way of working a background, is hard to do when you're on a mountainside. If you're in a meadow, it's not so difficult, but I wouldn't count on shooting much in a meadow. When moving requires going up- or downslope and re-setting your tripod, at times it's just not feasible. This means you need to be on your toes and try to predict, to the best of your ability, where the sheep are going, then set yourself up for the best background. I tend to find any large shadow area that I can use as a background. While not always the most informative of backgrounds, it's a lot better than some white boulder bouncing sunlight back at me.

Rocky Mountain bighorn sheep resting. Photo captured by Nikon D3 & AF-S VR Zoom-Nikkor 200–400mm f/4 lens with TC-17E II on Lexar UDMA.

Next, sheep tend to live in areas with big rocks, fallen logs, and other bright, reflective objects. What a pain! Not only that, but light can be streaky coming through a tree canopy or rock face. Getting the great shot requires being totally up on your game.

This brings in the light issue. Big game, including wild sheep, bounce light off their pelts pretty well. This means that if they have direct, bright sun on them, they are going to burn a hole in your film. Add to this the glare of their polished horns, and you could have an exposure nightmare. Gorgeous light is the only light to go after sheep in. Don't even start up that hill if there is full sun beaming down. Early morning, before the sun ever rises, is a great time to photograph sheep. In the late afternoon, when there are summer thunderheads forming, is also a great time. And, in the fall, when the light is low on the horizon anyway, is a natural time to photograph them.

Once you are in place and all the elements are working, you need to stop for a moment and take a deep breath. Working sheep requires a slower pace than most other critters. Unless fleeing a predator, sheep lead a rather slow-paced life. You need to be mentally prepared to take a nap—literally—when photographing sheep. Wild sheep often take "rests" where they just lay down, chew their cud, and take in the world. These rests can last hours and, while there are some photographic opportunities, you'll have to cool your heels for a while.

In time, you'll be in the midst of a wild sheep band. When you find yourself in this situation, remember to move slowly, don't cut off their escape route, and take lots of shots. Look for the behavior and you'll find the interesting shots. I personally have found that sitting down, or getting as low as I can, puts the sheep at ease faster, so they go about their lives and ignore me. This is when the best photography occurs. You've worked hard to get to this point, slow down and enjoy it.

> Wildlife photography workshops are a great place to learn, but just keep in mind that wildlife photography is not a team sport. The great images come from you putting in your time in the field without a crowd, when you control as much as is controllable by humans in a wild world.

The Birds and the Bees (Well, the Birds, at Least—I'm Not So Good with Insects)

From Florida to Churchill, Canada, from St. Paul Island to Tijuana Marsh, and almost all points in between, I've been incredibly fortunate to travel to many of the great wildlife spectacles North America has to offer. Bird photography is the pursuit of most wildlife photographers for the simple reason that you can basically find them everywhere. Even in the Arctic, when there is nothing living anywhere around (although I think ice lives), you will find a glaucous gull or king eider duck flying by. There is no better time to focus on birds than the spring, when hearts and minds are centered elsewhere.

When it's nesting season, all caution is thrown to the wind by birds. Besides, they are looking their finest with their spring colors. They really don't care about us, at least for a small window of time. That's when bird photography is at its hottest. Keep in mind that you can expand that window if you start at the bottom and work your way up to the top. What do I mean by that? Often, species along the U.S.-Mexican border are done nesting before those in Canada and Alaska have arrived at the nesting grounds. Where we live, those at the 4,000-foot level finish nesting when those at 8,000 feet are just starting.

How can you take advantage of this? Again, start in your own backyard to learn how birds' appearance and behavior changes in the spring. You'll see the males, who are the most colorful, setting up territories where they broadcast their presence using song. Song is incredibly important to them, and you can use it.

Western meadowlark. Photo captured by Nikon D3X & AF-S VR Nikkor 600mm f/4 lens with TC-17E II on Lexar UDMA

Most know about identifying birds on sight by size, color, and habitat, but few take it further and learn birds by their call or song. I found this knowledge incredibly important and useful. When you venture from your yard in the spring, quite often you'll hear a bird before you spot them. If you know their calls and songs, you can quickly determine if it's a lonely house finch or a spectacular yellow-breasted chat. One you normally would blow off, and the other you want to get in the viewfinder.

Another use for calls is kinda controversial in its application. As in, there are some locations around the country where it is literally illegal to use birdcalls to attract birds. In the spring, for a small window of time, you can use the taped calls of birds to suck them into your lens, just like using food or water. Why has this been outlawed in some places? Because if used incorrectly, it will draw birds off their territories and cause them to leave those areas, so no nesting happens at all. That has been detrimental to a couple of populations, so it has been outlawed. This is another great reason to work with biologists, to learn how to use such tools safely and effectively.

Binoculars are a great tool in spring when it comes to bird photography. Be it your own yard, a neighborhood park, or some other area, letting the bins do the walking for you is smart. Minimizing your impact until you are really ready to shoot often leads to better images. Use the bins to find the perch(es) a male bird prefers to broadcast from to attract a mate. A male might have a couple within his established territory, but he'll have one he prefers—you'll see him visit it over and over again. That's the one you'll set up on.

> *What's my favorite camera body to shoot with? The Nikon D3X.*

You don't need a blind. In fact, I hate blinds, because they make you blind, but they can help you with the time factor. There is no doubt that when you're short on time, hiding yourself cuts down the time it takes for a critter to come back to water or food or its favorite perch. Personally, the only time I use blinds is when I'm photographing a tern colony (their main defense is crapping on predators and they eat a lot of fish) or in Texas, where they are required. Either case—standing out in the open or in a blind—where you place yourself is incredibly important.

You're going to want to head out with your longest lens combo—whatever it takes to get your longest focal length. This is for two reasons: to minimize your impact on the birds' activity and success, and background control. You're going to set up with flash in mind. Whether you turn it on or not, you want to have that option available. Look for a neutral green background at first, so you can easily make the bird, no matter the species, visually pop. Once you've been in place for a while and the bird gets used to you, you can move to fine-tune the background. And the flash? It's there to bring out the color, that spectacular spring brilliance. You will have already tested out your flash back at home (won't you?), so you know your exposure compensation and you'll be all set to go.

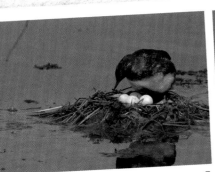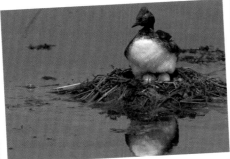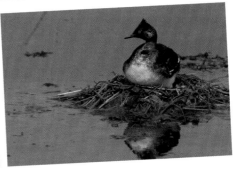

Eared grebe on nest. Photos captured by Nikon D1H & AF-S II Nikkor 600mm f/4 lens with TC-14E II on Lexar digital film.

What does this behavior lead to? It leads to baby birds, better known as nestlings. Photographing nesting birds is one of the most rewarding aspects of wildlife photography, I think. It's also one of the most risky for the subject. As I have said, no photograph is worth sacrificing the welfare of the subject. If shooting nesting birds is something that interests you, I encourage your to pursue it, but do so with great care. Hooking up with a biologist is your best course for every reason you can think of—from safety to actually finding a nest.

Quite often, once you establish a feeding and water station in your yard, in the spring, you'll find a nest. Heck, I'd build my home right next to a great restaurant and bar, too, if I could. Finding a finch, robin, or hummingbird nest in your yard is great. The first thing you need to realize is that nesting photography requires two flashes. As previously described, you're going to have to set them up so one is the main light and the other is the fill. Along with that knowledge is the fact that the light from the flashes has to have an unobstructed path to the nest. Anything between the flash and the nest will cause a shadow you won't like. Lastly, and this is the most important, the flash cannot obstruct the path the birds take into their nest.

When it comes to actually photographing the nest, there are some basics you need to think about. When the parents are on the eggs, there really isn't much of a photo op, other than a parent sitting on a nest. But there is a lot of risk to the nest and the safety of the eggs. It's best that you visit a nest with eggs just once, near the time they're going to hatch. This affords the parents and nest the greatest amount of protection from you creating a path that a predator can scent and take to the nest.

How do you know when the eggs are about to hatch? You do your homework, by figuring out when the eggs where laid and then using

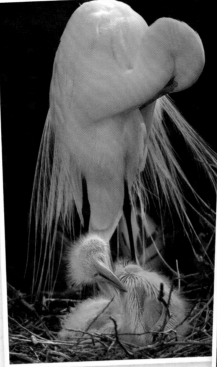
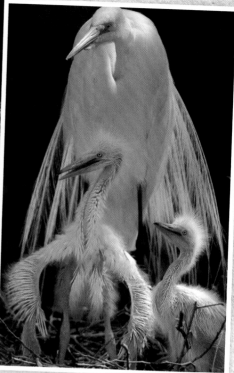

Great egret with nestlings. Photos captured by Nikon D2H & AF-S VR Zoom-Nikkor 200–400mm f/4 lens with TC-14E II on Lexar digital film.

a resource, like *Nests, Eggs, and Nestlings of North American Birds*, to determine when the eggs should hatch. Birds can easily abandon a nest of eggs, but once those eggs hatch, the maternal instinct kicks in and they will do almost anything to get those hatchlings out into the world. It's the process of raising the chicks where the great images come.

A great place to take this to the next level is the St. Augustine Alligator Farm Zoological Park in St. Augustine, Florida. They have a boardwalk that literally takes you right through an active rookery full of snowy, reddish, and great egrets; tricolored and little blue herons; and wood storks. The boardwalk is such that you are eye level with the nests. Go prepared to get crapped on, and bring a flash and short lens. You can learn more about nesting bird biology in a short time here than 10 nesting seasons in the field.

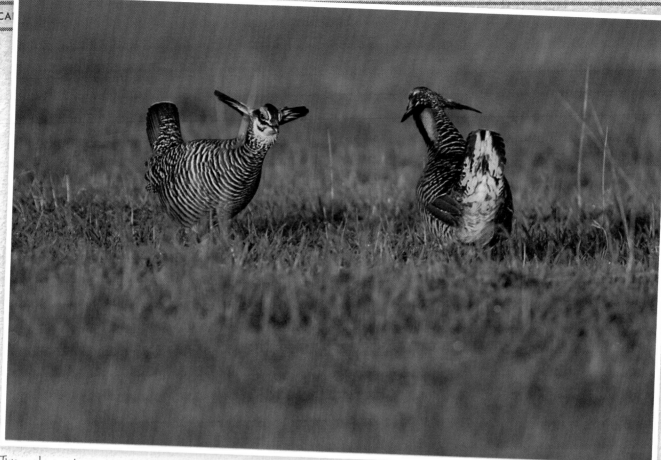

Two male greater prairie chickens performing a nuptial bow before fighting. Photo captured by Nikon D1H & AF-S II Nikkor 600mm f/4 lens with TC-20E II on Lexar digital film.

Don't forget, birds don't always sit on a perch and sing their hearts out to attract mates. One of my favorite families of birds, grouse, have a big meeting on a lek, and dance and drum to attract a mate. While nearly all of our grouse are in trouble one way or another (they have become extinct in many states/provinces throughout North America, and one species is extinct), there are still hundreds of public viewing areas where, in spring, you can see them perform. There are some locations, like in Kansas, where you can rent a photography blind and photograph the craziness that explodes as the sun comes up. It is a great spectacle well worth your time.

The greater prairie chicken (GPC) is about chicken-sized (a tad larger) and is part of a group often considered as grassland or prairie grouse, or more specifically, a pinnated grouse. Their pinnae (horn-like feathers on the side of their necks) are raised by the males when displaying on the lek—it's what makes them unique. The recognized subspecies of greater prairie chickens are the heath hen (extinct) and the Attwater's prairie chicken (close to extinction, as I mentioned in Chapter 7).

For the vast majority of the year, seeing a GPC is by chance, as they tend to scatter to the four winds. While they are scattered, they travel no farther than about one mile from the lek during the entire year. So, other than for a few hours each day during a few weeks each spring, they're out in the prairie foraging on small green leaves, seeds, and insects.

The peak period on the lek lasts for only a week to 10 days. Prior to that, and afterwards, there is a buildup of activity and then a winding down. If you had to generalize when this period is each year, for all the grouse it would be the first week of April. But this can vary by a couple weeks either way, depending on factors such as locale and weather. So, depending on your timing and the timing of the lek, you might see some things differently. Here are the basics, though, of what's up:

Like to sleep in? Well, that's not a luxury successful wildlife photographers enjoy. But wildlife photographers often get to take an afternoon nap under the clear skies and in the warm sun. That, along with our images, are our rewards for seeing the sun rise another day.

The males start flying into the lek prior to the dawning of the day. You'll hear them before you actually are able to see them. The males have only one real mission on the lek, and that's to mate. They take it very seriously. Each male will select what he perceives to be the best spot on the lek to perform. The GPC have a couple of different performances to attract the opposite sex and defend their territories: booming, territorial call, territorial fighting, male cackling, nuptial bow, flutter-jumping, and dancing. These can be performed in any order or combination, all depending on the heat of the moment.

When the males first arrive on the lek, they typically start with what's called a nuptial bow, booming, and then dancing. They start by stooping over, which looks like a bow, and at the same time, raising their pinnaes, thus exposing their air sacs. Once they've bent all the way over, they fill and expel their air sacs, creating what's called booming. After booming, they perform their dance, which is an incredibly rapid stomping of their feet in place for a few seconds, which can be heard as well as seen.

As the light increases, so does the presence of the males and their activity. As more and more males arrive on the lek, fights begin. Territorial fighting is quite a show that lasts for only heartbeats. It was not until looking at these images afterward that we understood what we witnessed in that flash of time. One of the males, I assume the dominant of the two, made the first move. As fast as a lightning bolt, he launched himself into the air. As he went up, he tried to rack the head/bill of his opponent, who at the same time reacted by launching himself. During this

Male greater prairie chicken bowing & booming. Photo captured by Nikon D1H & AF-S II Nikkor 600mm f/4 lens with TC-20E II on Lexar digital film.

brief aerial gymnastics, the two males tried to avoid each other's aggressive moves while trying to make contact themselves. None of this could be perceived while filming the fight, so when we saw the image-by-image blows that night, we were amazed.

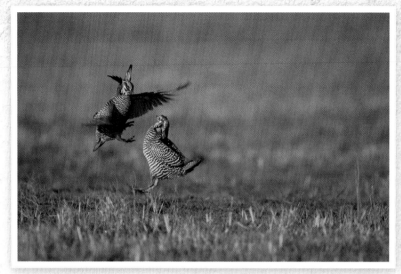
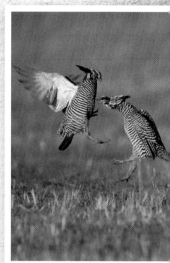

Two male greater prairie chickens fighting. Photos captured by Nikon D1H & AF-S II Nikkor 600mm f/4 lens with TC-20E II on Lexar digital film.

Once daylight actually breaks, the activity reaches its peak. Males on their territory boom and dance, boom and dance, boom and dance. They might then seem like they are about to boom and dance again when they suddenly just burst into the air. These flutter-jumps are brief, but are continually performed. During this whole process, a male might all of a sudden decide that another male is too close to his territory and off he'll go.

We watched one male who was just into fighting. He would run 20 or 30 feet toward the perceived aggressor and then, when right in his face, stop. At this point, they would either go right to the territorial fighting or have a stare-off. When the stare-off began, it would lead to another territorial fight or just more staring. They would circle each other and, in the process, sometimes charge each other, crouch and wing posture, or just stand still and stare at each other. To be honest with you, there were times when you could take a nap, wake up, and see the same males in the same place still staring at each other.

The males often give a territorial call and do what is called male cackling. This behavior was most common after the sun had come up and the territorial fights seemed to be slowing down. There was no order to any of this behavior, despite what I've written. Males do whatever they feel works for them right at that moment. Sex is a very powerful motivator! When the female(s) arrive, everything takes on a whole new perspective as far as the males are concerned. They start

booming, dancing, calling with all the heart they can display. If a female heads toward a group of performing males, they boom and dance even harder. The males who are left behind tend to blame their neighbor, so territorial fights may ensue. You could say the chaos turns into madness when the females arrive.

This whole scene on the lek only lasts for perhaps 90 to 120 minutes at most. The GPC leave the lek just as they arrived, by flying off. Though you might try to watch them to see where they land, they blend in so well that, as soon as they hit the ground, they disappear. At least until the next morning, when the show starts all over again.

I've been watching grouse on leks for over two decades and it still fascinates me. It is such a spectacle, an orchestrated chaos, that I'm drawn back to it year after year. This was my first year with GPC, and it won't be the last. But no matter if you're photographing greater prairie chickens, greater sage grouse, or sharp-tailed grouse, there are some constants we as photographers must observe—always.

First, I highly recommend you only go to a lek with someone who knows where they are, knows the rules, and can pass them

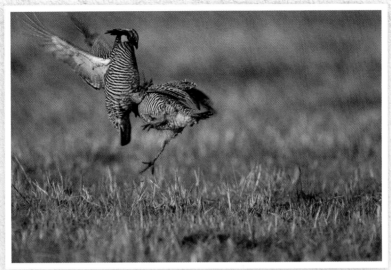

are so used to their presence that they totally ignore them. It is *essential* that you enter the blind prior to the birds arriving on the lek and that you don't leave the blind until the last bird has left the lek, although you can move around once you're in the blind.

Your success photographically is directly dependant on the place-ment of your blind. If you go to a place like I went to for the GPC, you're limited to the location of the blind that someone else has placed, more than likely a non-photographer, but a nature watcher. Don't let this freak you out. If at all possible, be in a blind that faces west, so you have the best light, and then pray a lot.

along to you. You can't just drive out to some barren-looking piece of ground and presume it's a lek. In the case of GPC, since they are so small, you can literally be on a road right next to the lek and never, ever know they were there (unless you know what to listen for and hear them).

It is imperative that you *never* walk onto or about a lek when the birds are present. You must enter a lek at least 30 minutes prior to the first bird's arrival. Do anything else and you run the risk of causing all the birds to leave the lek. All the grassland grouse are highly sus-ceptible to disturbance on the lek. No matter how badly we might want the photograph, the price is too high if you do anything less than what I'm describing.

Once you've found the lek, you'll need to have a blind. The vast majority of the lek tours have blinds that they take their folks to, so that's not a problem. Blinds are essential, since grouse are so easily disturbed. Something as insignificant as a car door closing can flush an entire lek (you also should limit your talking, and talk in a very low tone or whisper). Leks with blinds in place are great, because the birds

You need the males to be about 60 feet or closer. There will be some mornings when the males will be nowhere near your blind. There are other mornings when the males are so close you can't focus on them. What's the big variable in determining the males' distance? It's the females. You've got to hope that you have at least one female close to your blind to bring in the males. Males move to the females, and since the females tend to work their way through the lek, looking for the right male, things are in flux. So if you get in a blind and don't have any birds when the light starts to brighten, don't write off the morning. And don't leave your blind.

As the light levels increase prior to sunrise, you'll start seeing the birds. You look through your lens and see that gorgeous creature and your natural instinct is to shoot (at least it should be). Before you start blasting away, check your shutter speed. While you cannot perceive the vibrating fast movement caused by either booming or

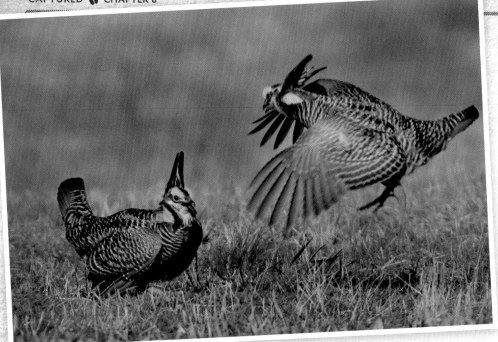

Two male greater prairie chickens fighting. Photo captured by Nikon D2X & AF-S II Nikkor 600mm f/4 lens with TC-17E II on Lexar digital film.

action. When photographing GPC, I found that working at 600mm worked best for photographing the aerial fights. Less lens gave me room to capture the birds as they exploded into the sky while they fought. More lens was so tempting with its image size, but since there is no warning and no time to remove a teleconverter even if there was a warning, using less lens worked the best.

There are two reasons, though, to have the longest possible lens in use: image size and background control. Since you cannot move physically to get the desired image size, you've got to use focal length. Other than those moments when I feel that action is going to happen, I have a teleconverter attached to the 600mm. This not only increases image size, but also helps with backgrounds.

dancing or both, those grouse are moving, so you need a shutter speed of at least 1/60 of a second before you start shooting. I normally wait until I'm around the 1/125 of a second mark before trying to capture any of the action.

The primary lens for me in photographing any grouse is the 600mm (though spruce grouse are so dumb, you can photograph them with a 105mm). Use this in conjunction with a 1.4x teleconverter as light levels increase. Looking at the shutter speed is when you know you can start using teleconverters. Stopping the action can only be done with shutter speed (don't be tempted to raise your ISO, you will have noise). You might be tempted to use flash to stop the action, but don't. This can disturb the birds by bringing attention to the movement in the blind, which is the last thing you want to do.

Focal length is an important consideration when wanting to capture action. There may be times when using a 1.4x or 1.7x is perfect with shutter speed and image size, but it might not be perfect for capturing

Leks are typically some type of grass field. Sometimes it's short grass and other times it's tall grass, but either way, it's grass. It never fails to happen that just when you've got the perfect light and the perfect subject, you'll have the perfect piece of grass killing your photograph. Since you can't call a halt to the action and go out and trim it, you need to either not take the shot or eliminate it optically. Longer lenses using teleconverters is the only solution I've found so far.

There were mornings we'd come back with 14 GB of images from just 90 minutes of shooting. There were other mornings when we didn't even fill a card. That's just the way it is. Because of this, I recommend you schedule a minimum of three mornings in a blind. Between weather, female movements, and learning which is the best blind, you need at least that many mornings to be successful photographically. With this in mind, I had only three mornings during my first encounter with GPC and, while I came back with the images you see here, I know there are much more and better I can come back with.

If Only They Were as Easy as Birds

Spring means baby mammals just as much is it means baby birds. But unlike birds, the males don't put on brightly colored fur and sing from perches or display on leks. Nope, and the females tend to go off on their own to some very secluded place to give birth. Once their young are the right age to they see the light of day, is there any possibility of photographing that spring life?

I always feel incredibly fortunate that I started off with access to small mammals. Yeah, moose are obviously a favorite of mine, but they just aren't as cute as small mammals (the joke is that moose are cute the first day of life and then get uglier every day thereafter). There is nothing cuter than fox pups and probably nothing more common in the mammal world that you might have the opportunity to photograph. The red fox, which is in every state and Canada, is pretty darn common. You have a good chance of finding a den and experiencing this for yourself.

❝ Learn from my mistake, photograph them all! ❞

How do you find a den? In all honesty, without the aid of a biologist, it is by sheer luck. You'd be surprised, though, how many I've heard about at the corner store—a little asking and they appear. In fact, you'll probably hear of and discover a couple before you find the one you think is photographable. Learn from my mistake, photograph them all! Stupidly, I've passed on photographing some dens because they weren't as pristine as I thought they should be. Now I could use those photos and I don't have them. If you have an opportunity—I don't care what it is—if there is wildlife involved, make the clicks.

The typical fox den is a slight mound above the ground, if anything. Otherwise it's a set of train-tunnel-shaped holes in the ground. A den typically has many entrances, you could think of some as escape routes. The main entrance is the largest one and has the

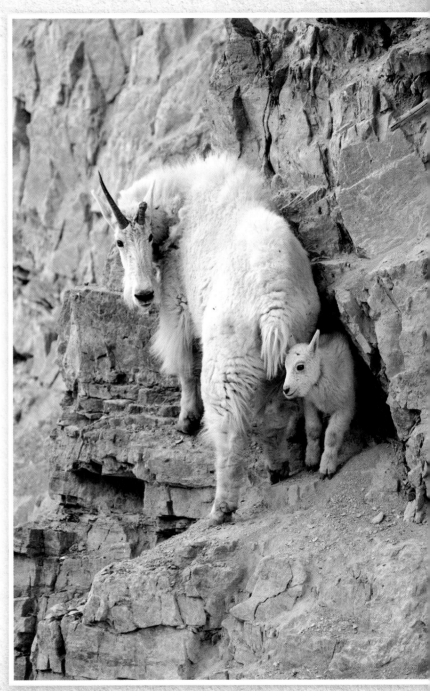

Mountain goat with kid. Photo captured by Nikon D3X & AF-S VR Nikkor 600mm f/4 lens on Lexar UDMA.

most amount of scat and food debris around it. Some of the entrances can be quite a distance from the main one. You'll discover this long before you photograph the den. This is when a spotting scope is a great tool. I prefer the Nikon EDG Fieldscope 65mm for sitting and watching a den before shooting it.

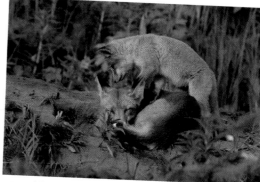

Red fox pups trying to get Mom to wake up. Photos captured by Nikon D3 & AF-S VR Nikkor 600mm f/4 lens with TC-17E II on Lexar UDMA.

Knowing how the entrances are used is important. When there are pups at a den, typically the male won't spend much time at it, but is off some distance. Often the female (vixen) will be bedded down outside the den by one of the entrances. Knowing this is important, because every time you approach the den, you want the parents to be either out hunting or down in the den.

The adults may or may not be wary of humans. It really depends on what interactions they've had and, until you're at the den, you won't know. That's why spending some time watching and learning the intimate biology is so important. Not that you can look at the adults and determine sex by simply looking, but you will get a sense of who is who by their actions. Who sleeps by the den or not, for example. You want to watch such things as the path they take walking into and out of the den. They will wear down paths with time, so figure them out. Do they burst out of the den or do they slowly rise and look around before coming out? This is important to know, as well. You want to

> Do I produce a killer image on every outing? Hell, how many times do I go out and not come back with a photo? My ongoing battle with that bastard the white-tailed jackrabbit is a good example. You see a photo in this book of it? Nope, because I ain't got one. Don't put that kind of pressure on your photography. You don't get the shot every time.

spend at least one day observing the den from a distance before you venture near with a camera, just so you understand the flow of life.

I hate doing this, but I recommend blinds at fox dens for one basic reason: you spend a lot of time looking at dirt. Seriously, you'll stare a lot at dirt. Don't take a book, don't play games on your iPhone, and don't take a nap (which is hard not to do with the warmth and boring time). But sitting in a chair for hours with nothing to shoot can get old and you can get antsy. Antsy typically translates to moving around, stretching right when a fox appears at the den. So when you pick your blind, make it one large enough that you can at least stand up and bend over in it to stretch your back, while holding your gear.

When working with the San Joaquin kit fox, half the time I'm in blinds and half of the time I'm out in the open. I'm always in my kit fox chair, my lucky chair I've used since the first den 20 years ago. The difference between when I use a blind and when I don't comes from my observation of the den. If I see the foxes flee into their den when a person goes by, I need a blind. And if the foxes don't even raise an eyebrow, then no blind is needed.

At McNeil River, on the path to the outhouses, there was a red fox den with pretty old pups. During the majority of the day, the pups weren't seen (kinda typical). You'd just see a parent sleeping. Near the end of the day and heading into dusk, the pups would emerge. Fox pups are not only the cutest thing you'll have in your viewfinder, but also they are the funniest things you'll watch. Seriously, you have to

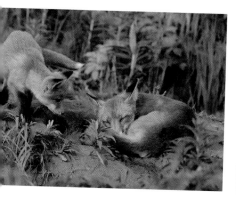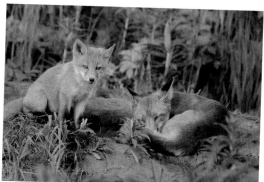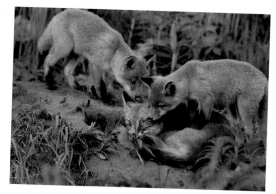

watch your laughing, as it will put them back underground—that I know from experience.

One evening, Jake and I were both standing at the den with our 600mm lenses trained on it. We'd seen the male out hunting, so we were hoping for a return-with-food excitement shot. We weren't there long before the vixen popped out and flopped down. We made a couple clicks in the fading light. The calm was short lived, as the pups emerged from the den full of energy, which is typical. They also seemed to be hungry, a combination which, if you're a parent, you can imagine caused the mayhem that followed.

"Come on Mom, play with me. Mom, did you hear me? I want to play. MOM, I said I want to PLAY! I see you, you're playing 'possum and they don't even live here in Alaska! Hmmm, let me sit and think about this for a minute. I've got it. Okay, Mom, try to ignore both of us giving you wet willies!"

The time stamp for this series of images is less than three minutes. That's as long as Mom took the abuse before snapping and telling the pups to go away. Here are your challenges in making these images: You have to be a distance away, so the behavior goes on in the first place. If there is no playing, then more than likely, you are negatively influencing the den. Next is background control. This den in Alaska was pretty easy, but normally there is junk around the den you want

to avoid, this includes the scat that can build up (one reason why foxes move their natal dens [dens with pups] a couple of times before the pups disperse). The biggest challenge, though, is shutter speed.

Most foxes at a natal den are active during the evening and night (not much during the day)—at the time the light is slipping away, and when you need the fastest shutter speed, is the norm. For small animal movement like a bird munching on a seed, deer chewing grass, or a red fox pup poking its nose in Mom's ear, you need at least 1/125 of a second to stop the movement. Animals have muscles in their head for this that, when in action, cause the eye to move. The eye has to be sharp in this business. So if a critter is doing these or other activities that work those muscles, the eye is moving.

> A warning: if you spend any time at a fox den, you will be hooked! You will look for more and you won't find any until the next spring. You'll look at your images and kick yourself for the ones you missed because either your finger was too slow or your shutter speed was. They will drive you down a road that, I just want to warn you, has no end.

There's Spring, and Then There Is Fall

Photographing birds is, in one big way, different than mammals. Birds fly (I know, that one is obvious) and because of that, they don't predictably congregate quite in the same place in the same numbers in the same way as the majority of the year. The exception is during the fall, when you can find masses of either birds or mammals if you're in the right place at the right time. The fall spectacle is another time when photographers should be out en masse amongst the congregations making the images.

I regret that I've not made it to even a fraction of all the great locales where these gatherings occur. I've never made it to some of the great shorebird stopovers in fall when hundreds of thousands jam into the small corner of a marsh. The reason? I keep going back to the same ones, because I never feel I've done all I could with them. The fall is the most romantic time to be with wildlife. The light is gorgeous, low to the horizon, with its warmth that wraps you up in a blanket, getting you ready for the bite of winter cold. The mammals are in their thick, luscious winter coats, with big game fattened up ready for the rut. There's an urgency in the air, and it's catching. When the sun passes the autumnal equinox, my mind and camera turn to two locales—Yellowstone and Bosque—where wildlife and wildlands are so inviting to the soul and pixel.

Yellowstone is one big ass-place! Thank goodness, because within its immense borders are some of our great wild treasures. In the fall, the north entrance is the site of Rocky Mountain bighorn sheep in rut as they move north to Paradise Valley and warmer weather. Rocky Mountain elk are not far behind them, moving in the same direction. They all funnel down to the Yellowstone River, just inside the park and literally right along the road. I'm always amazed how few photographers are here for this spectacle. It could be because they heard a couple of the stories of photographers who did shoot here and had no ethics and got busted. It could be, too, it's just damn cold for most, and of course, it's in really nobody's backyard.

What we've talked about concerning sheep still applies. And in this location, there are signs you have to obey that pretty much sum it up: stay off the hillsides. There is no reason to get off the road and, most of the time, the park rangers are there to make sure you don't. The road is U.S. Highway 212 to Cooke City, and what happens quite often is the bighorns on the hillside above the road cause avalanches, sending large boulders down on the road. We're talking rocks that would do damage to a vehicle, let alone you. They literally close the road with their activity (I find it pretty comical myself). Well, it being a highway, the rangers are there for traffic control, sheep control, and if they get in the way, photographer control.

A flock of American white pelicans. Photo captured by Nikon D3 & AF-S VR Zoom-Nikkor 200–400mm f/4 lens with TC-14E II on Lexar UDMA.

When this is going on, on the shoulder of the season (just before the park closes for winter), I highly recommend you take your longest lens and use distance as your friend. What seems to get photographers in the most amount of trouble is working in panic mode, as if these are the last sheep on the planet or this is the last time the activity will occur. They park where they shouldn't, and they walk and set up where they shouldn't, so in no time, they and any photographer around, because of their actions, are asked to move back. Just like always, take a moment, catch your breath, and check out the lay of the land. It pays big dividends.

If you visit the same location just a couple of weeks later when the park is closed, you can work the same sheep on the same hillside with a 200mm lens. This, again, emphasizes that timing is everything in this business. Since the sheep generally are active here in the afternoon, use the morning to explore another spectacular locale: Lamar Valley, also on Hwy 212, where vast herds of elk and bison can be found. This is a photographically rich location for wildlife and landscapes, and perhaps, a wildlife landscape. It really requires no more than driving, looking, and finding the subject that ignites your photographic imagination. You will probably pass at least one group of cars with folks all staring through scopes. Those are folks whose passion is wolves and wolf watching. They are such a huge wealth of biology info that you might want to stop, see a wolf through the scope, and find out where stuff is.

Bison in the fall are spectacular in their winter coats. There is no doubt you'll find them along the road at some point. Photographing them or the elk, or any other big game critter, brings up a common question. Where can you crop an ungulate (hoofed mammal)? There is no book, guide, chart, or website that provides the rules where you can and cannot crop a mammal. I once used to say, "Don't crop them so they look like some wall mount you took out into a field and photographed." That's until a photograph I had taken like that sold to a magazine for a nice price.

So, where do you crop a mammal? The only guideline I can provide you is to crop so the animal doesn't look awkward in the frame. And that's really not much help. You don't crop them right above the feet, which looks like a photographic mistake more than anything else. You can crop above the knees without much problem. You don't crop too close behind the shoulders, but also not too far back on the flank. They are symbols of the wilderness, so if your crop supports that feeling, then you're fine.

Bison. Photo captured by Nikon D2H & AF-S VR Zoom-Nikkor 70–200mm f/2.8 lens on Lexar digital film.

Since you're in the park, the one other place you've got to venture for the fall spectacle is near the West Entrance along the Madison River. Here, the Rocky Mountain elk are thick, as the rut is in full swing. The bull elk have massive racks that have done severe damage to cars and people alike, so the rangers are there for your protection probably more than the elks', though many won't see it that way.

This is another great place for the long lens. Not because you can't get close to the elk, because you can, but again for background control. There can be so many elk, at times, you will need a long lens to separate those in your composition from others in the herd. You will find that some of the best photo ops are when the sun has just set. You will need to watch your shutter speed, dial in minus exposure compensation, and use peak of action to get the sharp shot, but it can be done. It's these kinds of opportunities that challenge your

photography and help it grow to be better, so grab the bull by the horns and go for it.

The other end of the spectrum is down in New Mexico, at what has now become an international phenomenon—Bosque del Apache National Wildlife Refuge. This is where hundreds of thousands of sandhill cranes and snow geese gather, fueling up before heading south for the winter. This is a spectacle that words and images truly don't do justice to.

The information I'm about to share with you is, of course, strictly anecdotal information I've gathered over the years. While not truly scientific in nature, it's what I go by and use when I'm shooting at Bosque in the quest for the perfect image. It most definitely changes year to year based on one giant factor: water. The ponds accessible to visitors are flooded and regulated by man. The flooding of ponds is rotated (much to the irritation of some photographers). This is important biologically to promote growth of the water plants that many bird species depend on. If the ponds are not rotated between wet and dry, they'll end up choked out and basically rendered useless. While a pond might be flooded this year, it might be dry next year. Near the end of a rotation period, just prior to a pond being drained, it might have such plant growth as to not support the wildlife you want to photograph. So to make a bad pun, you need to go with the flow when at Bosque.

There are two basic giant photo ops at Bosque: the morning explosion and evening landing. These can truly be so overwhelming that you simply can't shoot. That's okay. There's no doubt they are like no other spectacle I've witnessed anywhere. But there's a lot more to Bosque than just these two daily events. Bosque supports 340 species of birds—sandhill cranes and geese are just two of

A family of Rocky Mountain elk. Photo captured by Nikon D2H & AF-S II Nikkor 600mm f/4 lens on Lexar digital film.

them. This is how I personally shoot at Bosque, in an attempt to photograph as many species as I can:

My favorite time to be at Bosque is the first two weeks of December. Bosque is open year-round, and there are birds to photograph all 365 days. When talking specifically about the sandhill cranes and geese, they're present in big numbers between November and February. I like December best for a number of reasons: lots of cranes and geese, good to excellent numbers and varieties of raptors, and it's usually the best time for great storms, creating really moody light, sunrises, and sunsets. While the majority of photographers take off after sunrise and don't come back until late afternoon, I like being at Bosque all day, except high noon. With that basic knowledge, this is how I work Bosque knowing the biology/rhythm of the place:

Harris's hawks feeding. Photo captured by Nikon D3X & AF-S VR Nikkor 600mm f/4 lens on Lexar UDMA.

The first day at Bosque is a scouting day to see what's new, where the birds are hanging out, and form a general plan on how I want to photograph during the next week (but I won't pass up a photo op). For example, the Flight Deck observation deck was the place for sunset shots for many years, with the majority of the cranes flying into its pond. For the last couple of years, three ponds along Old Highway 1, just north of the refuge headquarters, were the place to be. The difference is due to the flooding/growth schedule.

Another important place to shoot at Bosque is the farm fields, fields of corn grown specifically for the cranes, geese, and waterfowl to munch on. When the birds leave the ponds in the morning, the majority of them head to these fields. I head to the fields to see how much of the crop has been knocked down for the birds to eat. Once you get to the fields, you'll understand why, because where there is fresh food, you'll find the birds.

While doing all of this scouting, I leave no road, field, or pond unchecked. Many tend to just drive and never get out of the car. This can be a big mistake. There are lots of birds to be found by walking the various trails. To find some birds, like the infamous roadrunner, takes no more than a 15-foot walk. For many years now, an incredibly cooperative greater roadrunner has been hanging around the outhouse at the north end of the main pond. Getting

Mule deer. Photo captured by Nikon D3 & AF-S VR Zoom-Nikkor 200—400mm f/4 lens on Lexar digital film.

out and doing a little walking and looking almost always rewards you with head shots of this character. And keep an eye open, because on your walks, you can find and photograph bobcats, mule deer, and coyotes. With all of this firsthand knowledge (I tend not to believe what others tell me at Bosque, simply because we all have different goals photographically), I'm ready for my first shooting day.

I'm going to tell you exactly how I go about shooting at Bosque. Some of this might sound a little off the wall, but it's what I find

While I love my morning coffee, I tend to forgo the pleasure while at Bosque—the restrooms are few and far between. There's nothing worse than having to walk a half-mile to the outhouse, and no sooner do you arrive there than you hear the geese lifting off.

works for me. I stay in Socorro, which is about 30 minutes from the refuge (45 minutes if you're going to shoot from the back of the tour loop, a formal hot spot for morning liftoff). I leave Socorro so I arrive at the refuge about 15–30 minutes before sunrise. Getting to Bosque in total darkness and hearing the sounds is magical, but nowadays I tend to do that only once during a week's visit. Where I want to shoot sunrise dictates where I head. There are few places to gather, so knowing there can be as many as 200 photographers present, you might have to leave even earlier to get a spot.

One thing I do in December at Bosque is take my tripod into the room at night, because it's cold. Since it's not uncommon for one or more of the tripod legs to get into water, leaving them in the vehicle at night can cause them to freeze and not work well when setting up. I also get up a little earlier than normal to go out and start the truck to defrost the windows. It's very common to find ice on them, and if you have to take time to clear them and haven't planned for it, it might just cost you images.

I also tend to get up and check the local radar map for clouds. New Mexico has a well-earned reputation for killer sunrises and sunsets. There is nothing better than having that for a backdrop for your photograph. Knowing if there are clouds and where they might be can help me decide just where I want to be for the morning liftoff (and if I want to focus on cranes or geese). Driving down to Bosque in the dark, it's hard to see if there are clouds and where they might be. So this is just one more thing I factor in.

I also look at temperatures while I'm on the Web. Why? I check because if the temp is below freezing at the refuge, that means the ponds will most likely have ice. Birds roosting in frozen water make for a whole different kind of fun, and knowing this might also influence exactly where I'm going to go that morning.

Again, since it's typically dark driving down to Bosque, as kind of a last item on my checklist, I look to see if there is wind, and if so, what direction it's coming from. With all of this in mind, I pretty much know where I want to be for the morning. The last factor is where the birds are. No matter how well you've done all your homework, if the birds don't cooperate, it will be no more than a good exercise in planning. How do you find birds in the dark? Well, that's real simple—roll down your windows and listen. They aren't quiet at that time of morning, so by listening, you'll quickly determine where they are.

Once I'm at the locale where I think I want to shoot, I scout one last time. I don't set up my gear right away, but rather walk around and listen. Now remember, it's still pre-dawn, so we're not losing any shooting ops by taking one last look-see without gear. What am I looking for? I'm looking for birds up close. I'm looking for a giant congregation of geese or cranes up close. Why?

Trumpeter swans. Photo captured by Nikon D3 & AF-S VR Nikkor 600mm f/4 lens with TC-14E II on Lexar UDMA.

Snow geese during liftoff. Photo captured by Nikon D2H & AF-S II Nikkor 600mm f/4 lens on Lexar digital film.

ponds and not together, so let me address the current situation, because I don't think it will change in the next year. Let's start with the snow geese, since they are truly the showstoppers.

The snow geese gather in large flocks on the water. At sunset, you'll see lots of small groups here and there throughout the refuge. But during the night, they move to form fewer, but larger, flocks. They do this for self-preservation (predator avoidance). The ponds are shallow, so any predator attempting to grab an easy meal is quickly heard. The more ears to listen with, the greater the protection for the flock. Depending on the flooding rotation and water levels in the existing ponds, the geese gather accordingly. Flocks can move during the night if they have been harassed. Finally, as the sun begins to lighten in the east, for what appears to be no reason at all, flocks lift off in mini-explosions, only to circle and land with another flock on the water, making an even bigger flock.

Well, there are two reasons: The first is getting cool close-up shots of birds in the predawn color. It makes no difference to me if they are frontlit or backlit. These birds, for the most part, are habituated to people. This, in combination with their generally fidgety nature, often makes for some incredible close-up images. Look for clean water with a subject. What's clean water? This is water with no debris, grass stems, branches, or anything else that distracts visually from the surface of the water. One of the cool images to capture is a clean silhouette, and in order to accomplish this, we need a backlit subject, color, and a clean background—the clean water.

The other reason I look for birds up close and en masse is for the liftoff, which I think is better described as an explosion. The last few years, the masses of geese and cranes have been in different

When the real explosion occurs, this whole mass of geese lift off the water and head north to the farm fields. Typically, it's right before or right after sunrise. If you've never been to Bosque before, you might be so overwhelmed your first liftoff that you forget to push the shutter release. You also might be caught unprepared for the moment of liftoff. Here's one hint: watch the geese closely. When the geese are about to lift off, they start to shake their heads. It's a

small shake, enough to expel the moisture built up in their bills. This is the one sign I've found over all the years that gives a hint to their next move.

I still haven't gotten to why I want to be close to the geese at liftoff. My preferred place to be during liftoff is literally right under the geese (I've only been bombed once over all the years). When I say right under them, I mean the geese are no more than 15 to 20 feet overhead. Why do I want them so close? In my attempts to communicate photographically about the masses, the beauty, the spectacle, I like using an ultra-wide lens. With the birds this close, and this many, with a really wide lens, the images turn out magical.

The other morning subjects are the sandhill cranes. There are two species of sandhill cranes at Bosque, lesser and greater. The lesser are smaller, standing about 3 feet tall, and the greater are larger, standing at 4 feet tall. The vast majority of the cranes at Bosque are greater, which means you don't have to have a super-long lens to create some great images.

The cranes don't lift off en masse at sunrise. In fact, you could say they like to sleep in, since they don't start to stir until after the sun hits them. This doesn't mean that if you're going after cranes, you can sleep in and arrive late at Bosque. But it does mean you might have time to shoot at a couple of different locales. I think it's best when it's really cold and ice has formed on the pond.

Snow geese from below as they lift off a pond. Photo captured by Nikon D2H & AF-S VR Zoom-Nikkor 70–200mm f/2.8 lens on Lexar digital film.

Why ice? Cranes are very long-legged birds, but the ponds are pretty shallow, so the ice forms closer to their feet than their knees. Since they don't have much heat going through their legs, the ice forms right about their legs. This tends to force the cranes into tighter groups, which in and of itself is a great shot. The ice also tends to keep the cranes from lifting off super-early, which gives you even more time to shoot individuals or groups. But the greatest benefit of the ice comes from when the cranes go to take flight.

When there is no ice, but the cranes are in water, they tend to hop once or twice, and with their massive wings, they are instantly in the air. This is because they can't use their preferred method of taking off—running a short distance and making a gradual liftoff. When the cranes "explode" out of the water, there isn't much of a photo op until they are a little ways up in the air. When there is ice, the ice is enough to hold them down so that they can't just explode from the pond. They have to step up, out of the water, and then they walk a distance on the ice, until they feel they have enough of a runway to run a bit and take flight. Now there's a photo op!

Sandhill cranes can't walk on ice any better than the rest of us, so it's quite a show to see these long-legged birds trying to walk across it.

Sandhill cranes. Photo captured by Nikon D3 & AF-S VR Nikkor 600mm f/4 lens with TC-17E II on Lexar UDMA.

Slipping and sliding, they move so they are facing into the wind to take off. The ponds on Old Hwy 1 face east, so they are frontlit in the morning. The background is the very neutral tan grass. The combination of a slow moving crane in this light and the background is to die for.

The cranes don't take off en masse, but in groups of one to five. My preferred way of shooting is with a 600mm to isolate and capture these groups as they peel off, heading to the farm fields. I'll keep shooting as long as the light is great, then I'll just stand there and take it all in. It's possible I'll learn something new about the birds during this time. Simply watching them without a camera can be worth the trip.

The last two years, I've set up in one of two locales for sunset, near the Flight Deck (my preferred) or the ponds on Old Hwy 1. I've personally gone after just one photograph at sunset, the blur of cranes landing. In a nutshell, the successful blur is a combination of a slow shutter speed (1/15 of a second), great panning, and a solid background. At sunset, I'm generally shooting with a 600mm on a tripod, the 70–300mm VR on a second body on my shoulder, and either the 14–24mm or 24–70mm in a pocket (selecting one or the other based on if there will be a great sunset or not).

Greater sandhill cranes. Photo captured by Nikon D3S & AF-S VR Nikkor 600mm f/4 lens on Lexar UDMA.

Burrowing owl. Photo captured by Nikon D1H & AF-S II Nikkor 600mm f/4 lens with TC-20E II on Lexar digital film.

Shooting sunset from the Flight Deck, you can make incredible images, even if there isn't much of a sunset. The slightest color in the sky will reflect in the water, creating a gorgeous backdrop for the incoming cranes. But the last couple of years, the Flight Deck hasn't been the best, because of all the plant growth. This has meant shooting sunset at the ponds on Old Hwy 1. These aren't my favorite. Here, you really are dependent upon a great sunset to capture magnificent incoming flight shots. I still use the same basic camera equipment, but I tend to be pickier in my shooting.

One image you can capture beautifully at the Old Hwy 1 ponds are silhouettes. There are two ingredients necessary to make this work, I think. First, you need the color of a medium-to-great sunset. Next, you've got to wait until after the sun sets, and be willing to do a little shooting in the dark. When all the ingredients do come together, there is some fine shooting to be done.

The sunset shoot is mellower than, and not nearly as dramatic as, sunrise. There have been some sunsets where I've literally not taken a picture, but that's okay. The sights and sounds, while not photographically perfect, are perfect for the soul.

When you're shooting masses, be it birds or mammals, think a little outside the box. Shooting digital, and with the ease with which Photoshop permits us to create panos, shoot some. One of my favorite panos was done by a biologist friend of ours in Alaska. Ken used a 500mm lens and, from atop an abandoned bunker in the Arctic, did this amazing multi-image pano of the passing of the Porcupine caribou herd in front of the Brooks Range. It's stunning, and in just one image (though made of many), it expresses the majesty he witnessed that day. That's what this is all about. That's truly the end game to our pursuits!

Last Entry, for Now

On the wall in front of my desk are three very large maps of California, Montana, and Alaska. We first got the California map with a couple of boxes of pins that we were going to insert for all the places we'd worked on projects. You look at the map now, and you won't see a single pin. That's because we quickly realized that if we put in a pin for each location, today we wouldn't be able to see the map. I can look at it and get a picture in my mind for nearly every square inch of it. We're working to accomplish the same thing with the other two maps. And along the way, we've worked at bringing everyone along with us by sharing our journey through our images.

Photography is so much more than an f-stop and shutter speed, and yet, without those cornerstones, how do you move forward?

And yet we do. In my case, it wasn't at lightning speed and not without tripping and falling and having to pick myself up over and over again. I was given a book when I graduated from high school by an old teacher who thought its words would serve me well through life. There is one quote from that book that has. It is simply, "forever exposed on the thin emulsion of my mind."

That thought has served me in two ways: Those times when I missed the photo, I could console myself with it. But, more importantly, it's an anthem of what I couldn't let happen with the wildlife heritage we are so fortunate to photograph—they couldn't ever become mere memories. Are images that you have an emotional attachment to not valid just because they aren't perfect? Not in the least, they are just ones you don't share publicly (that often). That's why we all strive to make the best possible image: to share the wonders, the experiences, and of course, the talent we have as visual communicators. That is the challenge I leave you with.

Remember just how fortunate you are to take this journey, and how fortunate you are to have all the grandness to revel in and explore with your camera. It's up to you to leave that for the next generation in more than just your images. Use what you've learned in this book, and so much more you gain on your journey, to grab heartstrings with your photographs, so the next generation can have the opportunity to follow the same grand pursuit.

This is a journey I dream you all will make. It's my hope and desire that I've done more than provide you an f-stop, but stirred something much deeper about yourself, your photography, and the wild heritage that is yours to enjoy, explore, and experience. Come back with the images you can share with us and stir our passions, and you'll know the rewards we've been so blessed with. I've said it many times here: I, we, are so incredibly fortunate! Every day we get to start a new page—it's blank and we get to fill it in as our hearts dictate. The journal of a wildlife photographer, it's not over by any stretch of the imagination.

Top five places where YOU should shoot

#5 Your own backyard

#4 3/4 Glacier National Park

#4 Ft. Myers Beach, Florida

#3 3/8 Yosemite National Park

#3 Bosque del Apache National Wildlife Refuge

#2 1/2 Denali National Park

#2 Custer State Park

#1 1/4 Churchill, Canada, in spring

#1 Yellowstone National Park

The trio (Jake, me & Sharon) in Yellowstone's backcountry after a successful day of working with the Druid wolf pack. Photo by Jeff Cable.

Appendix 1
My Camera Bag & Gear

Bodies:

* Nikon D3X (1)
* Nikon D3S (2)

Lenses:

* AF-S VR Nikkor 600mm f/4G ED
* AF-S VR Zoom-Nikkor 200–400mm f/4G IF-ED
* AF-S VR Nikkor 200mm f/2G IF-ED
* AF-S Nikkor 70–200mm f/2.8G ED VR II
* AF-S VR Micro-Nikkor 105mm f/2.8
* AF-S Micro-Nikkor 60mm f/2.8
* AF-S Nikkor 24–70mm f/2.8G ED
* AF-S Nikkor 14–24mm f/2.8G ED
* AF Nikkor 28mm f/1.4
* PC-E Micro-Nikkor 45mm f/2.8D ED
* PC-E Nikkor 24mm f/3.5D ED
* AF-S Nikon Teleconverter TC-17E II
* AF-S Nikon Teleconverter TC-14E II

Accessories:

* Nikon SB-900 AF Speedlight Flash (2)
* Nikon SD-9 High-Performance Battery Pack (2)
* Nikon SC-28 TTL Remote Cord (2)
* Visual Echoes Better Beamer Flash Extender (2)
* Gitzo GT5560 SGT tripod w/Wimberley Head
* Gitzo GT3540 LS tripod w/Really Right Stuff BH-55 ball head

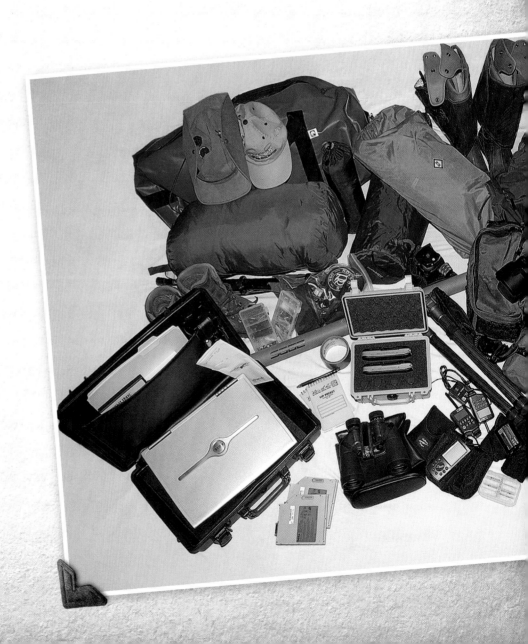

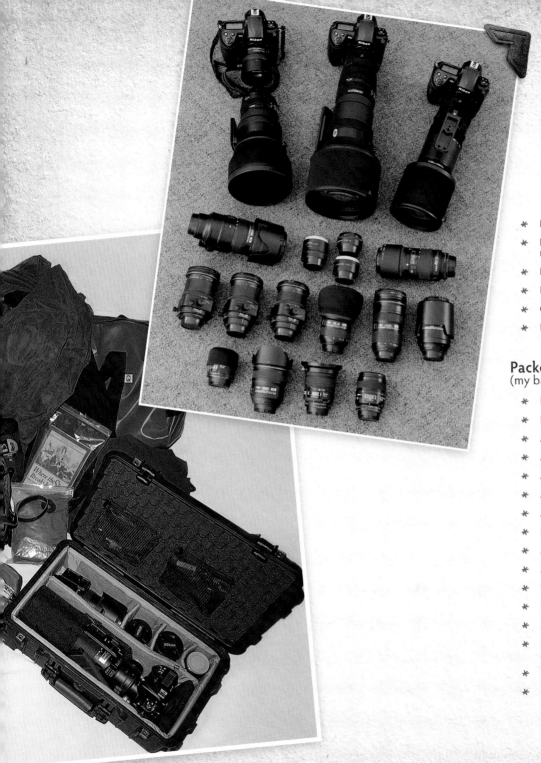

* Nikon 77mm slim Circular Polarizer Filter
* B+W 77mm .06 split graduated neutral density filter
* Lexar 32-GB 300x CF memory cards (10)
* Epson P-7000 Multimedia Photo Viewer
* Canon Vixia HF10 Camcorder w/boom mic
* Nikon Coolpix P6000

Packed in MP-1
(my bag of confidence):

* D3X (1)
* D3 (1)
* AF-S VR Nikkor 600mm f/4
* AF-S Zoom-Nikkor 70–300mm f/4.5–5.6 VR
* AF-S VR Micro-Nikkor 105mm f/2.8
* AF-S Nikkor 24–70mm f/2.8
* AF-S Nikkor 14–24mm f/2.8
* PC-E Nikkor 24mm f/3.5
* AF-S Nikon Teleconverter TC-17E II
* AF-S Nikon Teleconverter TC-14E II
* Nikon SB-900 AF Speedlight Flash
* Nikon SD-9 High-Performance Battery Pack
* Nikon SC-28 TTL Remote Cord
* PowerEx 2700mAh NiMH Rechargeable AA batteries (8 spare)
* Lexar 32-GB 300x CF cards (10)
* EN-EL4a Rechargeable Li-ion Battery (spare for D3)

Appendix 2
My Cleaning Kit

These are the contents of the kit I take with me everywhere. Everything resides in a NOMAR Mini Cargo Bag (http://nomaralaska.com) in two women's cosmetic kit cases from Walmart. I've broken it down to two small kits: one for CCD and one for general maintenance.

Mini Kit 1: CCD Cleaning

* VisibleDust Zeeion Anti-Static Blower Bulb (www.visibledust.com/products3.php?pid=444)

* VisibleDust BriteVue Quasar Sensor Loupe 7x (www.visibledust.com/products3.php?pid=602)

* VisibleDust Arctic Butterfly 724 (Super Bright) Sensor Brush (www.visibledust.com/products3.php?pid=3)

* VisibleDust UltraMXD-Vswab 1.0x (http://www.visibledust.com/products3.php?pid=452)

* VisibleDust Smear Away (www.visibledust.com/products3.php?pid=303)

* VisibleDust Sensor Clean (www.visibledust.com/products3.php?pid=301)

* Lens Tissue

Note: You can get your Moose-Adorama CCD cleaning kit here: www.adorama.com/MPDCK.html

Mini Kit 2: General Maintenance

✻ 1 bottle Lens Clens
(www.lensclens.com/products.html)

✻ 1 spare VisibleDust Zeeion Anti-Static
Blower Bulb

✻ 1 spare Nikon DK-19 Rubber Eyecup

✻ 1 spare Nikon DK-17 Eyepiece

✻ 1 spare Nikon Type E Focusing Screen
for the D3

✻ 1 tube Krazy Glue

✻ ½ of a white T-shirt

✻ 1 sub-mini flashlight

✻ 2 spare Nikon 600mm VR, 200–400mm VR,
and 200mm VR lens hood wedges

✻ 6 spare Nikon D3 PC/10-pin caps

✻ 1 Dumont HI-TECH Antimagnetic Tweezer
(www.micro-tools.com/store/item
_detail.aspx?ItemCode=TWZ-302-02)

✻ 1 12-piece drill bit set
(www.micro-tools.com/store)

✻ 1 Wiha screwdriver kit

Appendix 3
My D3 Settings

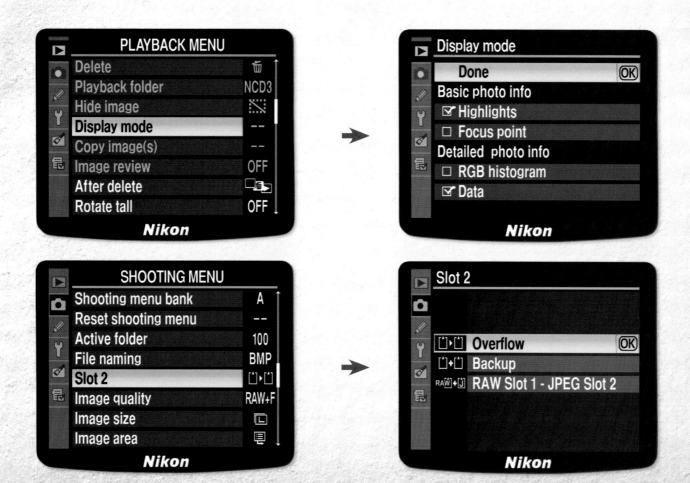

d Shooting/display

d1	Beep	OFF
d2	Shooting speed	📋
d3	Max continuous release	130
d4	File number sequence	ON
d5	Control panel/viewfinder	📋
d6	Shooting info display	AUTO
d7	LCD illumination	OFF
d8	Exposure delay mode	OFF

Nikon

d2 Shooting speed

Continuous High Speed	🔁	9
Continuous Low Speed	🔁	3

Nikon

d5 Control Panel/viewfinder

Rear control panel	⏱
Viewfinder display	[88]

Nikon

e Bracketing/flash

e1	Flash sync speed	1/250
e2	Flash shutter speed	1/60
e3	Modeling flash	ON
e4	Auto bracketing set	AE ⚡
e5	Auto bracketing (Mode M)	⚡+☀
e6	Bracketing order	N
f1	Multi selector center button	📋
f2	Multi selector	OFF

Nikon

f Controls

f1	Multi selector center button	📋
f2	Multi selector	OFF
f3	Photo info/playback	📋
f4	Assign Func. button	📋
f5	Assign preview button	📋
f6	Assign AE-L/AF-L button	📋
f7	Customize command dials	📋
f8	Release button to use dial	OFF

Nikon

f1 Multi selector center button

Shooting mode	RESET
Playback mode	🔍 ▶
Live view	•REC

Nikon

I have quite a teddy bear collection now (since the boys moved out) that often goes on field trips. I have three—one black, one tan, and one white—that are 12" tall that I use in my photography. They have taught me much, and can help you quickly learn how much exposure compensation you'll need to see, feel, and communicate the emotion of light. The goal of this exercise is to provide you with a set of images where you can visually see the effect of exposure compensation on a variety of tones in a variety of situations that you can then keep in mind for real life situations.

You'll need to have a black and a white subject for the test (I add a tan one to certain shots). I recommend stuffed animals with glass eyes (they are able to reflect catch lights). You'll also need to have a number of situations where you can photograph the subject, and a zoom lens in the 75–300mm range (an 80–200mm will do). The metadata will record all your notes for you.

A helpful hint: you can make shadows on the subject and background using a towel, a sheet of cardboard, or a diffusion flat (like those from Lastolite). Simply place them to block the light where and when needed. It can make the test go faster if you leave the camera and subject the same and just change the lighting patterns to fit your needs. Once you're all done, load all the images into one folder and look at them over and over again. Your taste in exposure will mature with time.

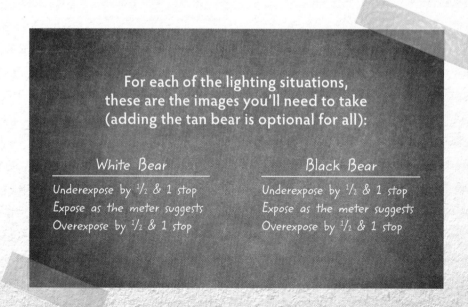

For each of the lighting situations, these are the images you'll need to take (adding the tan bear is optional for all):

White Bear	Black Bear
Underexpose by ½ & 1 stop	Underexpose by ½ & 1 stop
Expose as the meter suggests	Expose as the meter suggests
Overexpose by ½ & 1 stop	Overexpose by ½ & 1 stop

Here are the nine lighting situations you will need to set up to shoot those images:

Situation 1: Full shadow on subject and background.

Situation 2: 50/50 shadow on subject; full shadow on background.

Situation 3: Full sun on subject; full shadow on background.

Situation 4: Full shadow on subject; 50/50 sun on background.

Situation 5: 50/50 shadow on subject and background.

Situation 6: Full sun on subject; 50/50 sun on background.

Situation 7: Full shadow on subject; full sun on background.

Situation 8: 50/50 shadow on subject; full sun on background.

Situation 9: Full sun on subject and background.

INDEX: